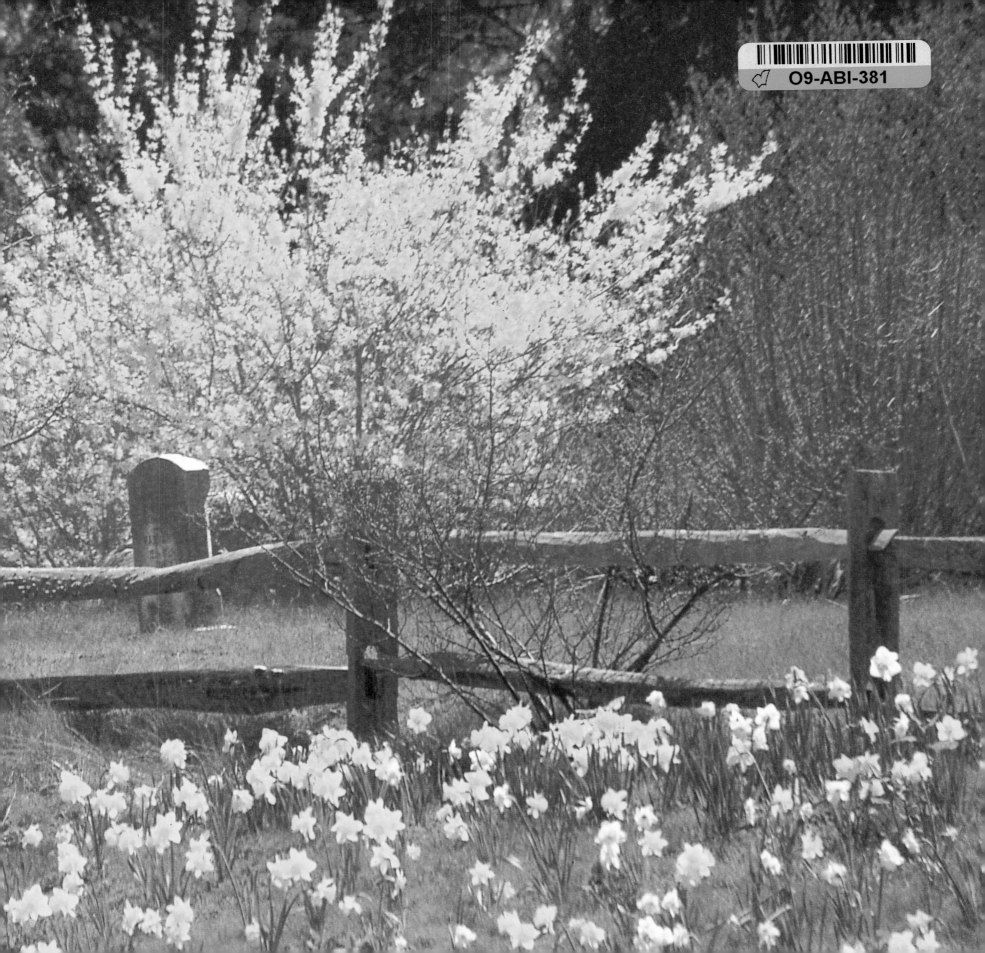

Cape Cod

GARDENS AND HOUSES

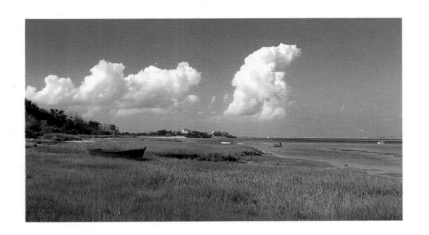

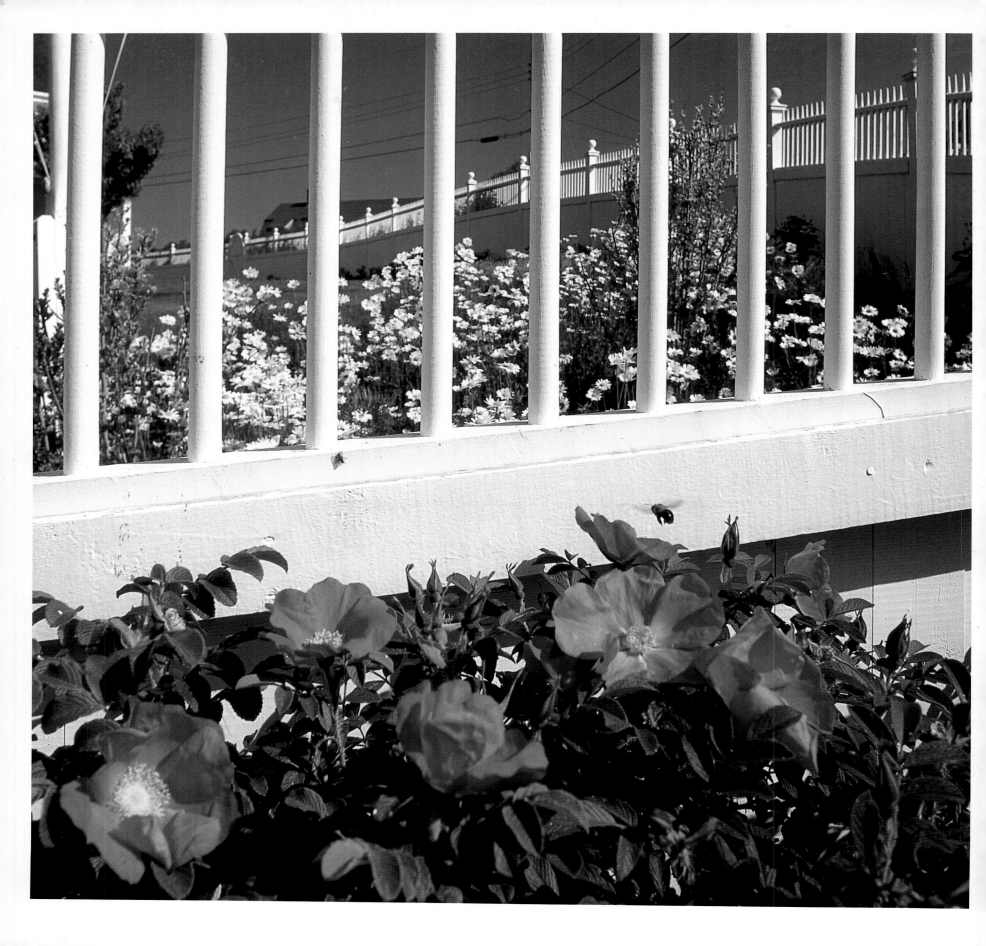

Cape Cod

GARDENS AND HOUSES

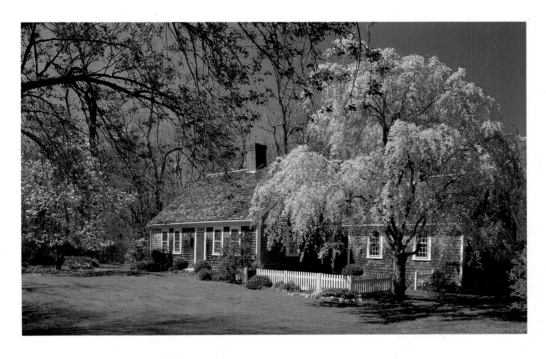

PHOTOGRAPHY BY TAYLOR LEWIS

WITH GREG HADLEY

TEXT BY CATHERINE FALLIN

Simon & Schuster

NEW YORK LONDON TORONTO SYDNEY TOKYO SINGAPORE

For Taylor,
who saw beauty in the world
from all angles
and who taught me
to see so much

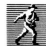

Designed by Taylor Lewis, Robert Reed, and Jeffrey L. Ward

Printed in Italy

2 4 6 8 10 9 7 5 3

Library of Congress Cataloging-in-Publication Data

Lewis, Taylor Biggs.
Cape Cod : gardens and houses / photography by Taylor Lewis ; text by Catherine Fallin.
 p. cm.
Includes bibliographical references and index.
ISBN 0-671-86859-4
1. Architecture, Domestic—Massachusetts—Cape Cod Region—
Pictorial works. 2. Interior decoration—Massachusetts—Cape Cod
Region—Pictorial works. 3. Gardens—Massachusetts—Cape Cod
Region—Pictorial works. I. Fallin, Catherine. II. Title.
 NA7235.M42C3744 1995
728'.37'0974492—dc20
 93-40741
 CIP

Acknowledgments

A book like this cannot exist without the generosity of many people. First and foremost we would like to thank the home owners, designers, and garden lovers who allowed us to take over their lives for a brief but intense stretch and who have become, we hope, lasting friends in the process. The most exciting part of writing and photographing a book like this is the people we meet who not only open their homes and gardens to us but also share with us their enthusiasm for design and interesting and intriguing places and people. Sharing their processes of restoring an old house or designing a new home or garden, choosing its colors and shapes, its lights and shadows, its marriage to its site, and feeling the excitement of its creation, is a joy to us.

We would like to thank Doris Cipolla, Priscilla Gregory, Jack Smith, Mac Perna, and the Yarmouthport Historical Society for getting us started and helping with historical facts; Paul and Diane Madden for their enthusiasm and support for our project and for introducing us to wonderful places and people; Rick Jones, Bill Baxter, and Bill Whitney for sharing their favorite homes and gardens and so much of their time; Ruth Streibert of Greensleeves for introducing us to the delights of Chatham. To Paul and Diane Madden, Rick Jones, Elizabeth Talbot, Tom and Ashby Crafts, Helen Baker and Duncan Berry, Page MacMahan and Will Joy for so generously giving us not only bed and board but also, most of all, friendship beyond the bounds, thank you from the bottom of our hearts.

As before there are the behind-the-scenes heroes of any book like this, our intrepid editor, Patty Leasure, and our steadfast agent, Pat Breinin, who never lost faith in us; our energetic and unerring copy editor, Shelly Perron, and proofreaders Susan Groarke, Nancy Inglis, and Pam Stinson, who saved me from embarrassment of never-to-be-admitted errors and burned the midnight oil with me yet again; Peggy Schwier and Michael Bertollini, who checked and cross-checked my facts. To Bob Reed, who came all the way from Sweden and offered not only his design expertise but his friendship as well; to Jeff Ward, who has more patience and fortitude in addition to his design talent than anyone I've ever known; thank you. To old friends Polly Wolbach, Kathie Gordon, and Pam Stinson, who came from far and near and sorted and numbered and labeled transparencies.

To Greg Hadley, who once again was not only the best assistant we ever had but also became an unfailing partner in continuing this project as professionally and tirelessly as his mentor. Only you can know how much that means to both of us.

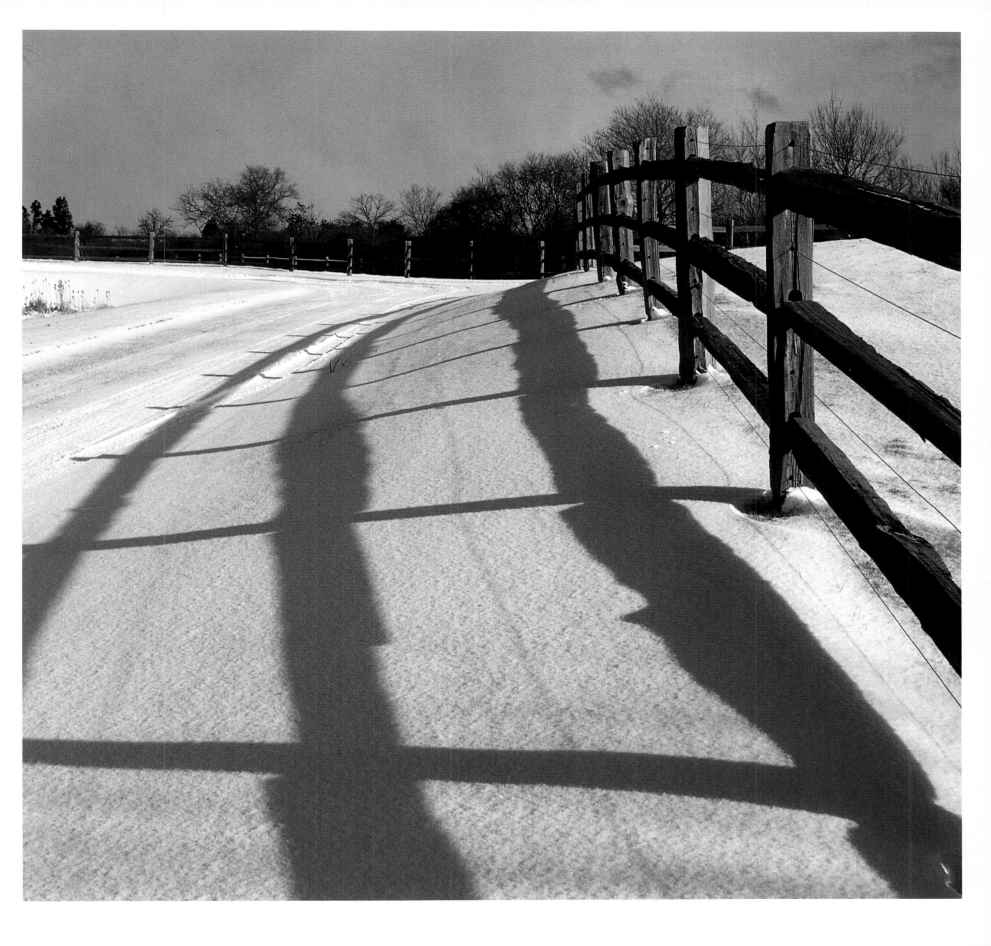

INTRODUCTION

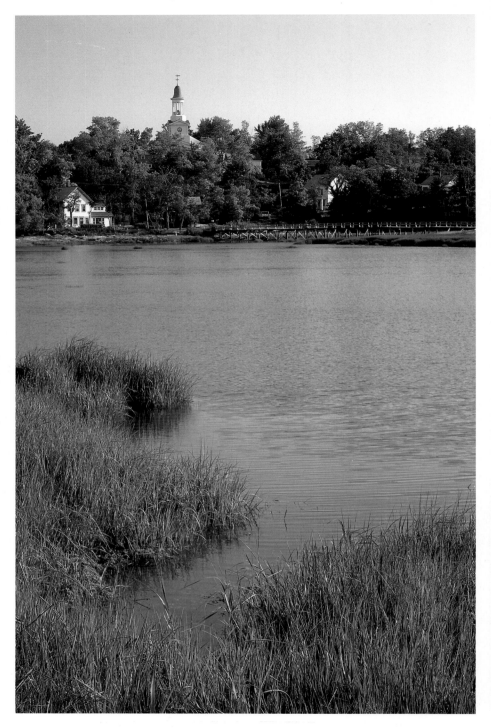

Cape Cod conjures up images of soft sandy beaches and sublime summer vacations; romantic tales of hearty seafaring men on clipper ships and whaling vessels, and stalwart *Mayflower* Pilgrim settlers. Rich in history, Cape Cod was one of the earliest settled areas in New England, with the Pilgrims first landing at Provincetown before going on to Plymouth.

The Cape Cod of today possesses a mixture of architectural styles dating from the 1600s. There are traditional Cape-style gray-shingled cottages and two-story Colonials with clapboard fronts; there are tiny summer cottages and beach houses, grand summer homes of the turn of the century and later, when the giants of industry flocked to the cooling summer breezes and clean air of the Cape from New York, Boston, and points beyond. Cape Cod has attracted a blend of hearty New Englanders and European settlers from its earliest days right up to the present. Many of the Cape's full-time residents remember blissful summers spent there in childhood, while others trace their families directly back to the *Mayflower* and the Plymouth colony, for the first year-round settlement on the Cape was in 1639.

Though Cape Cod has long been associated with the sea, the first Cape Codders were farmers. They found a land of vast salt marshes that needed no clearing in order to graze their cattle and sheep. They first built inland at the head of the Cape, for it was more protected from the wild sea storms and because there was fresh water in ponds and streams. Much of the land had been farmed successfully by the Native Americans who preceded those first colonists and who had enriched the soil with fish fertilizers and shells.

Cape houses, which have been built all over New England and copied all over the country, were reminiscent of the little yeomen's stone cottages—only built of wood—in England, where most of the farmer-settlers hailed from. Of course with the Cape's proximity to the sea, farming naturally progressed to fishing as a source of food and merchant sailors began to trade around the world. Shipbuilders began by building fishing boats and flat-bottomed whaleboats and the first catboats but soon were building the huge square-riggers that crossed the seas and went round the world. There are many sea captains' houses scattered about the Cape in Barnstable, Falmouth, Brewster, and Wellfleet.

The topography varies, from the soft rolling farmlands and flat

salt marshes of the Upper and mid-Cape to the irregular southern coastline of Nantucket Sound on the south. Wide estuaries and bays are protected by barrier beaches and dotted with islands. Farther out the Cape the shoreline becomes more rugged, with the turn of the Cape at the elbow at Chatham, which has forty miles of shoreline, twenty of which is ocean side. High on bluffs carved by the sea and wind are lovely summer homes, old ones built for sea captains and the "newer" ones for city dwellers.

Gardens thrive on Cape Cod and display no end of variety. Roses clamber over trellises and fences, rosa rugosa covers the shoreline. Bayberry, beach plum, shad bush, and marsh grasses hug the dunes and grow right up to the beaches.

Cape Cod is full of natural beauty in every season of the year. In the early spring, fields of snowdrops peek through the snow, then crocuses, narcissus, and later on tulips bloom. Fruit trees in old orchards as well as newly planted crab apples, cherries, and apple trees are also in flower. Lush rhododendrons in every color imaginable, azaleas, and Scotch broom abound in late May and early June. Mayflowers fill the woods; wisteria covers arbors and trellises and climbs chimneys and tree trunks. Lilacs and irises fill cottage gardens and line walkways and drives.

In June the summer begins, and with it, lupines and columbines appear; wild rosa rugosa and old roses, both climbers and shrubs, are followed by profusions of pinks and reds and whites, roses that climb walls and trellises, are planted formally with lavender, and cover porch rails and fences. Daylilies are everywhere in shades of oranges, yellow, and the new hybrids of everything from frothy pink to deepest orange and russet reds. Old-fashioned gardens of perennials of foxglove and delphiniums, larkspur and daisies, are tucked behind high privet hedges or low stone walls. Annuals such as zinnias in riots of color fill raised beds by the sea or add sparks of color to borders. A little of everything is planted in window boxes and wildflower meadows.

September brings the first touch of autumn to the Cape, where

the vibrant colors of a New England fall are softened by the more temperate climate of the coast. Marsh grasses turn golden, maples and oaks turn scarlet and gold, native shrubs turn bright red in the woods while farmers' fields are filled with pumpkins and squashes of every kind. The skies are crystal clear and deep blue with high scudding clouds. The sea is everything from calm to storm-tossed and turbulent, but mostly the days are full of sparkle. Children

return to school and summer residents return to their city homes. The crowds of summer visitors dwindle and the Cape settles back to the steadier pace of the people who live and work there year-round. The days and nights soften, the air is crisp, and the light becomes increasingly golden.

November signals the approach of winter. By then there are usually killing frosts and the flowers are gone, the trees are bare, boats are hauled for the winter, and storm shutters and windows are put up. Winter is probably the most dramatic of the seasons. Fierce nor'easters blow in with extreme high tides and strong winds; often deep snows cover the Cape, and the marsh grasses freeze. Ice is crusted on the marshes and ponds, snow covers the dunes and stone walls and blankets everything in glistening white. Dense fogs roll in, making roaring fires in fireplaces all the more appealing for their warmth and cheer.

The character of the Cape is marked by the people who live there, and each village has a personality of its own, defined as much by its residents as by its topography and its history.

Provincetown, Truro, and Wellfleet make up the Outer Cape, beyond the elbow, which is mostly marshes and windswept beaches and dunes bounded by the Atlantic on the east and Cape Cod Bay on the west. Commercial fishermen and artists make up the majority of the year-round populace. There are not too many full-timers on the Outer Cape, but those who live there are resilient and re-sourceful, and their New England sense of humor sees them through the long and often bleak winters.

Eastham, Orleans, and Chatham hug the elbow of the Cape and are home to commercial fishing fleets in the protected harbors at Chatham. Large numbers of summer residents are balanced by a healthy year-round community. Ponds and beaches, protected coves and high bluffs, overlook snug harbors and long stretches

houses. At times the road runs close to the marshes and over the rolling farmland; the sea can be glimpsed behind stone walls.

Hyannis, Harwich and Harwichport, Osterville, and Centerville on the south are legendary for their beaches and varied summer communities. Cotuit and Waquoit are small coastal hamlets tucked away on the south shore. Falmouth and Wood's Hole with their own blend of Cape Cod seafaring history and picturesque homes make up the southwest side of the Cape, where ferryboats embark for the Islands offshore.

Sandwich heads the Cape on the northwest side and is a historical collage of seventeenth-century cottages as well as the site of the nineteenth-century factory town that was home to the Sandwich Glassworks.

Today all the villages on the Cape have their share of wonderful antique stores, bookstores, and handmade crafts. There are fine wood carvers, sign painters, boat builders and restorers; specialty painters create everything from signs and boat buckets to doing interior glazing and decorative floor and wall painting. The tradition of fine craftsmen and the creative spirit of artists and designers and writers combine with Yankee ingenuity and perseverance to make Cape Cod a land of dreams and beauty.

We hope to show you some of its treasures with a sampling of the Cape's most special homes and gardens interspersed with some of our favorite glimpses of natural beauty.

of sea and beach. Chatham is typical of many New England coastal villages. Pirates roamed these waters, looking for ships to pillage. "Mooncussers" roved the beaches looking for ships that had broken up on the treacherous shoals or coaxing them aground.

Dennis, Yarmouthport, and Barnstable line Old King's Highway and are reminiscent of the heart of New England, with old trees touching over the road in summer, shading the old sea captains'

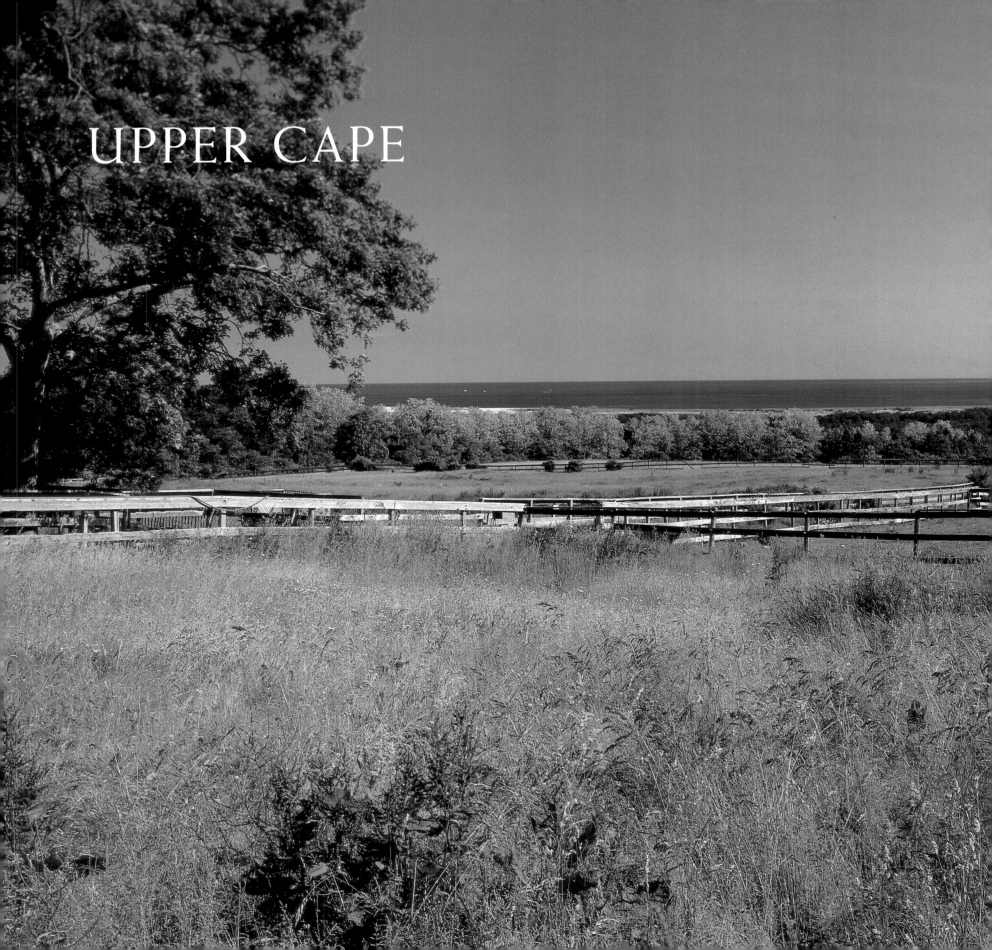

UPPER CAPE

A brick in the great-room fireplace bears the date of 1740, and it is likely that this Georgian-style Colonial house was constructed in that year, probably as a modest one-sided house, which was added on to throughout its life. The house was reportedly built by one of the Bourne family, whose ancestors were founders of Sandwich, the first settlement on the Cape, incorporated in 1639. The first settlers were farmers, and their stated purpose in settling the town was "to worship God and make money." They chose Sandwich for its proximity to an established trading post and to the salt marshes, which provided fodder for cattle without having to clear any forests.

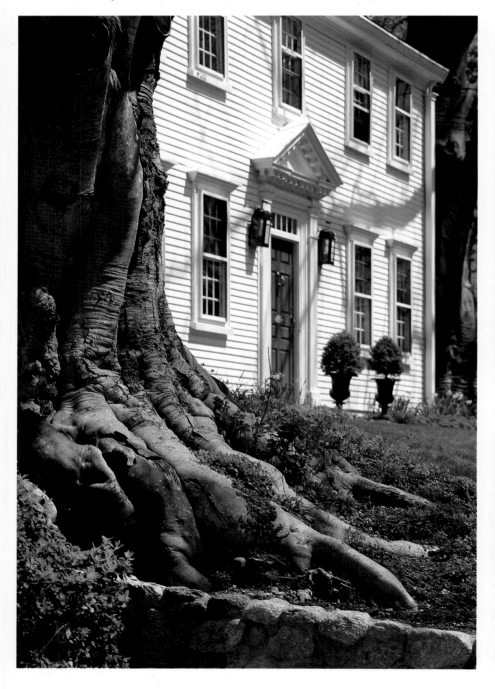

Built about a hundred years after the town of Sandwich was incorporated, Uplands is set unusually far back from the road. Paul and Diane Madden bought the house in 1984 and began restoring and renovating. They added the large master bedroom wing on the left and doubled the size of the kitchen by adding a corner fireplace and a comfortable sitting-dining area. Inside, the floors

and woodwork are hand-painted in patterns and traditional colors. Many of the furnishings were chosen for their reflection of the great eighteenth- and nineteenth-century relationship among Nantucket, Martha's Vineyard, and Sandwich. Being antiquarians and collectors of art and antiques, folk art, handmade crafts, cookware, and serving pieces, the Maddens have changed the dark old house into a warm and gentle mix of traditional and colorful details.

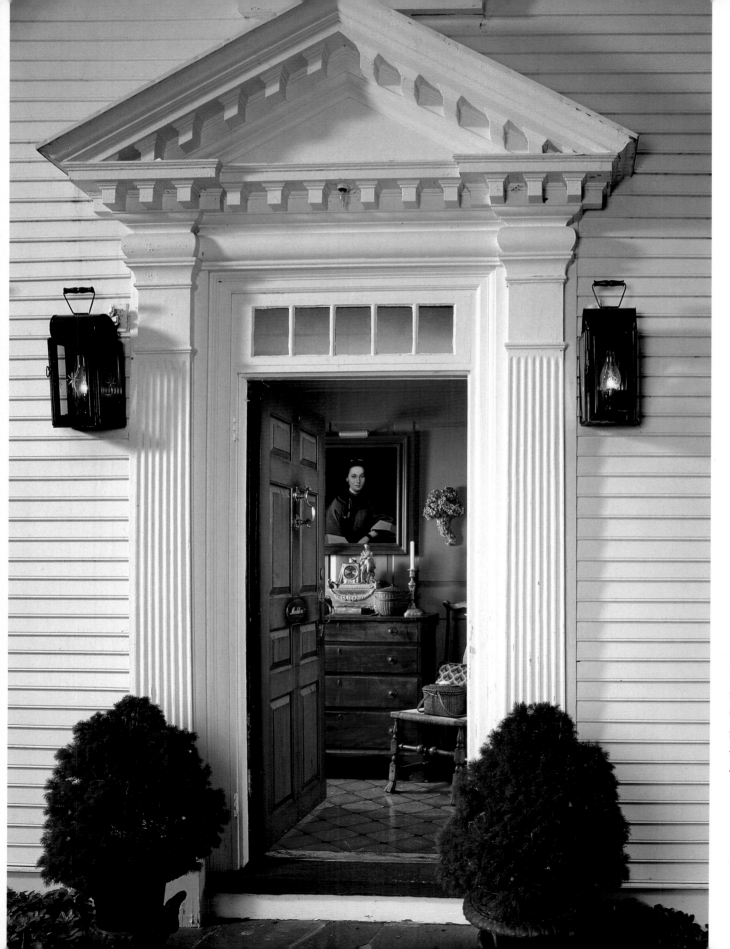

Inside the entrance hall, a nineteenth-century portrait of a Chinese courtesan hangs above a four-drawer Cape Cod chest, which holds a bronze doré clock with a figure of Napoleon on it.

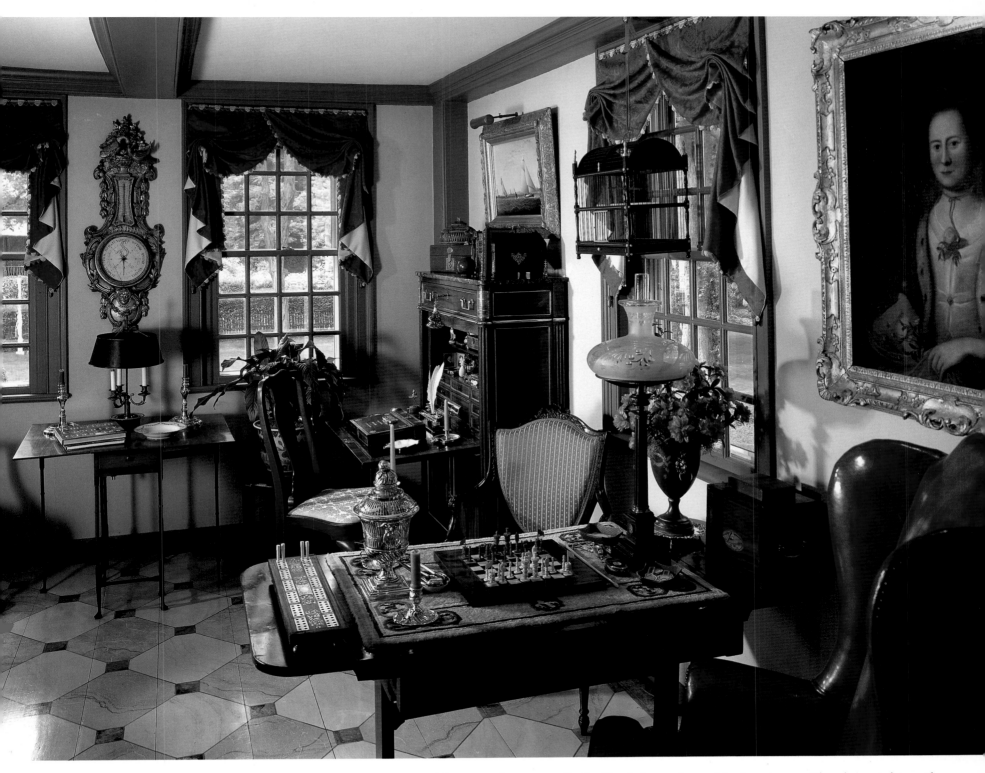

In the front parlor, an eighteenth-century mahogany spider-leg table holds a pair of eighteenth-century Italian silver candlesticks. An early-nineteenth-century gilded French wall barometer hangs between the front windows with window treatments designed by Diane in the style of the period. In the corner is a French abattant owned by the American portrait painter John Alexander, who was from Boston. In the foreground, the English gaming table is set up with a late-eighteenth-century Dutch chestnut urn, a nineteenth-century ivory-inlaid chess set with oriental export chessmen, and a mid-nineteenth-century ivory-inlaid cribbage board. To the right is a portrait of Eleanor Young painted by Charles Wilson Peale, c. 1770. The floors here and throughout the house were painted by John Canning of Connecticut.

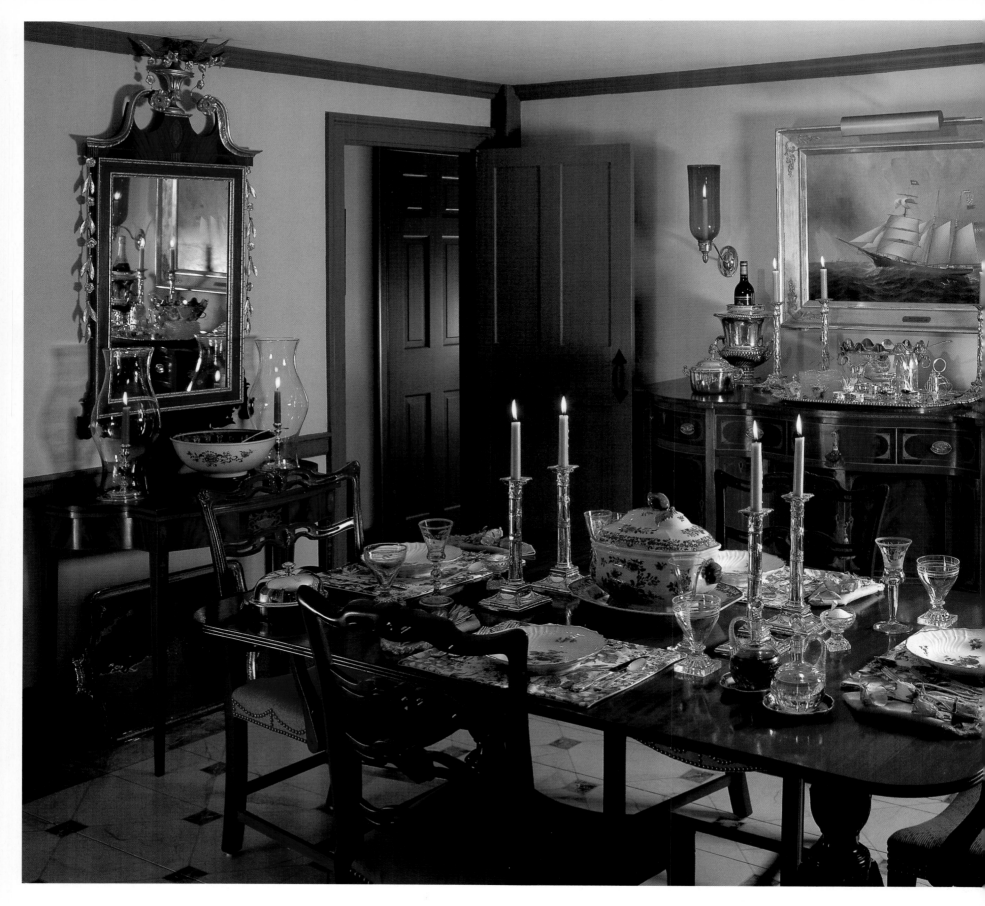

The dining room table is set with eighteenth-century Sheffield candlesticks, early-nineteenth-century French porcelain, and coin silver flatware. In the center is a Chinese export tureen with original stand, c. 1760. On the left is a gilt Hepplewhite mirror above a Hepplewhite card table. The inlaid Sheraton sideboard holds Sheffield period wine pails. A pair of early cranberry glass hurricane sconces flank a portrait of the ship *Melville Bryant*, painted by Elijah Taylor Baker, c. 1870.

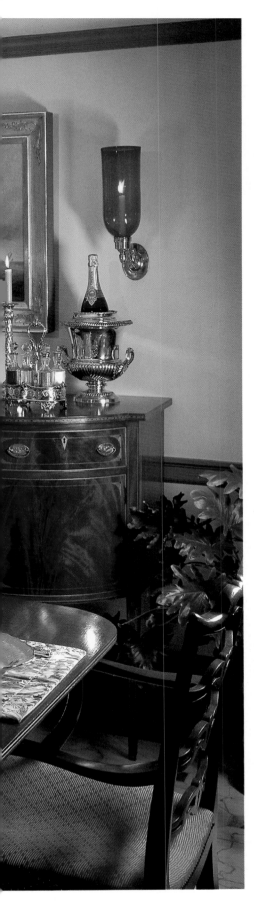

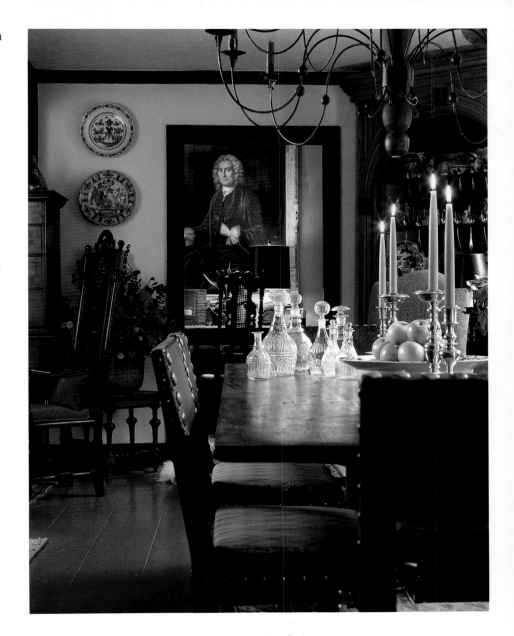

Seen through the doorway, at the end of the great room, is a portrait of Judge Benjamin Young of Maryland, who is a direct ancestor of Paul's, painted c. 1754 by the English court painter John Wolleston. The chair to the left of the door is a Jacobean cane-back armchair. Rare Sandwich glass decanters grace the long trestle table.

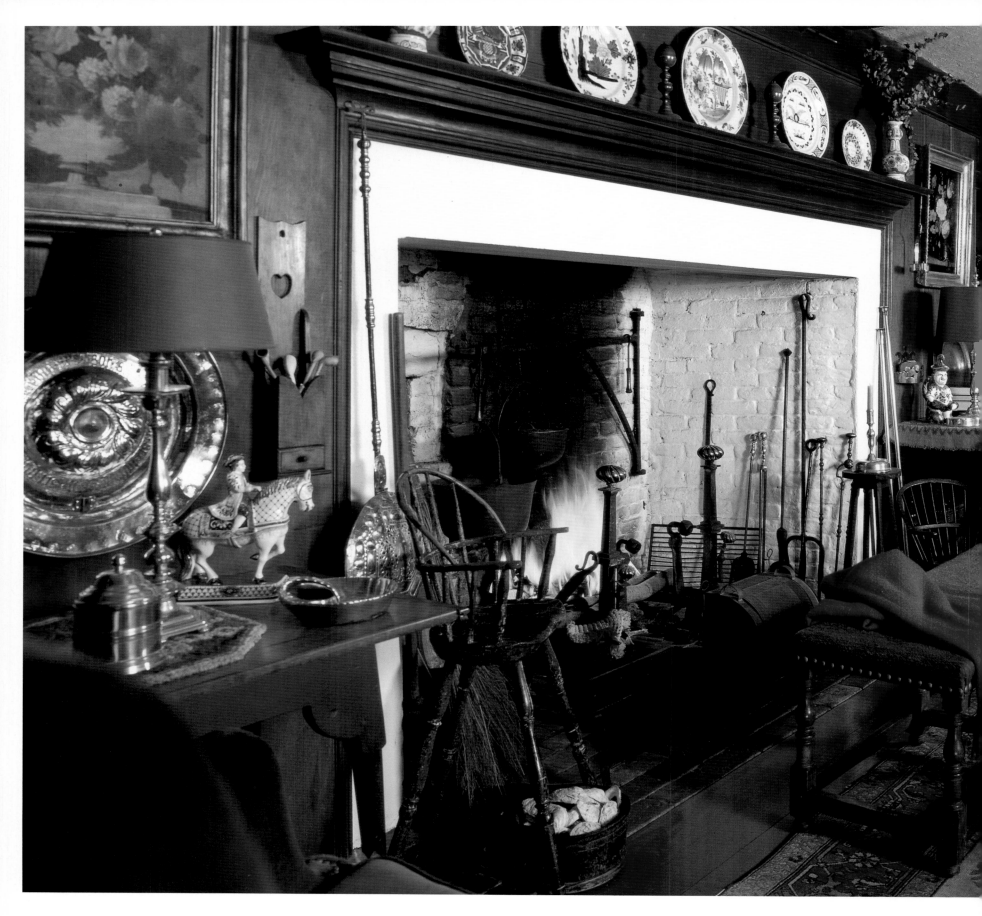

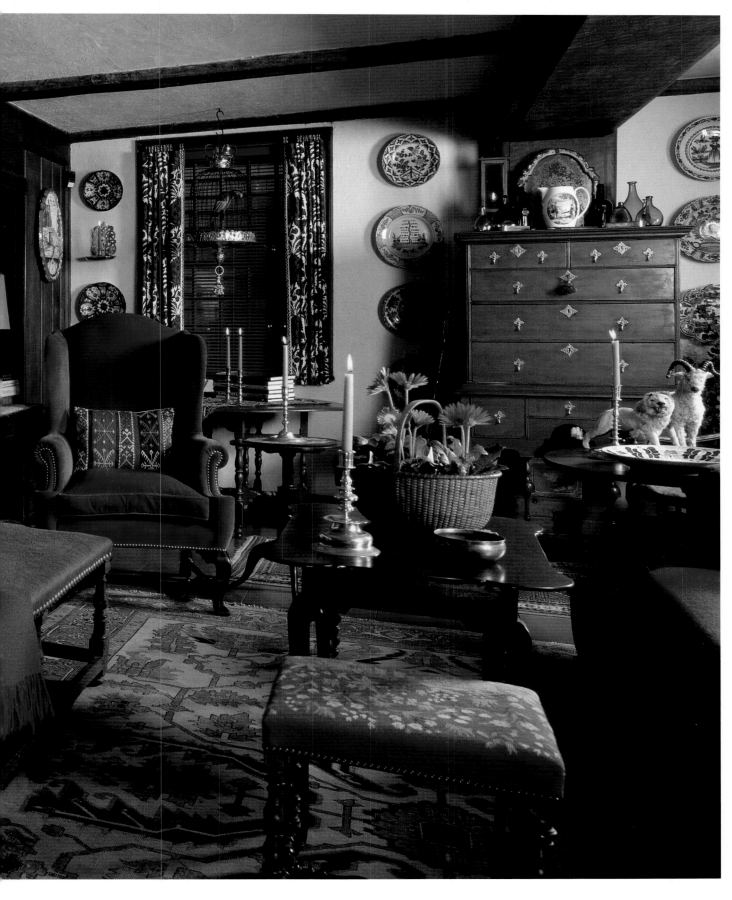

The great room is furnished with early-eighteenth-century pieces that reflect the Maddens' personal interest in early Queen Anne style. English and Dutch chargers line the mantel over one of the largest fireplaces on Cape Cod. Polished brass accessories, Cromwellian pull-up stools and chairs, the blue resist pattern of the window treatment fabrics, all represent the influence of eighteenth-century China trade. The large rug is a Serapi.

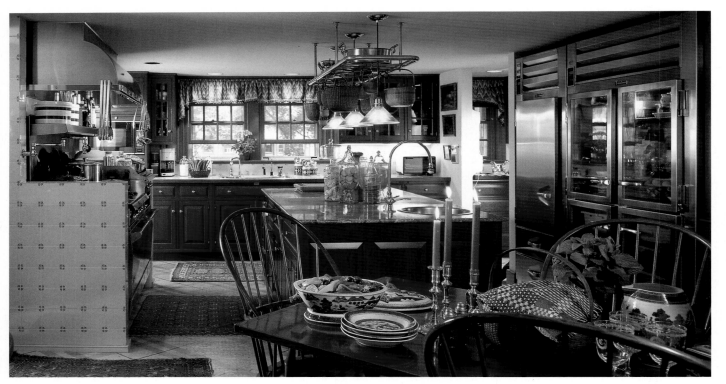

LEFT: The design of the kitchen, carefully planned by Diane, more than doubled the size of the original space. The large Vulcan stove, the glass-front refrigerators on the opposite wall, and the spacious center island bespeak Diane's love of food and its elegant preparation and presentation. Over the work island hang some of Diane's collection of Nantucket lightship baskets, filled with shallots, garlic, and other essentials for the kitchen.

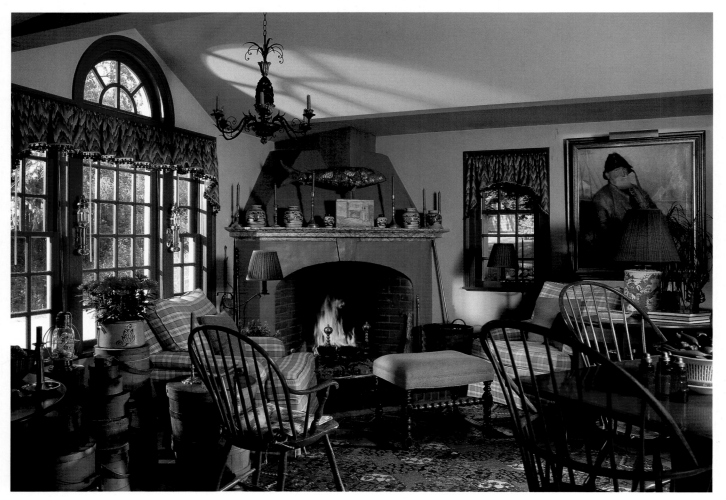

LEFT: The large windows and spacious corner fireplace with the red Bokara rug combine to give the room its warmhearted feeling. On the mantel above the fireplace is a nineteenth-century New England codfish weather vane among pairs of Canton ginger jars. The large painting, *Provincetown Neptune*, was painted by Gerrit Beneker in 1915. A painted American Windsor is pulled up near the fire.

BELOW: In this corner of the kitchen a Flemish-foot armchair covered in flame stitch complements the unusual surface colors of some of Paul's collection of Nantucket painted and decorated pantry boxes—firkins (with swing arm handles), piggins (single-handled), and kanekins (double-handled).

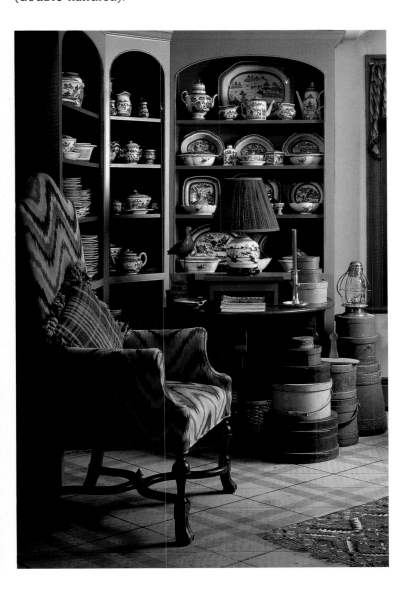

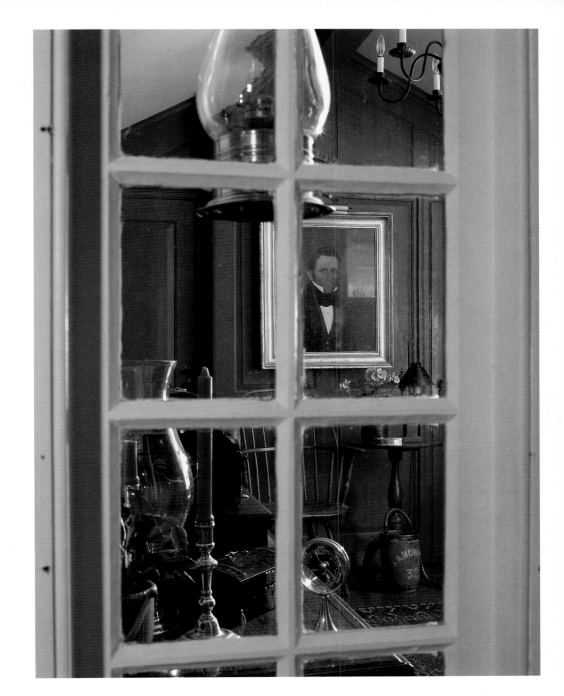

ABOVE: Through the hallway window can be seen a portrait of Captain John Pease of Martha's Vineyard, painted c. 1840. Beneath it is an American sack-back Windsor next to a Nantucket candle stand and a Sandwich fire bucket.

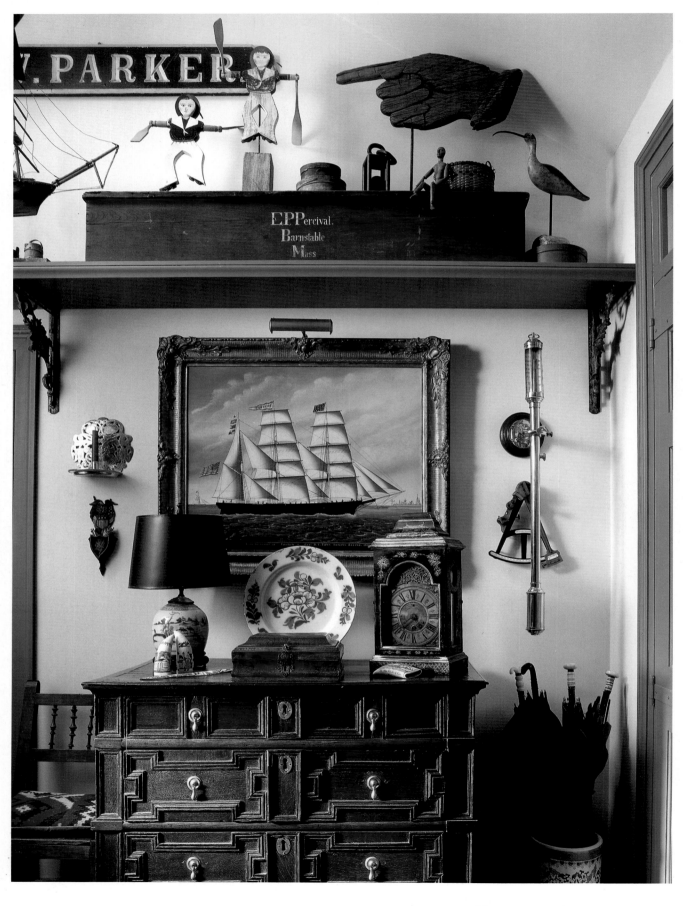

A tall hallway makes the transition from the great room to the new master bedroom suite. Furnished with an eclectic mix of English and American objects—an English ball-foot William and Mary chest with an English bracket clock on top along with a chinoiserie lamp, a large English delft charger, and examples of mid-nineteenth-century American scrimshaw. Above the chest is a portrait of the *Bark Belvedere of Boston,* painted by Carolus Weyts in 1867. To the right, a reproduction gimbaled barometer hangs above and over a brass quadrant signed by T.A. Gardner, Nantucket, who was a purveyor of marine instruments of the time. Above all this, the long shelf holds two Nantucket sailor whirligigs, a chart box that belonged to Edward P. Percival, Barnstable, Massachusetts, and a pointing hand weather vane from the old Cent School on Nantucket.

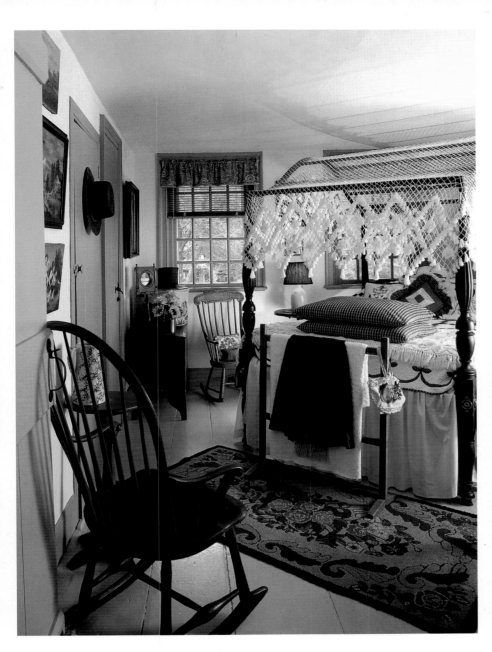

An upstairs guest room features a mid-nineteenth-century tester bed, a late-eighteenth-century Philadelphia rocker, a child's painted and grained rocking chair, an early blanket chest, and a hat box. On the closet door hangs an early jack tar sailor's hat, made of canvas and straw and painted with tar.

The master bedroom is decorated in cream and pink, which accentuate the snug feeling of the fireplace, with its pair of andirons with double lemon tops signed by O. Phillips, a New York maker. On the mantel is a Staffordshire lion. Above it is a portrait of the ship *Swordfish*, an extreme clipper, painted by Antonio Jacobson. Between the windows is a late Federal mirror with its original lemon gilt.

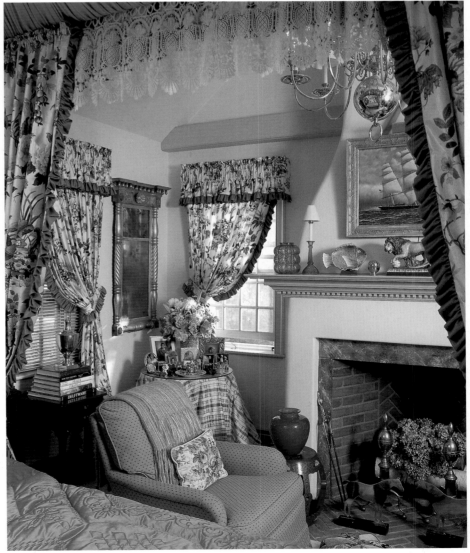

The barn is a replica of the original one on the property. The pond, formed by a large recessed area on the property, was dug out to supply the fill for the Sandwich town hall. It is now stocked with more than 350 koi fish. In early June, yellow, purple, and white irises are in full bloom while the lotus flowers are still in bud. Some time near the turn of the century, the property was left to the state of Massachusetts for an experimental farm and was known as Uplands Farms. Behind the house the land is terraced and was the site of a vineyard. The remains of an extensive irrigation system and a greenhouse are evident. Wonderful old trees—beeches, ginkgoes, American and English elms, a tulip tree, chestnuts, maples, cherries, and lotus—many unusual for the Cape, as well as a variety of fruit trees from the farm's orchards are found all over the property.

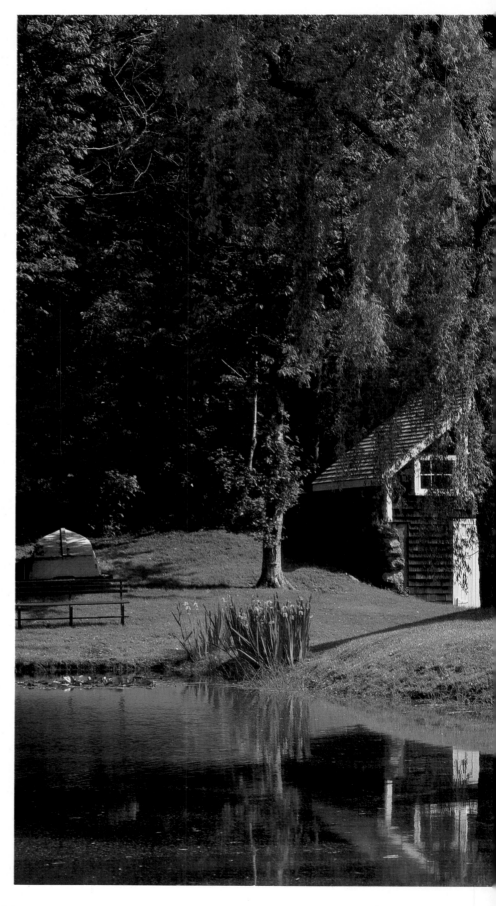

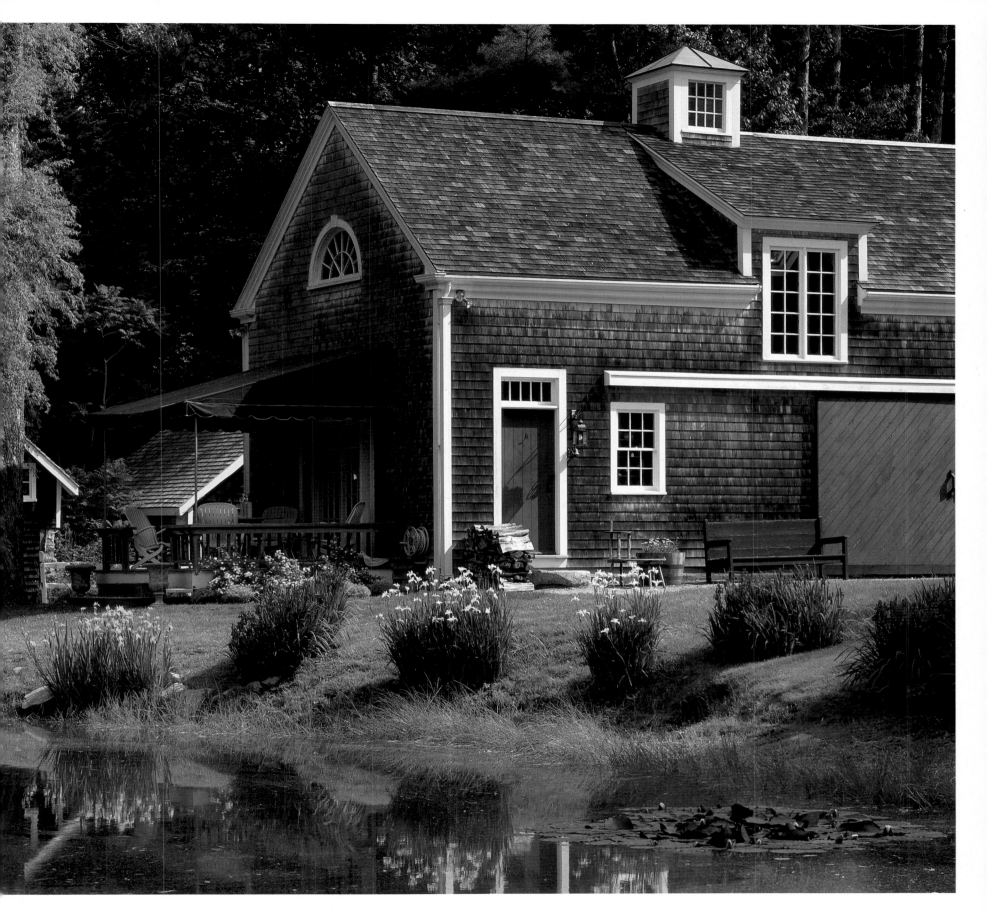

Near Sandwich, an old white farmhouse is nestled beneath ancient shade trees. Around 1835, the house was dragged by oxen to this site from its original location. A Greek Revival front was added later as well as several outbuildings. The entire property is a natural garden, belonging to Dr. Shirley Cross, a botanist who raises the wildflowers for the nearby Green Briar Nature Center, which is part of the Thornton Burgess Society in Sandwich. Paths formed from neatly stacked and tied newspapers meander through the garden. In early spring old-fashioned flowering shrubs and narcissus are bountiful. Later in the summer the large vegetable garden is surrounded by cutting beds of annuals and perennials. Twigs and sticks from surrounding trees are used to make garden stakes. Dotted around the property are brightly painted whirligigs and birdhouses on top of poles fashioned from tree limbs. As the seasons evolve so do the colors of the flowers.

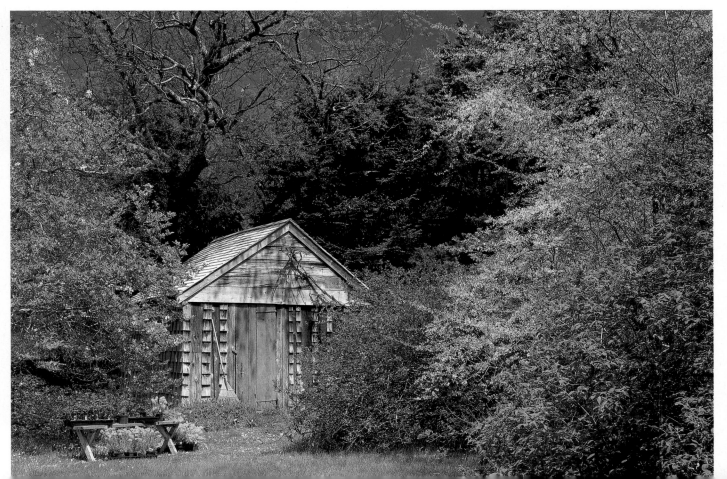

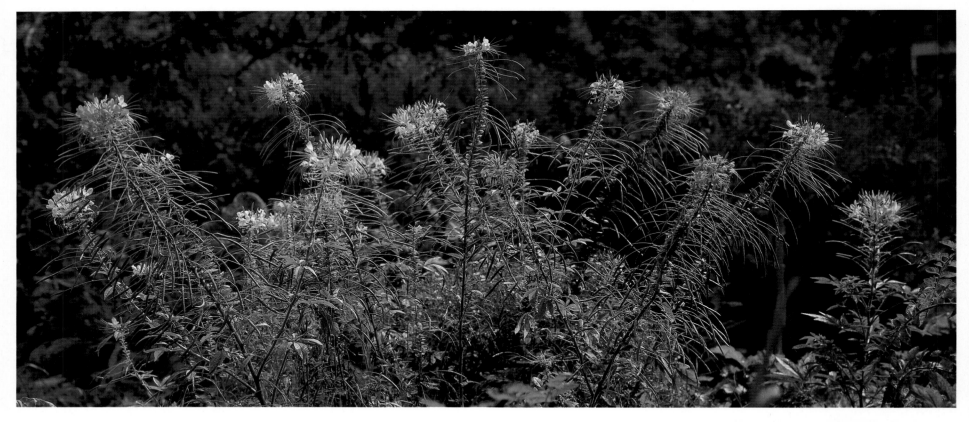

In August, cosmos, cleome, zinnias, and dahlias in riots of color are in profuse bloom in cutting beds in front of the vegetable garden.

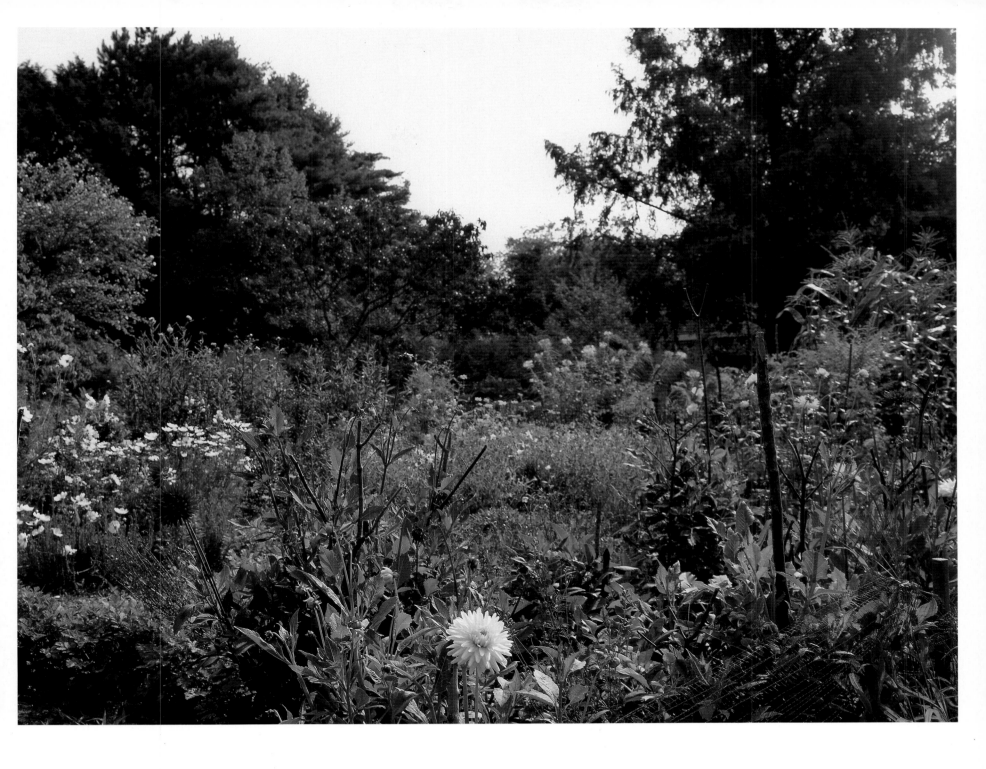

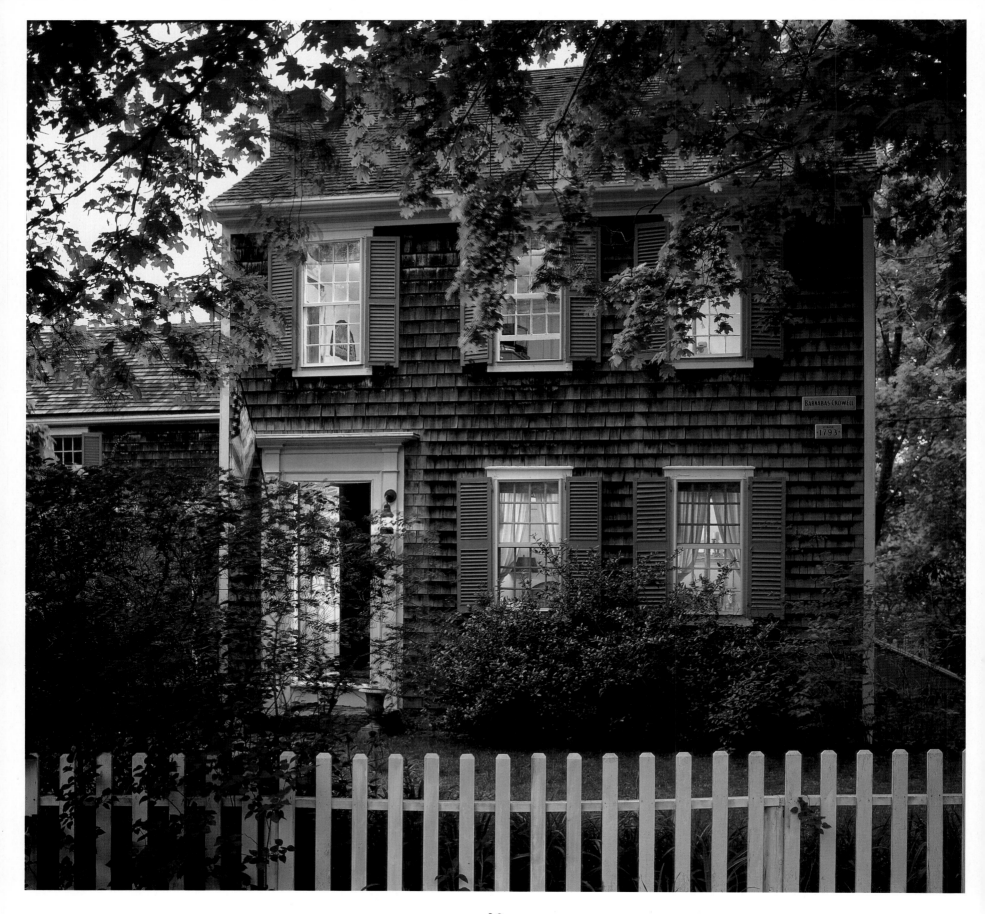

WINGATE CROSSING

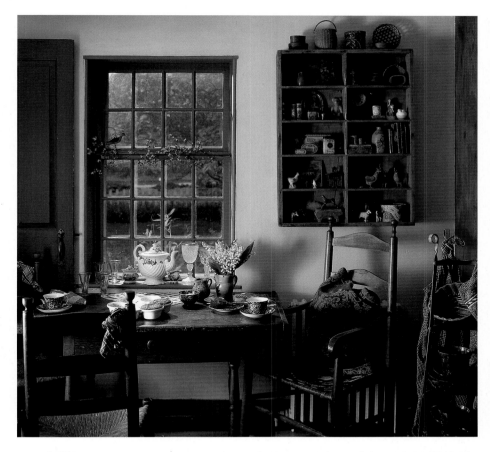

Wingate Crossing is a combination of three structures, a one-story kitchen attached to a one-and-a-half-story three-quarter Cape attached to a two-and-one-half-story Colonial. Though which came first is not certain, it is thought that the three-quarter Cape was built on this site for Barnabas Crowell, who married Mary White in 1793 and probably built the house around that time. The two-and-a-half-story Colonial was built earlier, around 1750, moved to this site from down the road, and attached to the smaller house. The kitchen was most likely attached about the same time. The Crowells were early settlers of the Falmouth part of the Cape, which was first settled in 1661 by a few settlers who moved there from Barnstable on the north side of the Cape. In 1686 the town was incorporated under the name of Succonessitt, but in 1693, the name was changed to Falmouth.

Claire Borowski bought the house in 1984 and began stripping off layers and layers of old paint in order to redecorate the house as it is now. She also added a dooryard garden, built the fence, and expanded the existing herb gardens and perennial border. The house is furnished with mostly American antiques and collections of interesting things Claire likes.

LEFT: The two-and-a-half-story Colonial section of the house, which was moved from down the road and attached to the smaller house on the left.

TOP RIGHT: The country shelves next to the kitchen window were chosen to hold a cluster of some of Claire's collection of little things. There is a little teacup with the inscription "a present for Charles," a wallpaper-covered trunk, porcelain whistles, and a number of items related to poultry. Late-eighteenth-century American ladderback chairs surround the breakfast table.

RIGHT: The mantel over the large kitchen fireplace holds sheep figurines and a slipware loaf pan inscribed "Mary." The painting above the fireplace is from the late 1800s.

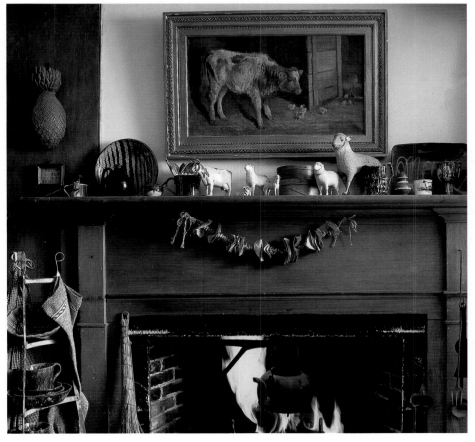

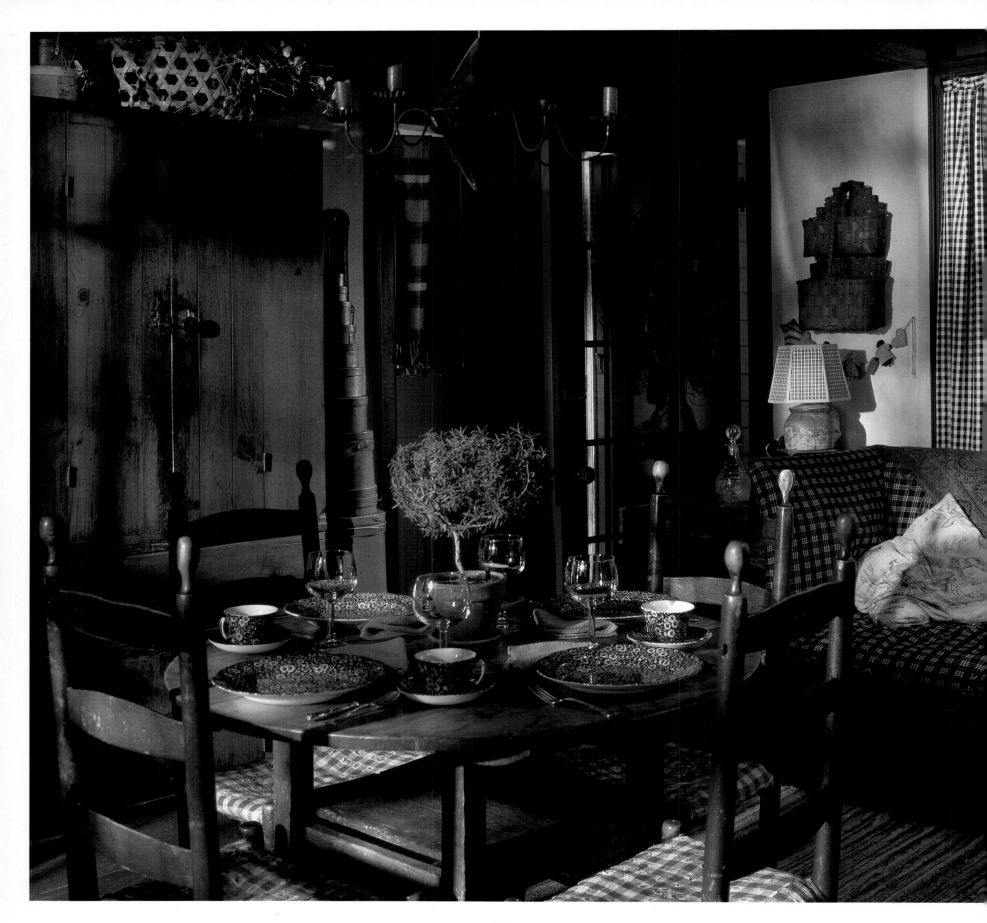

LEFT: The late-nineteenth-century cupboard has its original blue paint. On top of the cupboard is a large hexagonal cheese basket, which was used for aging cheese. Next to the cupboard is a tall stack of wooden storage boxes in candy colors. In the center of the keeping room is an eighteenth-century chair-table. Its thirty-six-inch-diameter top is perfect for the size of the room.

RIGHT: From the current pantry is a doorway into the keeping room with its paneled fireplace wall. On the table in the foreground are a stack of oval finger-lapped boxes in their old colors. The double loom basket on the wall has its original stain. The hand-woven carpets and blue-and-white-checked curtains and upholstery are typical of early-nineteenth-century Cape Cod interiors.

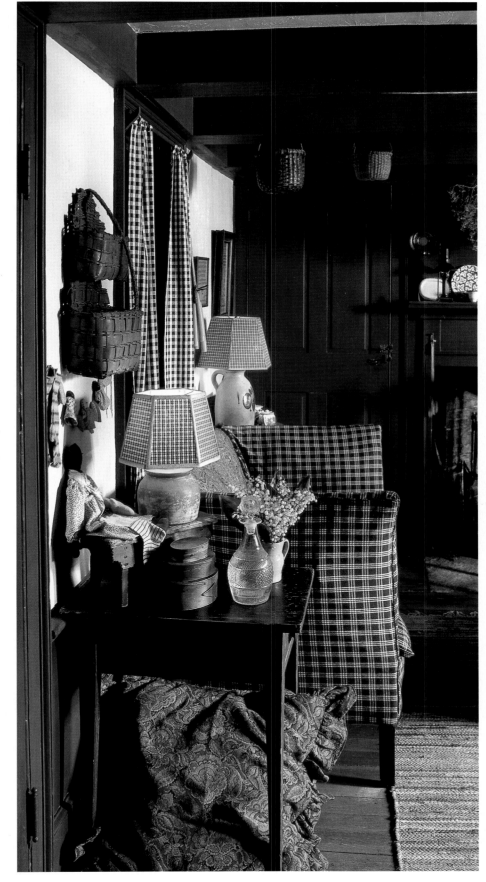

The keeping room has its original fireplace, complete with a beehive oven, which indicates that this was the original kitchen in the house. The mantel holds a collection of eighteenth- and nineteenth-century feather-edged creamware from Leeds.

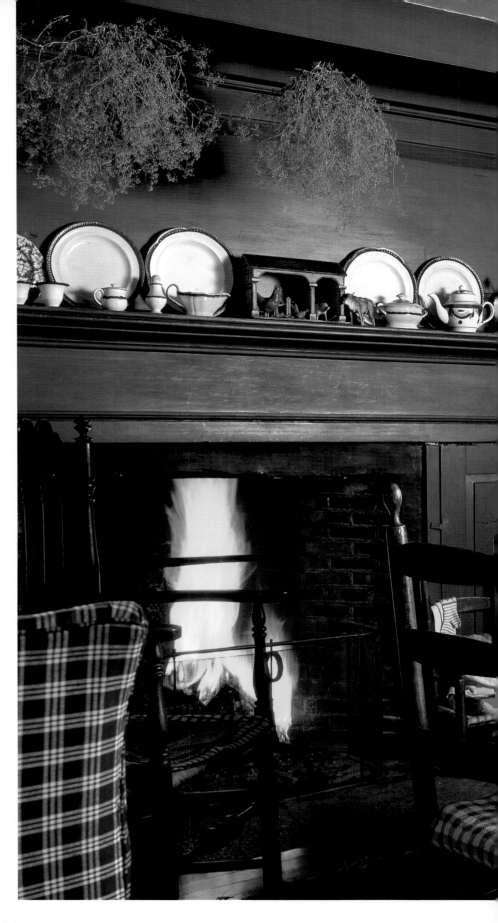

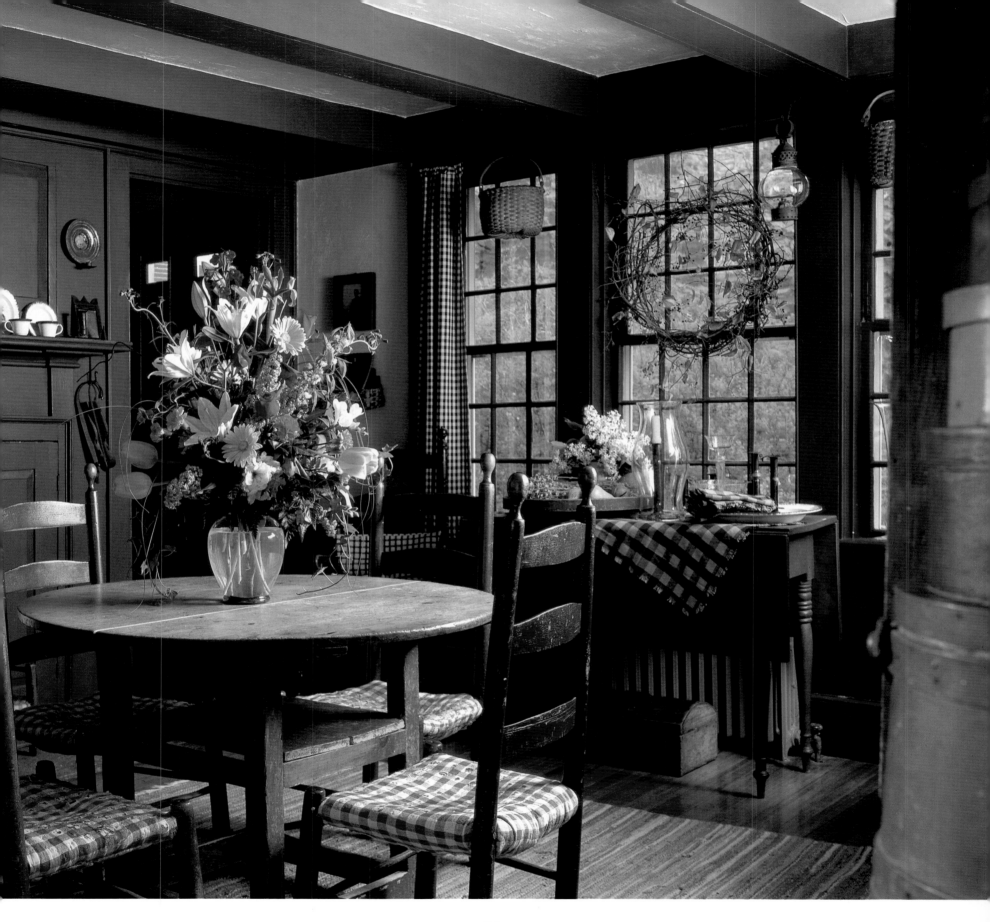

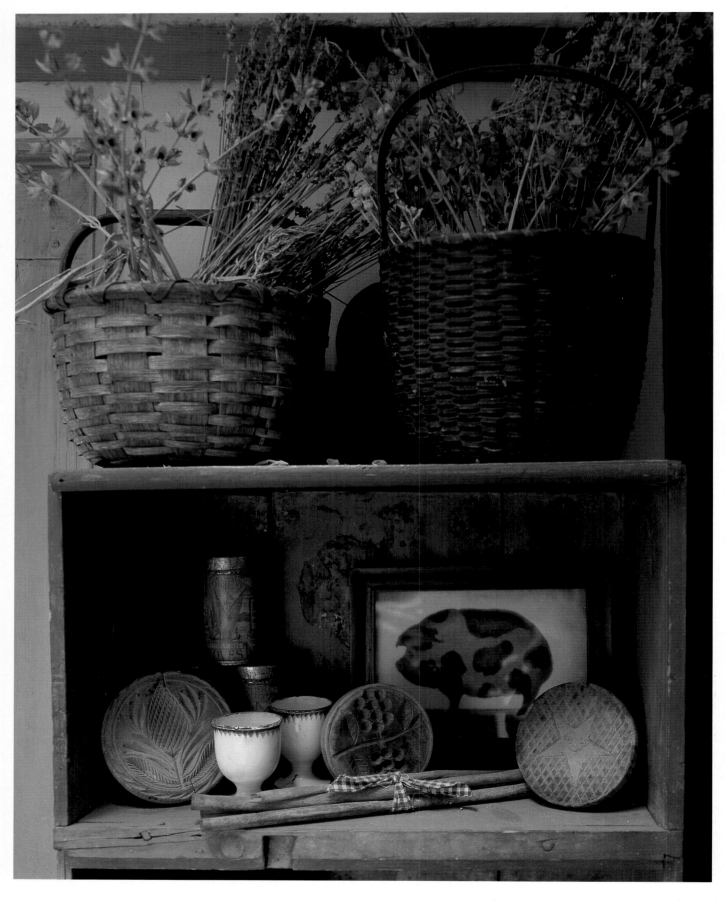

LEFT: A wall-hung cupboard in its original blue holds a painted basket, a collection of hand-carved butter prints, egg cups from Leeds, and a contemporary painting of a pig.

RIGHT: The upstairs bedroom in the Colonial section of the house overlooks the front lawn and gardens. Often referred to as a courting mirror and unusual because of its small dimensions, the mirror between the windows has a reverse painting of a church scene, c. 1820. Flowers in a redware vase decorate the table.

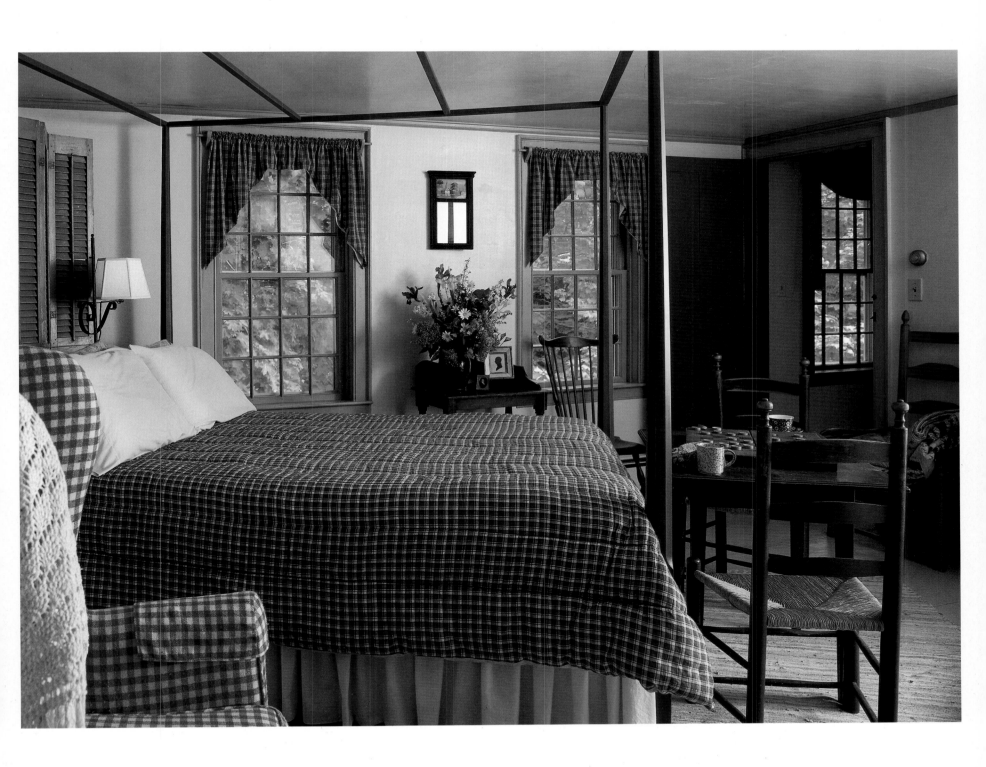

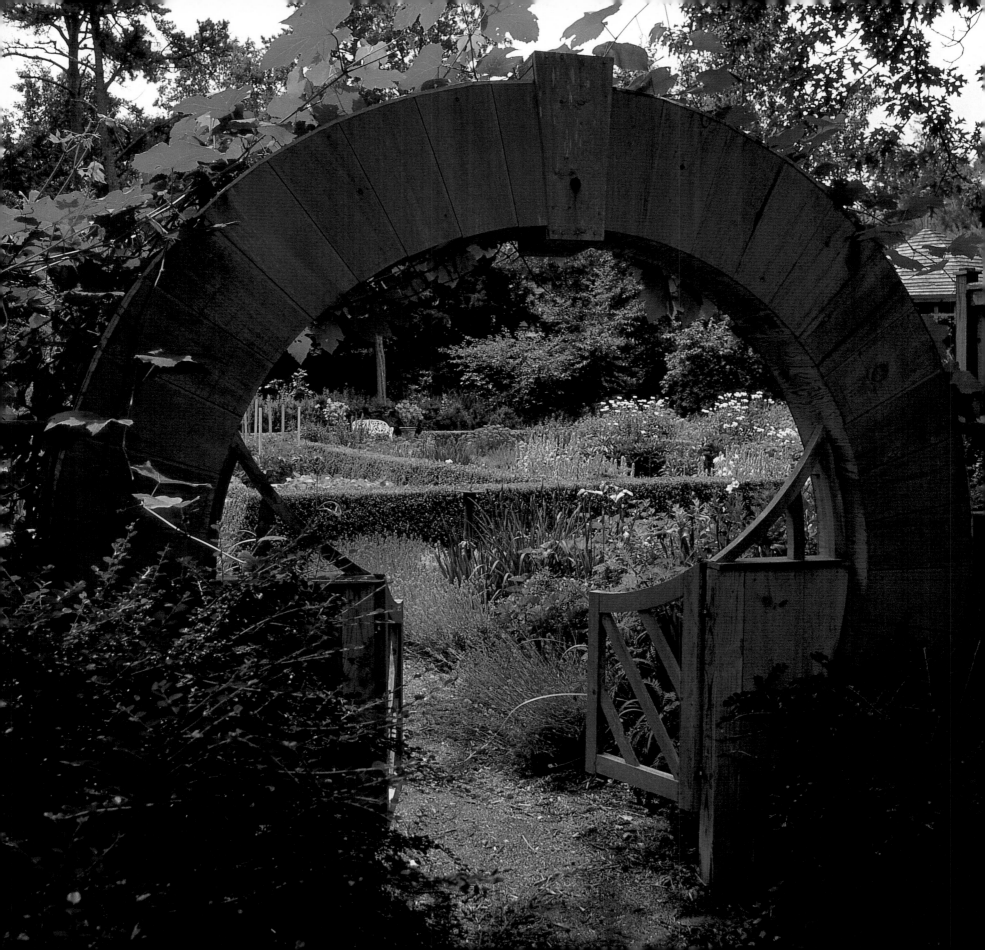

MOONAKIS HAVEN

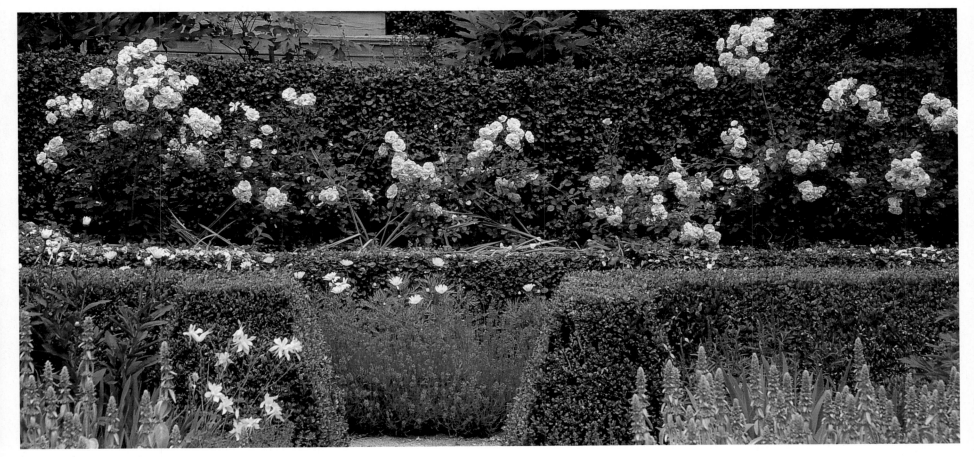

Occupying a single acre of land, this idyllic garden is the result of more than fifteen years of careful planning, experience, hard work, patience, and a large amount of love. Al and Nelda Doggart began this garden in 1977. At first, when the Doggarts saw the sunken area behind their home, they hoped it was a glacial kettle hole, but upon closer examination, discovered it to be a sand bog. The Doggarts spent more than four years building up the soil before they began planting the garden as it now appears. Then only vegetables were planted, then a year of only annuals to further nourish the soil. Meanwhile, on the top rim of the property they planted more than twenty hemlocks and over fifty pines around the perimeter to give them privacy and extra protection for their garden. In November when the winds are chilly, it is still comfortable to sit outside. The trees also provide windbreaks from severe winter storms. Then evergreen species like rhododendrons and boxwood were planted for their green color and shape in the winter garden. More than 350 boxwood cuttings were started in 1982 in the greenhouse and now form the full boxwood hedges that give the garden its formal structure. The hillsides sloping upward hold mature fruit trees for their spring blossoms and banks of heaths and heathers, planted for year-round foliage color and soft textures.

LEFT: In 1983 Al built the moon gate entrance, which offers a glimpse of the lush colors and rich plantings that unfold inside.

BELOW: Bonica roses and lavender (*Lavandula angustifolia* 'Munstead') are in full bloom in the beginning of July all along one edge of the perimeter near the house.

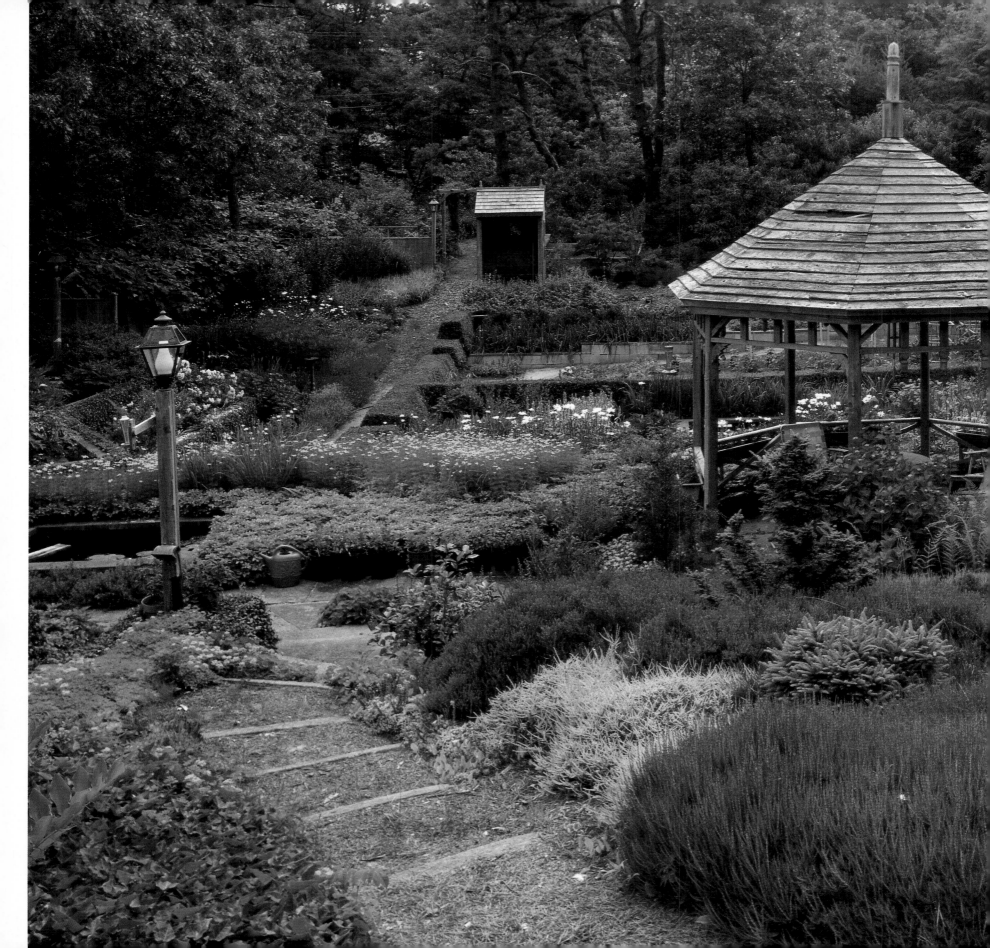

From the hillside on the southwest, paths lead into the garden, with ferns, evergreens, and ground covers on either side. Between the paths is a bank primarily of heathers with a few heaths mixed in. In the center foreground is a heather (*Calluna vulgaris* 'Long White'). The one with the yellow foliage is *C. vulgaris* 'Beoley Gold'; behind that is a heath (*Erica carnea* 'Winter Beauty'); and the last one on the right is *C. vulgaris* 'Mair's Variety'. Most of these heathers and heaths were started from cuttings in 1985 and 1986. The large gazebo was the first of the garden shelters to be built in 1980. Decorated with an acorn finial, it has weathered to a soft velvety gray over the years. To the right of the bank of heathers and the gazebo is a tall holly (*Ilex* x *meserveae*) and a cornelian cherry dogwood (*Cornus mas*), which blooms as early as February and has a red berry that lasts late into winter.

On the far side of the garden, part way up the northeast hill, is a little covered bench, "a wonderful place to sit with a cup of coffee in the fall."

BELOW: Pink Bonica roses and lavender in the foreground add soft colors in contrast to the strong colors inside the formal structure of the box-enclosed garden beyond. On the right, white Shasta daisies are mixed with Robin Hood roses, with the raised bed of coreopsis beyond.

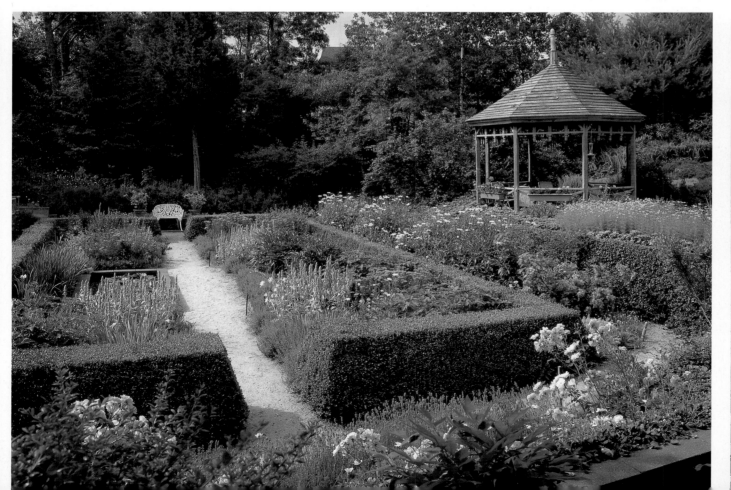

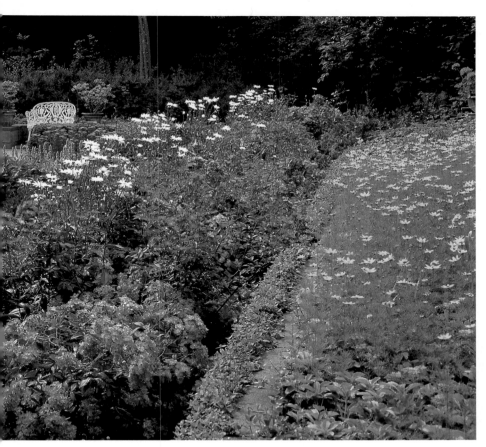

LEFT: Shasta daisies (*Chrysanthemum* x *superbum*) and Robin Hood roses create a long border between a raised brick-walled bed of coreopsis on the right and a boxwood hedge on the left. Inside the square is a brick-enclosed fish pond with water lilies, lamb's ears (*Stachys byzantina*), and red yarrow (*Achillea millefolium* 'Red Beauty') blooming in early July. Tree peonies and iris bloomed earlier in the season. Beyond the far boxwood hedge is the vegetable garden.

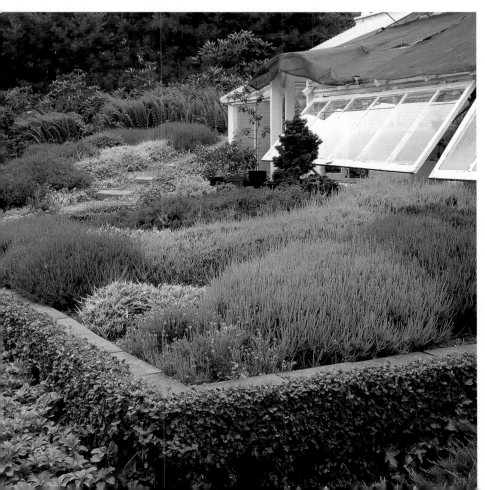

LEFT: Red snapdragons have been planted to attract hummingbirds. Mounds of heaths and heathers have been planted in front of the greenhouse for their continuous and delicate blooms and to provide variations of foliage color and texture year-round. The heaths bloom from late fall through the winter into very early spring. The heathers bloom mostly in the summer. The big mound in the front is *C. vulgaris* 'Silver Knight', the yellow is *C. vulgaris* 'Beoley Gold', and the long yellow patch is *C. vulgaris* 'Spitfire'.

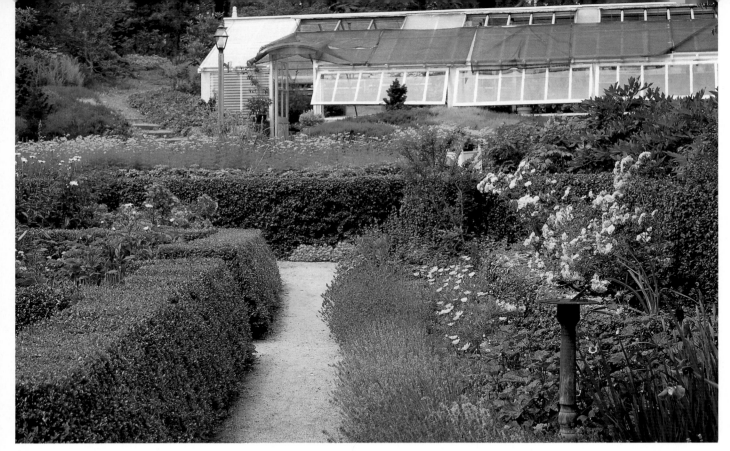

RIGHT: Japanese iris.

ABOVE: Marguerite daisies
(*Chrysanthemum frutescens*)
separate the lavender from the
roses on the right border of the
path that leads across this side of
the garden to the greenhouse.

RIGHT: Lamb's ears, red yarrow,
and yellow coreopsis have all been
planted for their color and for
early July bloom. White
columbines arrived as volunteers
in the garden and add a soft
accent to the overall scene.

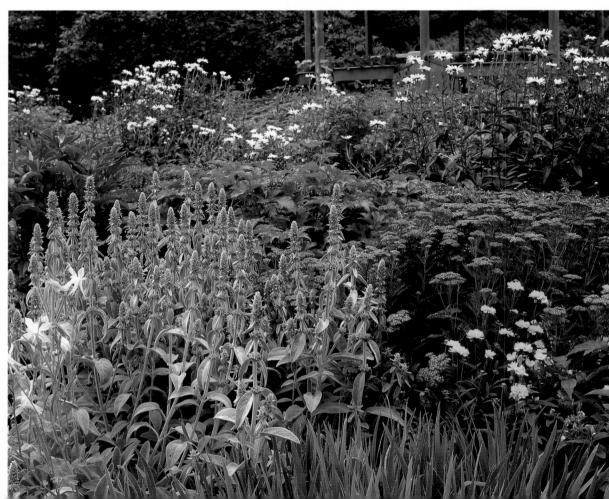

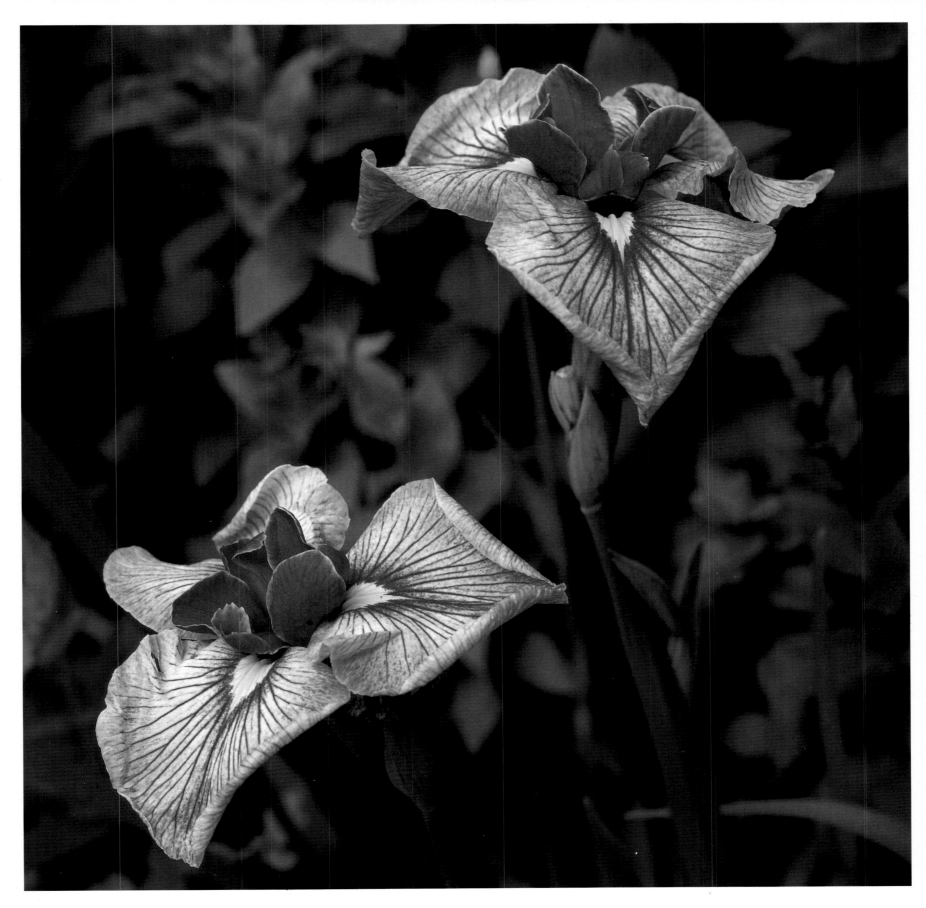

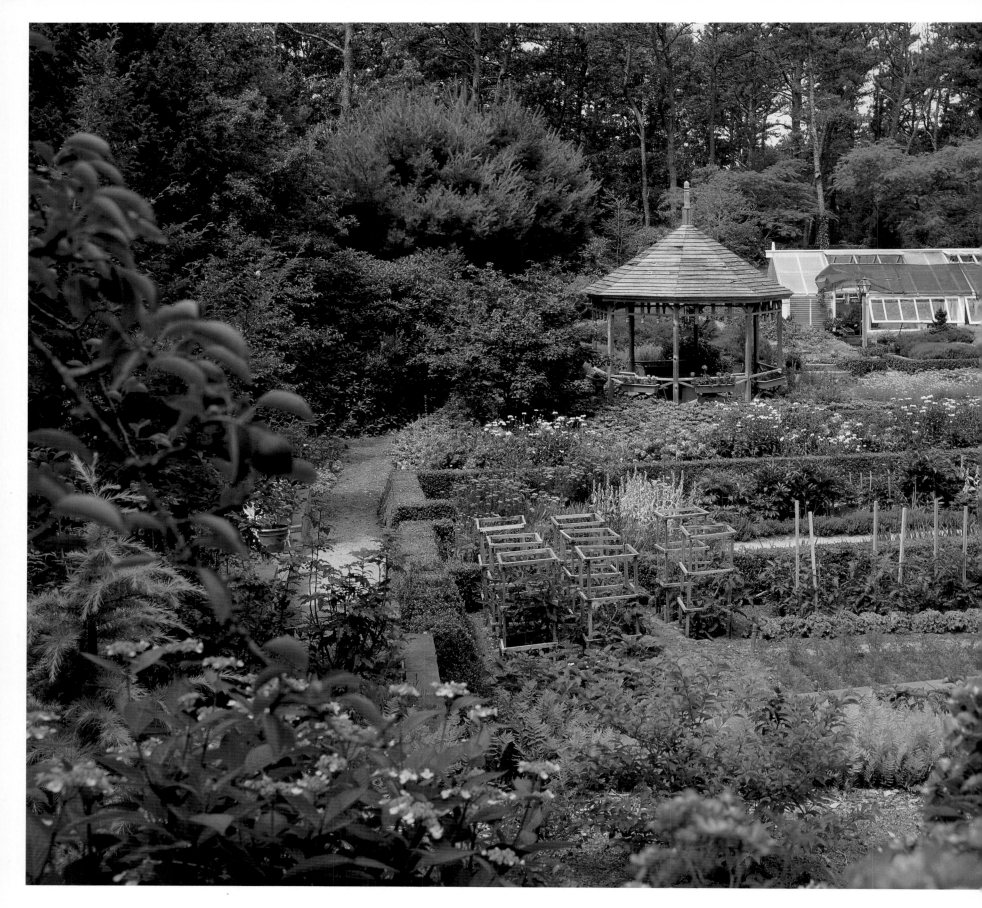

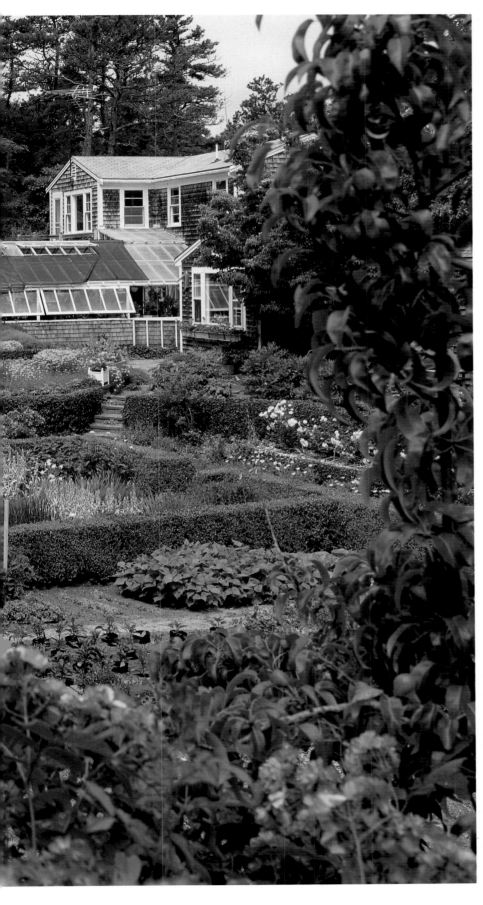

A red Bartlett pear on the left and a peach on the right in the foreground are a few of the fruit trees the Doggarts planted around the perimeter of the garden because of their showy spring blossoms. A little lacecap hydrangea is in the lower left foreground of this view from the northeast hillside toward the house and greenhouse.

ON THE BAY

This contemporary home was built in 1988 in a traditional Cape style, but when Miriam and Bob Talanian bought it, they decided to make a few important changes. They added the large entrance hall with windows around it to allow light to come into the formal living room and dining room as well as provide the home with a formal entrance. They also added the master bedroom suite and changed the facade of the garage to match the rest of the lines of the house.

The location of the house on the Moonakis River as it enters Waquoit Bay affords the site with glorious views, but when the Talanians bought the property there was no landscaping to enhance those vistas. They have now planted extensive gardens, both front and back.

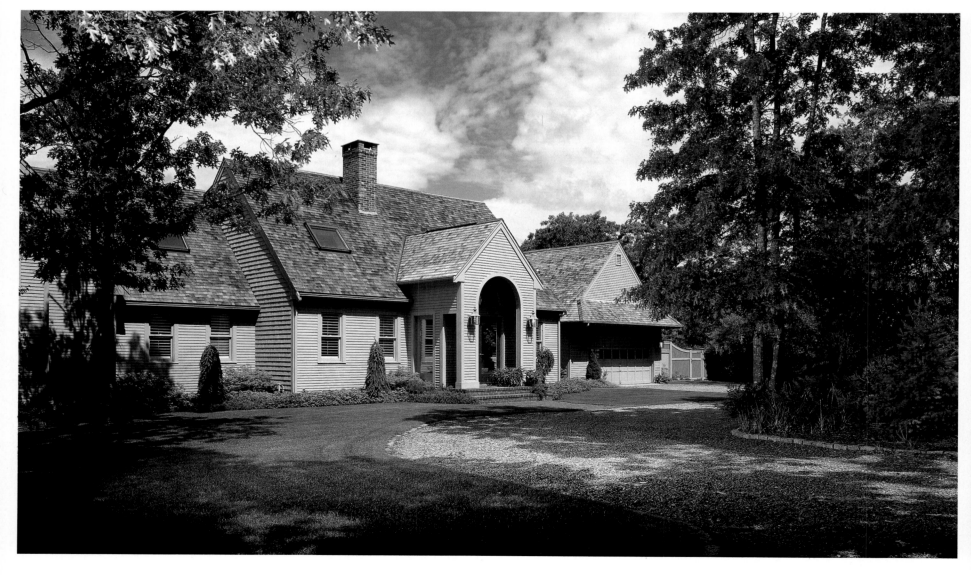

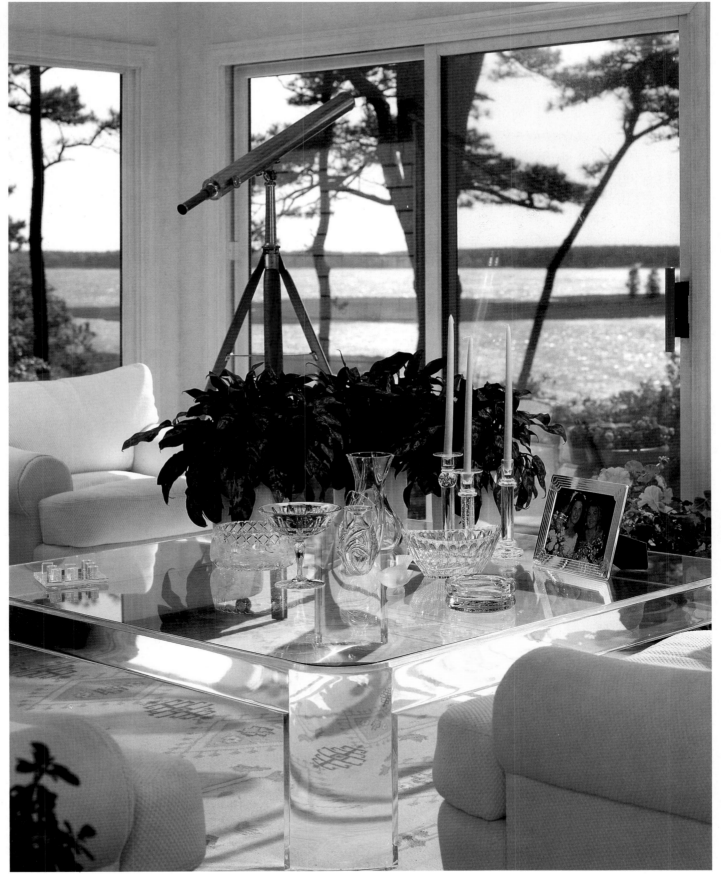

The living room across the back of the house is glass enclosed to make the most of the glorious view outside. From this viewpoint, a marsh breaks the water of the Moonakis River. Beyond the river is Washburn Island and beyond that Waquoit Bay, which as a designated National Estuarine Research Reserve contains some 2,500 acres of bay, salt marsh, and coastal ponds that provide protected habitats for many plant and animal species.

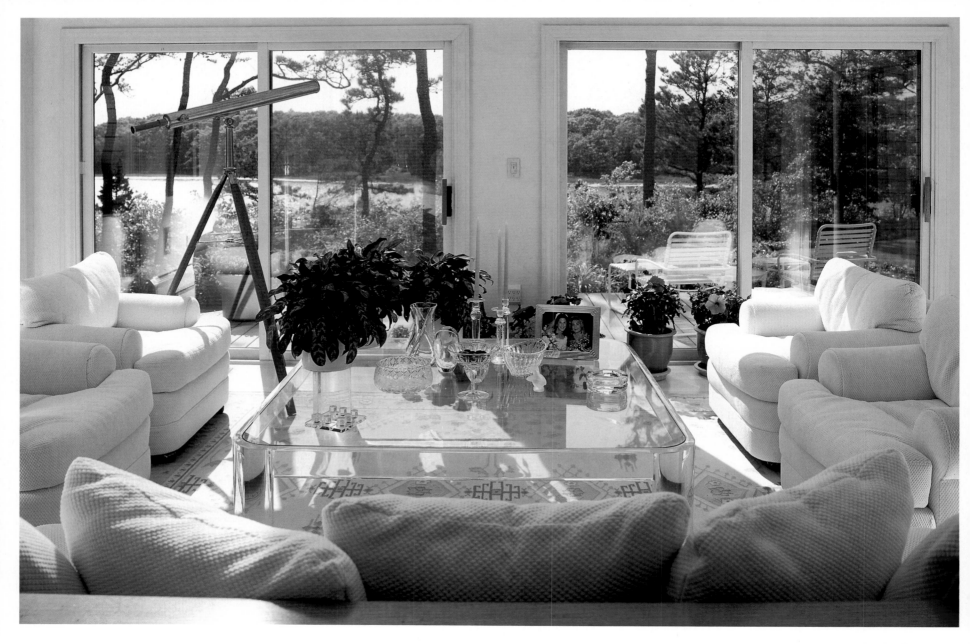

The Talanians made no structural changes to the room, but they did pickle the dark oak floors to maximize the lightness of the room. The large table, made of poured molded acrylic with a glass top, allows the pattern of the dhurrie rug to show. The table holds a family collection of crystal. A brass nineteenth-century English antique telescope with Italian optics rests on an antique English surveyor's stand.

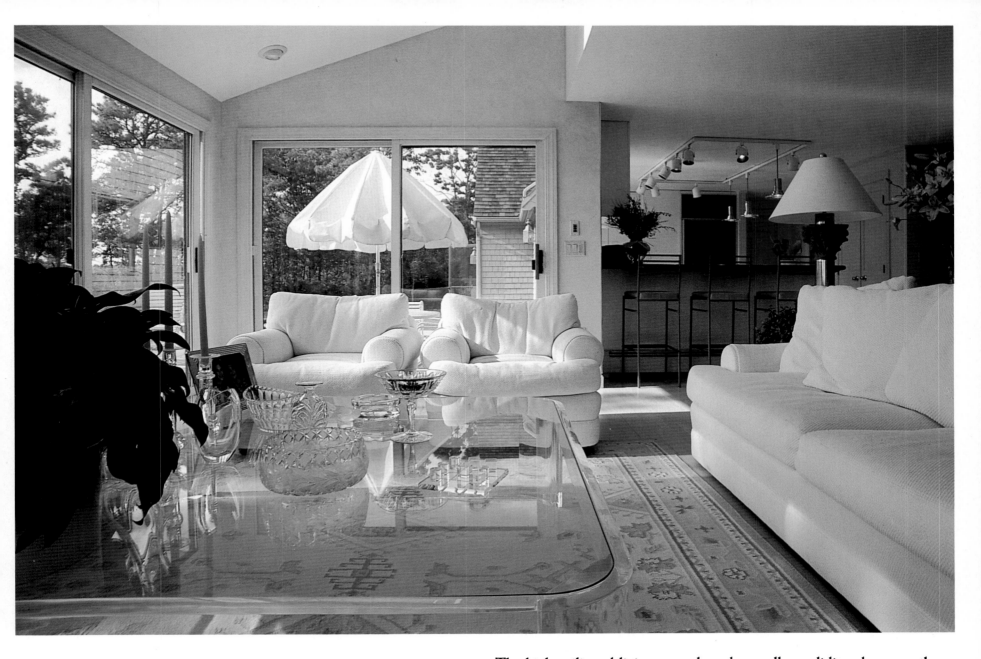

The high-ceilinged living room has glass walls or sliding doors on three sides that lead to the deck outside, which overlooks the pool. Beyond the living room is the contemporary high-tech kitchen.

A large wooden swan, carved in Rhode Island, accents the sofa table in the living room.

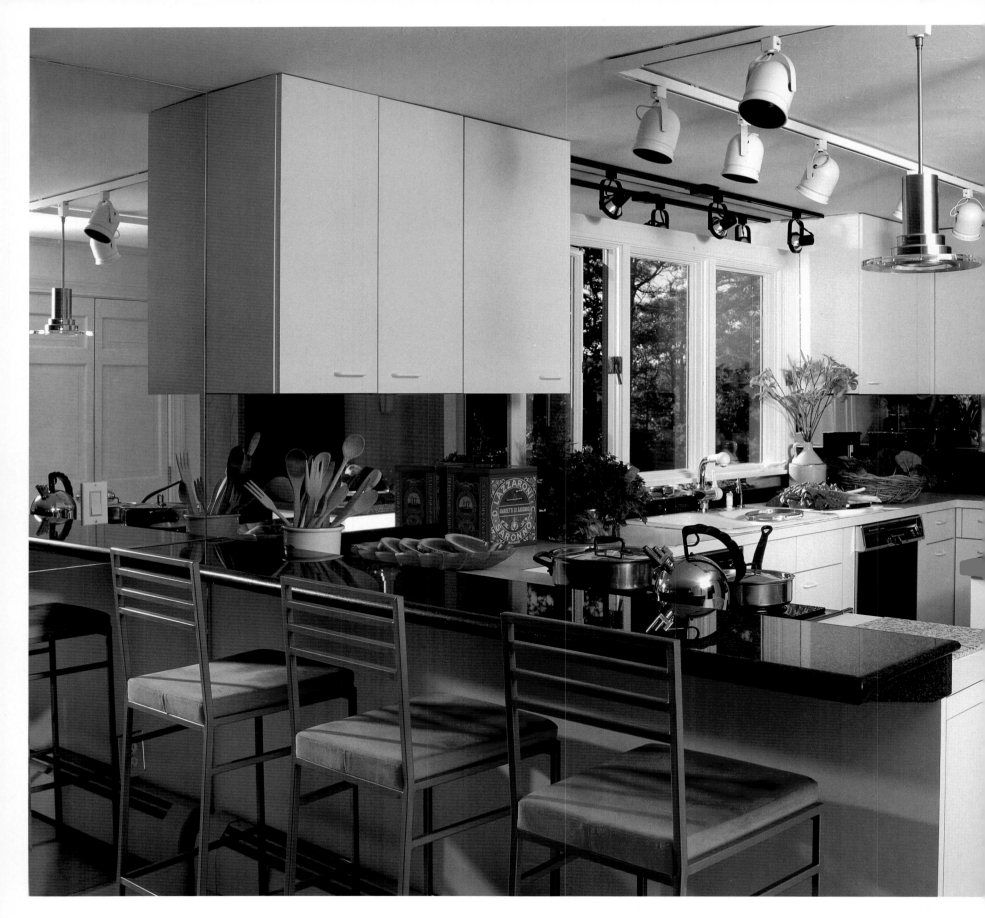

Extensive changes were made to the kitchen when the Talanians bought the home. The cabinetry was rearranged and changed to all white. The three light window and mirrored walls were added, again to maximize the light and openness of the space as well as to enhance the views from the room. Granite tops were added to the bar and center island, and new high-tech appliances installed.

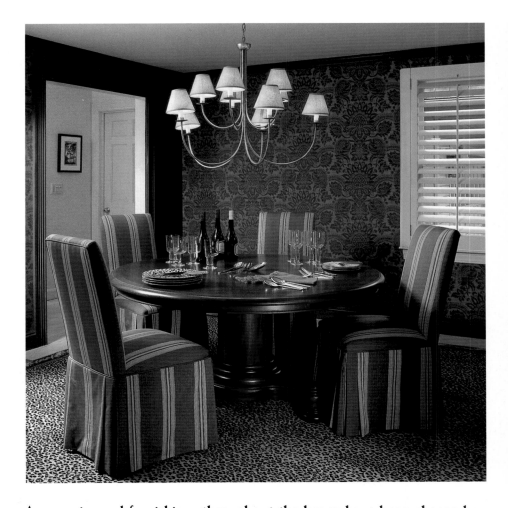

Accessories and furnishings throughout the house have been chosen by Miriam and Bob from their travels. In the dining room, the chandelier is one of those purchases. Made by a Provence artisan, bought in Lyons and sent home, the chandelier is made of gold-leafed metal. The sculpted wood table, which is the centerpiece of the room, was made by Miriam's brother, Gerald Caputo, who also embellished the other rooms of the house with his architectural woodworking details. The rug was specially made for the room of leopard-print wool with a tapestry border. The wine and water goblets are hand blown and were made by Carlo Moretti in Venice, Italy.

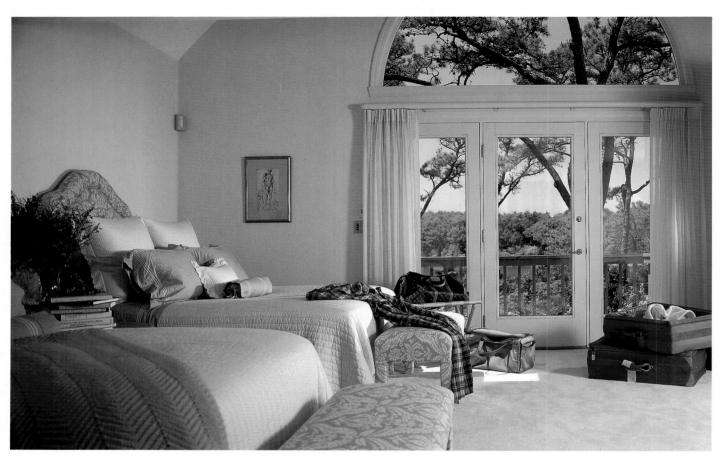

LEFT: A cathedral ceiling was added to the original master bedroom suite by pushing up through the attic. As everywhere else in the house, the dominating reason for the decor is to take advantage of the magnificent water views.

BELOW LEFT: The master bath with its skylights, high ceiling, and large windows has all the light and warmth of the rest of the house, including a water view from the tub.

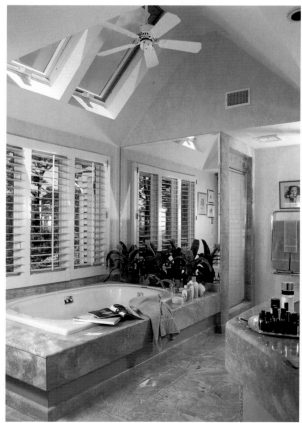

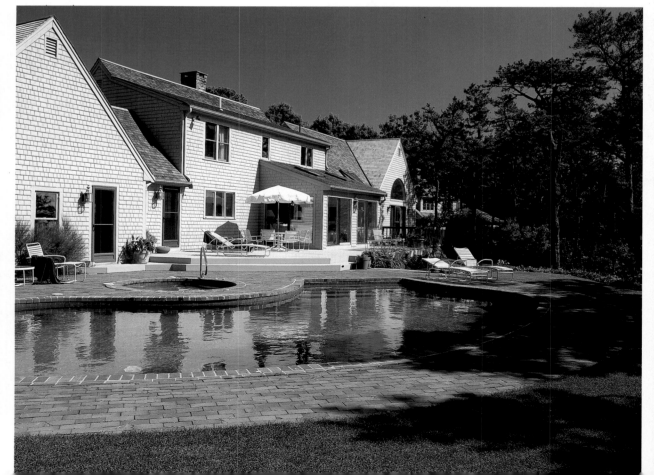

LEFT AND ABOVE: The dark-bottomed pool curves around the spa just outside the back door of the garage and the back hall from the kitchen. The sweeping landscape from the deck encompasses the entire mouth of the Moonakis River as it opens into Waquoit Bay, which is renowned for its shellfishing, especially scallops. All the plantings have been added by Miriam and Bob since they bought the house.

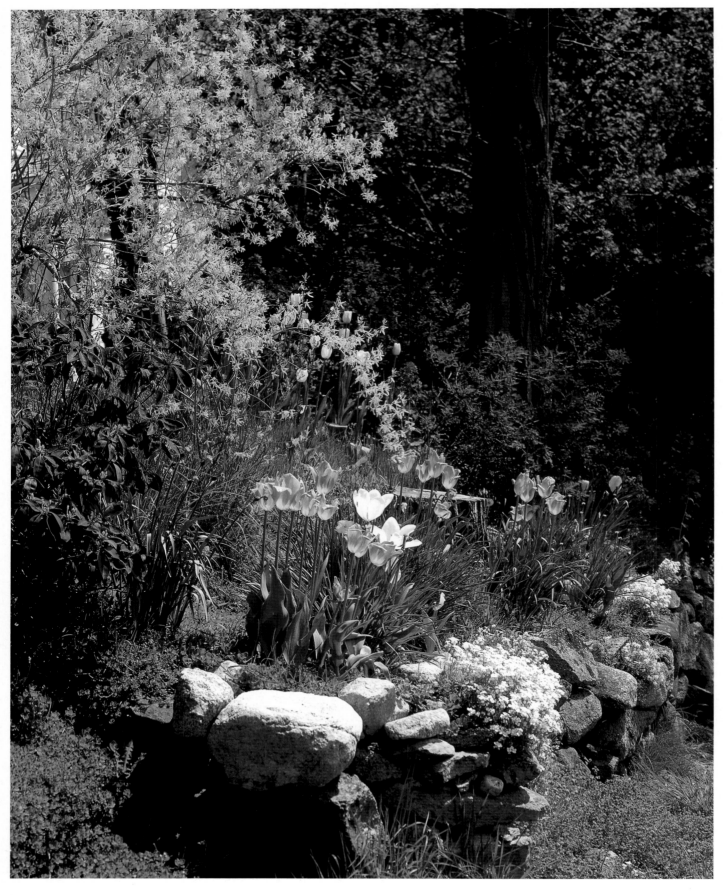

In early May, this rock garden sparkles with bright tulips backed by forsythia. Cascades of candytuft spill over the rocks. Sweeps of money plant are purple at this time of year, turning to silvery white in late summer.

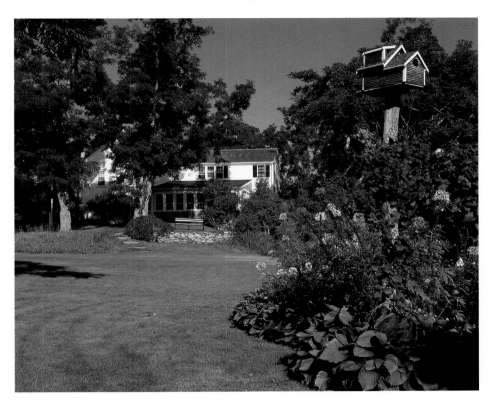

SPRING HILL

 When Quaker Judah Allen married Rebecca Wing, he built the original narrow single-room-deep house on this site on the Boston–Providence stagecoach route. Allen then purchased the adjacent gristmill and millpond from his brother-in-law Samuel Wing. The house and property has a long history much like that of the town of Sandwich. The property was owned by a succession of prominent townsmen who were farmers and millers until 1836, when Clark Hoxie sold the mill to Stutson and Jarves, the forerunner of the Boston and Sandwich Glass Company. The mill house became the Sandwich Glass workshop of John B. Vodon, a Belgian glass engraver for the company.

For most of the nineteenth century, the town of Sandwich was an industrial center, with the Boston and Sandwich Glass Company employing literally hundreds of workers, who produced as much as 100,000 pounds of glass a week. The company was founded by a Boston businessman named Deming Jarves, who in 1828 paid the passage from England for Edward Haines upon the recommenda-

tion of his brother, Benjamin, who was already employed by the company. Edward was an experienced glassmaker, and in 1850 he purchased the house, then known as Locust Knoll, from Clark Hoxie. The house had been expanded into a large two-story Colonial in the 1820s, and Haines expanded it further into a two-family house with two kitchen ells.

Edward Haines and members of his family owned the house until 1975, when Tom and Arlene Ellis bought the house and began extensively landscaping the beautiful grounds, including the mill-pond. They also purchased the mill house, thereby rejoining the property. Careful attention has been spent on the plantings, some of which are quite mature after eighteen years. At the time the Ellises bought the property, there was neither landscaping nor gardens. Tom has added an arbor and planted around the pond's perimeter so that now something is flowering all through the season, be it masses of spring bulbs and flowering shrubs, banks of irises or daylilies, or long winding paths filled with hostas and other shade-loving plants.

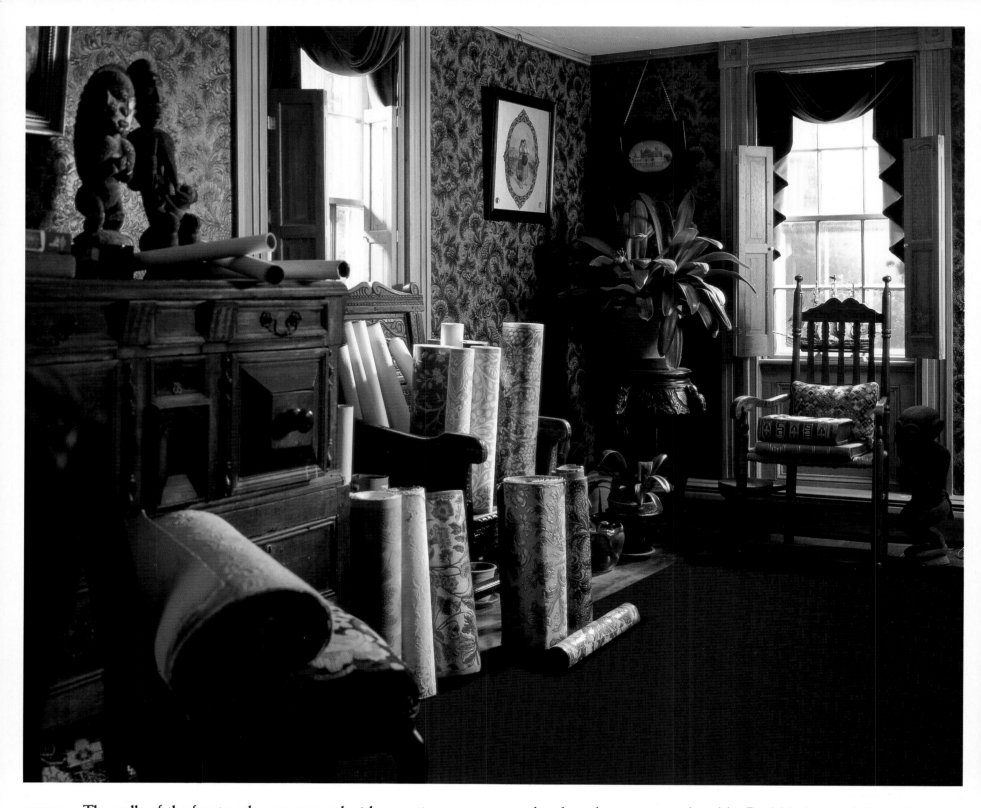

ABOVE: The walls of the front parlor are covered with an antique embossed wallpaper called Orange Walnuts, stamped P.B. #5185M, Paris, attributed to Paul Bolin in the late nineteenth century. It is part of Arlene's extensive collection of more than eight hundred rolls. The woodwork in the room was glazed by Paul Medeiros of Cape Cod. An English chest-on-chest of late-seventeenth-century design stands next to an oak Tudor panel-back chair that holds rolls of wallpaper. In front of the window across the room is a banister-back chair, c. 1740.

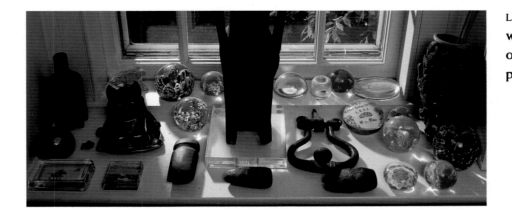

LEFT: On one of the library window shelves is an assortment of utilitarian items and glass paperweights.

BELOW: Arlene has painted the living room with a fanciful mural depicting the seasons of the year at Spring Hill. An antique Chinese carved cedar chest serves as a coffee table. The Ellises have displayed here some of their eclectic collection of objects, such as the antique working model sailboat on the left and the colored glass on the window shelves. A few of the pieces were found in the old mill pond on the property.

BELOW: A collection of antique primitive and Louis XV chairs hold stuffed animals. The library shelves and windowsills hold more of the Ellises' collections, which include an extensive library including books about Cape Cod history and landscaping.

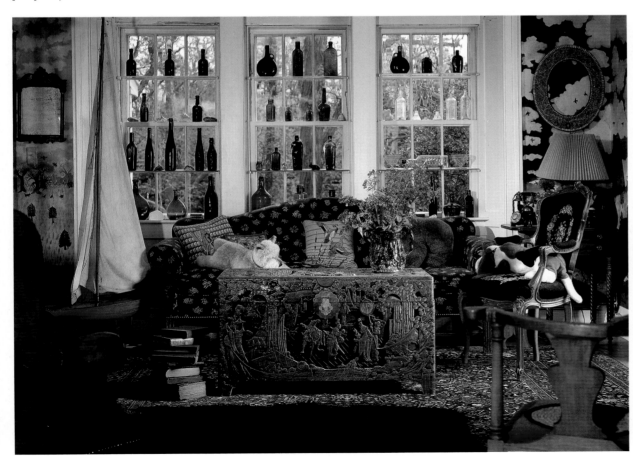

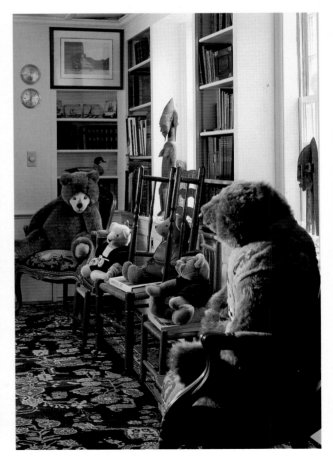

LEFT: One of the upstairs guest rooms has a colorful Lone Star quilt on the 1840s rolling-pin-design bed. A knuckle-arm and ram's horn Windsor from the eighteenth century sits in front of the window.

RIGHT: The plain curved staircase in the front hall shows the simplicity of the original structure.

RIGHT: The shed on the property in early May is surrounded by tulips and late-blooming daffodils.

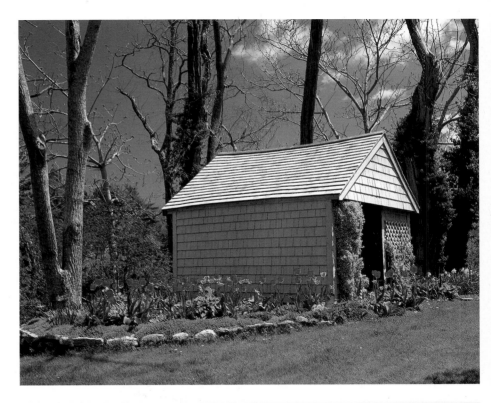

BELOW: In early June, wild phlox and bleeding hearts (*Dicentra spectabilis*) add color contrasts to the greens of large hostas, ferns, and artemisia, which provide lush texture. By this time of the season, the trees are nearly fully leafed, and this path from the pond to the house is turning into a shade garden.

BELOW RIGHT AND OVERLEAF: The millpond is planted with yellow water iris (*Iris pseudacorus*), grown from seed in masses along the banks, in full bloom by late May and early June.

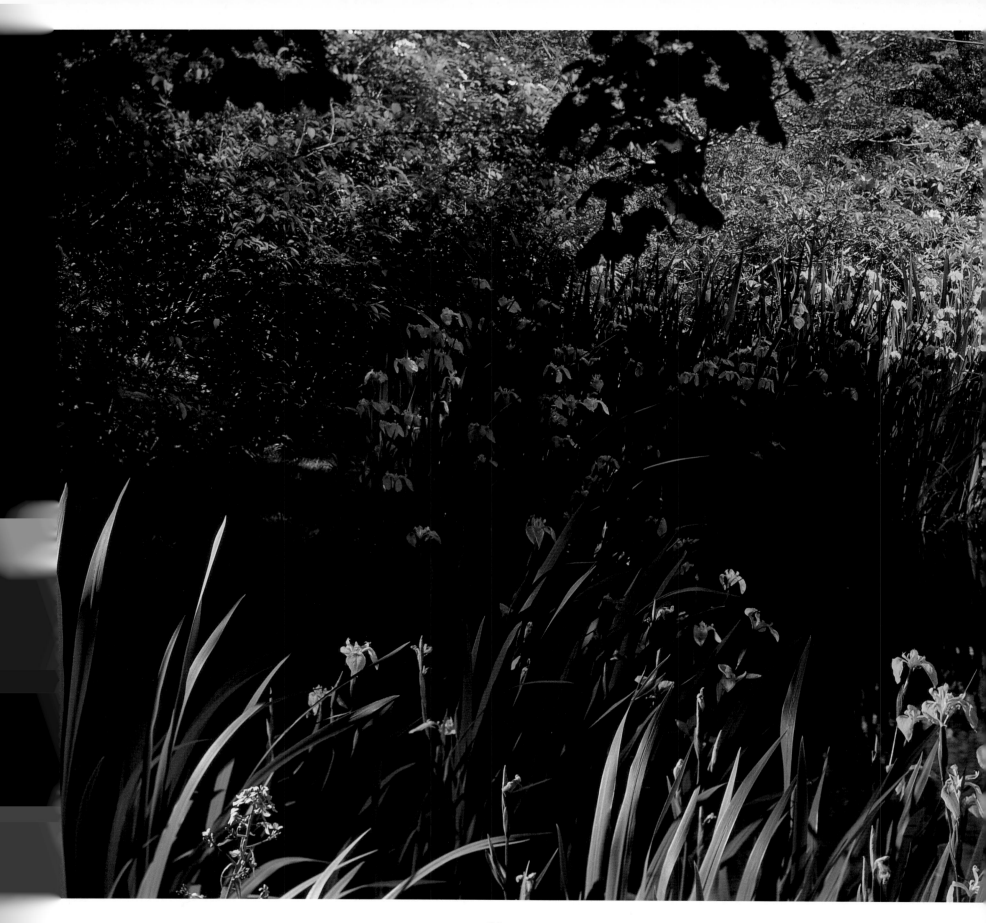

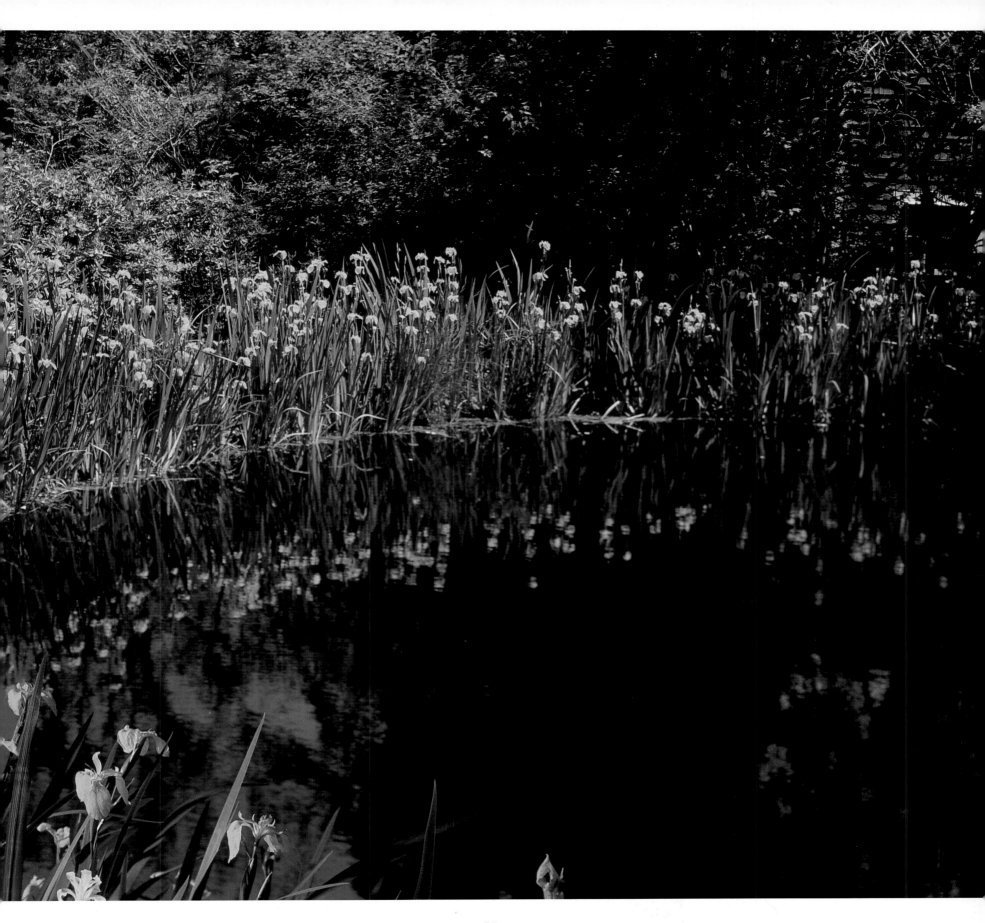

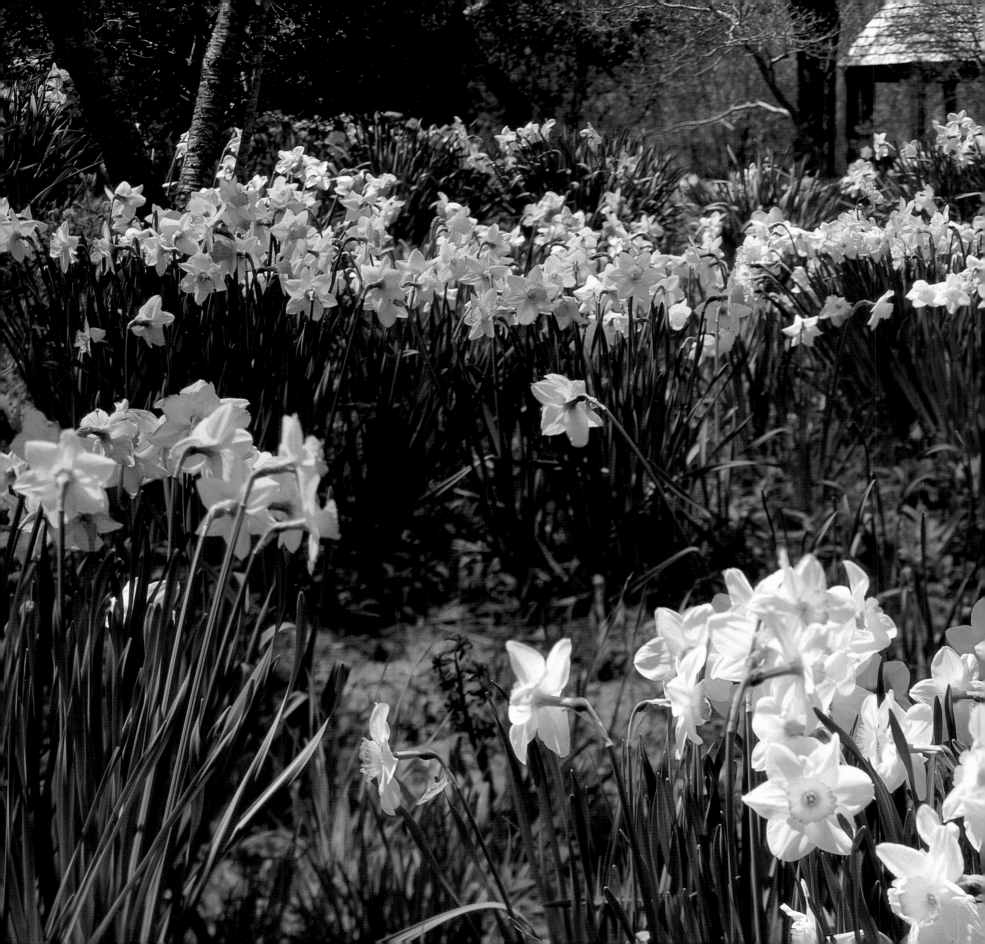

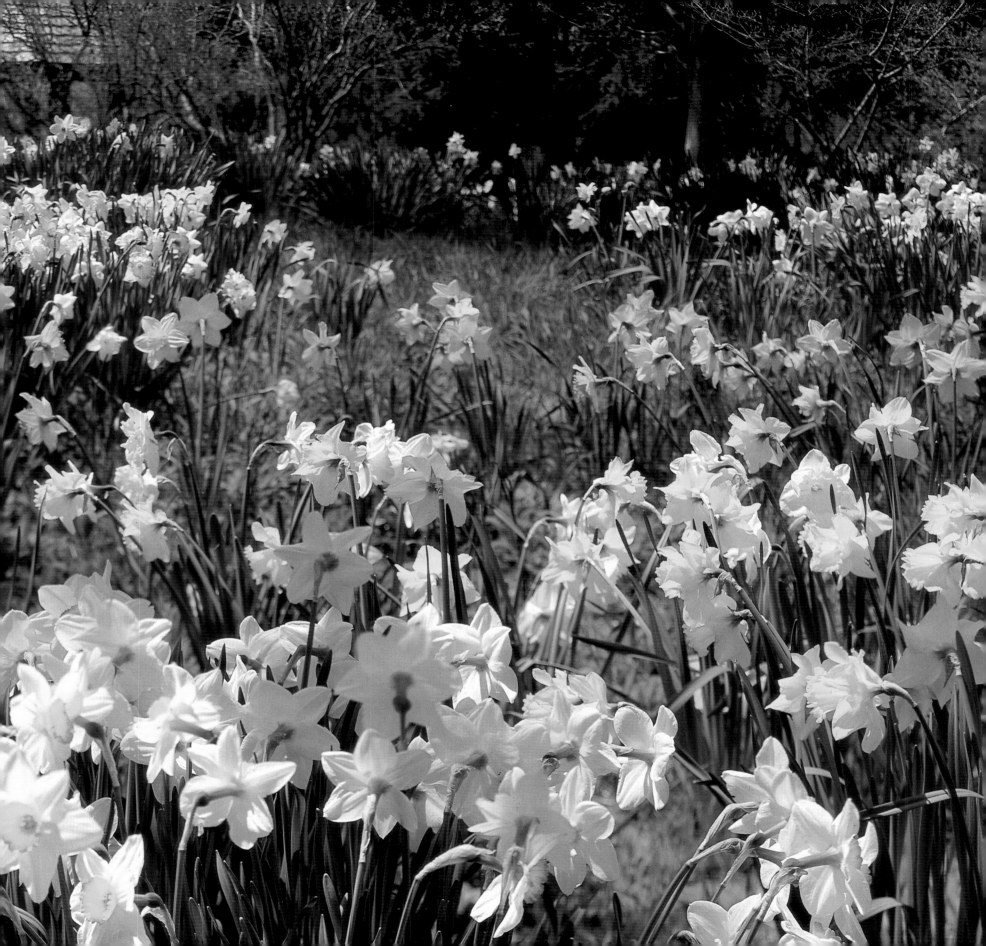

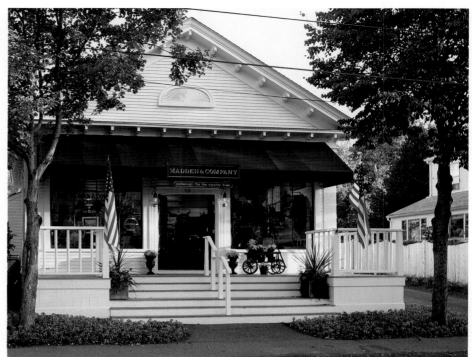

MADDEN & COMPANY

Sandwich was the first incorporated village on Cape Cod and is filled with history, beautiful old churches, the Sandwich Glass Museum, old historical homes now turned into bed and breakfasts and inns, and a number of antique stores and unusual shops. Like so much of Cape Cod, many old homes are now either bed and breakfasts, inns, or stores. Madden & Company was originally built to be a church. It was then turned into a hardware store, and then a community center, and has now been turned into a shop that features "gatherings for the country home," as the owners describe it.

In 1991, Paul and Diane Madden bought the building and began renovations. They have preserved the best characteristics of the old building while modernizing it for its present use. The main room was gutted up to the ceiling and then up to the original beams. The double front windows were no doubt put in during its incarnation as a hardware store. Paul and Diane have filled the store with items they both enjoy. The store is a personal reflection of their interests and tastes in collectibles.

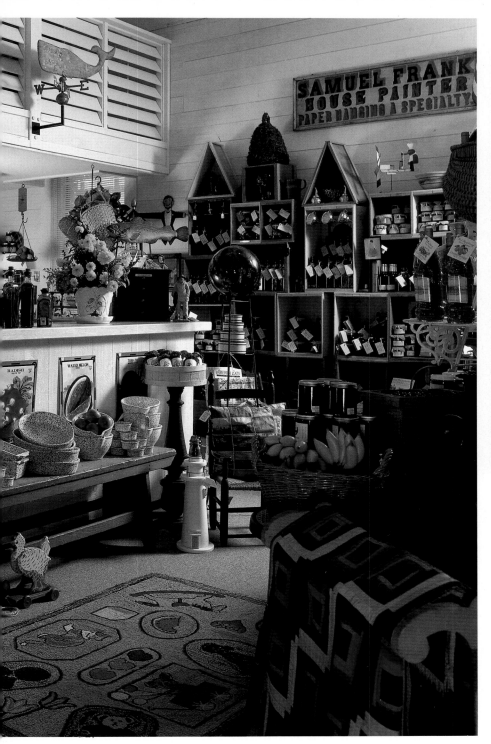

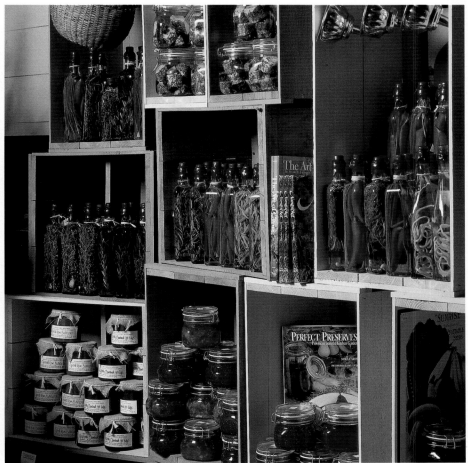

Inside the store are folk crafts from, in general, the Cape and New England, gourmet cookware and foodstuffs, also predominantly Cape and New England in origin, as well as antiques, cookbooks, toys, and clothing.

MID-CAPE

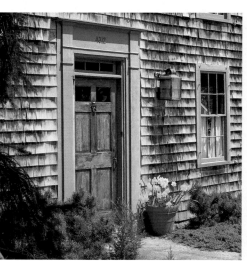

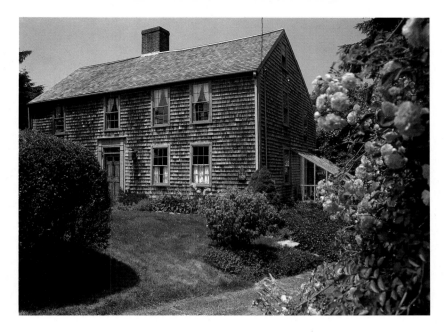

THE OLD GORHAM HOUSE

Located on the old stagecoach route from Boston, sometimes called Old King's Highway, this early raised saltbox was built about 1678 by John Gorham, the son of John and Desire Howland Gorham, he a colonel in King Philip's War and she the daughter of one of the *Mayflower* Pilgrim settlers of the Plymouth colony. The Gorham family was an important family in the early settlement of Barnstable, the second oldest town on the Cape, incorporated in 1641. The John Gorham who built this house owned both the local gristmill and the tannery, two important businesses for the town in its early days. John Gorham is also associated with the beginning of offshore whaling as a commercial enterprise. In 1680 he hired a man from Long Island to help develop shallow-draft whaling boats, which were then used in the local waters offshore, where whales were abundant. These boats became the backbone of the whaling fleets of Cape Cod, Nantucket, Martha's Vineyard, and New Bedford. The small craft were later used to fight the French in the Northeast and Canada during the French and Indian Wars.

The house was built as a traditional one-and-a-half-story saltbox, with a large twenty-foot-square fireplace, and three flues on each floor. The entire house hangs off that central chimney. At some point the saltbox roof was raised to enlarge the second floor into full rooms across the back of the house. The original roofline is visible inside. The house remained in the Gorham family until 1904.

In 1974, Rick Jones bought the old Gorham house and began extensive restoration. An ongoing project, the house is now carefully restored and cared for, and the grounds, though close to the heavily traveled road, are beautifully planted behind the high privet and low stone walls, and beneath large shade trees. Masses of hostas and other shade-loving plants under the old trees are interspersed with broad sweeps of color from perennials that bloom from early spring through late summer. Behind the house, a manicured and formal terraced backyard and pool are peppered with masses of colorful perennials and annuals.

The front door with its original bull's-eye windows was added to the house in the late 1700s. A rare commodity at that time, glass was used sparingly. Bull's-eyes were the ends of the piece of glass that was being blown; the pontil mark in the center was made by the end of the rod attached for blowing.

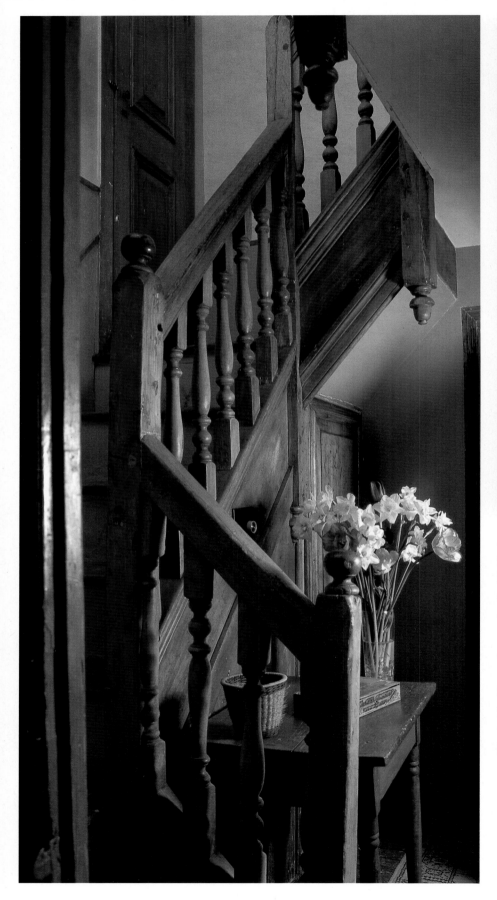

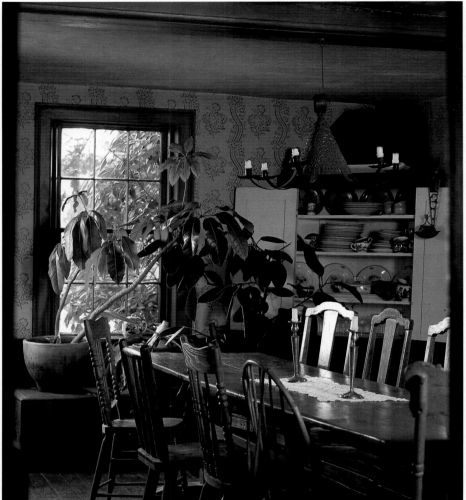

ABOVE: The dining room table top was made from one of the floorboards in the attic. It was then attached to legs formed from lumber left on the property when Rick bought it. Unfortunately the table was too big to fit through any of the doors, and even the window, so it had to be taken apart and reassembled inside the room.

LEFT: In the front hall the steep, narrow boxed stairs are exceptional for the period because of their Tudor design with acorn finials. They turn twice before they reach the second floor. Rick stripped the stair hall of all the layers of paint and finished it in its natural wood.

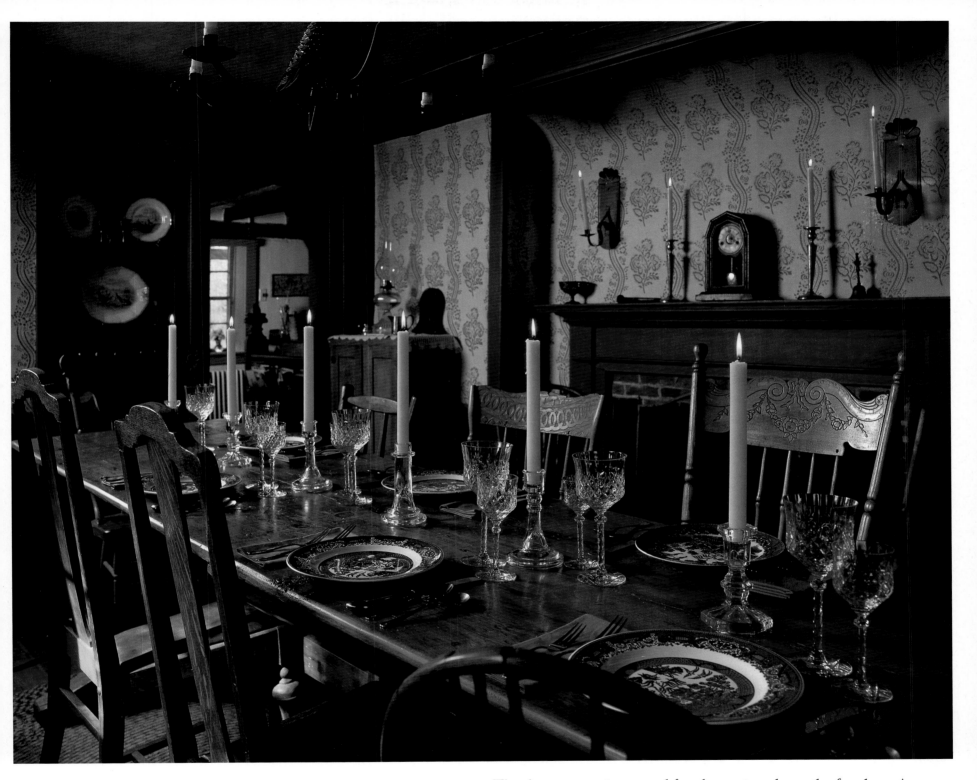

The dining room is unusual for the coving above the fireplace. A collection of nineteenth- and early-twentieth-century chairs surround the long table. The only lighting in the room other than daylight is that from candles.

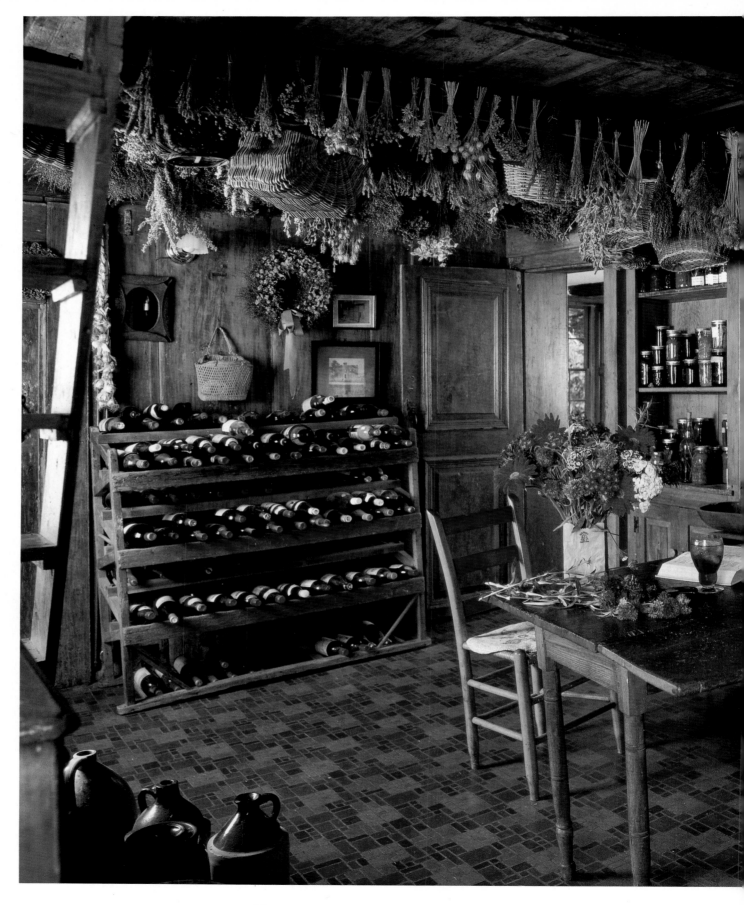

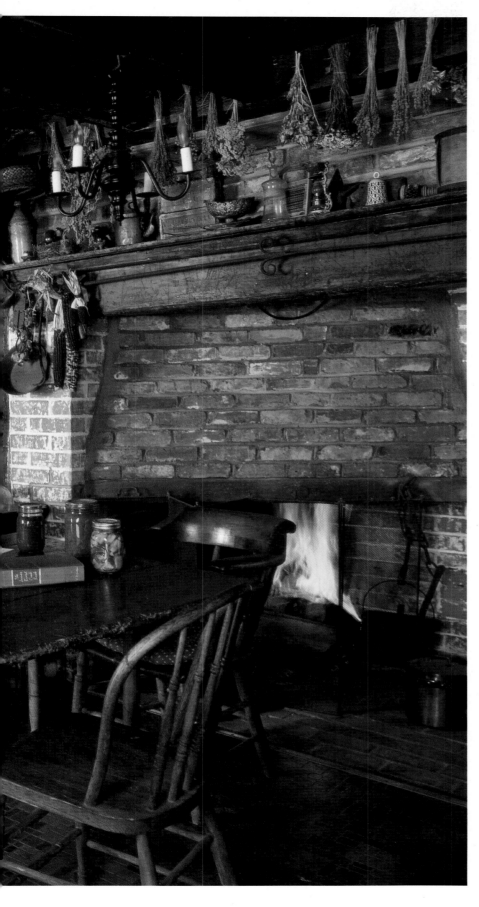

The kitchen, originally the keeping room in the house, features an enormous fireplace. Rick added the present inset fireplace so that he could have fires in the kitchen. Some time in the past, there had been a major fire in the chimney, and the chimney had been replaced, as had some of the beams beneath the floor. Noticing that there was an especially steep tilt to his kitchen floor, Rick went down to investigate and discovered that new beams had been put in under the house after the fire but had never been joined. That was one of the first major projects he undertook.

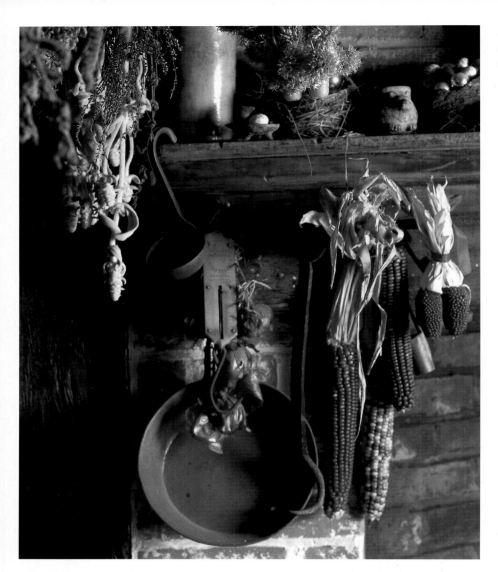

An arrangement of corncobs, cast-iron pan, and dried flowers on the brick fireplace surround.

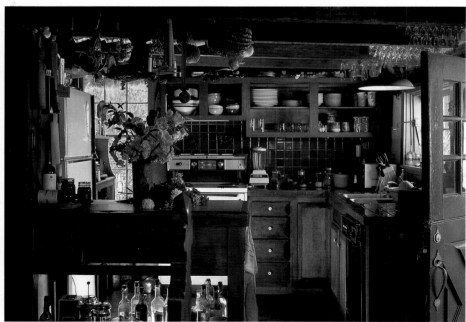

The working end of the kitchen has nice light from the window that in late spring is filled with wisteria blossoms from the tree outside.

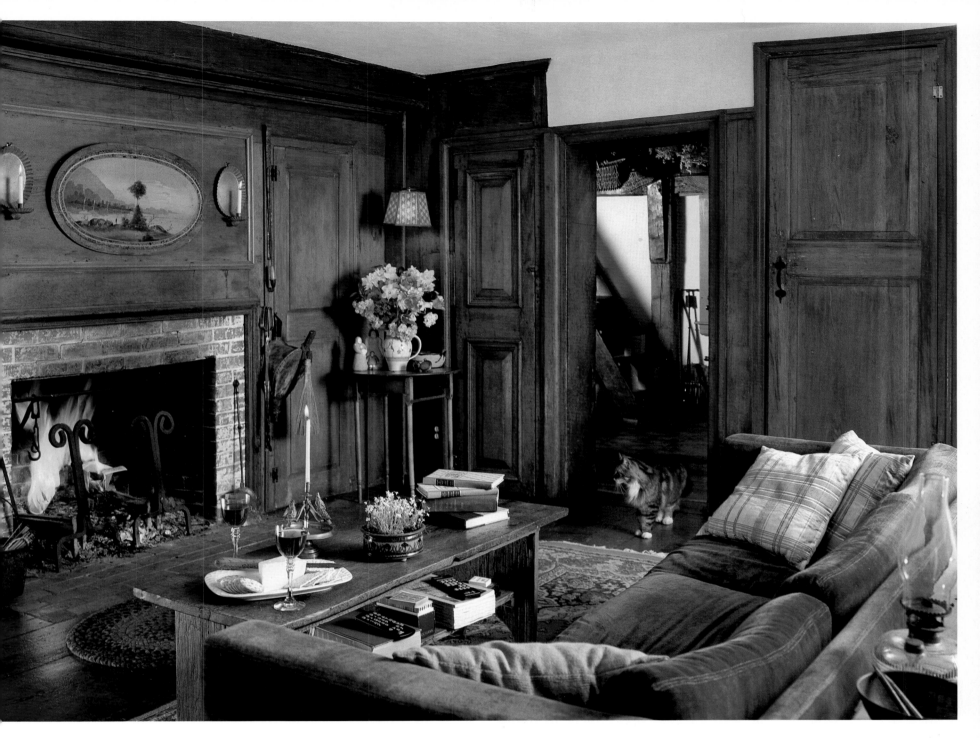

The front room, now a comfortable living room, was the first and only room for a time. It was built first, with fourteen-inch-thick walls and inside shutters on the windows. Called Indian shutters, they were used for protection from the elements as well as from possible Indian attack. The rest of the house was added soon thereafter. Up a few steps on the right is the borning room, located off this room and the keeping room. When Rick bought the house, the old walls were sagging. In beginning repair, he discovered the walls to be made not of plaster as we know it but of ground seashells and horsehair. The painted oval that hangs over the fireplace was bought at auction in Sandwich. The original paneling has been stripped of its paint.

LEFT: Ship's knees, so-called after marine architecture, are visible at the corners of the two bedrooms on either end of the upstairs hall, and throughout the house. The extra-wide pine floorboards were known as king's lumber because anything over twelve inches was not supposed to be used in house building but to be saved for His Majesty's ships.

RIGHT: The master bedroom with its paneled fireplace wall has one of the three fireplaces on the second floor off the large central chimney. After Rick moved into the house, he discovered that some of the floorboards in front of the door had been replaced with plywood. He decided to replace them with original floorboards from the attic. When they were laid down, they were half an inch higher than the boards around them.

RIGHT: A field of lupine, planted from seeds brought back from Maine, blooms profusely in late May and early June. The many shades of blues and soft pinks are accented by bright azaleas.

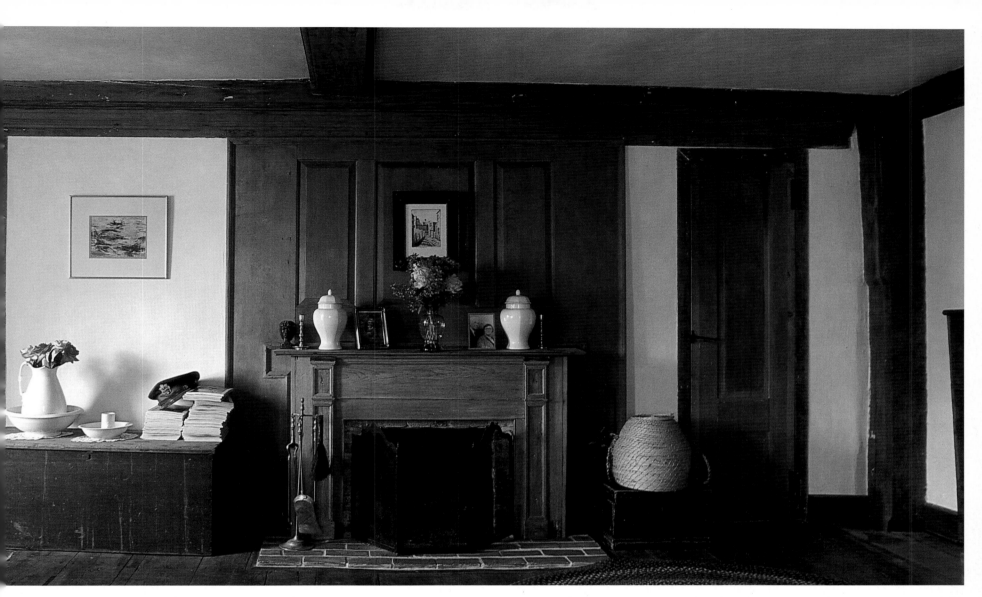

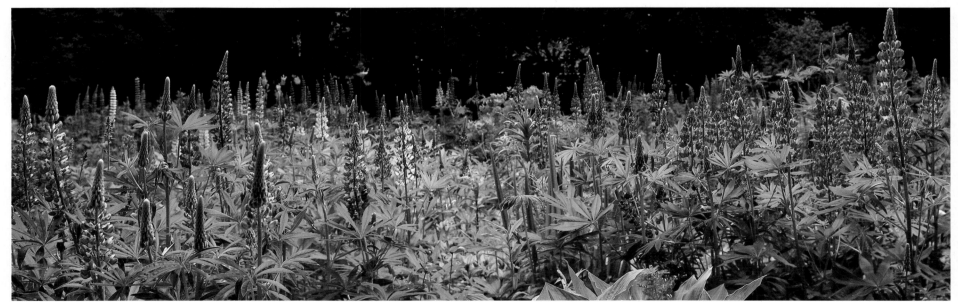

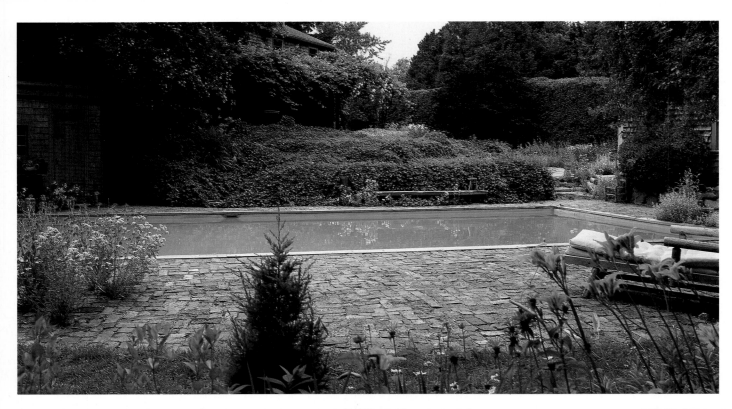

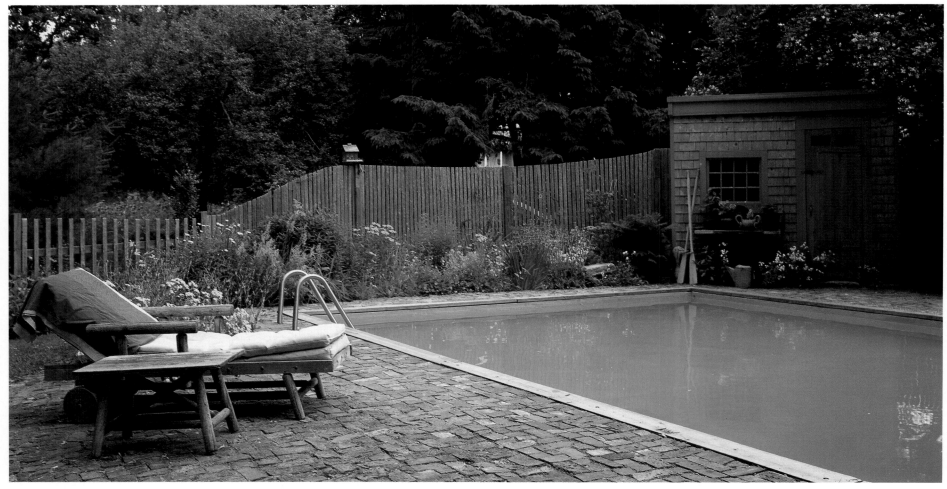

LEFT: Daylilies and red monarda frame the foreground looking from the pool to the back of the house across an ivy-covered terrace. The arbor that runs along the back of the house is covered with grapes and New Dawn roses. A winding stone path planted with gloriosa daisies (*Rudbeckia hirta*) and other perennials add color along the path that leads from the pool past the old barn and up to the house. Near to the house is a mass of snow on the mountain (*Aegopodium podagraria* 'Variegatum') behind a large clump of early-blooming white phlox.

BELOW LEFT: A more formally planted border fills the area between the fence and the pool behind the house. The brick around the pool is from the original chimney to the house, which Rick dug out of the marsh pond at the rear of his property. Planted in spaces between the brick itself is red *Lychnis coronaria* and white feverfew (*Chrysanthemum parthenium*). Along the fence is a border of tiger lilies, heliopsis, gloriosa daisies, primrose (*Oenothera missouriensis*), lady's mantle (*Alchemilla mollis*), more red lychnis, and feverfew. Solomon's seal (*Polyganatum*) and ferns fill the corner next to the shed. A young everbearing rose near the shed will, in a few years, cover the fence behind it.

RIGHT: Wisteria in bloom outside the kitchen window in late May. When Rick bought the house, the old tree covered the whole side of the house and was strangling the chimney, so he cut it back severely, and now it is thriving again.

HARRIS MEADOWS

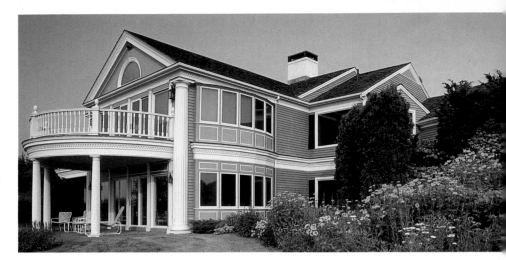

On land that was settled by his great-great-grandfather Thomas Harris in the early 1800s, Jack and Lucile Harris have planted nearly seven acres of colorful landscaping above the salt marshes that stretch down to Barnstable Harbor. Thomas Harris was a merchant sea captain who sailed from Boston to Russia and was the first American to receive a medal from the British government after the War of 1812 for standing by the British ship *Britannia* for thirty-six hours in a storm. Both Jack's great-great-grandfather and his great-grandfather were sea captains who, typically for their day, had large farms along the coast. They would be gone from home for long stretches of time, and their families would manage the farms, which sustained most of their needs. On this property were orchards, pastures for grazing horses and cattle, large vegetable gardens, and probably wheat and corn. The property, much larger than it is now, extended down to the salt marshes, which were common land.

Jack has been spending his summers on Cape Cod since the early 1920s and remembers the old boathouse down by the water that was one of the first lifesaving stations on the Cape. Jack and his wife, Lucile, bought this property and its cottage from cousins and have been working on it ever since. First they tore down the cottage and built a new house. Later on they built the house they are now living in, and about ten years ago, Jack laid out the plans for the extensive gardens. The Harrises wanted lots of color, which has been the keynote of their plan. Along the entrance drive is a colorful mix of rosa rugosa and blue hydrangeas that welcome visitors with a rush of intense color in June and July. Along the side of the house at the base of a steep bank is an enormous terraced border of perennials, planned to bloom in early to late summer. From the upper deck of the house is a magnificent view of Barnstable Harbor and Sandy Neck beyond. Between the house and the marshes, the Harrises have planted vast borders of daylilies, from pale yellow to dark orange and reds, for their color in June and July, and a curving rock garden with mounds of perennials.

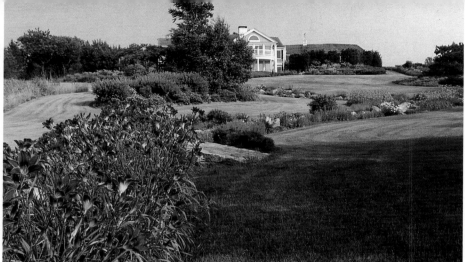

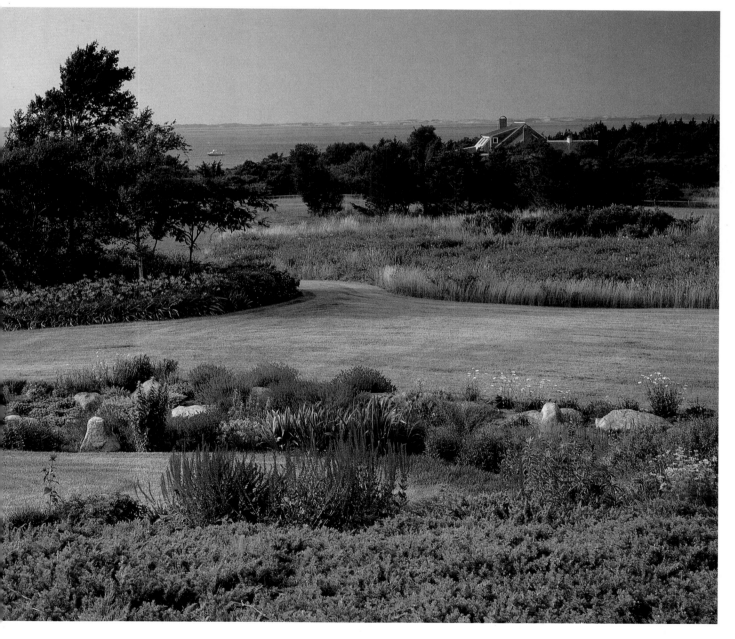

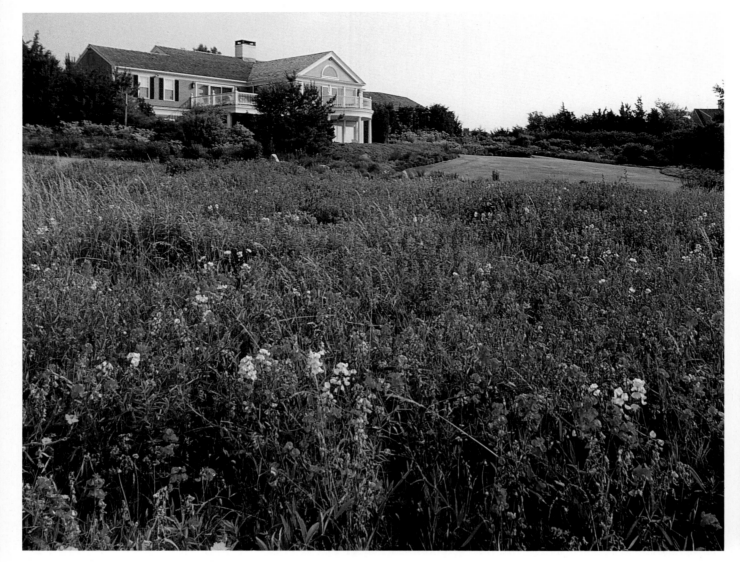

ABOVE: A vibrant wildflower meadow is near the edge of the marsh, its predominant colors changing from year to year as the season progresses. Typically, different wildflowers in a meadow will be stronger from one year to the next. This season the colors are predominantly pinks and purple. The field is mowed in the fall after it has reseeded itself.

ABOVE RIGHT: Below the upper deck, and close to the house, this waterfall provides the sound of falling water outside the downstairs rooms.

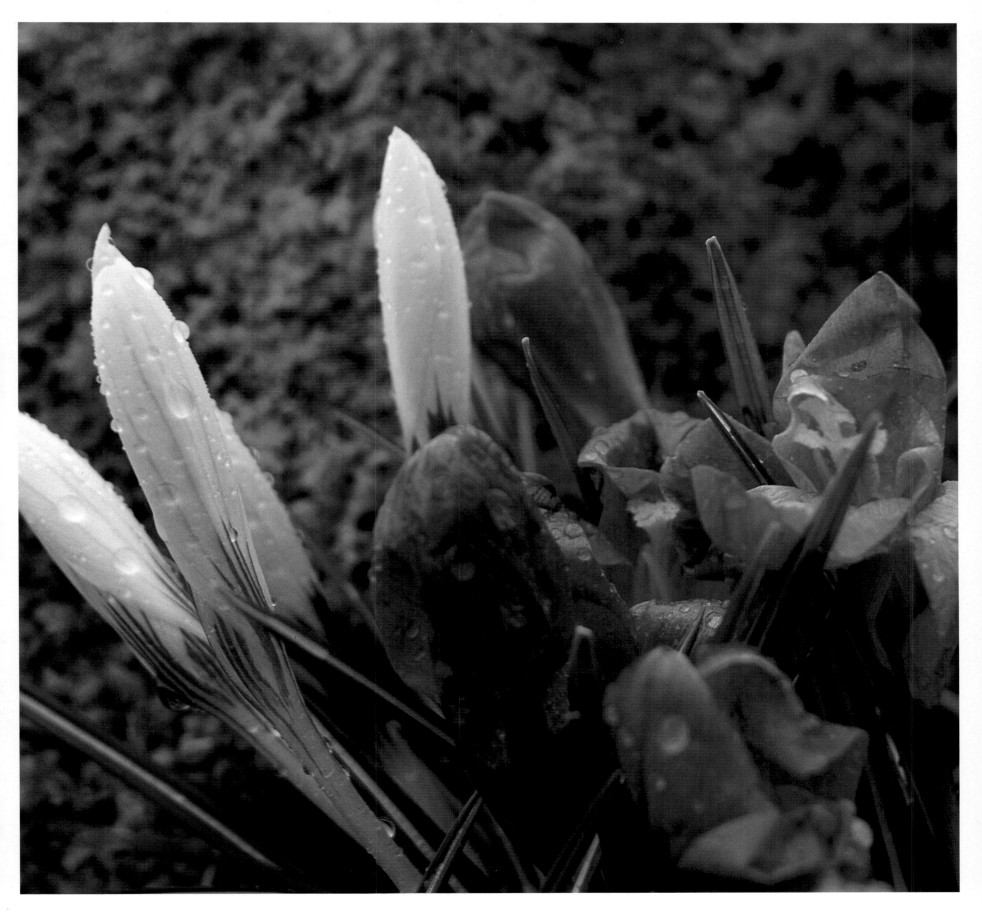

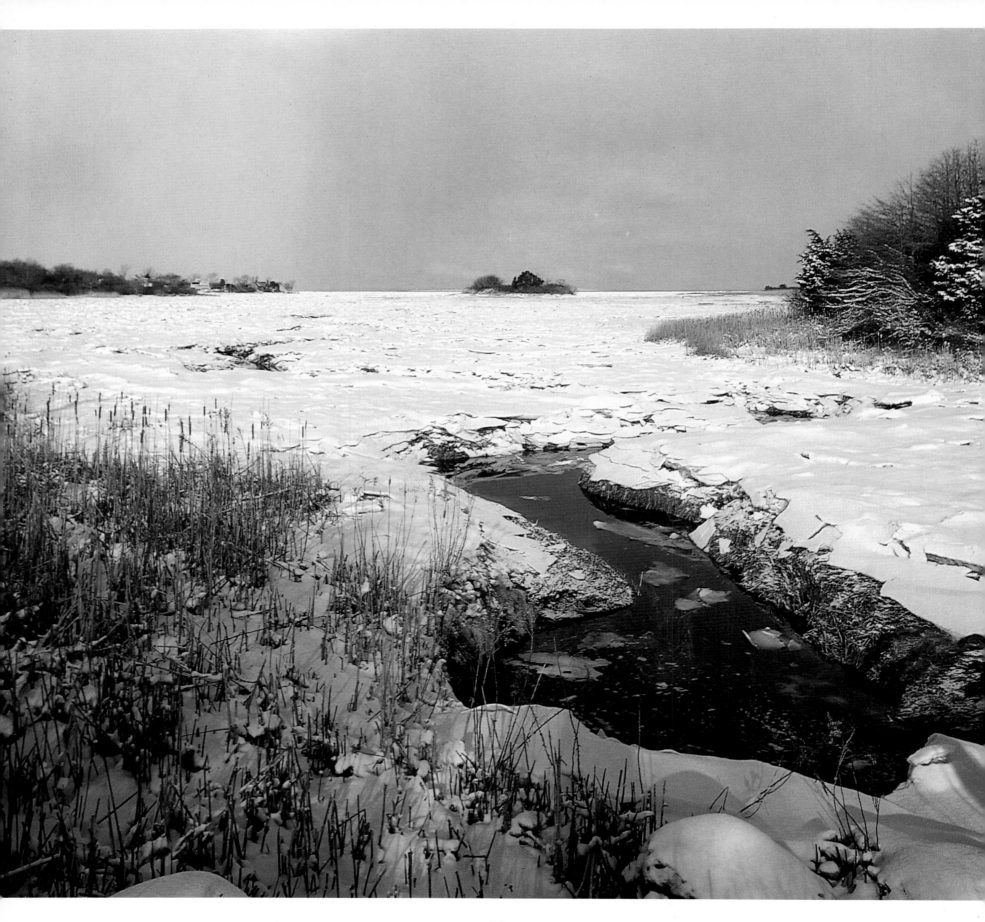

Located on the main road in Yarmouthport, this gray-shingled Cape officially dates to 1780, but evidence exists that it was built as early as 1743. The house sits on a rise above the road with views going all the way to the water behind. The house has unusually deep dormers on the second floor, and inside it has double front parlors on either side of a hall that passes between the two fireplaces. There are five fireplaces off the center chimney.

Jerry Finegold and the late Tom Rowlands bought the house in 1969 and took it through extensive renovations. They raised the low roof in the back and added on to the second floor, making large suites of bedrooms and baths. Downstairs they added on an entire kitchen wing with a bedroom and bath above, as well as extending the depth of the house. In addition, they extensively landscaped the grounds, adding a brick terrace around the pool in the back.

The house is furnished with an eclectic mixture of furniture, sculptures, antique accessories, and paintings. The owner enjoys cooking and entertaining, and in its layout, furnishings, and interior design the house reflects both the tastes and the sociability of the owner.

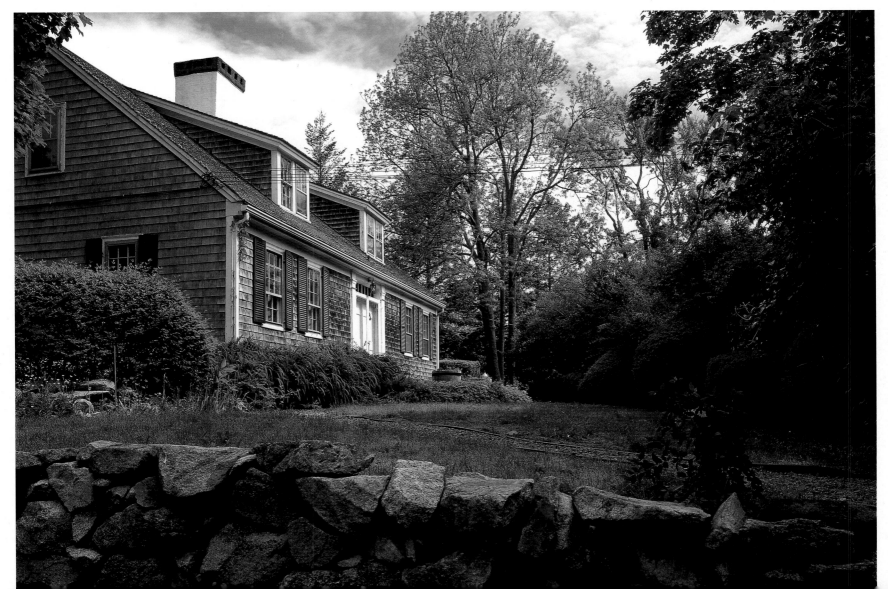

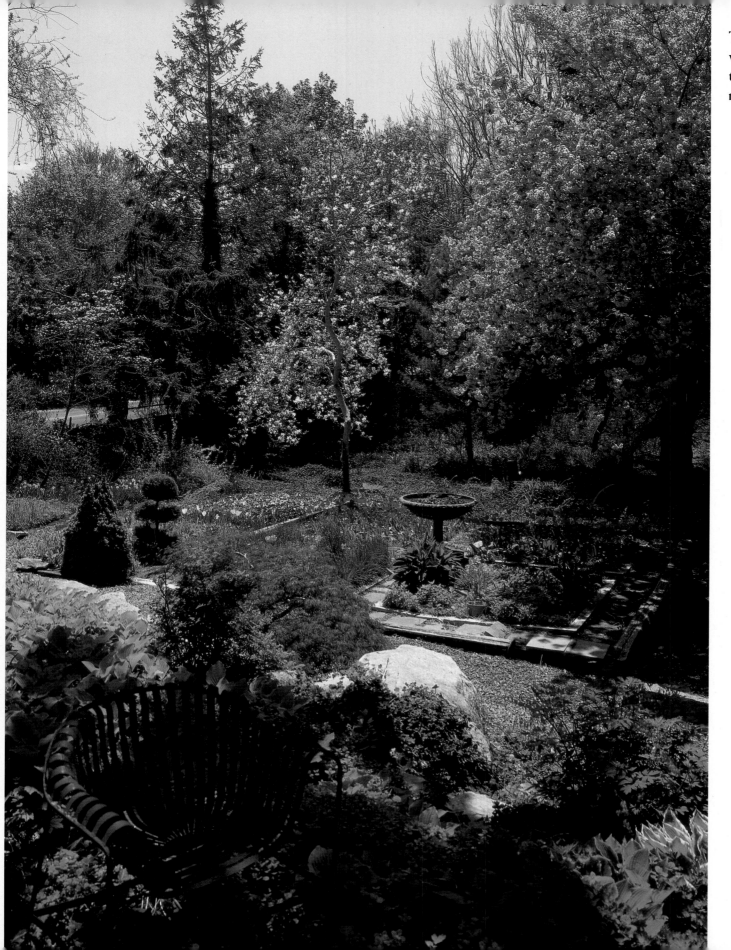

The garden in early May is filled with daffodils and tulips beneath the flowering crab apple and magnolia trees.

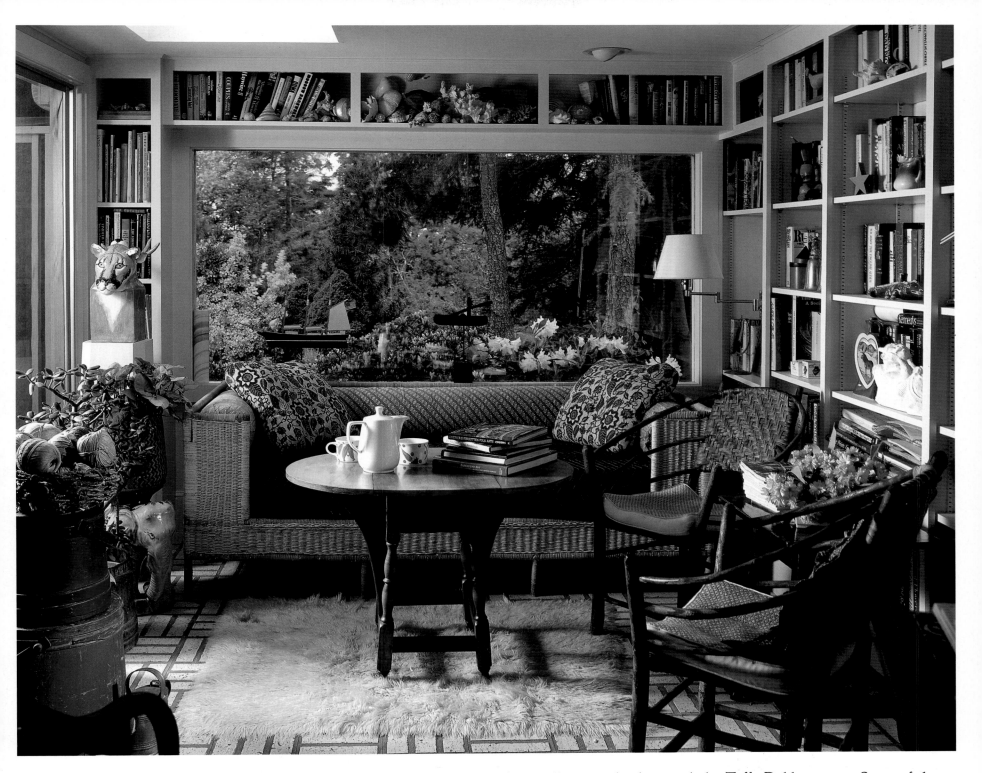

The library sun room overlooks the garden. A white rhododendron is in bloom just outside the window in late May. The room is furnished with comfortable wicker. The two-headed lion on the pedestal on the left is really an ice bucket, made by Taffy Dahl in 1973. Some of the owner's collections of folk sculptures line the windowsill behind the wicker settee.

The dining room opens into the main living room with its twin fireplaces on either side of the long and wide entrance hall, which runs between the two fireplaces with a common chimney that is joined above. Symmetrical front parlors can be seen through the doorways on the far side of the large room. At one time this large living room was obviously divided into two rooms. In fact, the house may have been a two-family structure in its early days. There are two steep staircases up to the second floor on either side of the large living room.

The dining room is part of the addition the current owner made when he bought the house. Tom Rowlands made the large round table, which comfortably seats ten, and is surrounded by reproduction Louis XV chairs. An antique Canadian armoire is on the left wall in the living room.

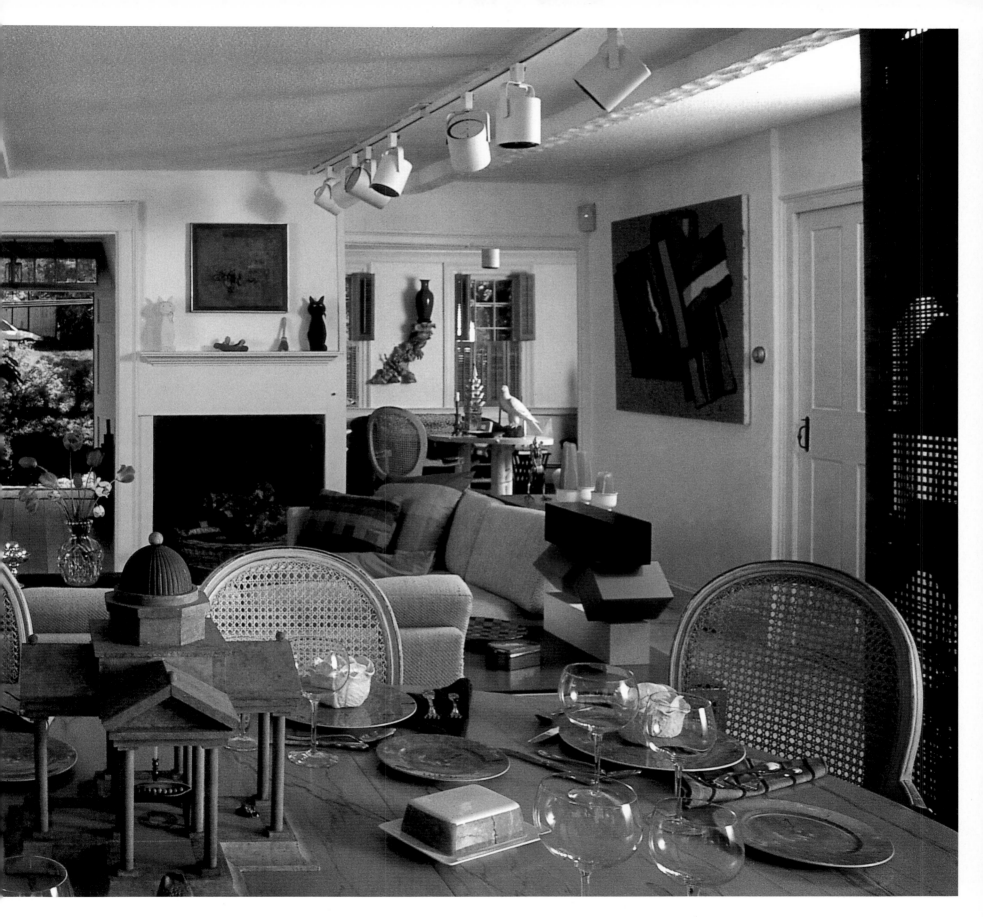

ABOVE: Apples made of wood, wicker, enamel, and twigs line the mantel beneath this self-posed photograph of Tom Rowlands.

LEFT: A Greek temple sculpture made by Tom Rowlands is the centerpiece on the table in the dining room. The large oil painting on the wall behind it is one of Tom's series of Taos paintings.

RIGHT: A small narrow room that serves as a wine storage room and bar is made to appear much larger than it actually is by lining the ceiling with mirrors.

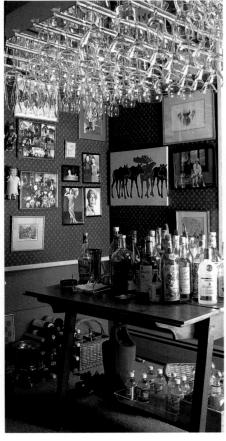

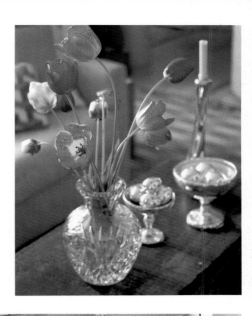

RIGHT: A Baccarat crystal vase holds tulips from the garden.

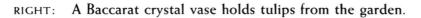

BELOW: One of the front parlors can be seen through the doorway on the far wall. The large painting is by Tom Rowlands. The little silver cock on the table behind the far sofa is *Le Petit Coq* made of silver forks and spoons by Gérard Bouvier.

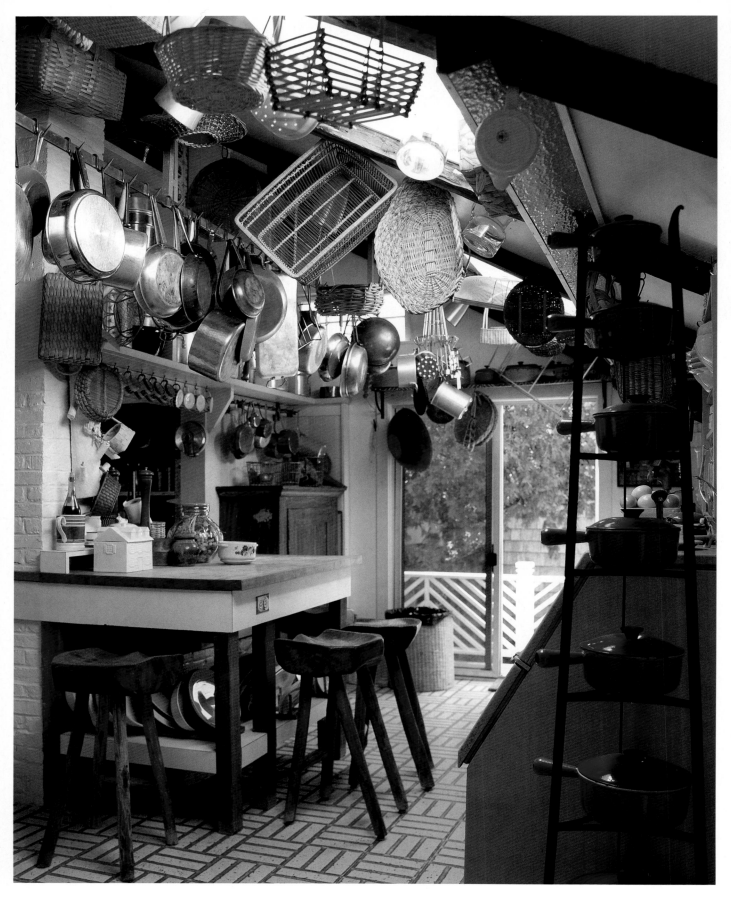

The kitchen is all new and was added when Jerry and Tom bought the house. Decorated with Portuguese tiles, the kitchen features several separate work areas after the design of many professional kitchens. One corner of the room has a desk and bookshelves out of the mainstream of kitchen activity.

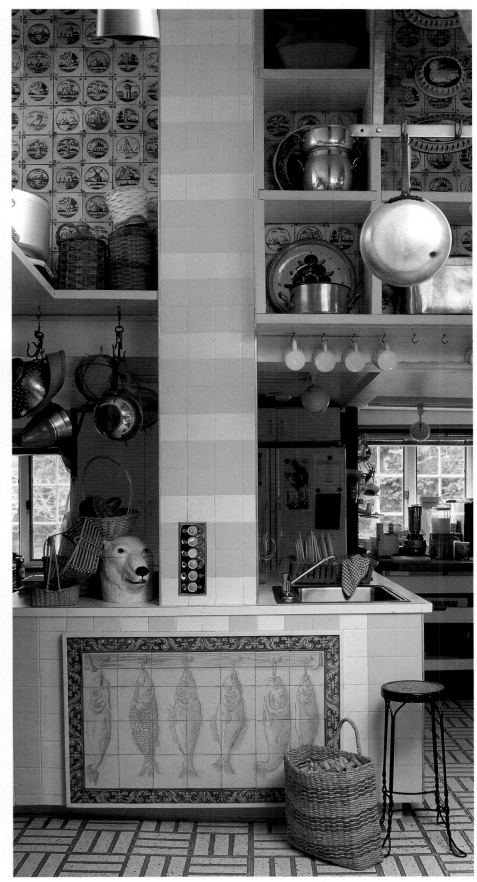

There are two levels of garden and pool areas behind the house. The first level down from the house consists of a bricked terrace and the large studio, which also opens onto the lower level. The lower level also contains the large swimming pool and its attendant deck.

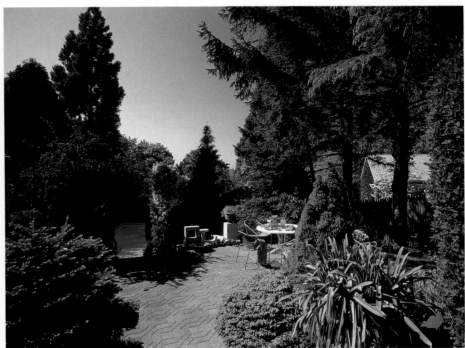

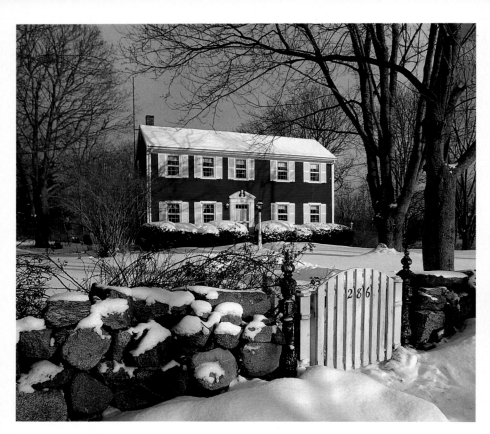

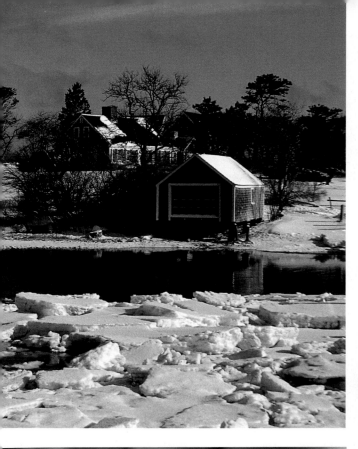

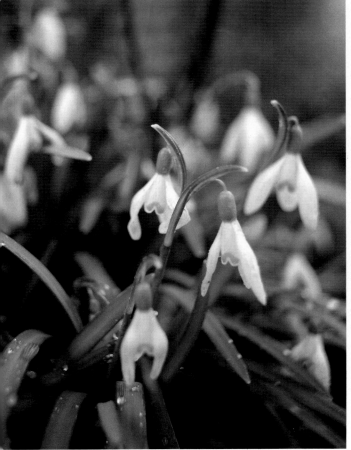

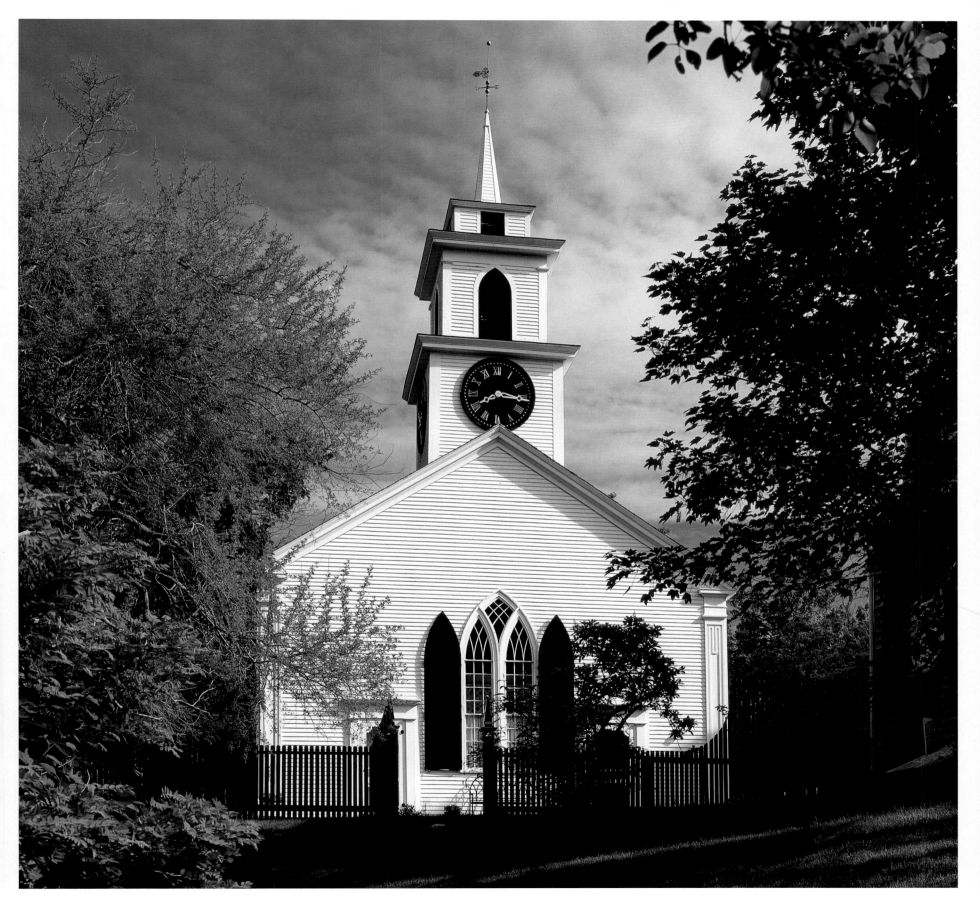

STRAWBERRY HILL MEETINGHOUSE

This white clapboard meetinghouse in Yarmouthport was built around 1836. In the 1930s a parish house had been added to the church. Helen Pond and Herbert Senn had seen the abandoned church in the 1960s and were interested in buying it, when they finally noticed someone was living there. In 1973 they acquired the property and began its restoration. The parish house was the first project. It was gutted, replumbed, rewired, insulated, new heating added, and in general shored up. Herbert and Helen added the vaulted ceiling and glass wall at one end and decorated and furnished it in romantic Gothic. Herbert used Horace Walpole's Strawberry Hill in Twickenham, outside of London, as his inspiration for the interiors. At the same time they were redoing the parish house, they began to secure the church against the elements. They repaired the tower, adding the cornice and actual louvers and in general making it appear more proper. The steeple had been lost in the 1944 hurricane, and the tower roof had been temporarily replaced, but after nearly thirty years it was open to the elements and home to countless pigeons. The broken clock and church bell were found in the tower. The clock has been repaired and now works, but it is doubtful that the bell will chime again. The cost of its re-casting is enormous.

LEFT: Gothic tracery design adds interest as well as support to the glass wall in the parish house living room.

OVERLEAF, PREVIOUS PAGES: The front of the 1836 meetinghouse restored to its present graceful Gothic style.

BELOW: The front of the meetinghouse has its original shutters, which were found in the cellar, repaired, and rehung.

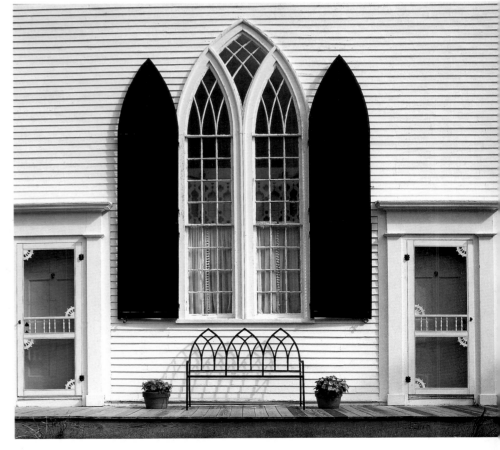

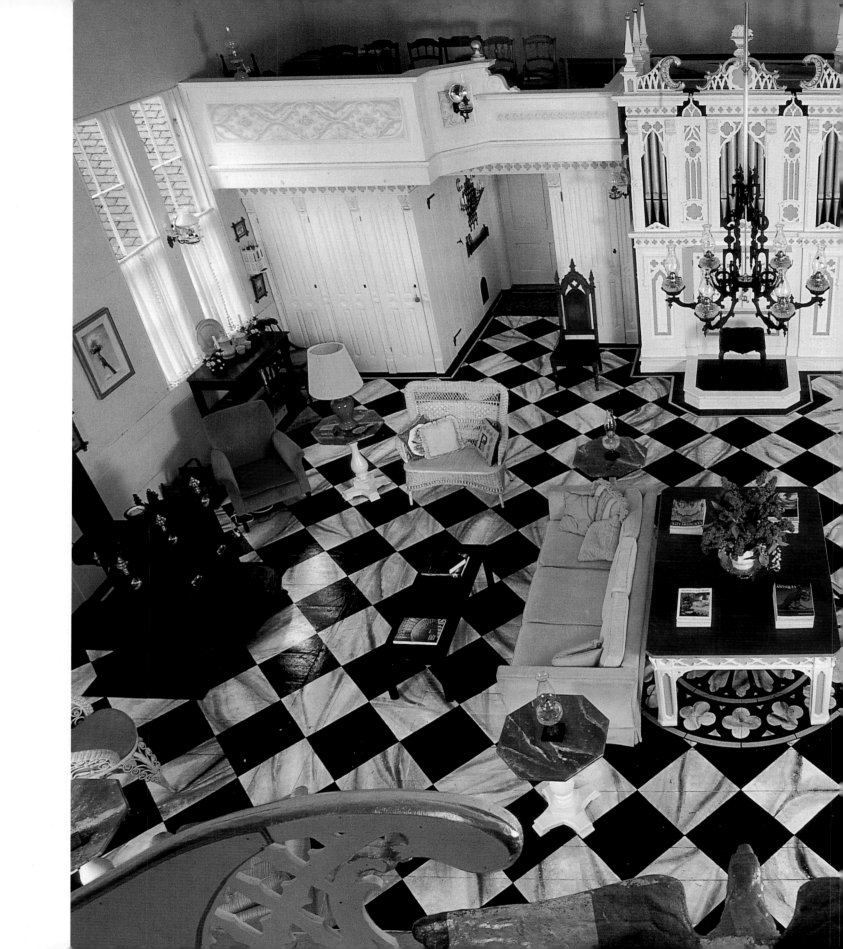

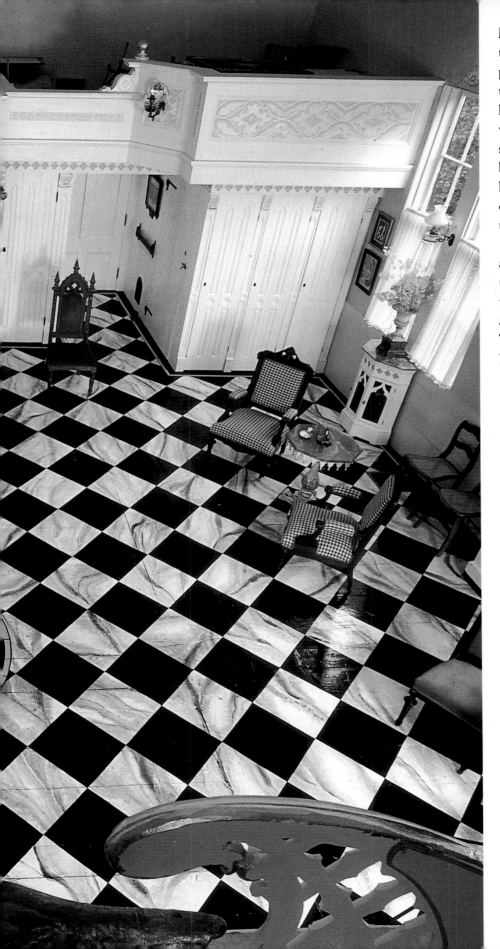

Now the music room, the sanctuary served as Herbert's workshop while the rest of the structure was under restoration. The floors have been painted in a faux marble checkerboard to camouflage the floorboards that run at right angles to one another. The floors of the aisles were laid in one direction and those for the pews in the other. The pews were carefully removed, numbered, and stored in specially built racks so that if and when the meetinghouse is again a church, everything will be intact from the original structure. The hymnals and church records have also been preserved. Herbert has been careful that all of his ornamentation is removable so that all can be returned to its former unembellished state without harm.

The Franklin stove was added for supplemental heat. On its surface are some of Herbert's cast-iron ornament collection—Victorian tassels used to decorate iron link fencing around cemeteries. The railing with the large eagle is the most recent addition to the room. The cupboards and balconies above the organ on the far side of the room were added. The room was finished to its present state and furnished as a large living room for Christmas of 1992.

BELOW: The cold air return with its fancy grating in front of the vestibule doors is from an old church in New York City. The red cut glass overlay above the doors is from the Third Avenue elevated in New York City. The long bench comes from Worden Hall, a meetinghouse in Dennis, Massachusetts.

BELOW RIGHT: The pipe organ may be the oldest organ built in New England. Its case dates to about 1830. In 1973, when Herbert and Helen bought the meetinghouse, the organ was badly damaged, with broken pipes, trackers, and other serious damage from raccoons. It has now been restored and embellished by Herbert. Everything has been encased carefully to preserve the original case.

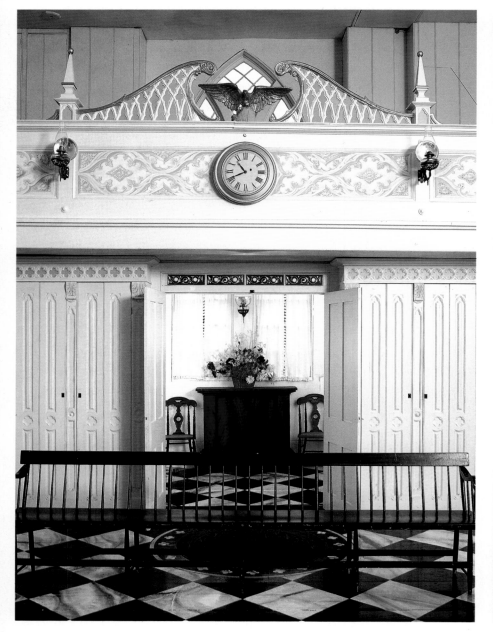

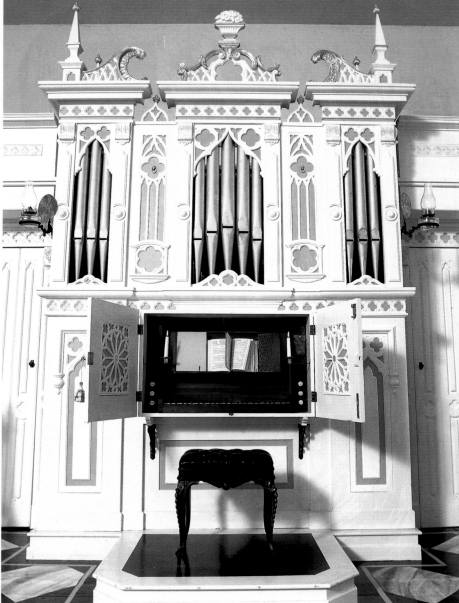

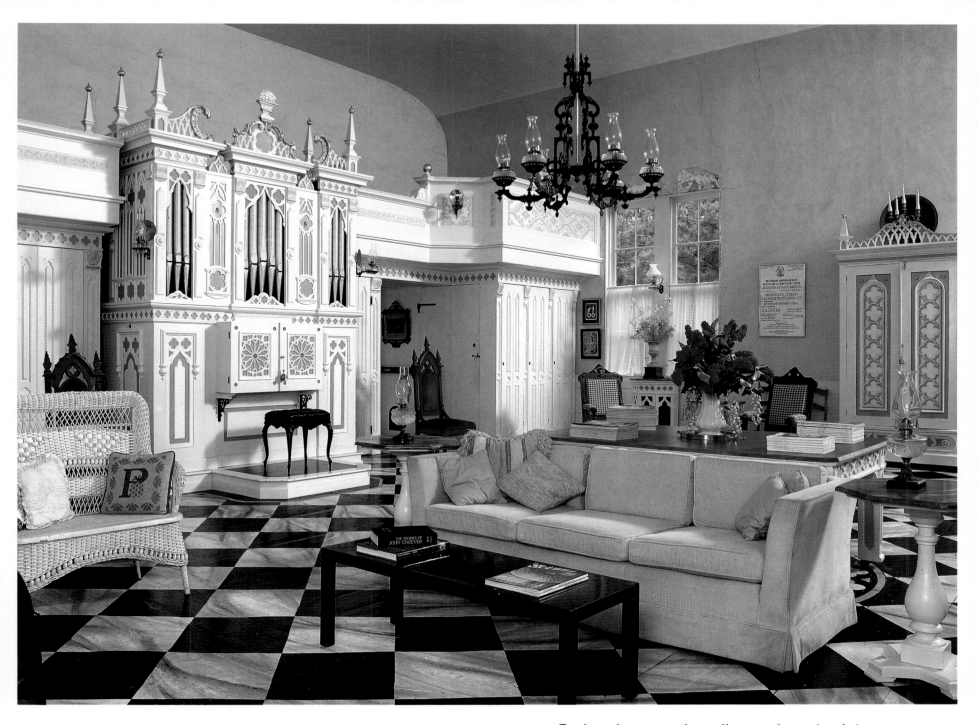

ABOVE: Cupboards against the walls on either side of the room were built because storage space was quite limited in the parish house. The spaces between the organ and the cupboards lead into the parish house living room.

Herbert calls this combination sitting room and guest room his one quote, because it is fashioned after Horace Walpole's round room at Strawberry Hill in Twickenham, England. Walpole had his room designed by Robert Adam after the rose window in the former St. Paul's Cathedral in London. All the fanciful traceries and romantic Gothic designs are at play in the trompe l'oeil vaulted ceiling. Painted on seamless muslin and then applied, the ceiling took Herbert and Helen approximately one week to paint and mount. On either side of the windows and at the ends of the sofas are cupboards fronted with false books to look like bookcases. When the room is being used as a guest room, sliding doors, just visible on either side of the room, close it off for privacy from the living room. Both sides of the doors, as well as the spandrels and ceilings on either side of the room, are painted in trompe l'oeil Gothic designs.

In reviving and preserving the meeting house, Herbert and Helen have worked in the tradition of the great designers and scenic wall painters, like Tiepolo, who worked on the Palladian villas in the Veneto in the seventeenth century, and Angelica Kaufman, who worked with Robert Adam on the great eighteenth-century houses in England. Herbert and Helen have continued the refined wall decorations into the twentieth century with the restoration of the nineteenth-century church.

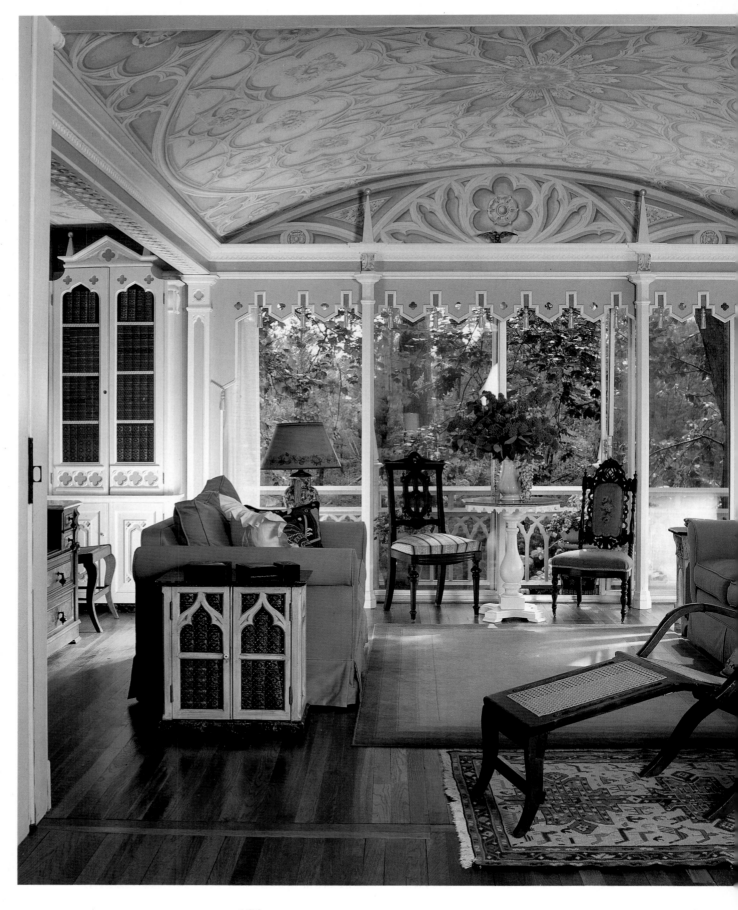

The big window at the end of the living room of the former parish house is supported by guy wires that end in cast-iron stars. The window is further supported by the Gothic screen on the outside. Above the sofa is one of two sleeping balconies on either side of the upper level. On the wall to the left of the glass wall is a model of the final plan for the Gothic window.

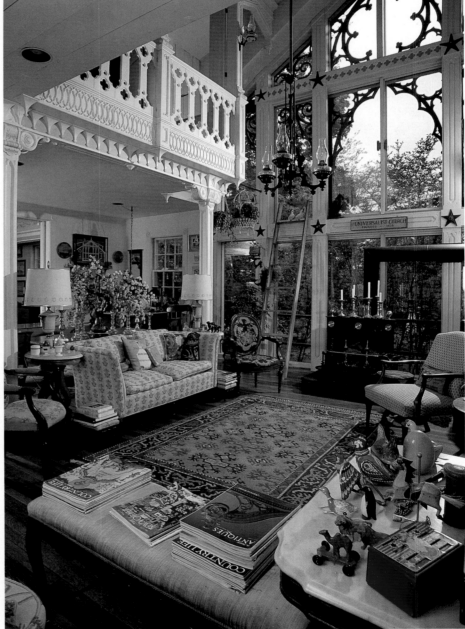

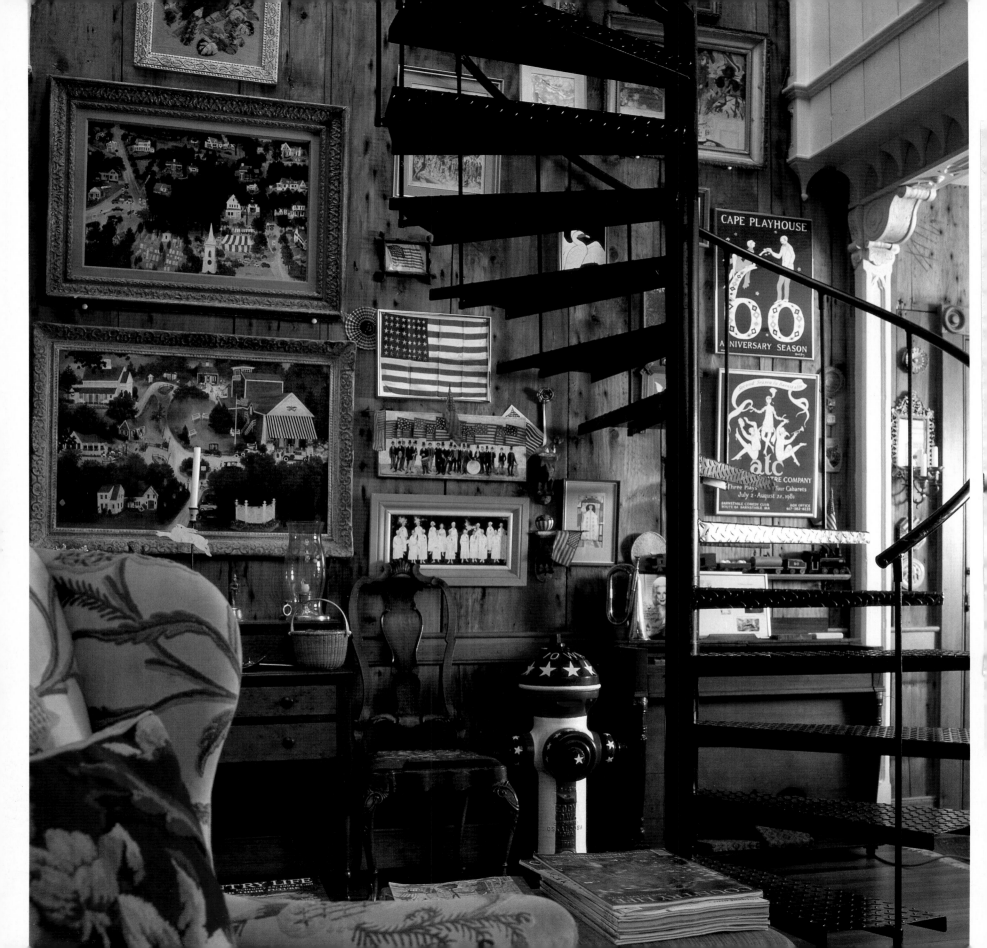

Even the bathroom has been Gothicized with the addition of the cabinetry and hanging shelves along with some of a collection of Victorian cast iron and deer horns.

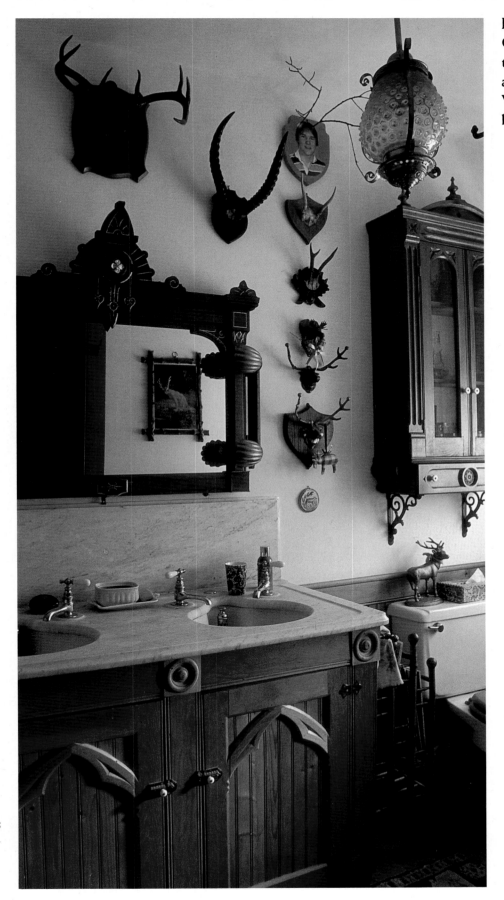

The back wall of the living room behind the spiral stairs that lead to the sleeping balconies above is lined with paintings by local artist Ric Howard of scenes of Cape locales and events. Also on the wall to the right are two Edward Gorey posters, one commemorating the sixtieth anniversary of the Cape Playhouse in Dennis, where Herbert and Helen have spent their summers as set designers for many years. They also design sets for the Boston Opera Company and Broadway.

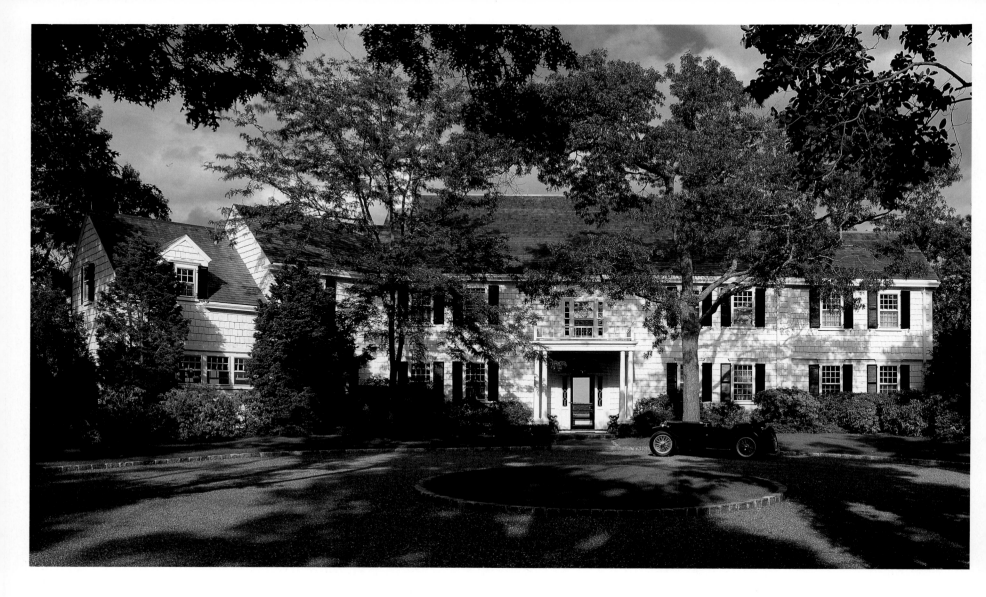

EASTWIND

I deally located on the water's edge, this white shingled country Georgian summer home was built in 1931. The front entrance opens into a great hall with a grand circular stair. A door at the end of the hall opens out on to the lawn, which slopes down to the water. When the present owners bought the house, one of the first things they did was remove the granite-walled raised planting beds from around the bases of the old trees. They chose to simplify the entrance to the graceful white house by planting green lawn and evergreens that would follow the contours of the house along the front. The grounds around the house were also relandscaped, and a pool and garden were added.

Inside the house, the owners completely redid the kitchen wing and the master bedroom suite and redecorated the rest of the house, furnishing it with a combination of antiques and collections of things they enjoy. With its large screened porch and sun porch rooms, as well as numerous upstairs guest rooms, the house has plenty of space for entertaining and is well designed to create an elegantly comfortable summer home for the owners and their family.

ABOVE: **Parked in front of the house is the owner's 1939 MGTA.**

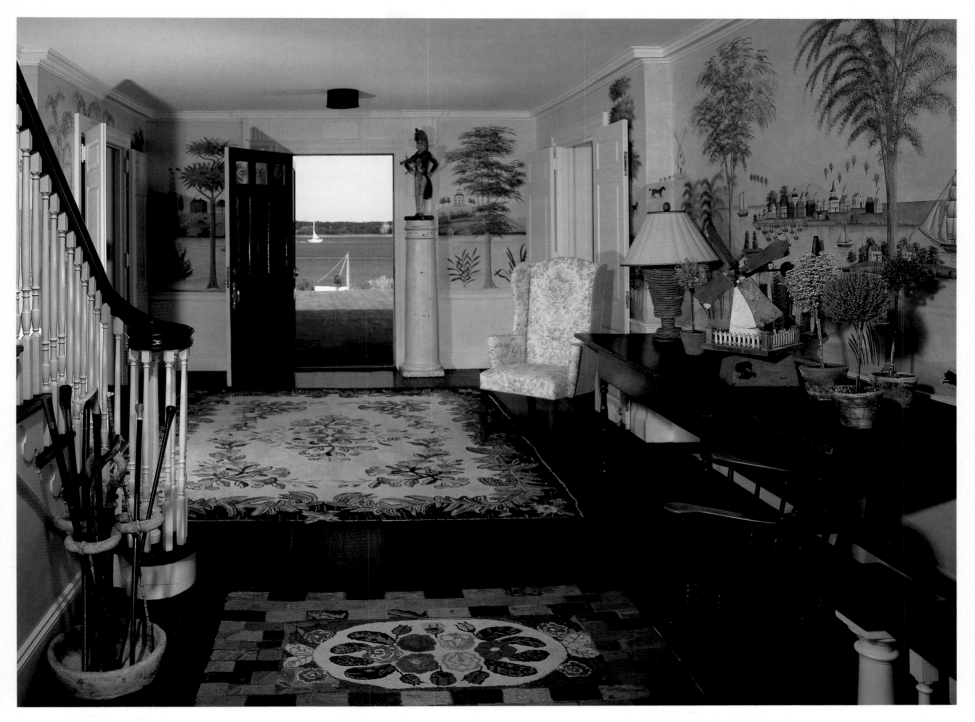

Being collectors of seventeenth- and eighteenth-century paintings, the owners are admirers of the murals of Rufus Porter and have carefully researched his work. When they met James Alan Smith, the owners learned that someday he wanted to paint a Rufus Porter–style mural. When they acquired this house, with its grand center hall, they decided to have Smith paint a personalized New England scenic mural à la Rufus Porter.

A Rhode Island Windsor chair, c. 1790, is next to the long Connecticut altar table, c. 1780, which nearly fills the wall between the doors into the living room. On the table is an early-nineteenth-century American whirligig. An early-nineteenth-century sailor, a shop sign for a ship's chandlery, stands next to the door at the end of the room. Nineteenth-century American hooked rugs line the floor.

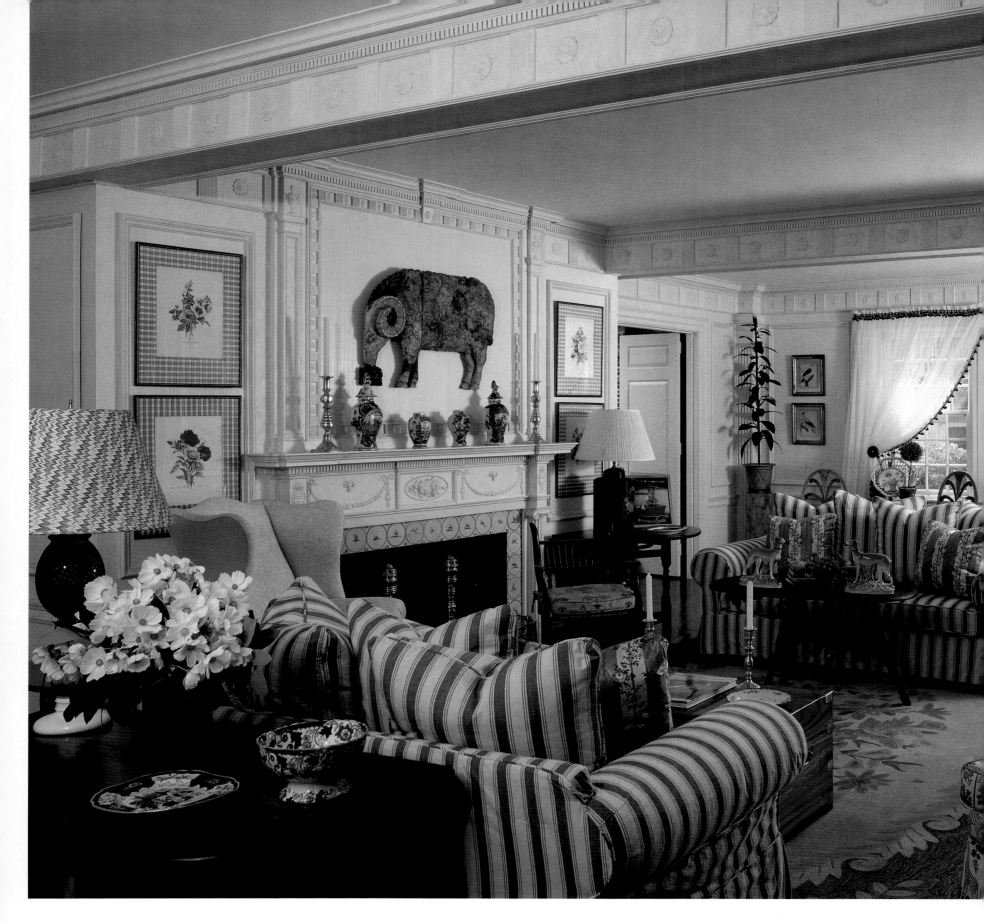

The comfortably furnished living room is a mix of soft upholstered furniture and antiques. They are enhanced by the intricate moldings and mantelpiece, which are typical of the country Georgian style of the house. Above the mantel is a carved wooden ram believed to be a shop sign for a Scottish wool merchant. In the foreground, on the sofa table, two pieces of Spode, Imari pattern, c. 1840, are part of the owners' extensive collection of porcelain. A Chinese camphor wood chest with brass corners functions as a coffee table in front of the nearest sofa. On the floor is a large nineteenth-century American hooked rug. A pair of russet Staffordshire dogs sits on an eighteenth-century American tuckaway table, with its original paint. Next to the piano is an eighteenth-century American ladderback chair with mushroom-capped arms. Beneath the windows are two of four rare chairs with Prince of Wales feathers. They are early-twentieth-century reproductions of a famous set of twenty-four chairs made in the 1790s for Elias Hasket Derby, a Salem merchant in the China trade. The chairs were made for his pleasure boat, *Cleopatra's Barge.*

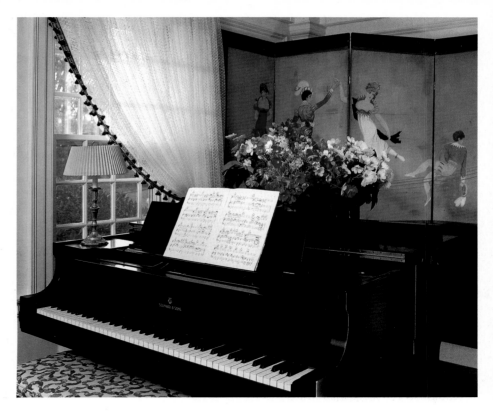

ABOVE: In the corner of the living room a nineteenth-century Italian screen stands behind the piano.

RIGHT: Between the windows are two sailors' valentines, both done by local Cape artist Ralph Cahoon. The octagonal frames are contemporary but done in traditional nineteenth-century octagons and made of shells. Designed with shells from beaches around the world, the original valentines were made on board whaling ships by sailors for their wives and sweethearts back home.

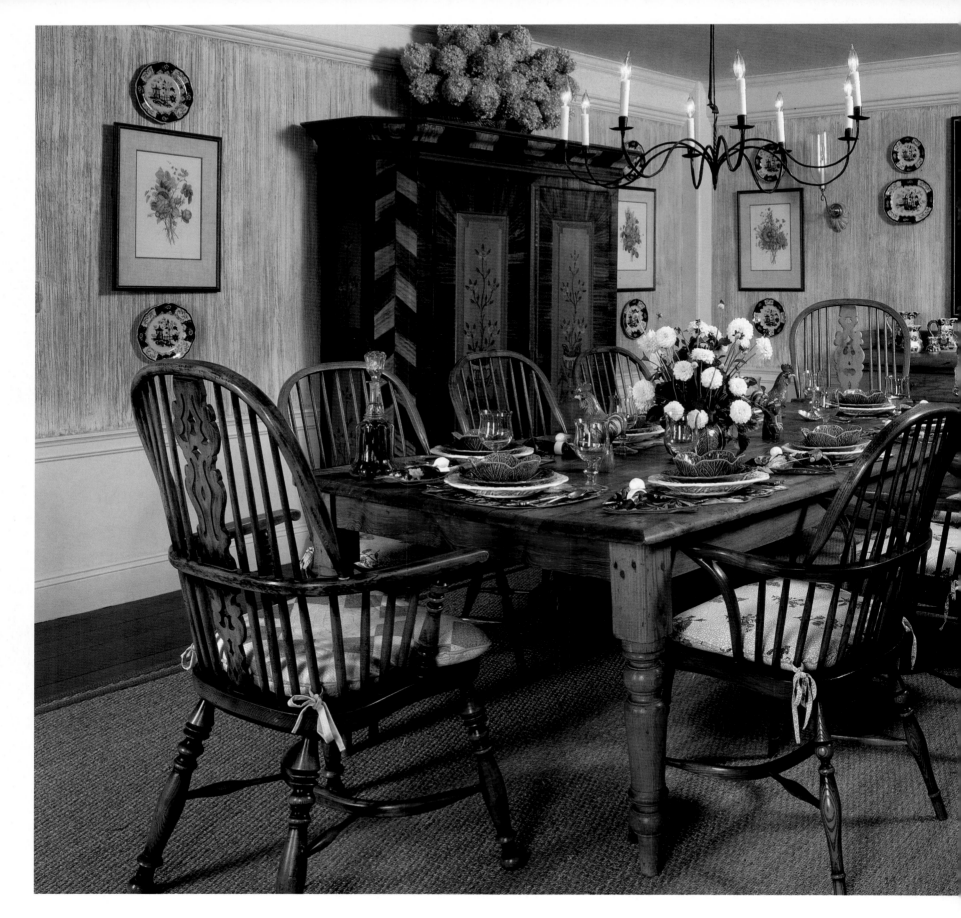

The formal dining room has striated plaster walls, which have been glazed to create the colorful background for the large Swiss kas, c. 1780, and the rest of the dining room furnishings. Early-nineteenth-century English yew wood Windsor chairs surround the antique English tailor's table. More of the owners' collection of Imari Spode porcelain decorates the walls and the top of the chest. A silver caster with rare yellow Sandwich glass condiment bottles is on the back right corner of the table.

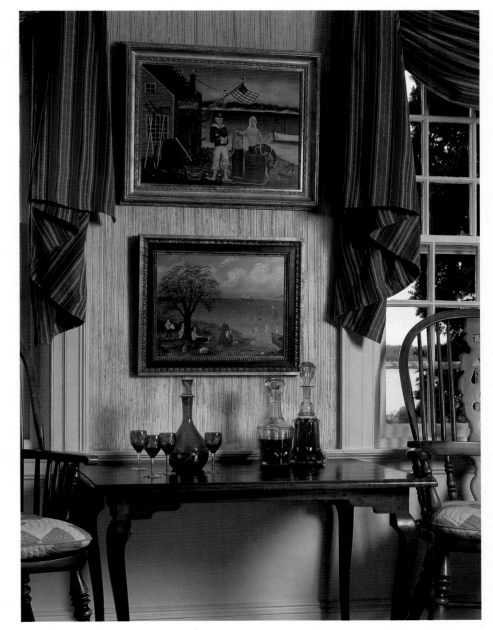

Two Cahoon paintings, the top one by Ralph Cahoon and the bottom one by his wife, Martha, are both typical of the Cahoons' whimsical depictions of Cape Cod. The paintings hang over a Bermuda tea table, c. 1760, in the dining room.

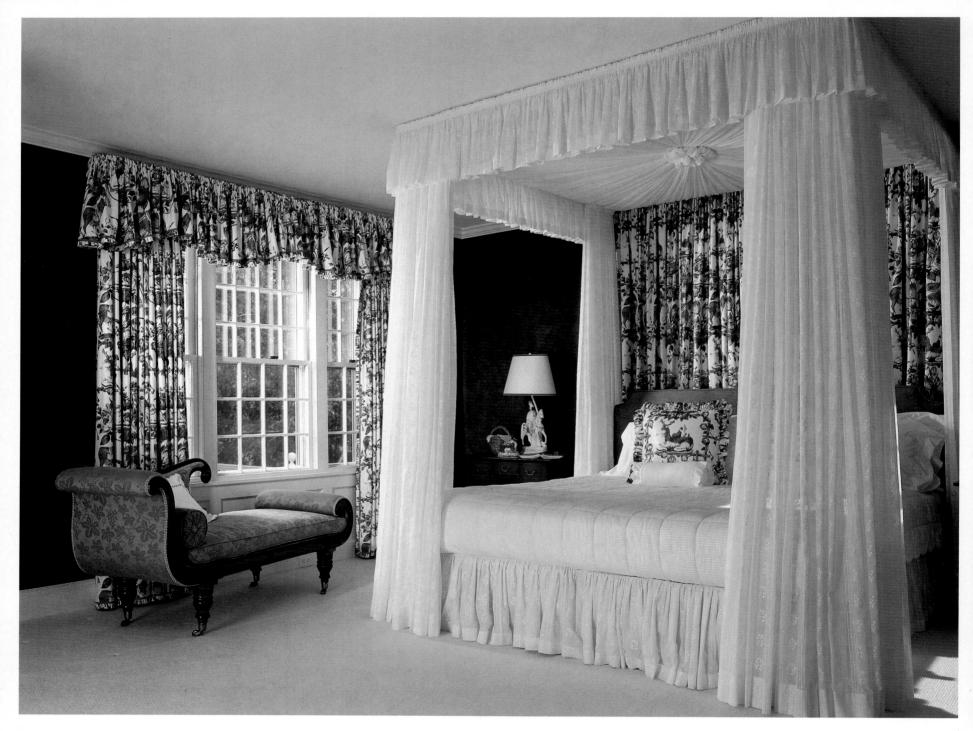

ABOVE: In the master bedroom, an eighteenth-century-style bed is beautifully dressed in embroidered chambray and colorful chintz. A Staffordshire figurine made into a lamp accents the rich colors of the fabrics. A Regency daybed in Empire style is in front of the windows overlooking the water.

TOP RIGHT: The enclosed sun porch, furnished with comfortable wicker chairs and sofa, is a favorite room for summer relaxing. TOP, FAR RIGHT: A little guest house opens on to the pool and perennial borders. The flagstone terrace outside the kitchen and sun porch is a quiet spot for lunch. RIGHT: The sweeping green lawn with the graceful old oak trees lends a sense of timelessness to this gracious summer home.

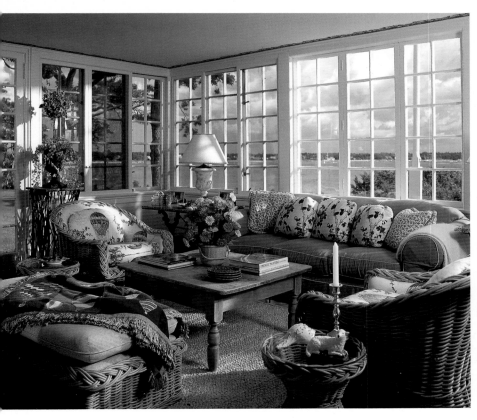

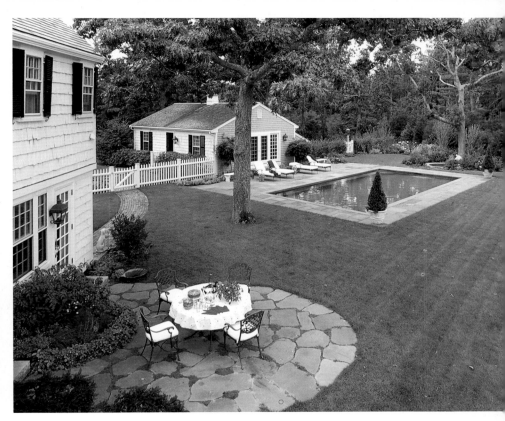

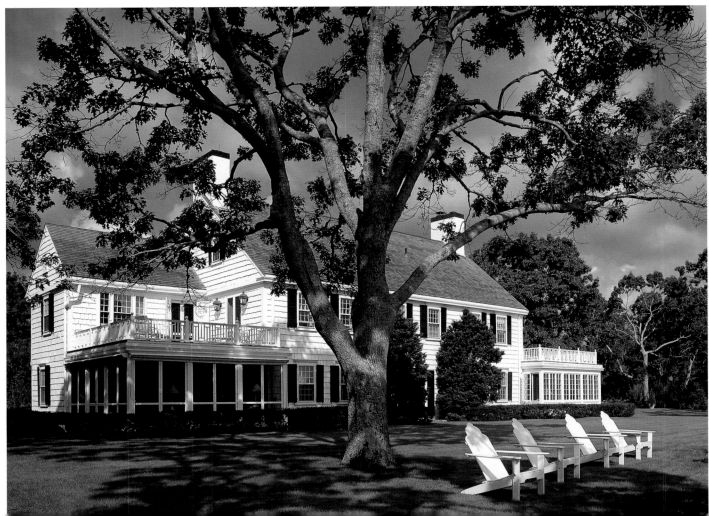

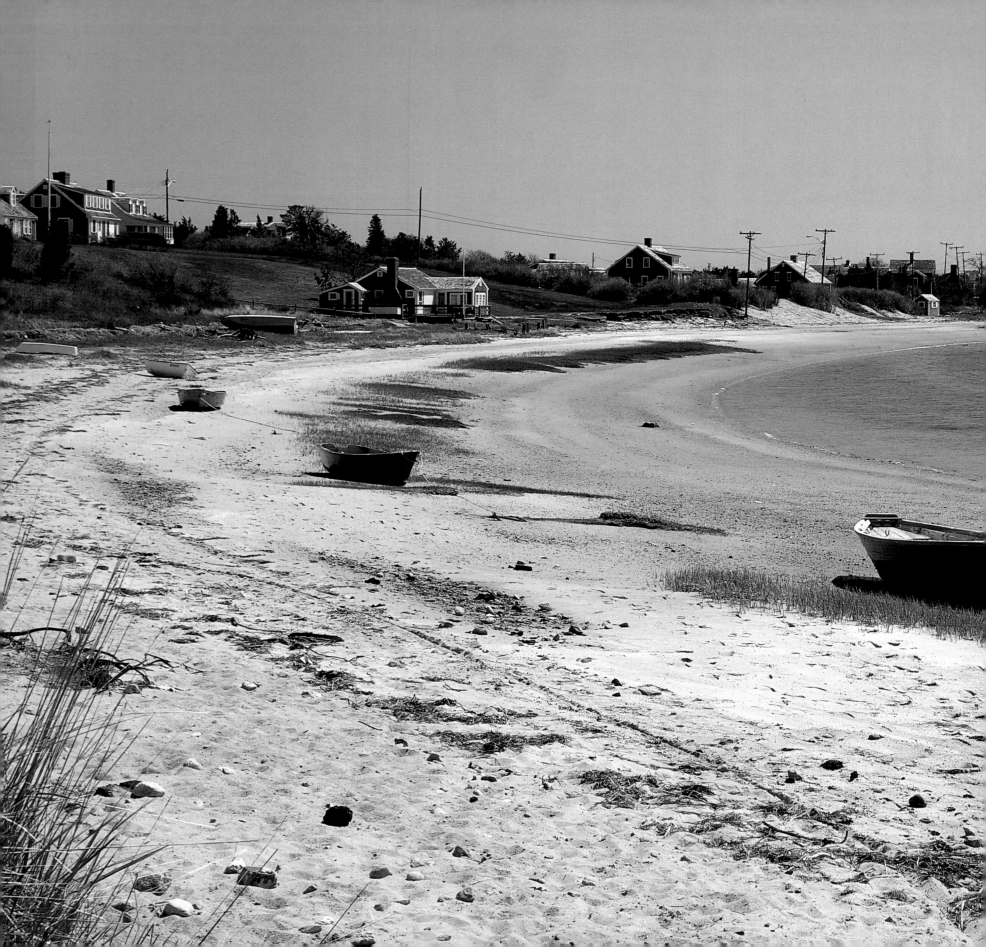

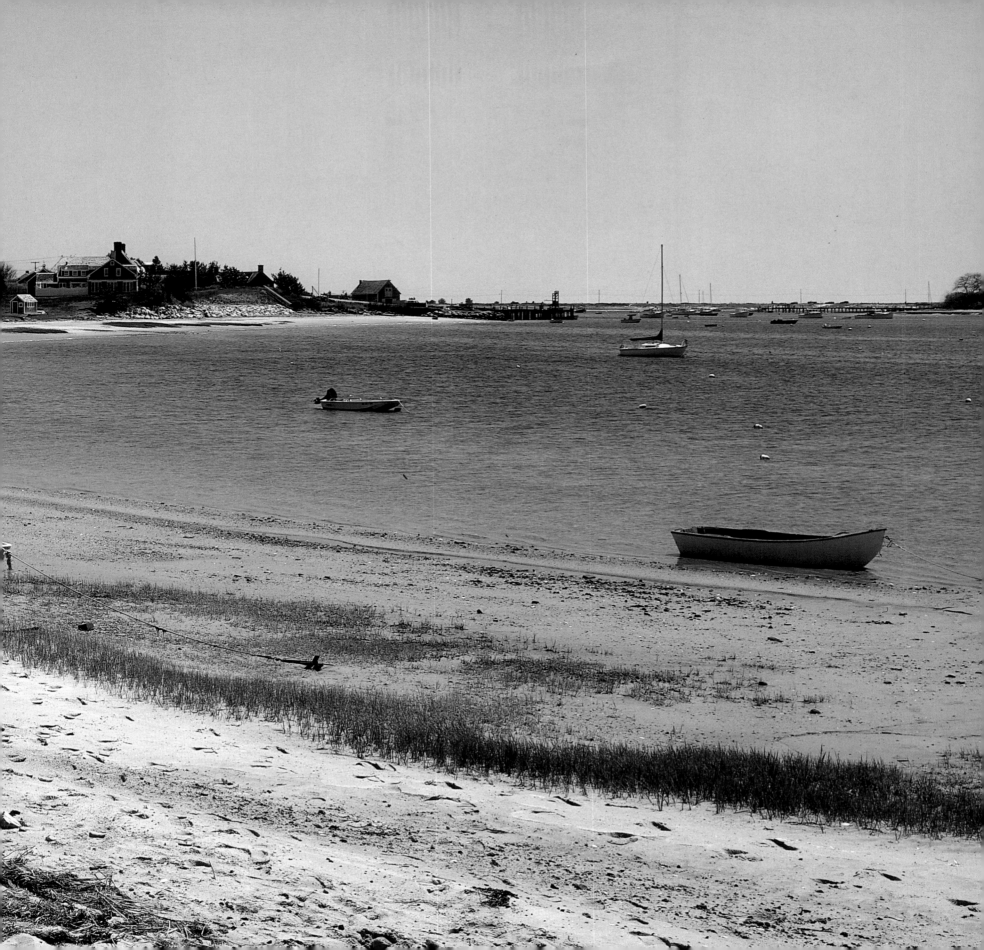

Y-NOT

Near the water in Osterville is this interesting house and garden. When Richard FitzGerald bought the property in 1984, only the little one-story house and windmill were on it. The windmill is about thirty years old and was connected to the little cottage. Both have been gutted and renovated into guest quarters that are completely private from the main house. The main house has two stories, with a cathedral ceiling in the living room. The master bedroom and library are upstairs, above the dining room and kitchen downstairs. Double French doors in the living room open on to a canopied garden room, which in turn opens into a walled garden between the side of the house and the street. In fact, wonderful gardens, each with a distinct personality, surround the house on all sides. On the front, the house is set very close to the street but nonetheless has a tiny enclosed garden behind the fence. Wisteria covers the upper balcony, which opens off the master bedroom. Behind the house are more gardens sheltered by high fences. Tall arborvitae conceal the fences on the street side. Inside, the house is furnished with colorful fabrics, interesting antiques, and collections that appeal to Richard. In essence, the house is a splendidly comfortable refuge.

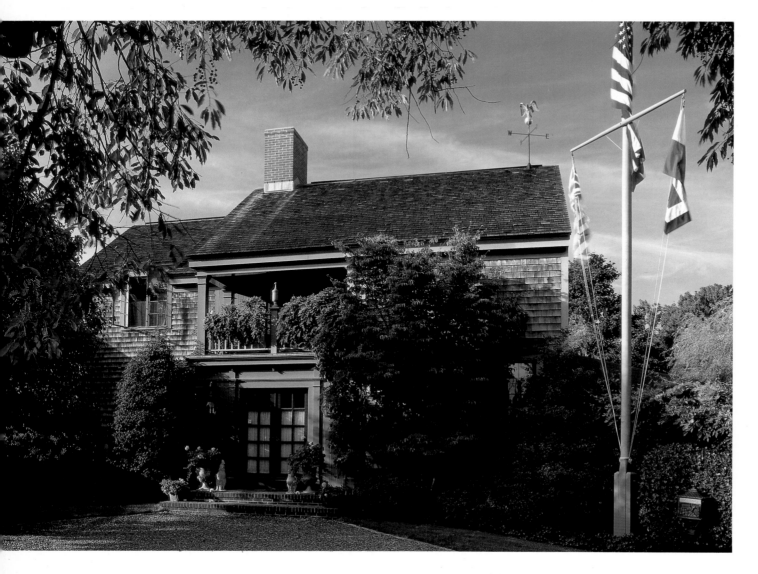

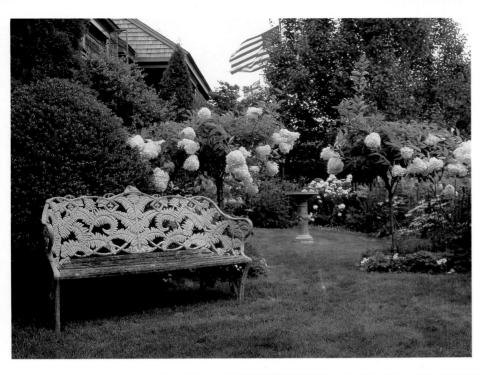

LEFT: Tree hydrangeas (*Hydrangea paniculata grandiflora*) and a Victorian iron settee mark the entrance to the fenced cottage garden in front of the house. Blooming in August are colorful phlox and rudbeckia.

BELOW LEFT: The wooden milkmaid, with remnants of its original paint, comes from the Isle of Wight and dates to about 1840. It was probably a dairy or creamery sign.

BELOW: The little cottage and windmill serve as guest quarters for the main house. Though attached, they have entrances of their own and open on to the garden behind the rosa rugosa–covered fence. The garden, planted in the traditional cottage style, has something colorful in bloom from late spring throughout the summer.

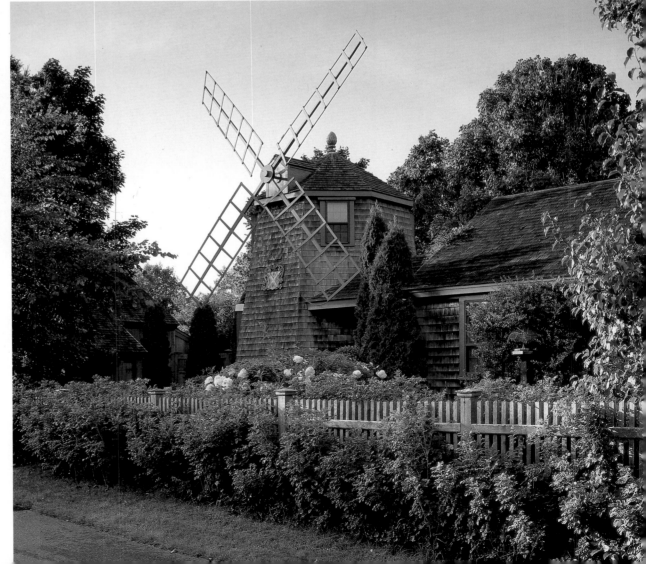

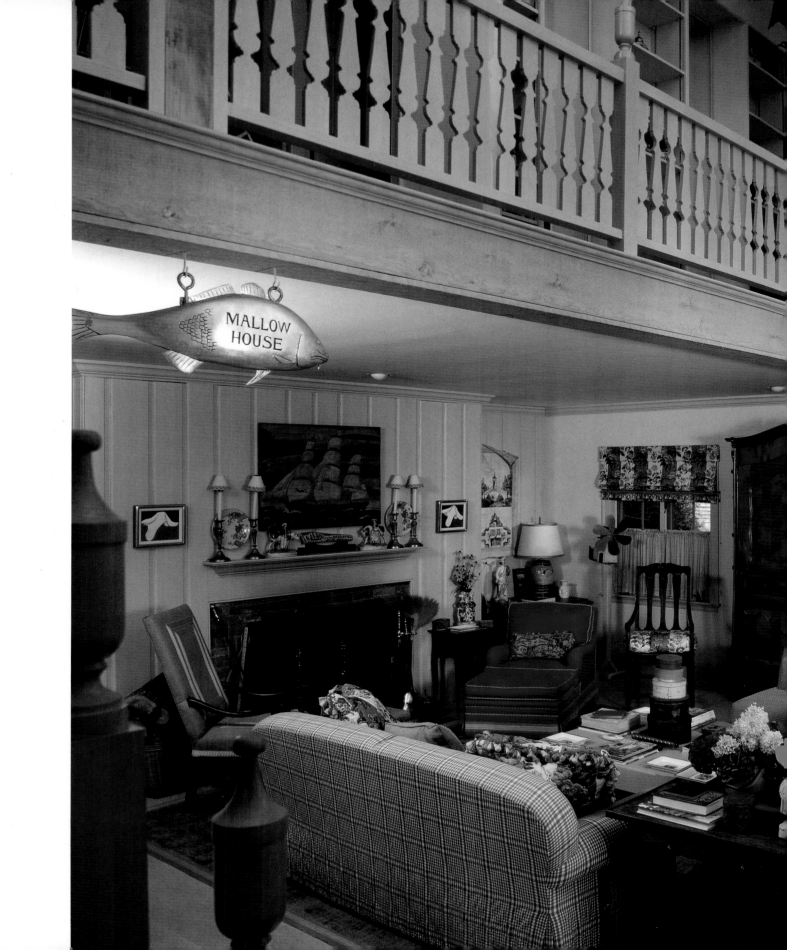

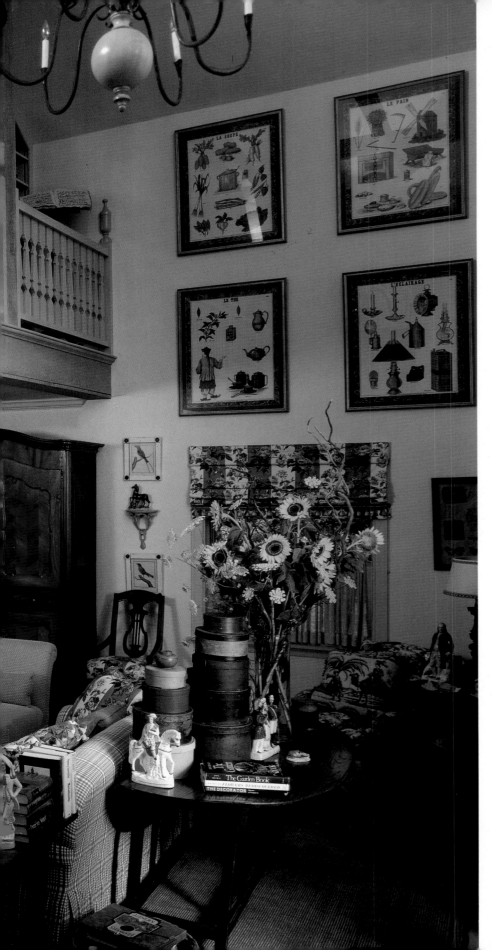

A staircase leads from the corner of the living room to the library wall at the top. An eighteenth-century French country cabinet on the far wall is flanked by French country chairs. In the recessed wall next to the fireplace hangs a painting of an English folly. Part of Richard's extensive collection of Staffordshire porcelain accents the mantel and is displayed throughout the room. In the foreground a codfish sign bearing the inscription MALLOW HOUSE was made for Richard's former house in Chatham.

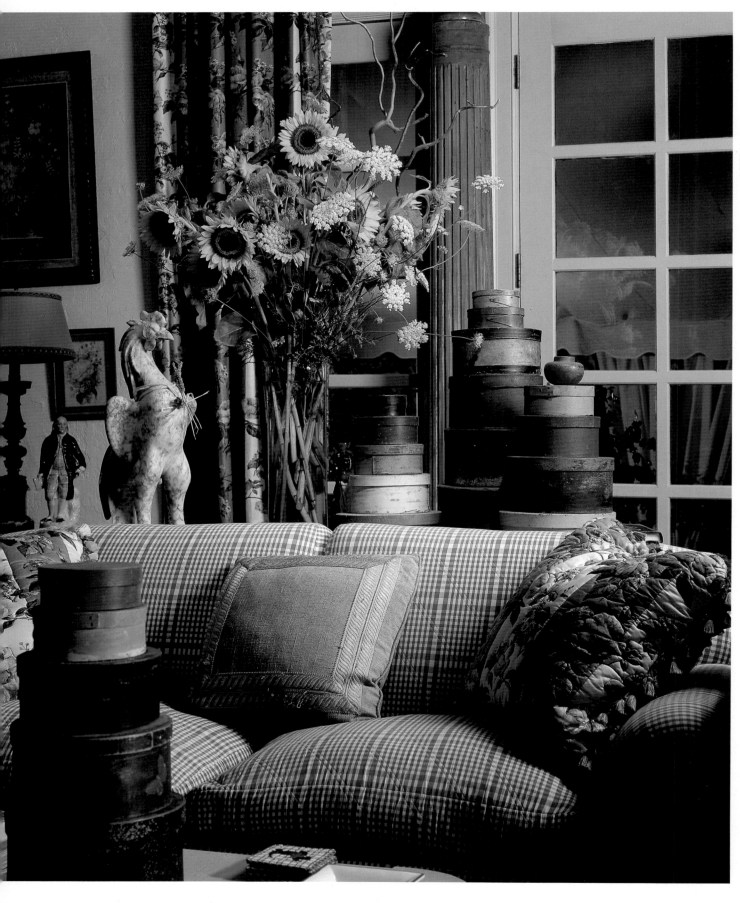

The colors of the Brunschwig et Fils fabrics in the upholstery and the window treatments are heightened by the rich colors of Shaker pantry boxes arranged on the coffee table and the sofa table. The crowing cock is made of Italian marble. Double French doors open on to the canopied terrace in the garden.

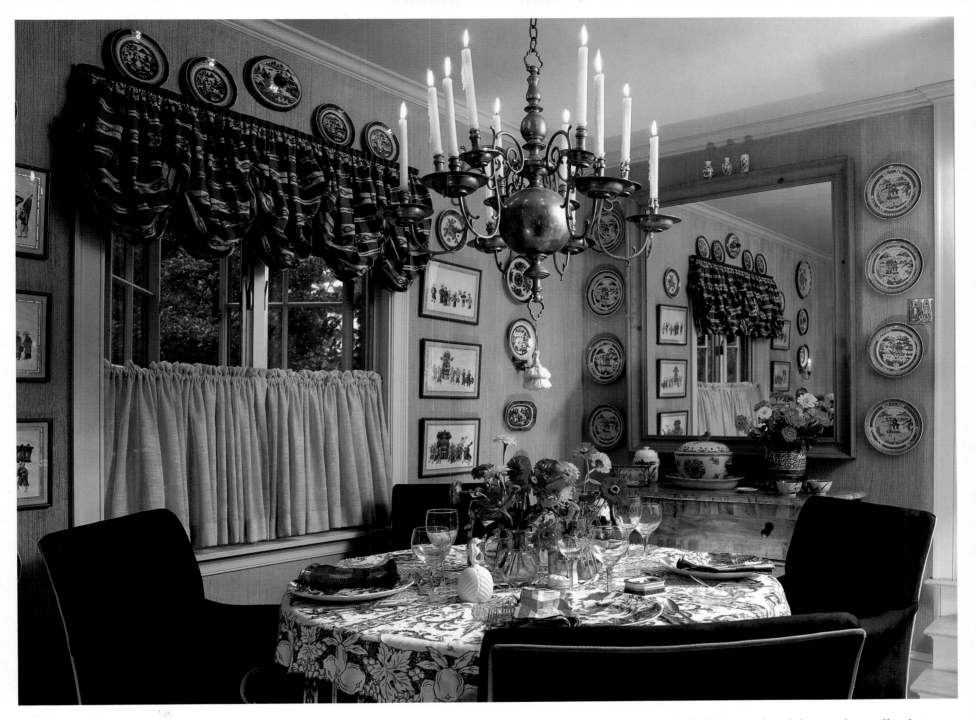

An eighteenth-century Dutch bell brass chandelier with candles hangs over the table. A painted Scandinavian chest along the wall holds a blue-and-white Chinese export tureen. The combed and glazed plaster walls are accented with a combination of delft and blue-and-white Chinese export plates. Chinese processional paintings on rice paper hang on either side of the dining room window.

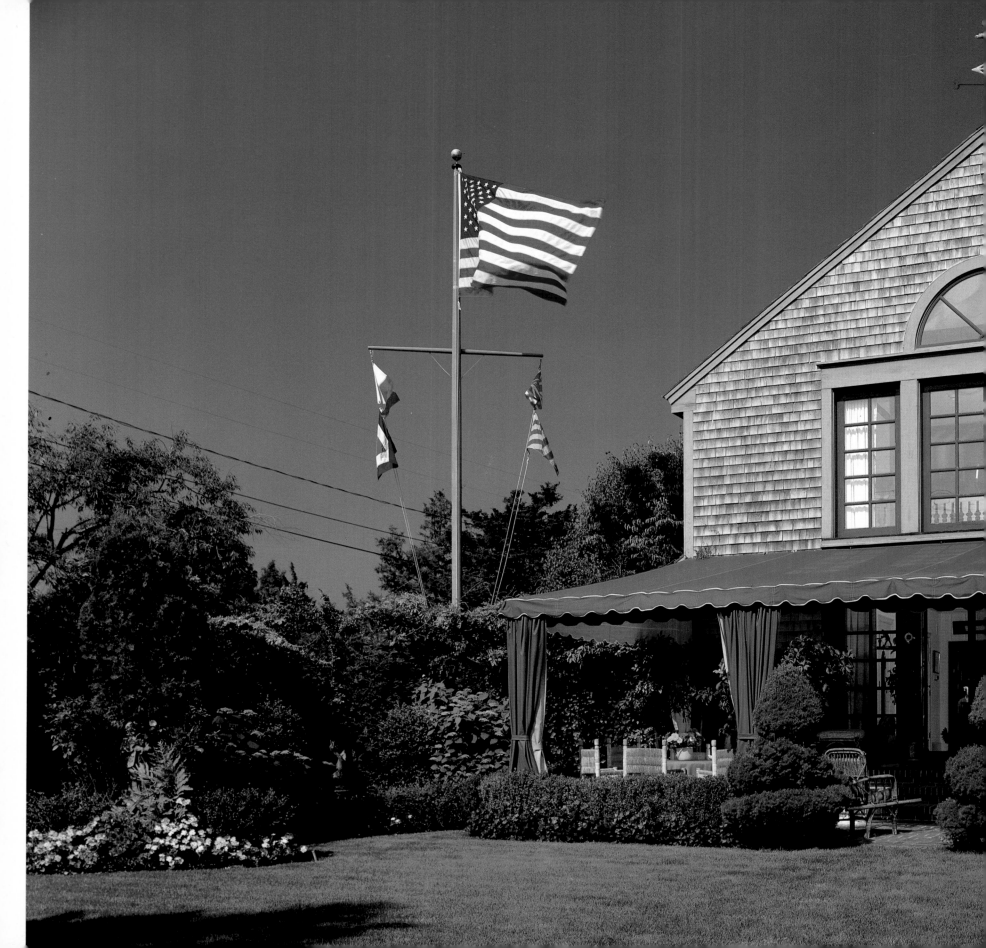

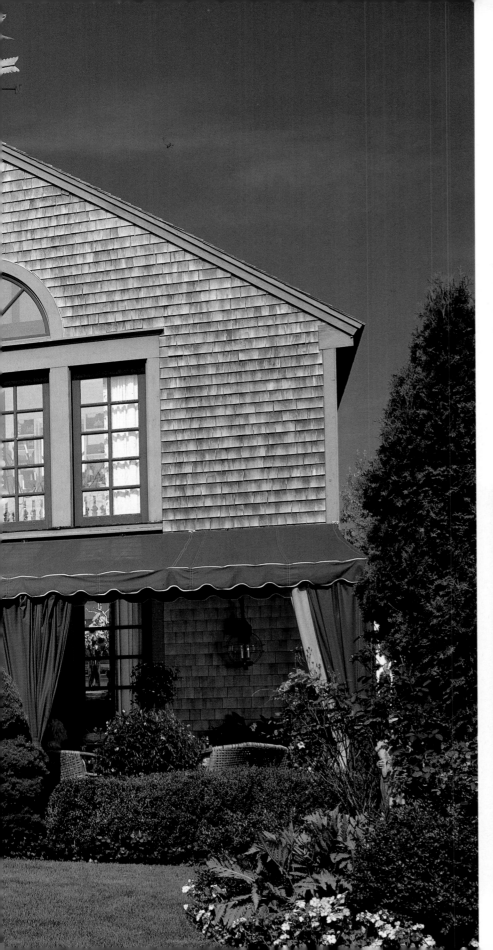

A large brick terrace covered by a canopy and furnished with wicker and willow furniture makes a comfortable garden room that is open to the outdoors yet sheltered from the sun, wind, and all but the most driving rains. The carefully planted garden is surrounded by a tall fence behind the privet hedge, which forms a backdrop for the rest of the carefully chosen shrubs, garden sculptures, and roses. An eighteenth-century American eagle wind vane adorns the peak of the roof.

The formal garden stretches out beyond the table set for cocktails. At the far end of the garden a small pavilion contains a sitting room.

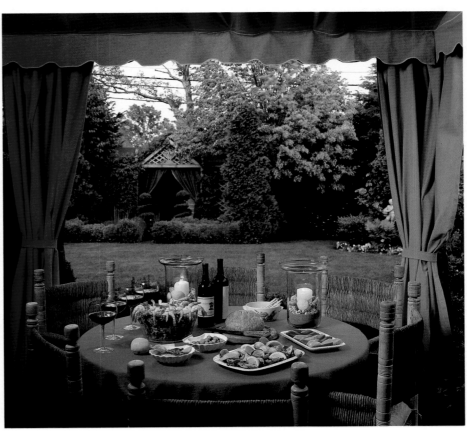

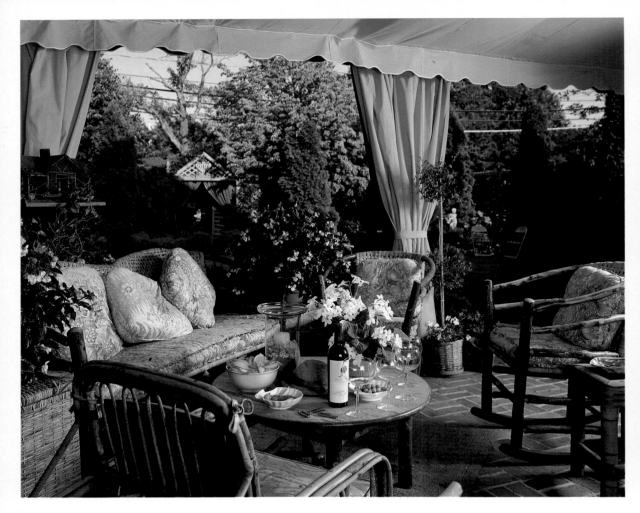

ABOVE: One side of the terrace is a comfortably furnished sitting area
with softly cushioned willow settee, rocker, and armchairs. Large urns
of begonias and impatiens add soft color accents to the scene.

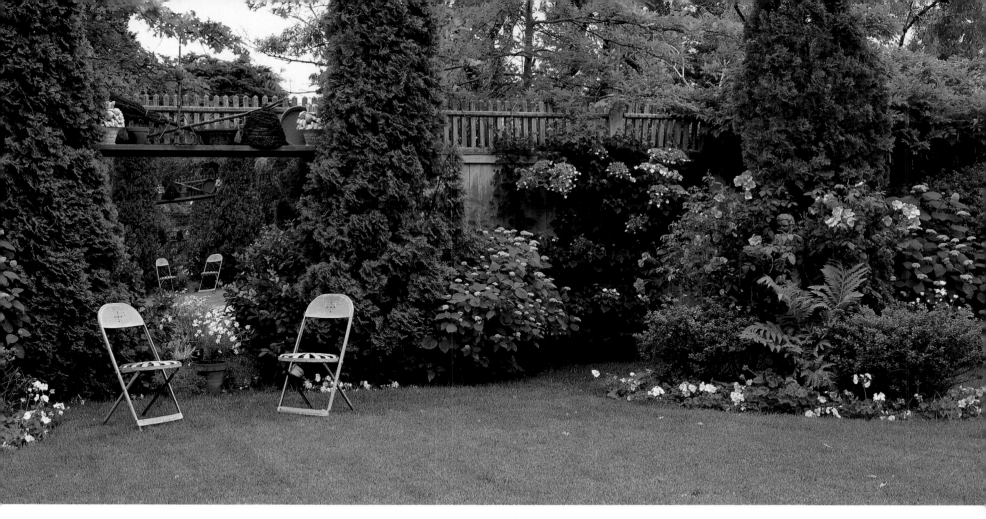

ABOVE: Reminiscent of eighteenth-century French gardens, the relatively small formal garden is symmetrically planted within the fenced walls, which contain strategically placed mirrors that make the garden appear to go on forever. On either side of the facing mirrors are statues of the four seasons surrounded by Betty Prior roses, ferns, and borders of lush impatiens. Tall arborvitae and climbing hydrangea, along with lace cap hydrangeas and other shrubs, are planted along the fence.

RIGHT: The statue is *Autumn,* one of four seasons that are encircled with Betty Prior roses at the sides of the mirrored sections of the walled garden.

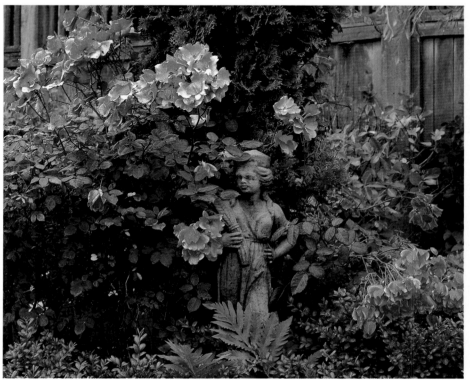

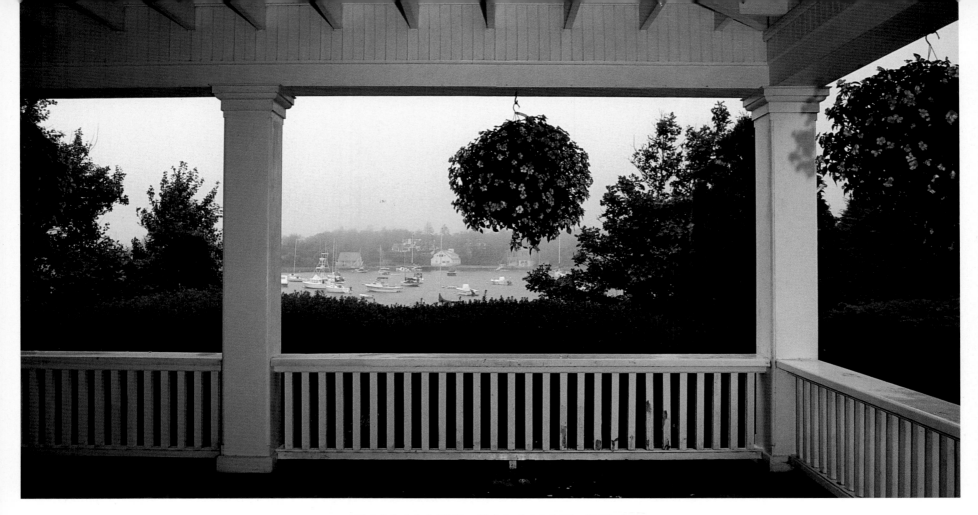

SUMMER BY THE SEA

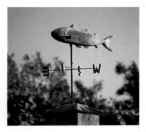

This grand shingled Arts and Crafts–style summer home was built in 1916 for a wine merchant and his family who had homes in both New York and France. They used the house only in July and August—the height of summer on Cape Cod. The house remained in that family until 1978. Jim and Beth Maher bought the house in 1983, when their children were babies, and have spent their summers on the Cape ever since. They worked from the outside in, adding the gardens and revamping the landscaping around the old house high on a hill overlooking Wychmere Harbor. Inside, the house had the dark wood tongue-and-groove walls typical of summer homes of the day, and a large heavy brick fireplace in the living room. Upstairs were seven bedrooms and two maids' rooms on either side of a long hall. The first thing the

Mahers did inside was to remodel the kitchen. They took out the butler's pantry and added a door from the front hall to the kitchen. The house had been built with servants' quarters in the back, and the remains of the buzzer system still existed.

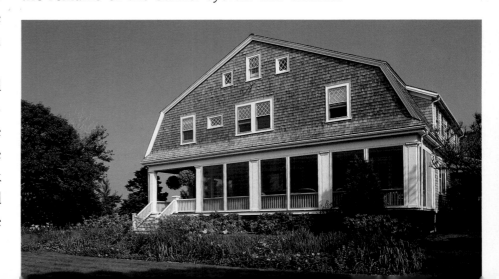

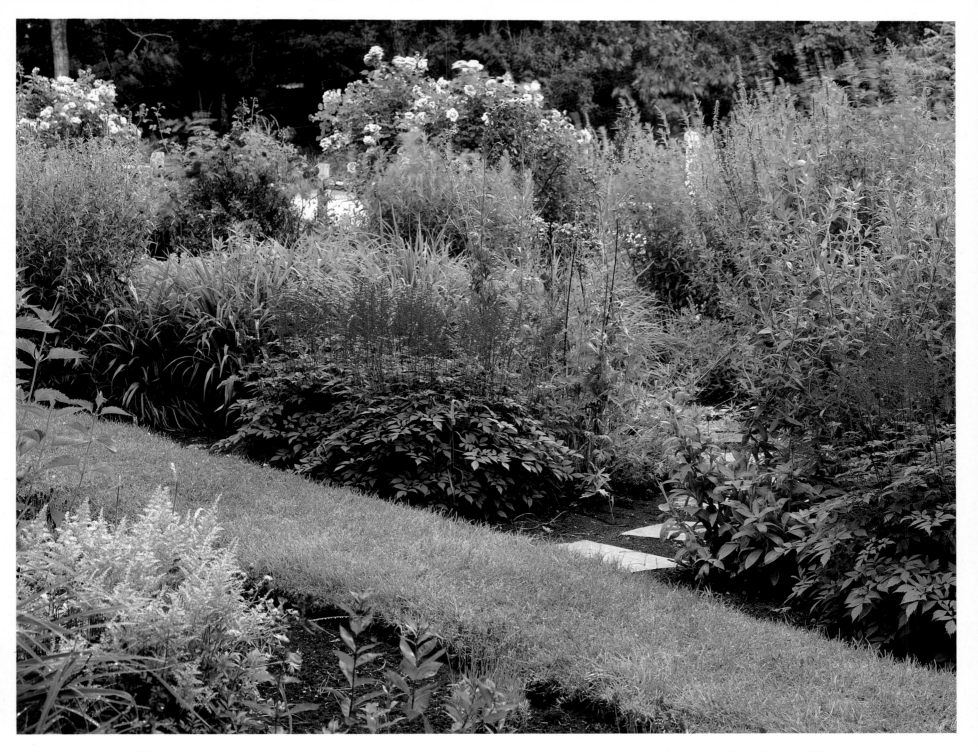

LEFT AND ABOVE: When the Mahers bought the house they found the semblances of bygone gardens, which were terribly overgrown. They cleaned out and replanted the large garden by the driveway first and then worked on the large daylily bed next to the croquet court. The large wraparound porch, typical of shingled summer houses of that vintage, is screened in on this side of the house. The large garden above in late June is filled with roses along the outer borders. Astilbe, delphinium, and larkspur, all in vibrant colors, are among the first of the perennials to bloom in this garden, which is planted for mid- to late-summer enjoyment.

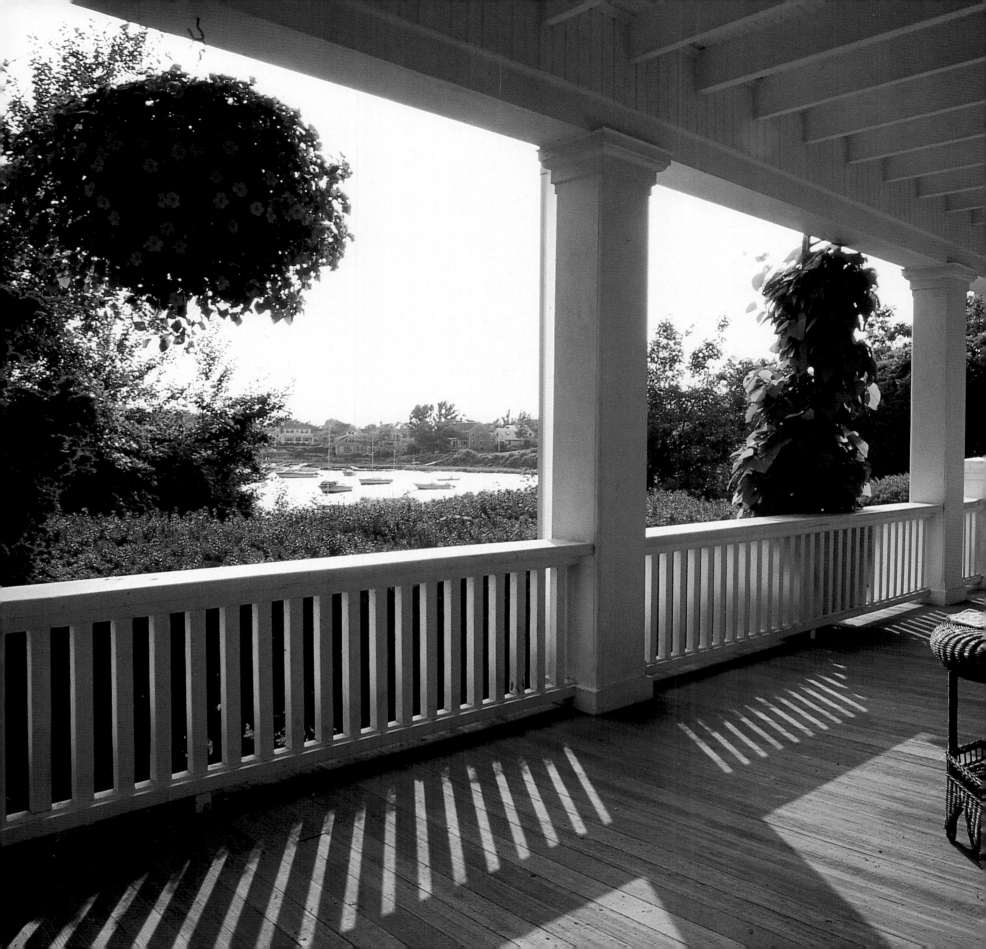

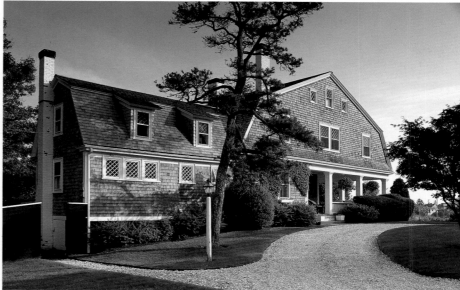

The long oyster-shell driveway leads to the main entrance on the side of the house.

The long covered porch across the entire front of the house is furnished with Victorian wicker furniture. Huge hanging pots of pink impatiens frame the harbor view.

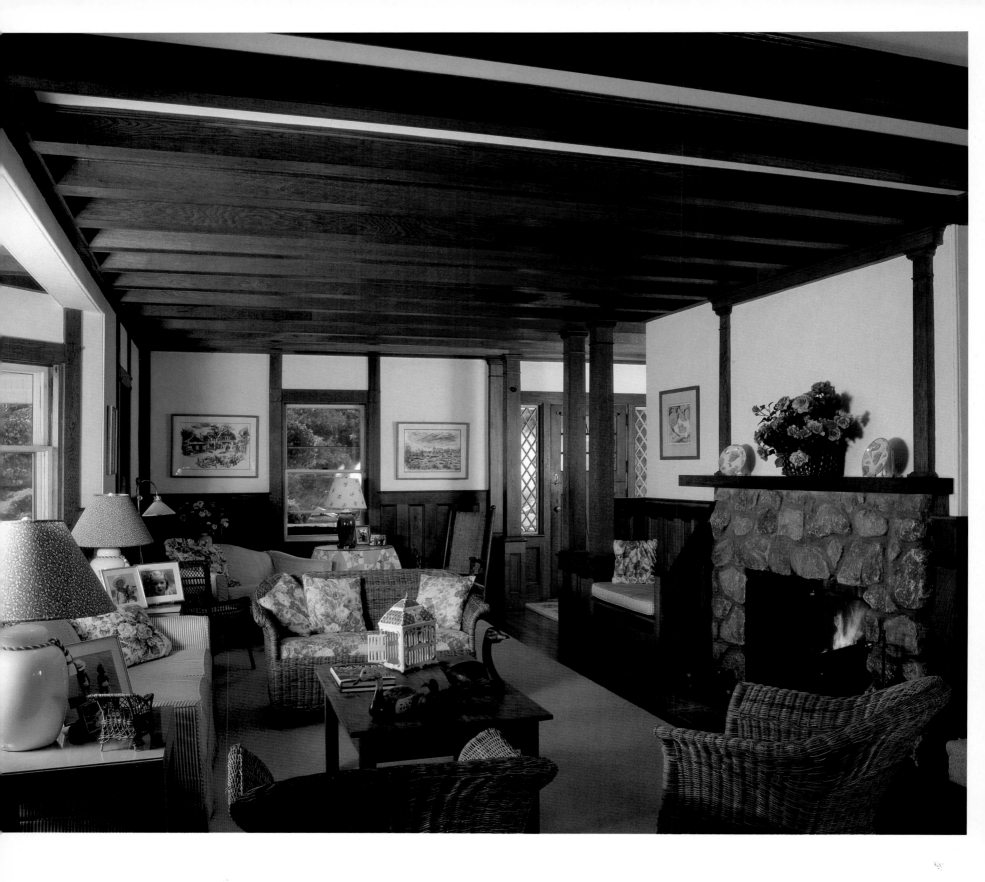

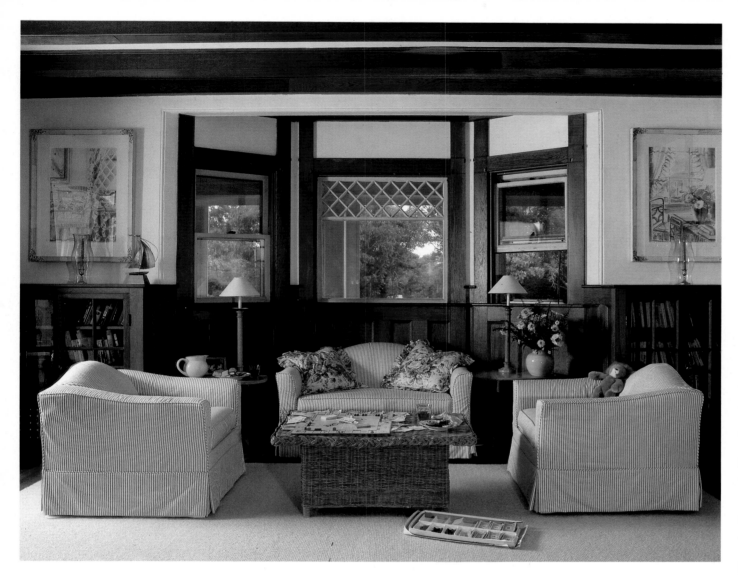

LEFT: This end of the living room is a cozy place for children's games on a rainy day or a comfortable place to curl up with a book.

BELOW: The kitchen has been updated for a family of six in the 1990s. The white walls and country pine hutch add brightness to the dining end of the kitchen.

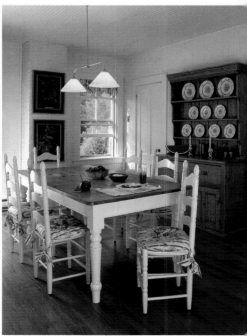

LEFT: The flavor of the Arts and Crafts—style living room with its dark wooden beams and wainscoting has been kept. The stone fireplace has recently been done over, replacing a heavy porous brick one. The wood mantel and surround have been carefully done to match the existing woodwork in the room.

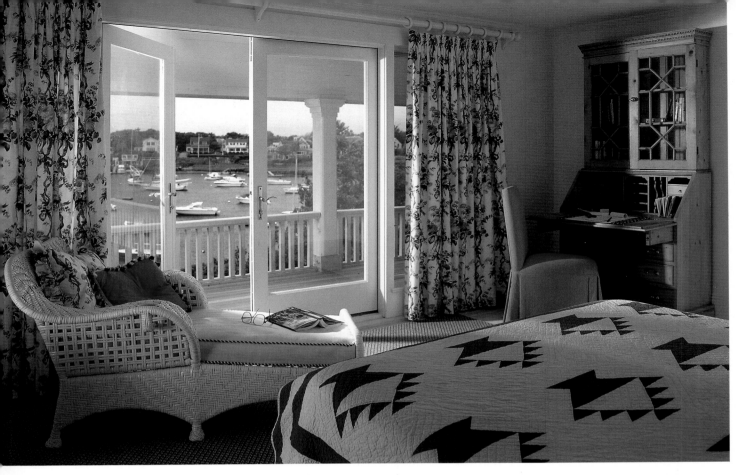

The master bedroom has its own balcony overlooking the harbor.

A boy's bedroom with all the necessary accoutrements for a good summer on the Cape.

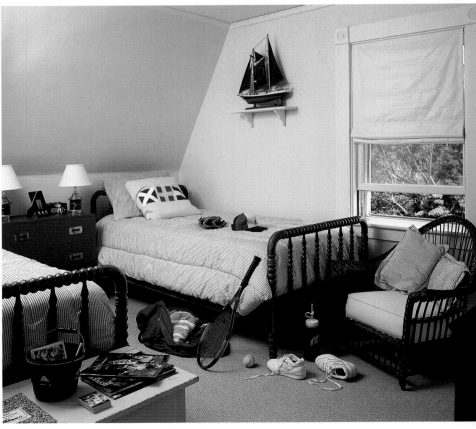

LOWER CAPE

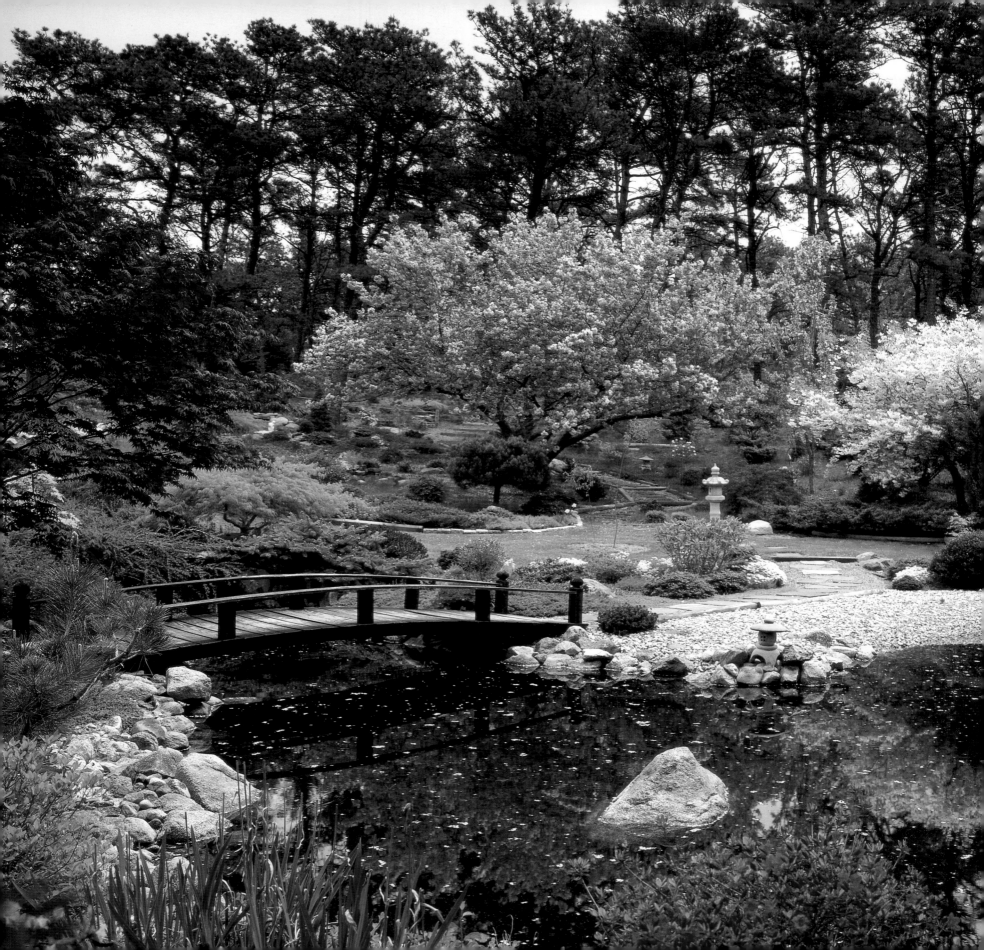

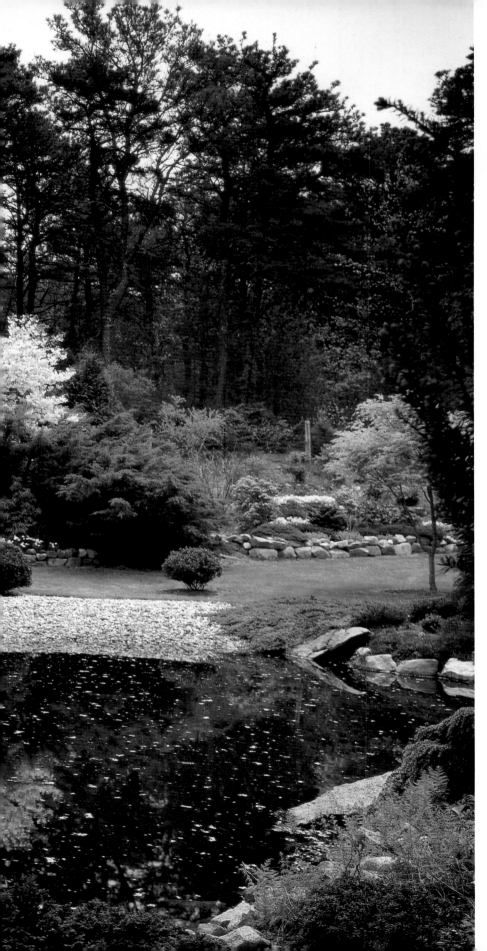

CAPE COD JAPANESE GARDEN

 On property bought and farmed by his great-grandfather in the mid-nineteenth century, Joseph Hughes has created a Japanese garden with all its attendant tranquility and seasonal color balances. After the Civil War, John Consodine, who came to this country from Ireland, used the money he had earned in the war to buy this property, build a house, and begin a farm. He planted orchards, potatoes, wheat, and corn, raised cattle and horses, and worked as a gardener for one of the nearby estates. After World War II, the owner at the time added lilacs, rhododendrons, and rose of Sharon on the rolling pastureland. The largest 'Kwanzan' cherry tree was planted in 1960.

Though he had been working on the property since 1950, Joseph decided to plant more ornamental trees and shrubbery when he and his wife, Nancy, moved here in 1981. He wanted spring and early summer blooms and fall seasonal color changes in foliage. Since the climate of the Cape closely resembles that of Japan, as well as that of Great Britain, Joseph decided to carry out a Japanese style of garden with reflecting pools and waterfalls for sound, a little teahouse for meditation, irregular stone and rock pathways through the plantings, many of which are planted for texture as well as color. In addition to being aesthetically pleasing year-round, this type of garden is easier to maintain than one of perennials or roses. It also requires less water once the trees and shrubs are established.

In the center are three Japanese cherries (*Prunus serrulata*) brilliantly blooming in mid-May. The largest one is a 'Kwanzan', the tall one behind it is 'Amanogawa', which means Milky Way, and the smaller white one to its right is a Mt. Fuji or 'Shirotae'. To the left of the Kwanzan is a large red Japanese maple (*Acer palmatum* 'Bloodgood') roughly fifteen years old. The bright green maple in front of the Bloodgood is an *Acer palmatum* 'Dissectum.' In front of and between the Kwanzan and Mt. Fuji cherries, the little low red tree is another maple (*A. p.* 'Dissectum Ever Red '). The bright green maple on the far right is a small variety 'Katsura'. Just over the rail of the bridge is a prostrate blue spruce (*Picea pungens* 'Glauca Procumbens').

RIGHT: Down the hill is a large red Bloodgood maple. To its right is a brighter yellow-green Katsura maple. Closest to the pond is an Ever Red maple, and immediately above it is a Sargent crab apple. Immediately above that is a young *A. palmatum*, which will get much larger. The dark green is a Sargent weeping hemlock (*Tsuga canadensis* 'Pendula') and a false cypress (*Chamaecyparis obtusa*) behind it. At the corner of the bridge is another cypress (*C. o.* 'Nana Gracilis'), and on the right is a flowering Arnold crab apple (*Malus* x *arnoldiana*).

In the foreground is a Japanese maple (*A. p.* 'Kasagiyama') with 'Purple Gems' azaleas immediately behind. To its right is a pale pink rhododendron 'Pioneer Silvery Pink', in back of that is a bright red 'Mother's Day' azalea.

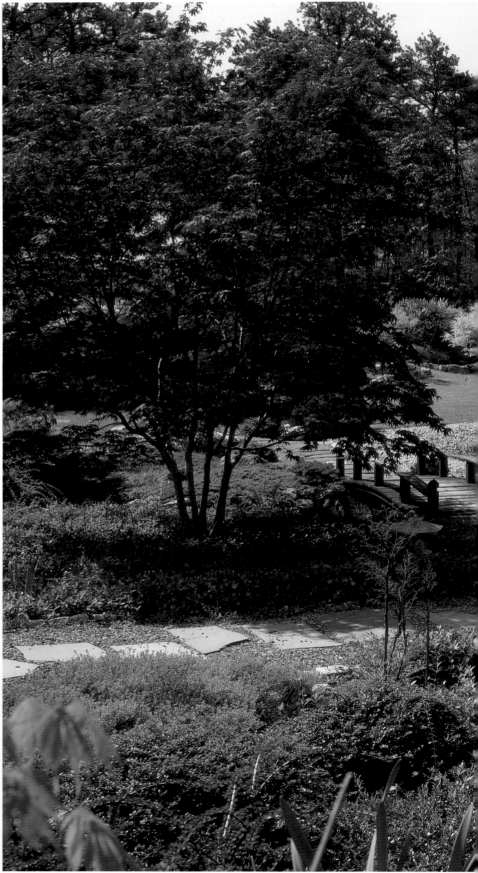

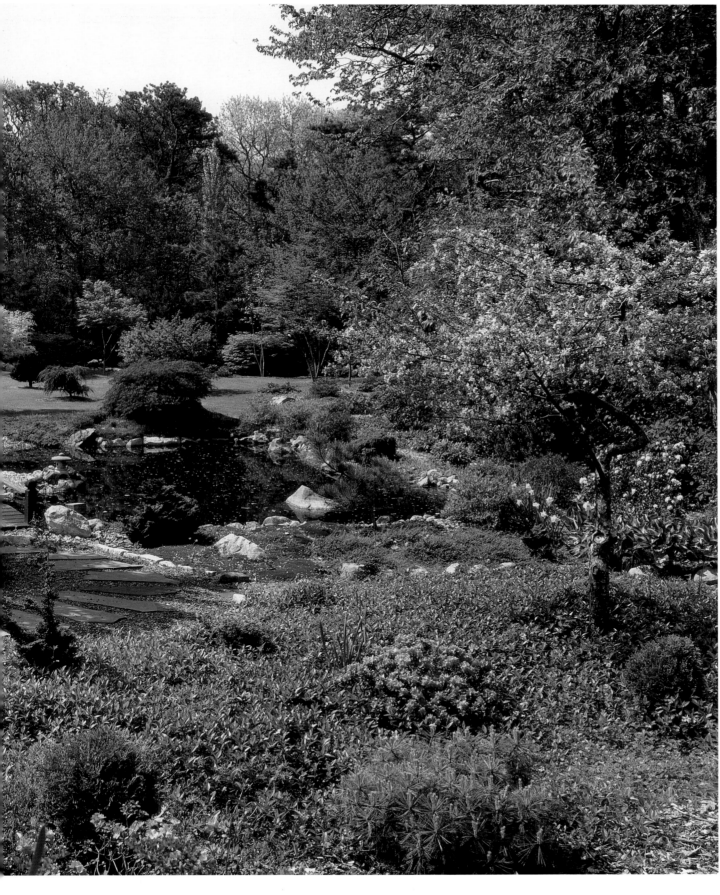

BELOW: The blossoms of a Sargent crab apple (*Malus sargentii*) are about to open in mid-May.

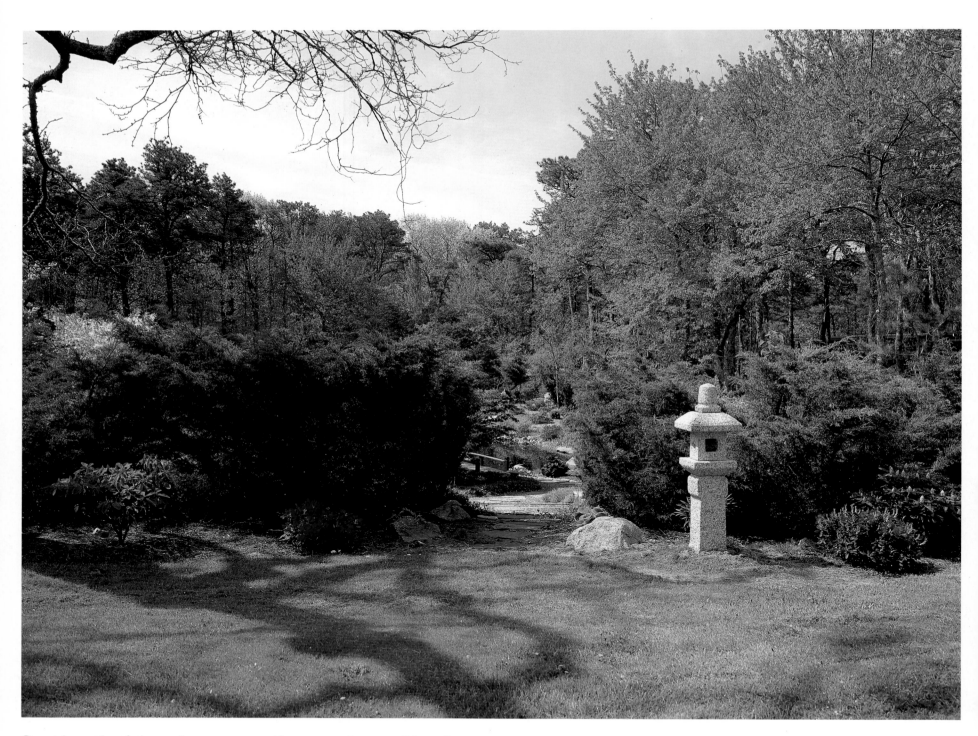

On either side of the path are junipers (*Juniperus chinensis* 'Hetzii').
The dark red that appears behind them is the Bloodgood maple. To the
left of the path, the blooming rhododendron is 'Sumatra'. To the right
of the lantern is a 'Baden Baden' rhododendron.

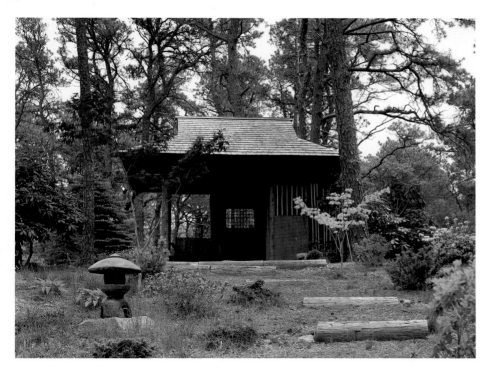

LEFT: In front of the teahouse is a young Bloodgood maple, and on the left in the back is a low reddish maple (*A. p.* 'Garnet'). The bright green in the right front of the teahouse is another maple (*A. p.* 'Shigitatsu sawa'). The pale cream flowering rhododendron is a 'Mary Fleming'.

BELOW: On a sunny May day the colors of the rhododendrons and flowering fruit trees are exuberant. On the left in the foreground is a rhododendron 'Elizabeth', then the Ever Red maple, then the Bloodgood maple. The yellowish green behind the Sargent crab apple is the small Katsura maple. White apple blossoms form a backdrop for the whole scene. Farther to the right are pink cherry blossoms. The new little maple above the rocks is an *A. p.* 'Yukon'. Below the Hetzii junipers are three conical evergreens on the hill—arborvitae *Thuja occidentalis* 'Techny'. In the rock garden is Japanese andromeda (*Pieris japonica*), a variety of heathers, and candytuft.

A Kwanzan cherry in profuse May glory towers over the little red Ever Red maple beneath.

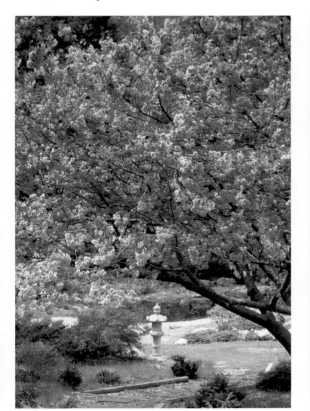

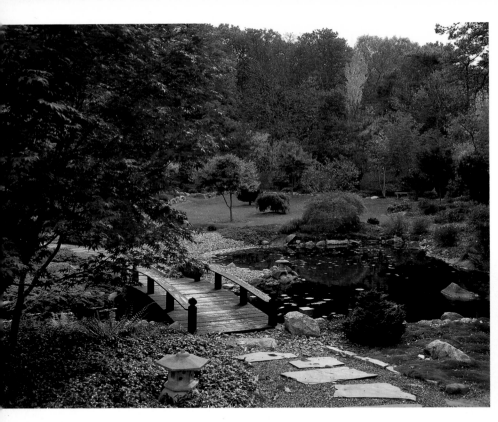

In the fall, the scene takes on an entirely different color scheme and look. In the initial stages of their brilliant fall color changes are the large Bloodgood maple in the left foreground and just beyond the pond a Katsura maple, still green except for its top. Reflected in the pond is a smaller Ever Red maple just passing its peak. Three Burning Bushes (*Euonymous alatus*) are evenly spaced across the back, with their bright red leaves accenting the background in its progressive stages of fall color.

This young Japanese maple is about ten years old and is in its full fall glory in front of a Colorado blue spruce.

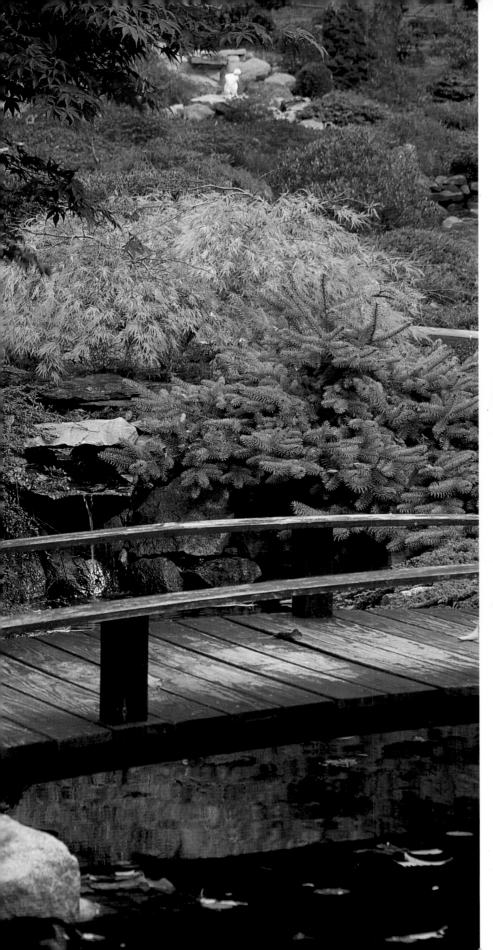

LEFT: The red berries of a rockspray cotoneaster (*Cotoneaster horizontalis*) accent its dark green leaves across from the bluish green of a little blue spruce, both of which are lovely foils for the vibrant orange of the Japanese maple (*A. p.* 'Dissectum Viridis') that has just peaked in late October. Above that peeks the bright red top of another maple (*A. p.* 'Dissectum Crimson Queen').

BELOW: The Kwanzan cherry turns a soft orange in the fall and makes the Japanese maple next to it appear all the more fiery.

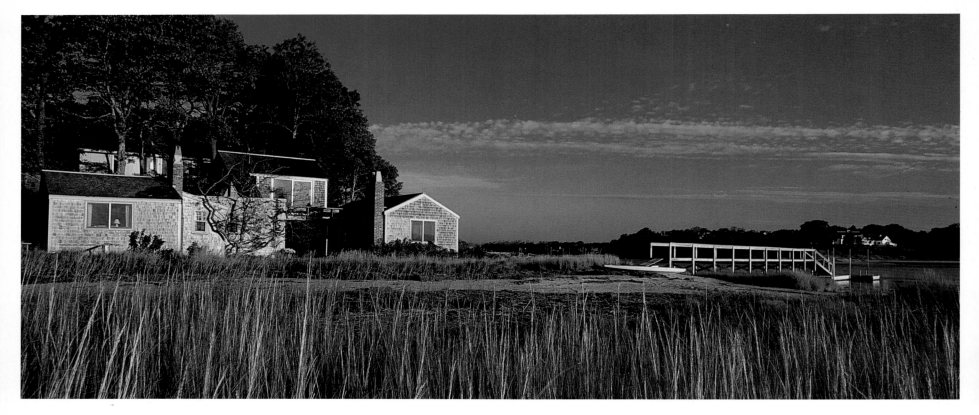

THE BEACH HOUSE

Snuggled into a bluff, this little beach cottage can be reached from the water or from a series of steps cut into the bank at the end of a long sandy lane. Though it has a delightful feeling of timelessness, the beach house is thoroughly up-to-date. There are actually three separate pavilions, each with its own outside entrance, which open on to a center brick patio. The first cabin was built in 1938 as a gunning camp with one main combination bed-sitting room. A cozy fireplace was its only source of heat. Attached were a tiny bunk room and kitchen, with an icebox and a hand pump. There was no electricity and the outhouse was up the hill. In 1944 Howard Key Bartow bought the cabin, and his family spent every summer here. In 1964, his daughter, Sue Christie, began modernizing the camp by adding electricity and building the second two-story structure, which included the first indoor bathroom, next to the living room, upstairs, all above a shed for storing boats. Then in 1968, Sue and her husband, George Christie, added another living room wing, with a large brick fire-

place, and turned the two-story section into a kitchen downstairs and a master bedroom upstairs. The three structures are grouped around a protected brick patio. They lived in the camp year-round from 1977, when they moved to Orleans, until 1983, when they built a new house on top of the bluff.

The cottage was not always so close to the water, but after the severe winter storms that opened Pleasant Bay at the Chatham Break in 1987, the tidal flow in the bay has changed by a foot and a half. Each year the little house is in danger of being washed away in a harsh winter storm. The Christies are doing everything possible to preserve the cottage. Conscious of its fragile ecology, they close up the house in the fall and conscientiously rake away the eelgrass that sweeps in on the tide and holds the water inside. The electric heat bars are raised nearly to the ceiling so that they won't get wet when the high storm tides creep into the cabin. Bit by bit, the beach is coming back each year as sand from Chatham washes in, and the cut is moving south, giving hope to the Christies that their beloved beach house will survive.

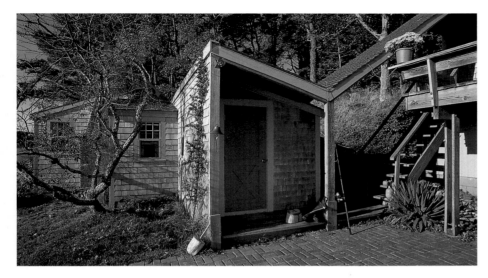

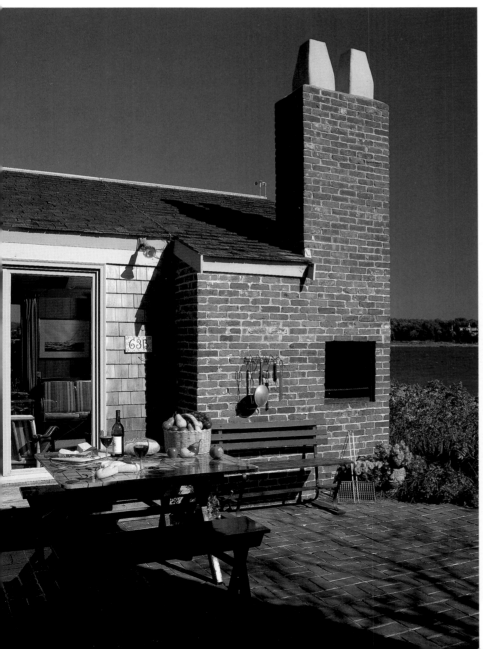

ABOVE LEFT: The blue door opens into the former kitchen of the old gunning camp. The living room juts out behind on the left. To the right the stairs lead up to the master bedroom, with its magnificent view of Pleasant Bay. The kitchen is under the stairs and to the right.

LEFT AND BELOW: The brick center patio, which connects all three structures, makes a summer living room, complete with a cooking fireplace. The colorful picnic table was painted by Cape artist Peter Hunt for the family.

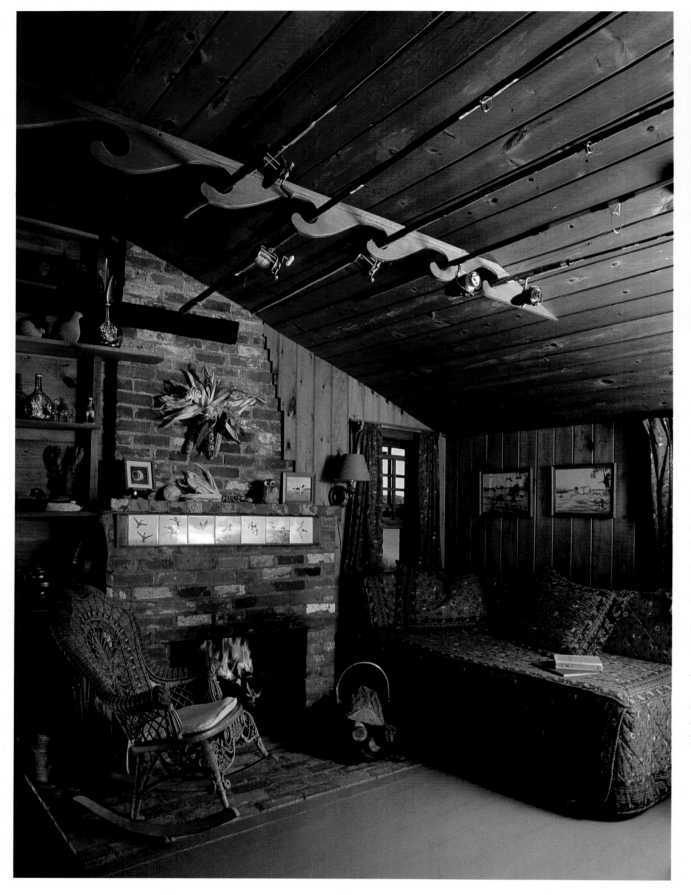

LEFT AND ABOVE: The original gunning camp living room. The tiles above the fireplace were hand-painted by G. Soderbom, who also painted the picture on the mantel of the field dog. Sue's grandfather, E. Stanley Wires, was a noted tile collector and was instrumental in bringing Soderbom to the United States after World War II. On the other side of the mantel is a painting of a shell done by Elliot Orr of Chatham. The room has been changed very little and thus retains all of its original rustic charm.

RIGHT: The bunk room has not changed at all since the camp was built in the 1930s.

BELOW: This new living room was built in 1968. A ship's knee found on the beach was made into a sculpture by Cape artist Vernon Smith. Moravian tiles of each sign of the zodiac crown the fireplace. They were a gift from Sue's grandfather. In addition to the picnic table, Peter Hunt also made the coffee table for the family.

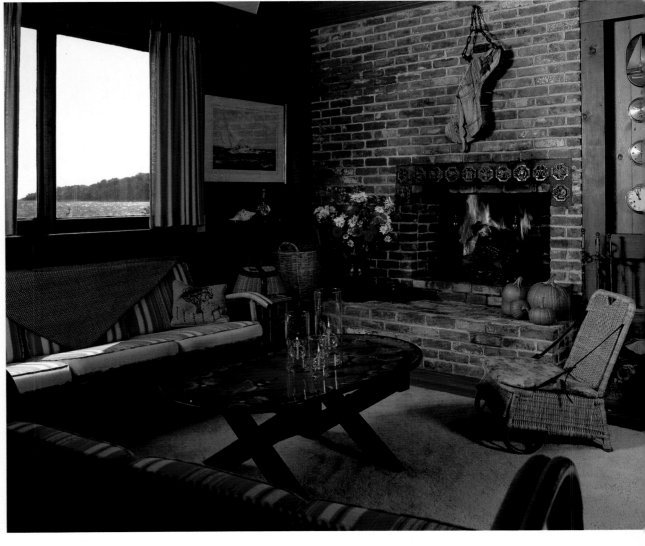

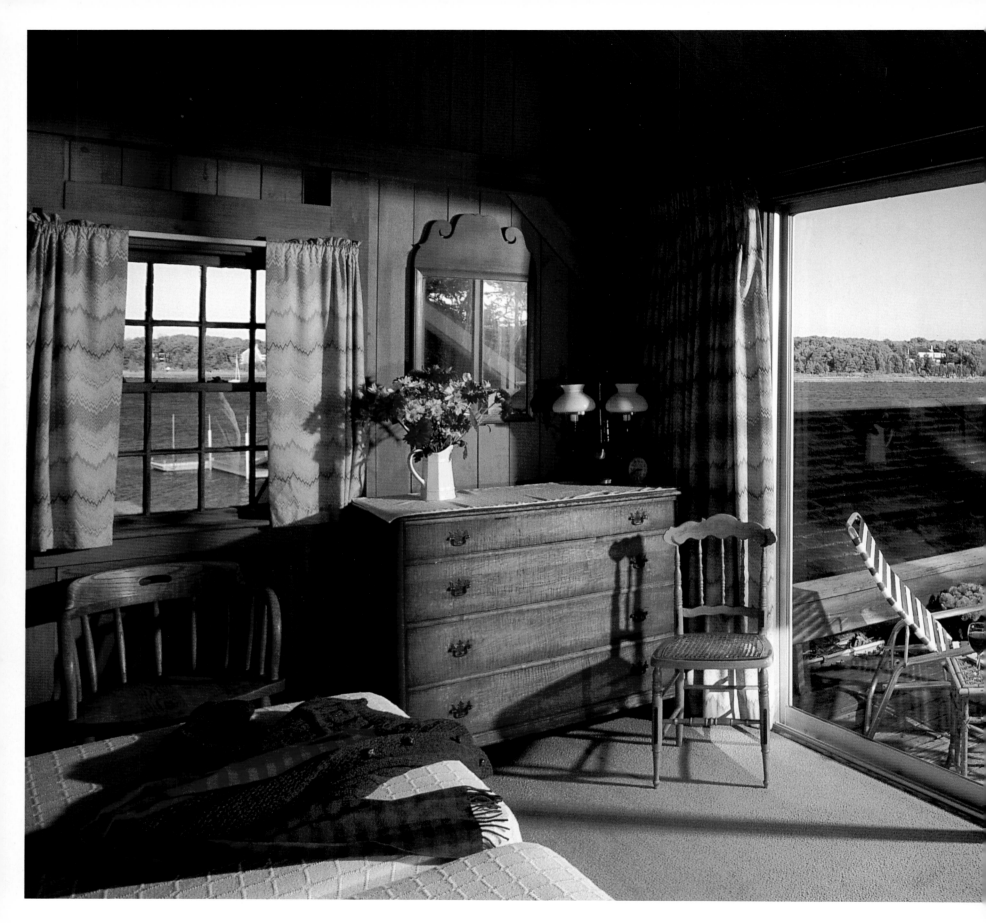

Part of the 1964 addition, the master bedroom, with its high deck, was formerly the "new" living room. When the 1968 wing was added, the space was converted into this enchanting master bedroom, with its seemingly endless view of Pleasant Bay.

BOXWOOD HILL

This eighteenth-century house with a twentieth-century addition is named Boxwood Hill after the lushly planted grounds, which feature extensive boxwood planted by the present owners, William Baxter and Allen Ward. They bought the property in 1968 and began work, first on an 1840 schoolhouse that is now an antique store, and then on the house. It is not known who built the little half-Cape or exactly when, but the property was in the Foster family of Brewster for generations before Allen and Bill bought it. The original part of the house is a late-eighteenth-century typical half-Cape with a keeping room, a borning room, front parlor, and a sleeping loft with loft stairs. At the turn of the century, from this site, it was possible to see all the way to Eastham. At that time the little schoolhouse, now turned shop, was the freight station on the Cape railway.

In 1971, Allen and Bill began the large addition, which added a cathedral-ceilinged living room of grand proportions, two bedrooms and two bathrooms, all connected to the rest of the house by a long breezeway.

The extensive landscaping is an ongoing process that began in the 1970s when Bill began bringing boxwood up from Hampton, Virginia, and camellias from North Carolina.

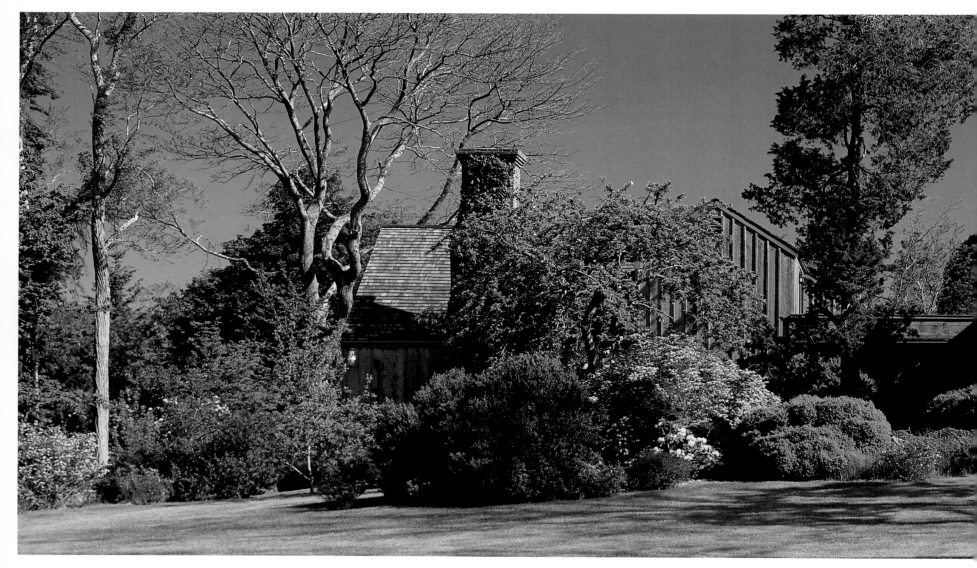

Mature boxwood adds deep green accents to the profusely blooming camellias that surround the fenced-in part of the property. The ones seen, left, are the later-blooming ones at their peak the second week in May. Rhododendrons and camellias are mixed with boxwood along the back of the property below.

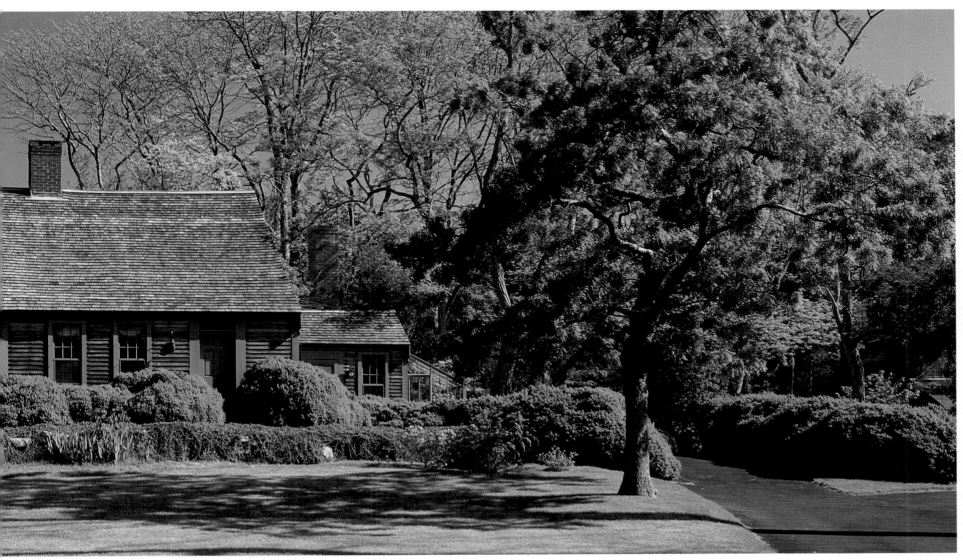

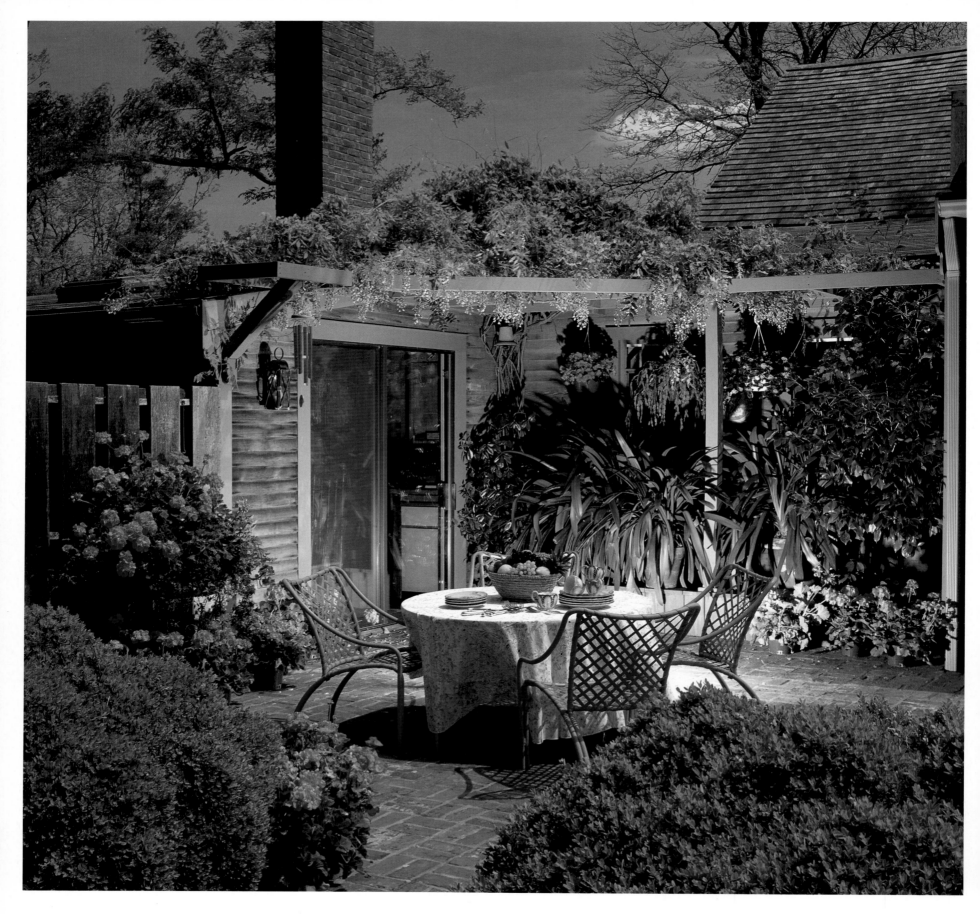

LEFT: A brick patio and walks through boxwood hedges were added off the kitchen and breezeway, making the area into an outdoor room. By Memorial Day, the patio is lightly shaded by the wisteria-covered arbor accented with masses of pink geraniums.

RIGHT: A later renovation involved the kitchen, nearly doubling its size. At one end is the breakfast room and attached greenhouse. The fireplace was rebuilt, keeping its original proportions. Above the mantel hangs a nineteenth-century Continental portrait of a lady. A grouping of unmatched chairs surrounds the little French breakfast table. The one with the orange cushion at the table is a Lancastershire next to a Rhode Island baluster back. Next to the fireplace is an American ladderback. On the floor are nineteenth-century American hooked rugs.

BELOW: Variegated deep pink camellias (*Camellia japonica* 'Kumasaka') make a lush backdrop for the little birdhouse on the kitchen side of the house.

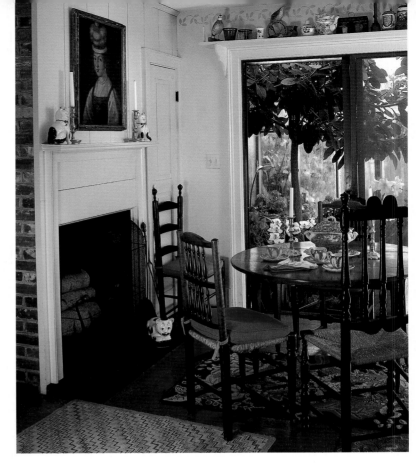

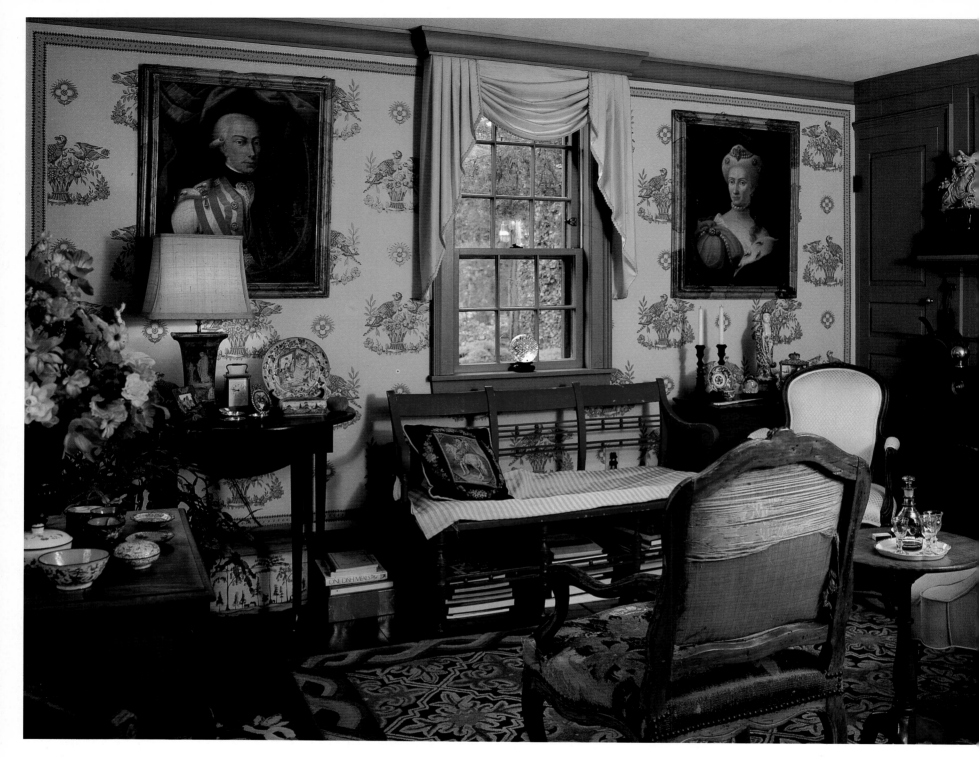

The front parlor is furnished with American, English, and French period antiques. The wallpaper is a special reproduction printing, done for this room by Waterhouse Wall Coverings, of a paper that was in Allen's great-grandfather's home in Massachusetts. Eighteenth-century portraits of the Duke and Duchess of Tuscany in faux marble frames hang on either side of the window. The red fancy Sheraton settee is early-nineteenth-century American. An American hooked rug in an unusual formal pattern covers the floor. A pair of Chinese porcelain Foo dogs on the mantel are some of the oriental accessories used throughout the room.

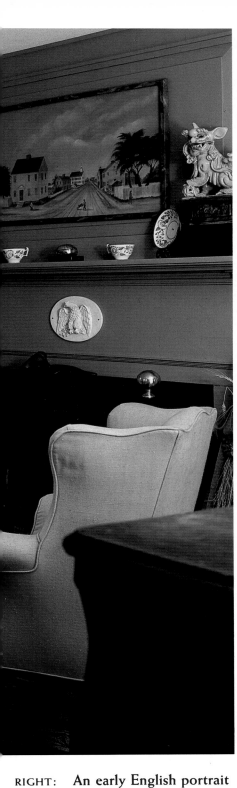

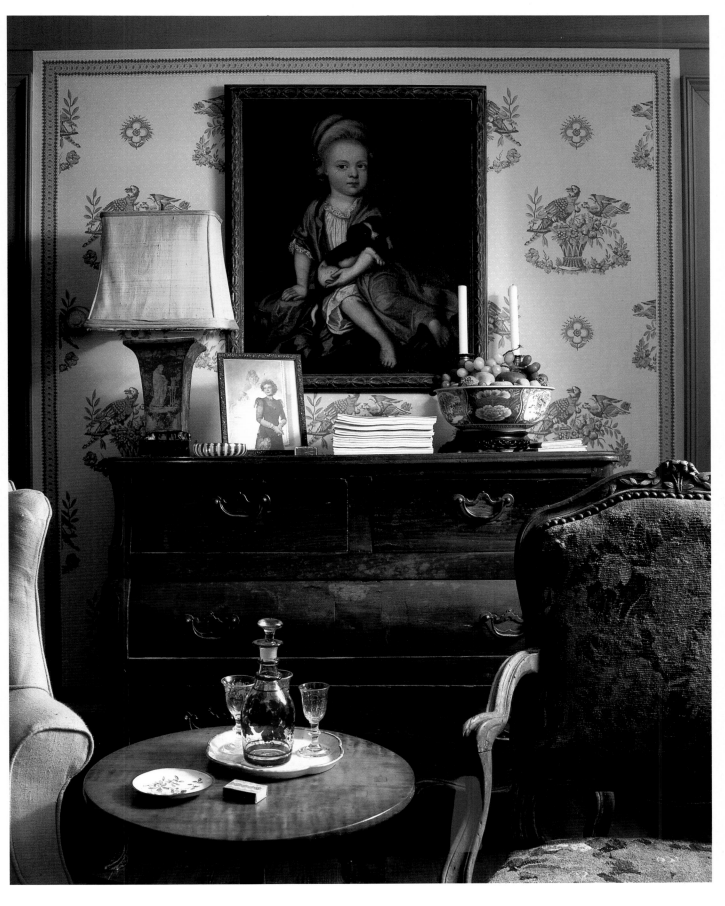

RIGHT: An early English portrait hangs above an eighteenth-century Italian chest. The tapestry-covered chair is an eighteenth-century Louis XV piece next to an American candle stand, c. 1790.

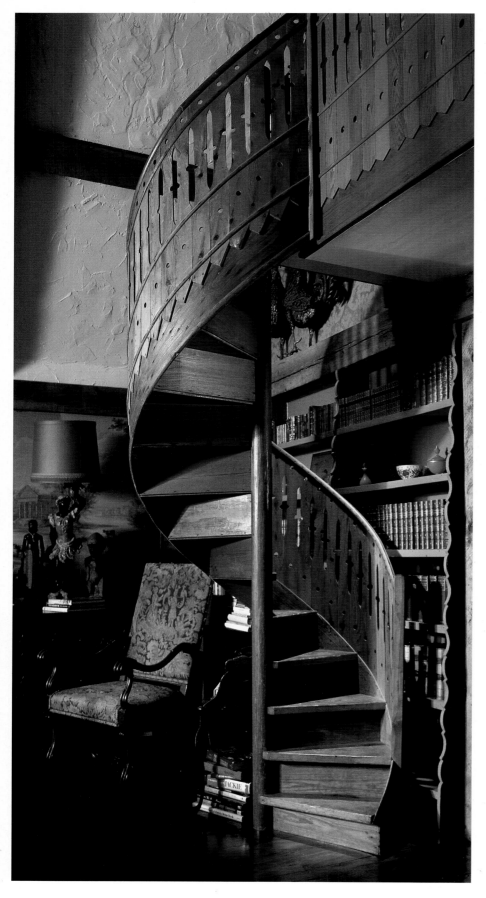

LEFT: Spiral wooden stairs from an old English ship lead to the upstairs bedroom from the living room of the twentieth-century addition. An Italian carved gilt lamp sits on a Louis XV fruitwood two-drawer chest.

RIGHT: The wall covering around the large window is Scalamandré damask. Austrian deer heads with real antlers on carved wooden heads date to the early eighteenth century. Early-eighteenth-century Spanish portraits of a rooster and a hen flank the large window. Most of the furnishings are French with oriental accessories. A Louis XV fruitwood period table in the center of the room is nearly centered on the large Moroccan rug.

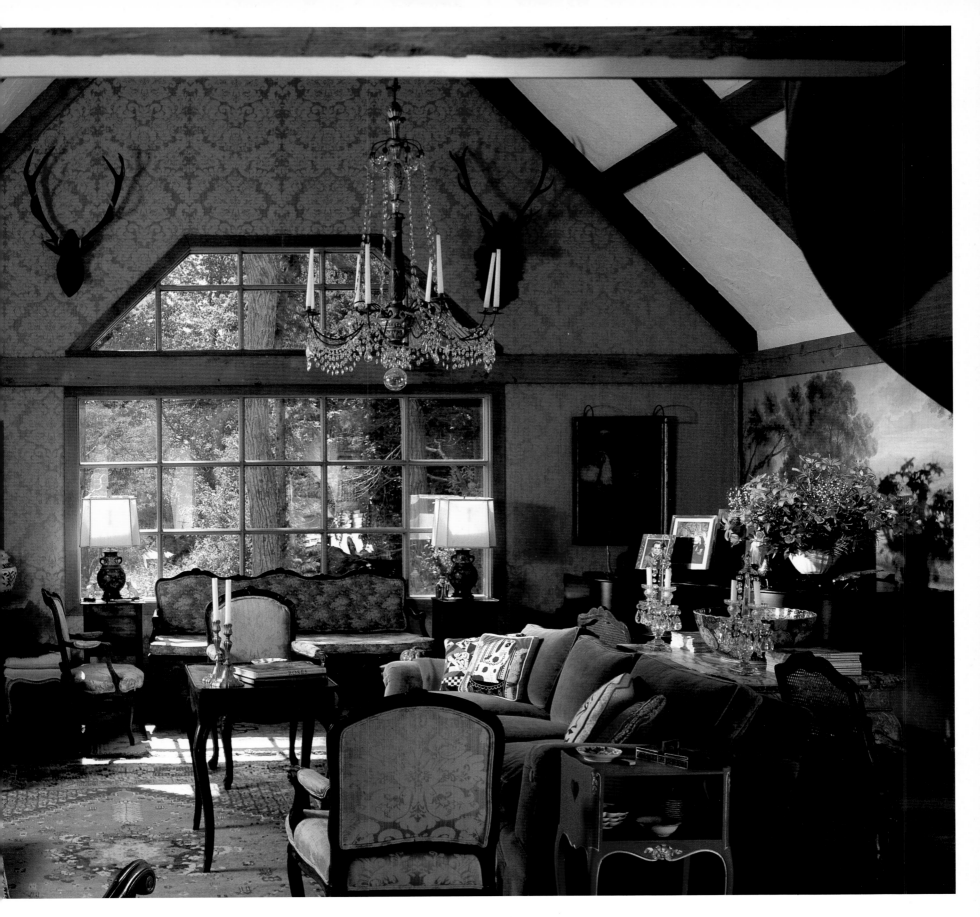

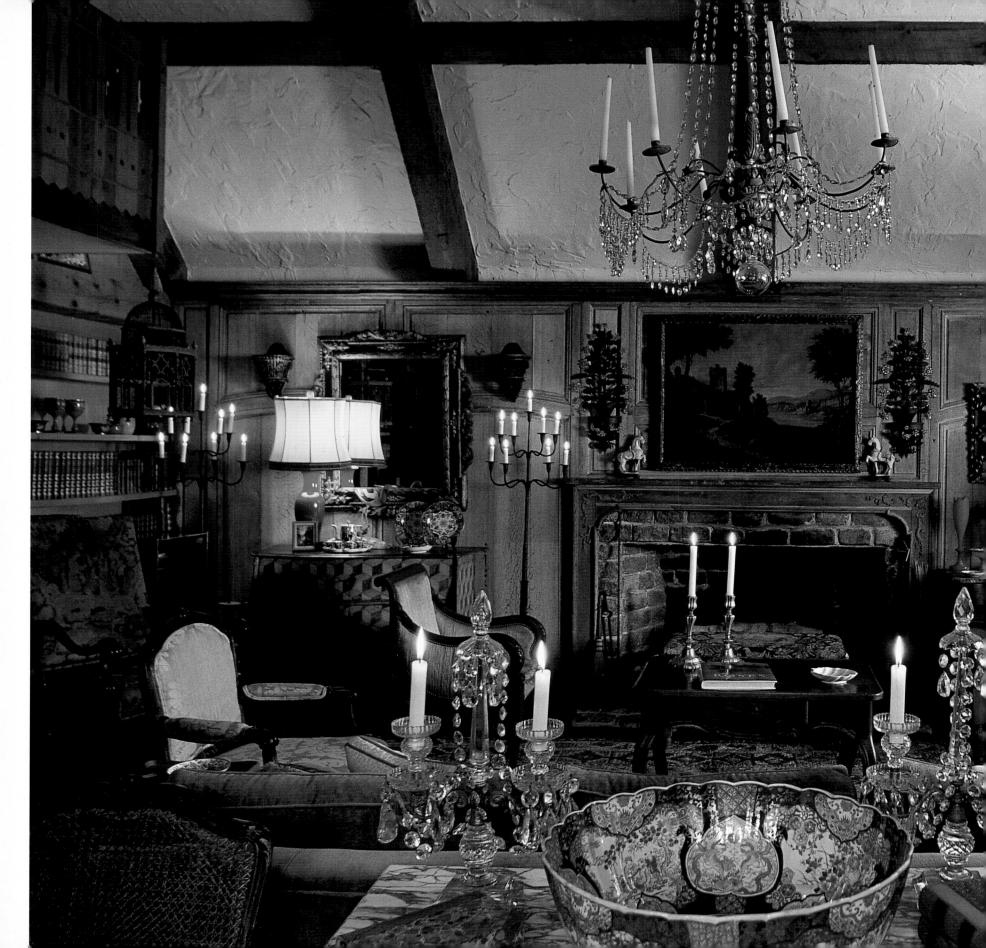

The twentieth-century wing was designed by Eleanor Raymond of Cambridge, Massachusetts, who was one of New England's first women architects. She was extremely careful to keep the addition, which is so much larger than the old house, in balance with it. Though a new room, the paneling is French and the floorboards and doors are old. Cobblestones from Boston were used to make the fireplace. A seventeenth-century Italian painting hangs over the mantel. To the left of the fireplace is an early Italian chest, decorated in the twentieth century in a painted diamond pattern. The pair of chairs by the fireplace are English, George IV, 1820–1830. The red tall clock with "Firenze" painted on its face is early nineteenth century. In the foreground, a pair of Waterford candelabra and a large Imari bowl sit on a marble-topped table reportedly originally from Blenheim Palace.

SEASIDE ROSE GARDEN

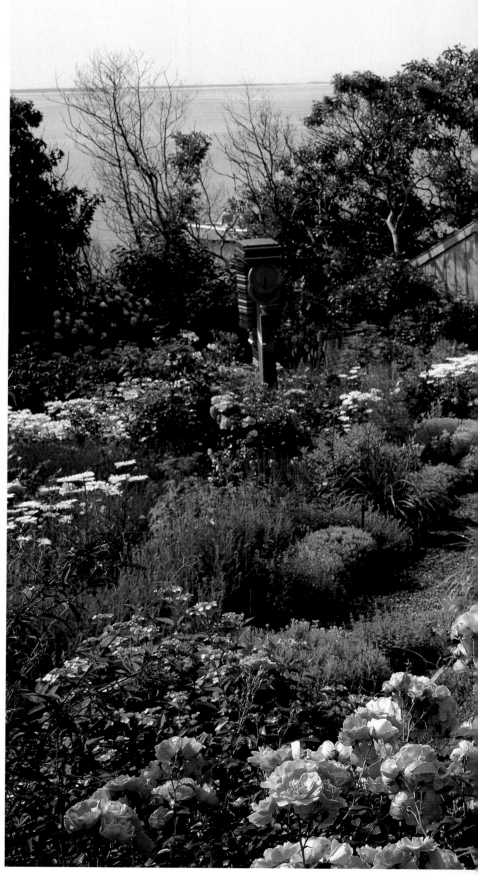

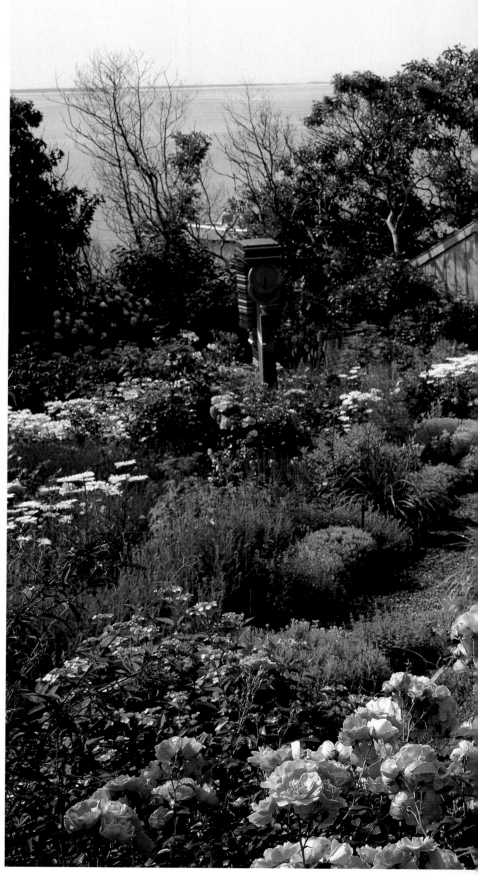When Chotsie and Allan Blank built this house overlooking Pleasant Bay as a summer and holiday home, Chotsie decided she didn't want so much as a blade of grass to have to care for. But some old roses came up in the garden and she was hooked, so first she planted some roses at her home in California. Then here in Chatham, the vegetable garden needed more light, so the gardener cut down some trees. There was so much more space with the trees cleared that Chotsie began planting roses around the tennis court. The rest of the garden progressed from there. With rose gardens on both East and West coasts, she has found that roses such as the old English white rose Nevada, which doesn't tolerate California heat, do well here on the Cape. The climbers and David Austin roses thrive in the Cape's climate. Planted to form a pattern leading up to the tennis court, the garden features red Robin Hood roses at either end along the court with pink Fairy roses in between. Although this is predominantly a rose garden, lavenders and gray foliage perennials have been added to complement the roses. Brightly painted iron sculptures, created by Allan Blank, are strategically placed throughout the garden. On the left is *Peppermint Tree*.

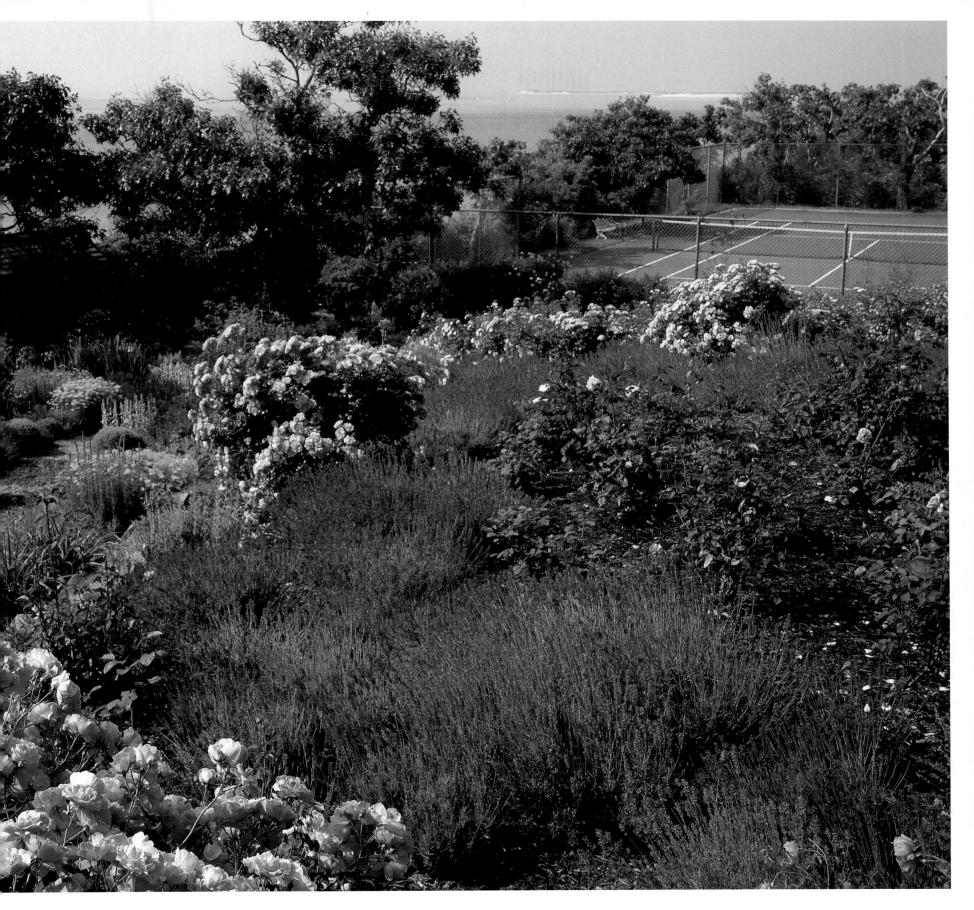

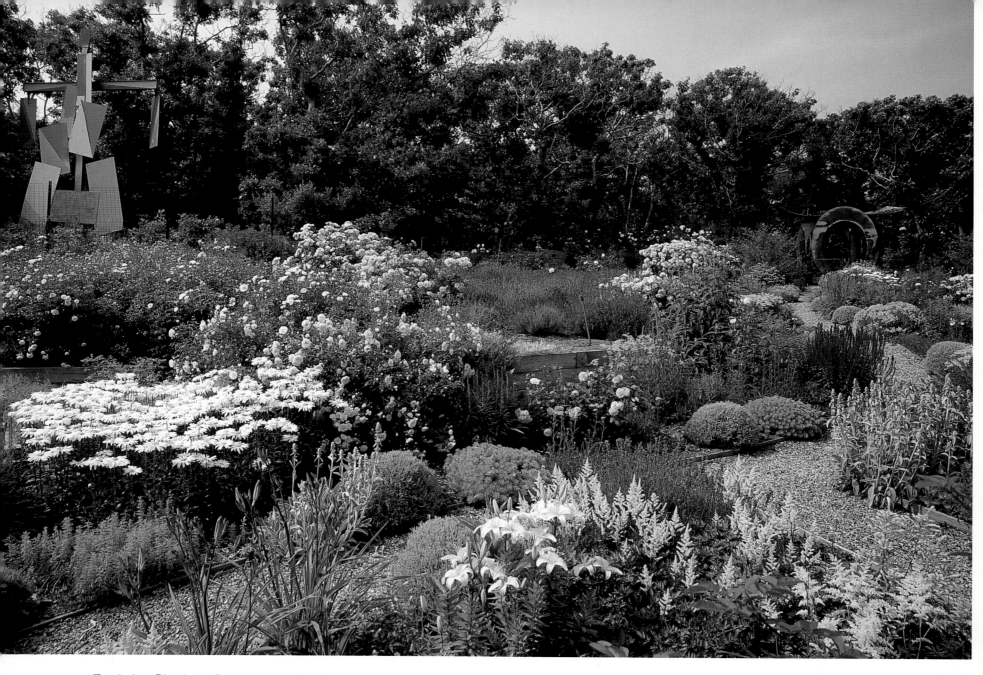

ABOVE: *Fred the Chatham Scarecrow* is the large multi-colored iron sculpture on the left. Named after the Blanks' gardener, at whose request Allan made this "scarecrow," the more than twenty-foot-high sculpture has movable parts. It created quite a stir when it was finished and sited on top of this high bluff. The Blanks have watched boats suddenly turn around and circle back for a closer look. The sculpture on the right is *Soaring Arches*. Lilies and 'Bridal Veil' astilbe are in the foreground, with Shasta daisies (*Chrysanthemum* x *superbum* 'Everest') and white Nevada roses behind.

RIGHT: Lavender separates masses of Bonica roses with red yarrow behind.

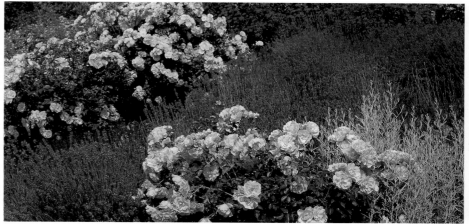

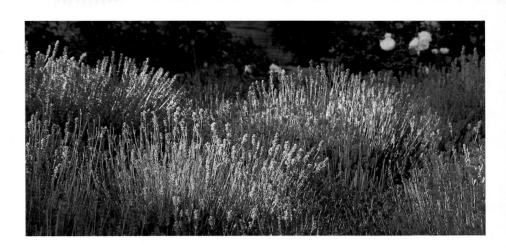

RIGHT: Sunlight makes wavelike patterns on the lavender.

BELOW: The pathway to the tennis court has mounds of santolina, artemisia 'Silver Mound', lavender (*Lavendula angustifolia*), yellow coreopsis (*Coreopsis verticillata*), and red yarrow (*Achillea millefolium* 'Paprika Galaxy'), among others, planted to complement the reds and pinks of the roses throughout.

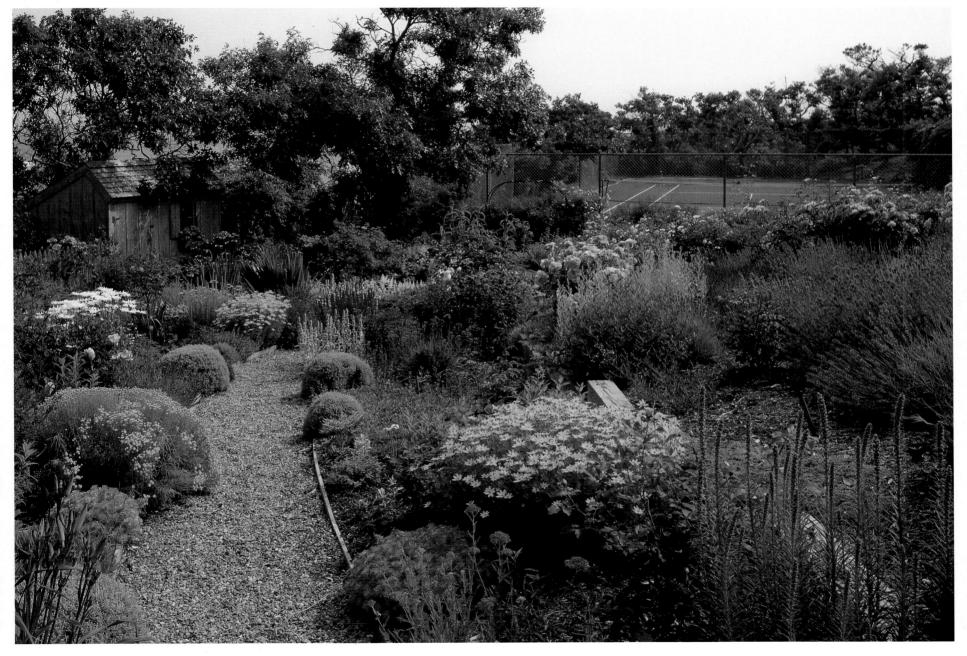

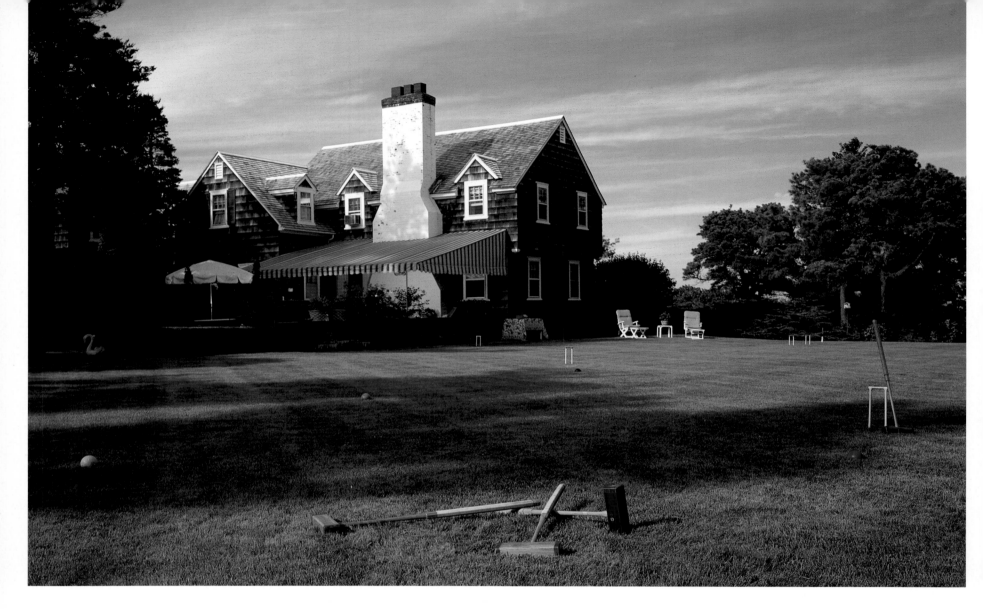

CHATHAM CROQUET

 When in 1972 the present owners bought this marvelous rambling summer home overlooking Chatham Harbor, the property included a manicured croquet court surrounded by tall neatly trimmed privet hedges. The previous owners expressed the hope that the new owners would continue the tradition of Sunday afternoon croquet. And that is just what the family has done. The game they play is an eleven-wicket game called Old Black Point. Played in teams, it is a game of strategy. The lawn is clipped to a specific height every Thursday so that the court will have the right speed.

In addition to carrying on the tradition of Sunday afternoon croquet, the owners have rejuvenated and beautifully decorated the old house, built sometime in the late 1920s, as well as expanded the gardens on the property to include a large rose garden and a cutting garden beside the house. The large lawns lead to a sandy bank and a path to the beach. The outdoor terrace, with its protective awning, makes a lovely garden room in the summer as well as a perfect viewing spot for the croquet matches.

RIGHT: The entrance to the side garden is through a carefully clipped beech hedge. Planters of pink geraniums mark the flagstone path into the croquet court.

LEFT: A tidy garden shed sits in the midst of the cutting garden. A Queen Elizabeth grandiflora rose, planted for its profuse blooms, is in the foreground.

RIGHT: A climbing Blaze rose envelops the trellis that forms the entrance to the rear garden.

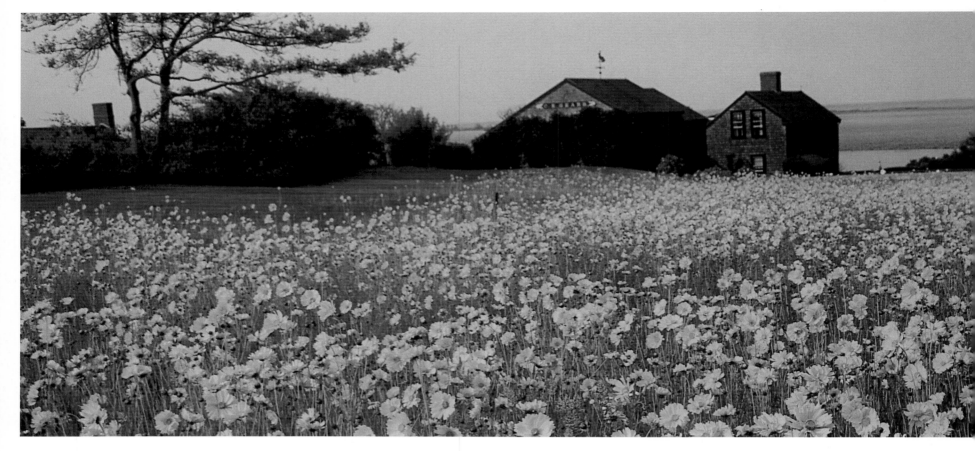

SUR MER

Soon after Barbara Townson Weller bought the property called Sur Mer from her father's estate in 1981, she began opening up the land. First she sold the old house near the road, and it was moved to Orleans. Then in 1983, she planted a wildflower meadow—a traditional mix of wildflowers with one color changing into another as the summer progressed. Gradually the coreopsis began to take over, and now, depending on the amount of rainfall, there is a sea of bright yellow from mid-

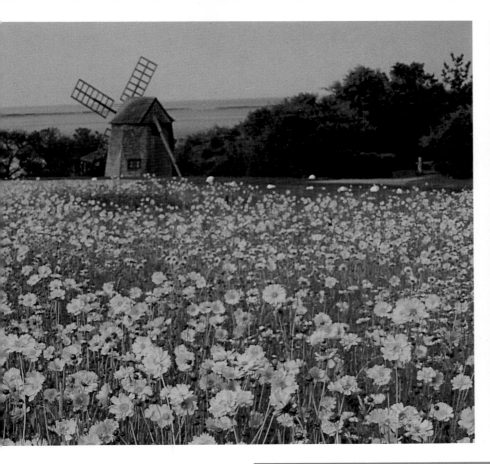

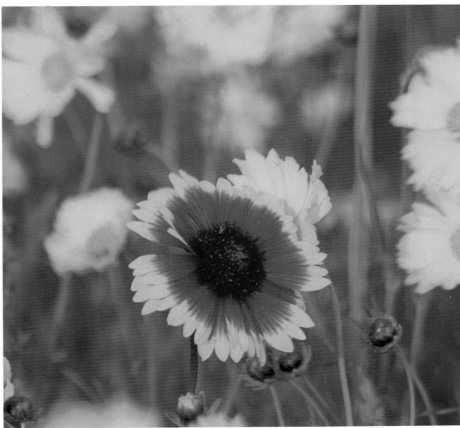

June until early July from the road and down the slope to the blue water of Chatham Harbor. This stretch is the only open land along Shore Road with an unbroken vista to the sea. Behind the wildflower field is an old windmill, c. 1820, that was moved here from Cockle Cove in the early 1900s and was still operating when Barbara was a child. Barbara's father bought the little house called Sur Mer in 1929. It too had been moved to this site from elsewhere in Chatham.

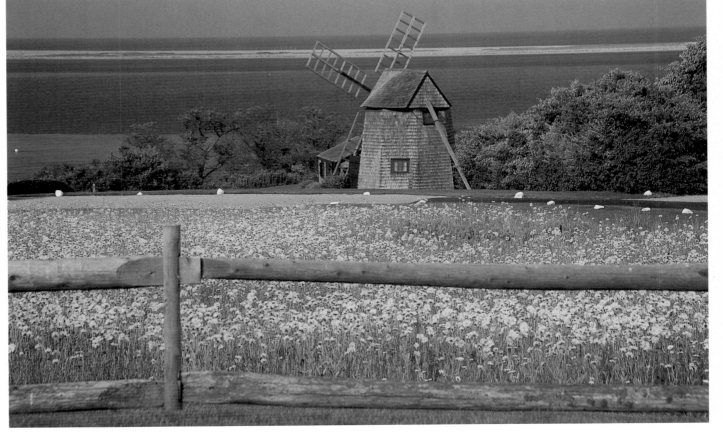

BELOW: Beside the house is a birch (*Betula jacquemontii*) and, next to the bulkhead, a bright pink broom (*Cytisus burkwoodii*).

BELOW RIGHT AND TOP RIGHT: A combination of flowering shrubs, shade-loving plants, and annuals in stone and terra-cotta pots ornaments the walk and front entrance. Close to the house is a variegated mountain andromeda (*Pieris floribunda*). Low-growing juniper, spiky blue fescue, and frothy white sandwort (*Arenaria montana*) combine to create a patchwork of textures and soft colors.

RIGHT: Three levels of a wraparound deck connect the rooms across the back of the house. Built-in planters contain heaths, heathers, cotoneaster, and outside the kitchen, edible herbs and annuals. On the west side of the deck, a tall ornamental grass (*Miscanthus sinensis* 'Gracillimus') is next to the steps, which are covered in a combination of thymes and Irish moss, all of which creep over and spill down the hillside. The steep bank between the deck and pond has been naturalized with native plants—rosa rugosa, inkberry (*Ilex glabra*), bayberry (*Myrica pensylvanica*), and beach plums (*Prunus maritima*).

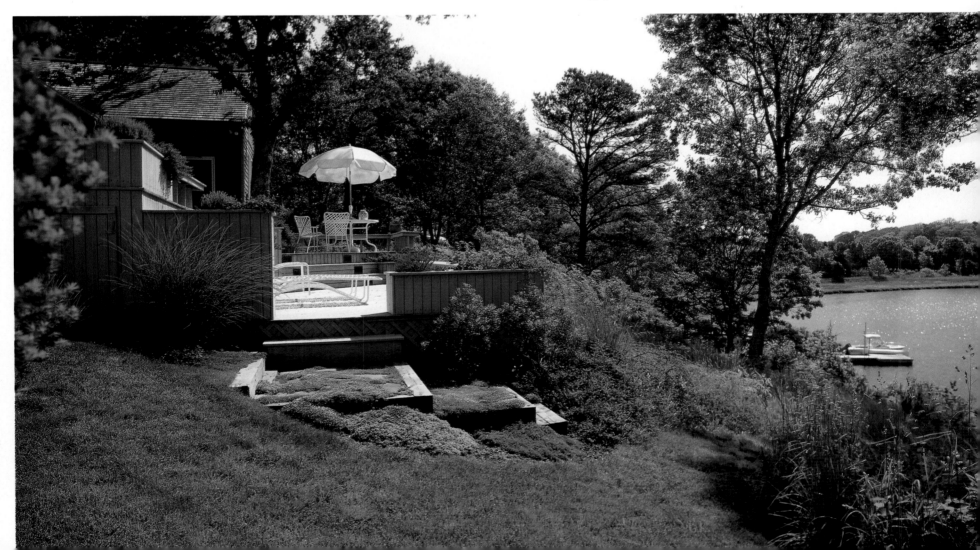

The original house on this site was a simple four-room ranch built in the late forties or early fifties. Ed and Nancy Benz bought the house and property in 1981 and gradually began renovations. First they added all new windows and then, a few years later, a sunken living room next to the kitchen to take advantage of the water view. The decks and landscaping around the back between the house and the pond came next. Then in 1989, they added the master bedroom, with its cathedral ceiling and loft studio, on the opposite side of the house from the sunken living room. Little by little, the Benzes have added perennials and other flowering plants around the house.

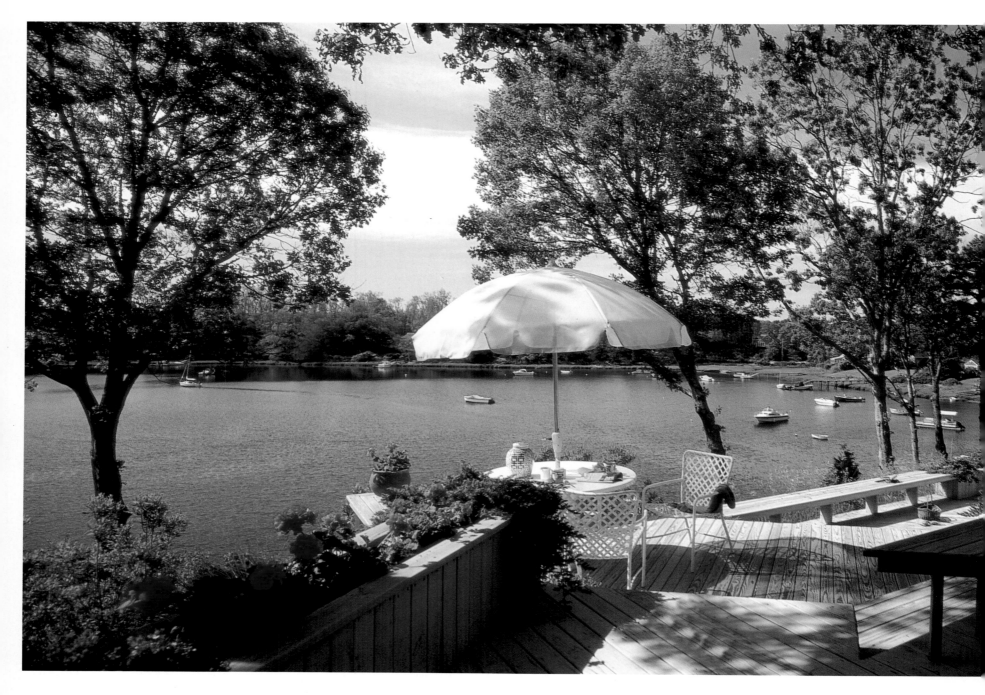

BELOW AND RIGHT: The expansive deck faces south and therefore gets morning sun year-round. On those occasional hot days in summer, the afternoon shade and cool breezes offer an agreeable respite.

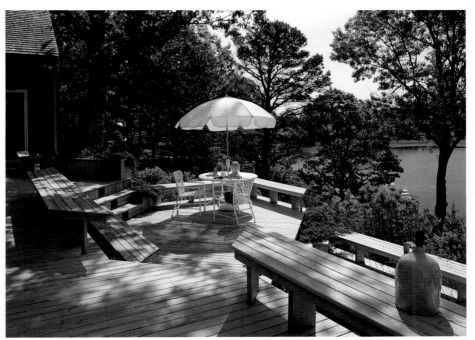

BELOW AND OVERLEAF: The second living room is a few steps down from the kitchen-breakfast room. A collection of nineteenth-century bottles, collected on trips up and down the East Coast, lines the tile-top divider between the rooms. A continental terra-cotta oil jar stands beside the windows overlooking the water. The carved bird on the coffee table is from Point Pleasant, New Jersey, and was carved by Captain John S. Loveland, c. 1888.

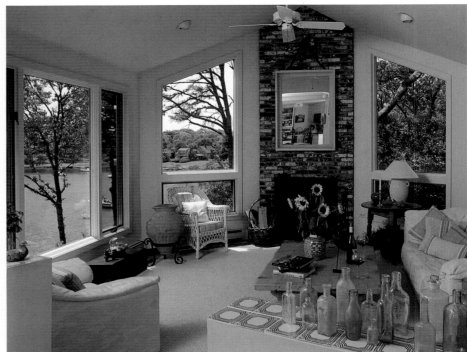

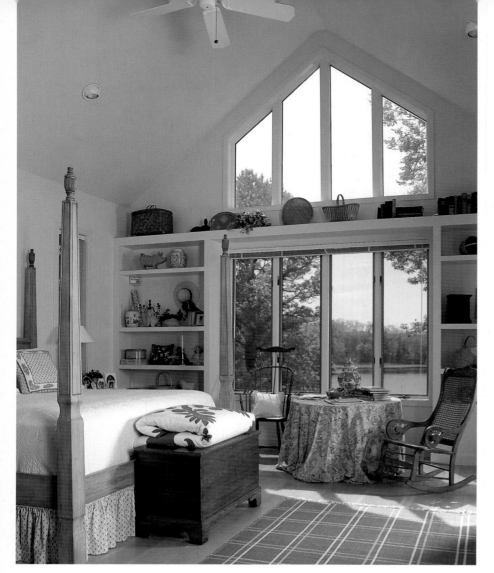

The latest addition to the house is this master bedroom suite, with its cathedral ceiling. At the foot of the bed is one of Nancy's quilts, in the Hawaiian breadfruit pattern. Her studio, with quilting frame set up, is in a loft room above part of the master bedroom and bath. On the eighteenth-century-style bed, which was made in Mexico, is a white-on-white quilt from France. One hundred years separate the two chairs flanking the table in front of the window. A comb-back Windsor, c. 1740, is on the left, and a Victorian wicker rocker is on the right.

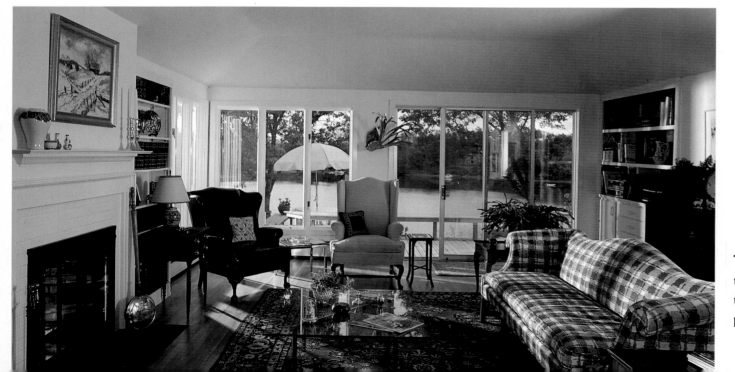

The living room in the center of the house has an excellent view of the tri-level deck and all its plantings as well as Lonnie's Pond.

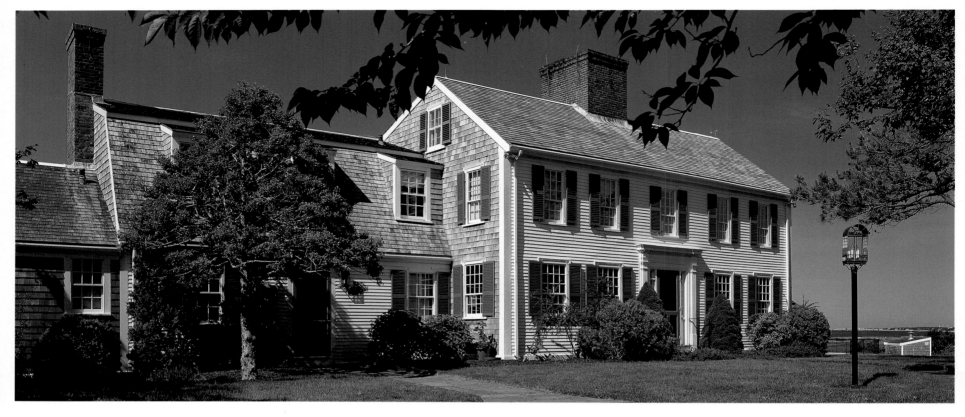

CAMP MOONPENNY

This enormous house is a combination of a very old house in the front and several new additions on the back. The original house was built in 1633 in Hingham, Massachusetts, for Perez Lincoln, Abraham Lincoln's great-grandfather. Nine generations of that family lived in the house, which served as a garrison from 1638 to 1640. When the street in Hingham where the house was located was being widened, the house was sold for one dollar to a family named Howe, who moved it to its present site in Chatham in 1939. As is apparent from the back of the house, it has been added on to many times. Helene and Grant Wilson bought the house in 1984 and added lots of new windows to open up the views, as well as the bright kitchen wing and adjacent flagstone terrace and stone walls.

There are many rooms in this huge eclectic summer home, which is casually furnished and accented with a combination of bright paintings and whimsical sculptures.

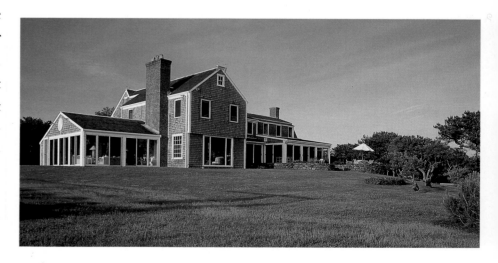

RIGHT: Dan Daniels of Rockland, Maine, sculpted the iron birds and the lion that decorate the flagstone terrace, seen below.

BELOW: The flagstone terrace off the kitchen wing overlooks Stage Harbor in the distance. The curving stone wall that encloses the terrace is planted between the edge of the flagstone and the wall with a combination of edible herbs and colorful perennials. Planted in the curves are yellow potentilla, chives, Russian sage (*Perovskia atriplicifolia*), feverfew (*Chrysanthemum parthenium*), little blue campanula (*Campanula glomerata*), geraniums, loosestrife (*Lythrum virgatum*), oregano, and garden sage, among others.

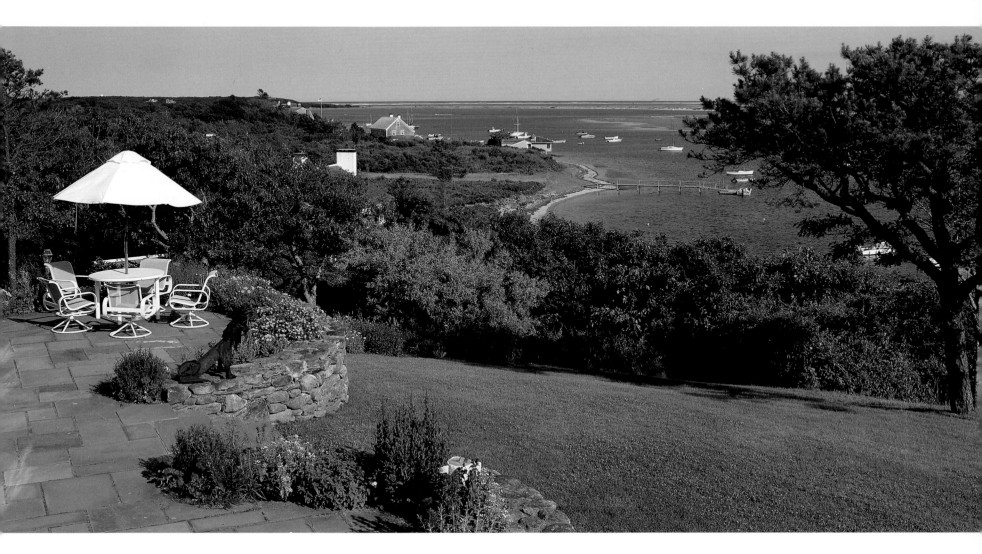

BELOW: In the entry hall, which is in the original part of the house, two carved wooden sculptures called pole people, made in North Carolina from fence posts, flank the doorway that opens into one of the front parlors. The beams are the original ones brought with the old house when it was moved from Hingham.

LEFT: In one of several living rooms downstairs, *Aunt Millie*, a soft sculpture made by Michele Malpica of Canaan, New Hampshire, is ensconced in a rocker by the deep fireplace. Whimsically formal dog and cat portraits flank the fireplace.

RIGHT: A still life of summer flowers by Sybil D'Orsi, of Teaneck, New Jersey, hangs over the fireplace in the sun porch— one of the additions made by previous owners. This room was fashioned from a barn that was moved here from Vermont. The Wilsons enjoy collecting folk art and have displayed part of their collection on the Cape. On the mantel, the rabbit with the sunflower was made by Donna Yackey and *Mr. MacGregor* by Cindy Teyro. The efficient cleaning woman is sculpted in resin by Louie Rhoades. The clammer and Windsurfer bunnies on the hearth were made by Barbara Doyle of Chatham.

RIGHT: Since the house is sited on a high bluff, the views from almost every room in the house are spectacular. The Oyster River, which leads to Oyster Pond, is in the foreground. The lighthouse, now privately owned, is on Hardings Beach. In the distance is Stage Harbor.

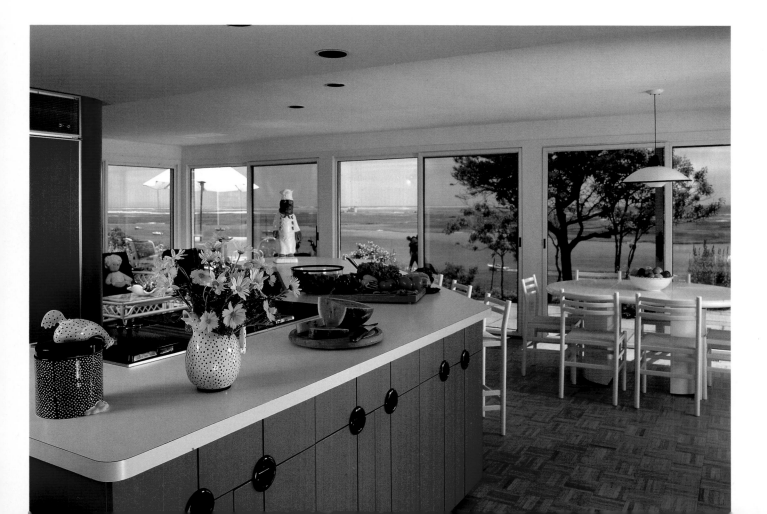

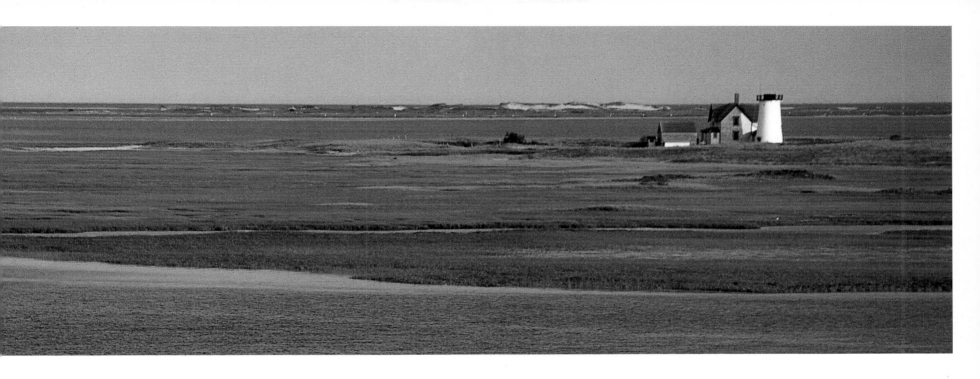

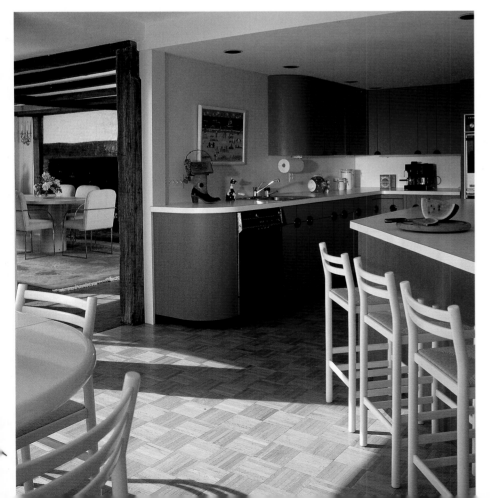

LEFT AND FAR LEFT: The bright red appointed kitchen was added by the Wilsons when they bought the house in 1984. Originally this kitchen space was a group of several small rooms, which included a servants' kitchen. The Wilsons made several rooms into one large one and added on to create the glass-walled sitting area that opens on to the flagstone terrace.

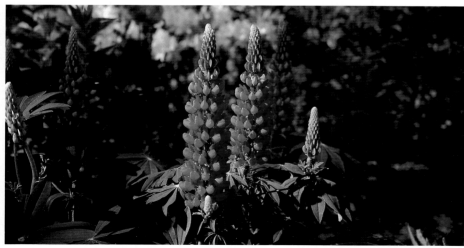

RIVE GAUCHE

In the interior of the house and especially in its gardens, the home of Ruth and Frank Hogan, an artist and an art collector and dealer, respectively, reflects their love of Cape Cod's art and color. Situated on one of Cape Cod's many saltwater ponds, the landscape is ever changing—whether it be a foggy spring day, clear summer skies and sparkling water, or when the marshes turn to gold in the fall. After one of fall's first frosts, the mist rises like smoke off the water. Of course, at the height of summer, the pond is filled with all kinds of working and pleasure craft, while in late fall through early spring, only the working craft and a few hardy year-round homeowners' boats are in the water.

In addition to painting oils and watercolors, Ruth Hogan makes white-line woodblock prints in the tradition of the original Provincetown printmakers. She studied the craft from Ferol Warthen, who had studied with one of the first Provincetown printers. The technique of white-line woodblock prints was developed by an artist named Bror Nordfeldt, who settled in Provincetown in the summer of 1915. He had been designing woodblocks in the traditional Japanese technique of a different block for each color. Becoming impatient with the time-consuming process, he developed a new technique of making a V groove in the wood between the colors, thereby making it possible to use one block with many different colors to make a print. Each color is in a separate piece of the block and is painted and transferred a segment at a time; thus the V groove becomes the white line of the print. Nordfeldt soon taught his new method to the rest of the group, which carried on the tradition. Though the process was developed by a man, for a number of reasons the printmakers were mostly women. This style of printmaking became popular during World War I. Since it did not require a large studio, and could be a communal activity, printmaking was a practical indoor occupation for the winter months. The artists would spend their winters producing and their summers selling.

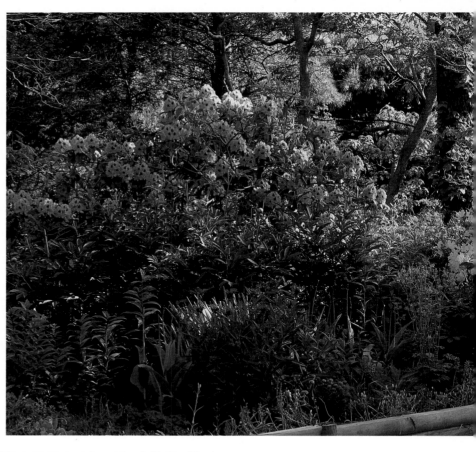

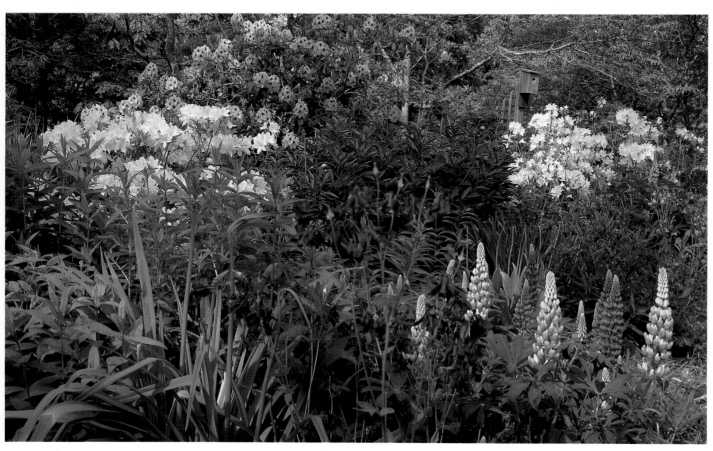

Ruth's garden is her summer studio. The color combinations of the garden in late May range from strong deep blues of the columbines, iris, and perennial bachelor's buttons (*Centaurea montana*) to the powerful reds and pinks of lupines, backed by yellow, purple, and softer shades of pink and cream rhododendrons. Most of the perennials have been started from seeds Ruth has acquired from friends because she liked the colors. As the summer progresses, the garden's colors and flowering plants change. As the seasons change so does Ruth's palette. However, most early mornings find her at work in the garden.

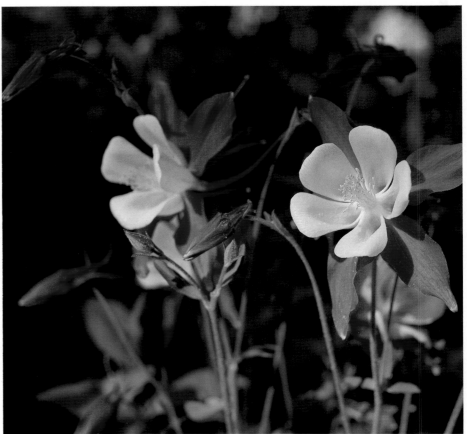

The Hogans' dining room is furnished with nineteenth-century Georgian-style ladderback chairs surrounding a mahogany pedestal table and a mahogany Sheraton taper-legged sideboard. Some of the Hogans' favorite paintings line the walls. All the paintings were done by Provincetown artists and were painted in the 1920s, because many artists had flocked to Provincetown during the war in Europe and had stayed because of the European flavor of the little fishing village. On the left is *Provincetown at Low Tide,* painted by Emile A. Gruppe. Next to it is *Provincetown Bakery,* by C. W. Ashley. H. A. Vincent painted *Venice,* which hangs to the left of the window; and on the right of the window is a painting by Joseph Birren entitled *Chip Hill.*

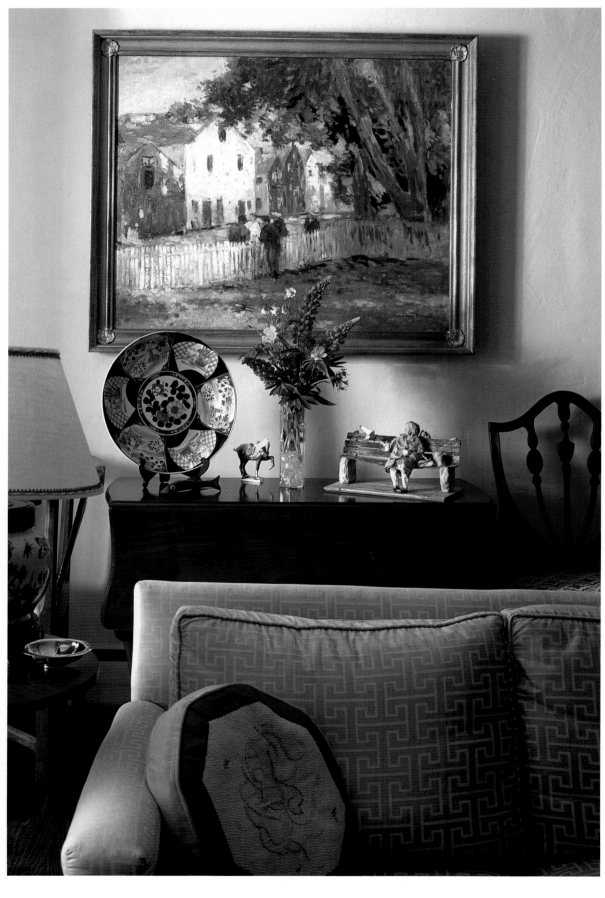

LEFT: The oil painting, by George Elmer Browne, *The West End of Provincetown,* was painted in the 1920s. A papier-mâché sculpture by Pamela Jason sits on the mahogany Pembroke table next to an Imari plate and a ceramic horse that the Hogans acquired on a trip to China. The oriental details are repeated in the ginger jar made into a lamp on an eighteenth-century candlestand.

RIGHT: Twelve of Ruth's woodblocks from which white-line woodblock prints are made hang on the Hogans' kitchen wall. The prevailing subject matter is Provincetown and, often, artists at work there. The one on the upper-right corner is the Provincetown printmakers at work; the lower-right corner is Christmas in Provincetown; and the second one from the bottom in the middle row portrays artists painting at the beach in Provincetown.

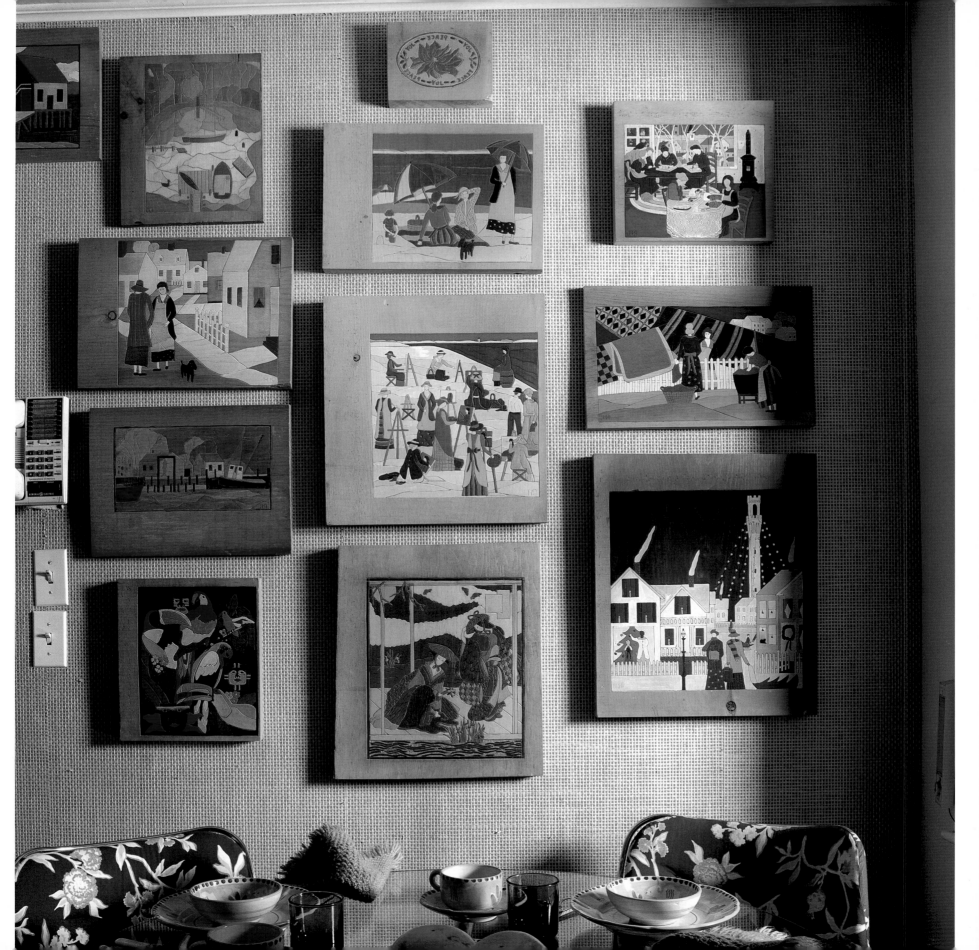

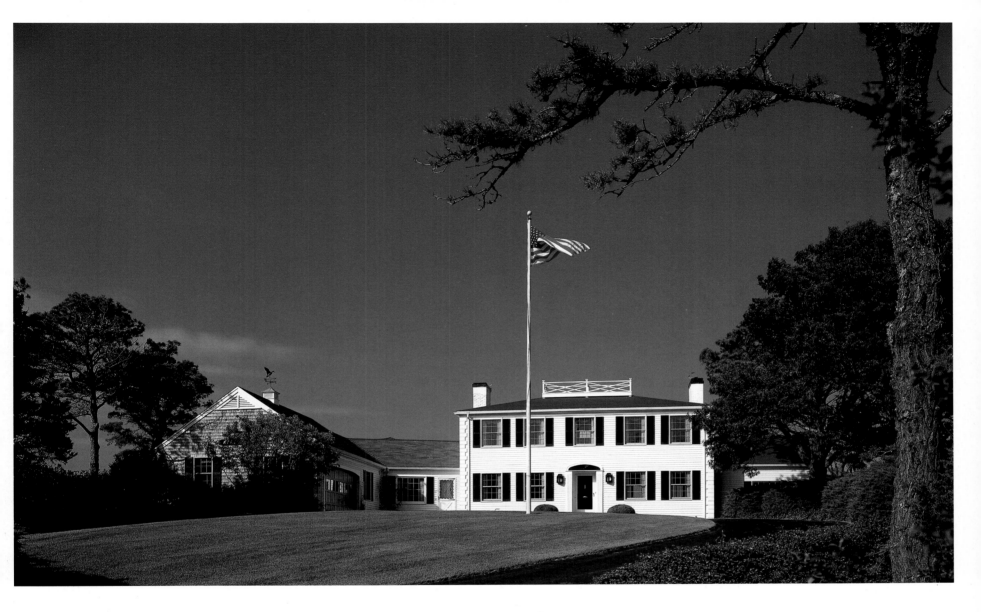

KITE HILL

On top of one of the highest points on the Cape, overlooking magnificent Pleasant Bay, sits this large traditional home. Built in 1970 on property that had been in the family for generations, the house has the classic lines of a sea captain's house of yesteryear. Approached from the front by a long circular drive, the grounds are elegantly simple. From the back of the house, the vista across more generous lawns encompasses miles and miles of the shoreline of Pleasant Bay. The house sits on a hill at the southwest end of Pleasant Bay and overlooks the Narrows and Sipson's and Little Sipson's islands, with Nickerson Neck the point of land to the right. Muddy Creek empties into the bay, across the road.

The owners of the house have added on to it since they originally built it. They have enclosed a deck to make a copious sun room on the back and have added a large master bedroom wing. The gardens have been added throughout the years and provide the perfect accents for the incredible view.

BELOW: Hydrangeas (*Hydrangea macrophylla* 'Nikko Blue') and juniper (*Juniperus horizontalis* 'Blue Rug,') along with a yew (*Taxus baccata*) hedge mark the sides of the terrace, with its few steps up to the endless sweep of Pleasant Bay in the distance. Along the left side of the generous green lawn is a colorful border of strong pink Betty Prior roses and lavender, interspersed with perennials in complementary colors to balance the splash of color that contrasts with the blue of the bay in the distance.

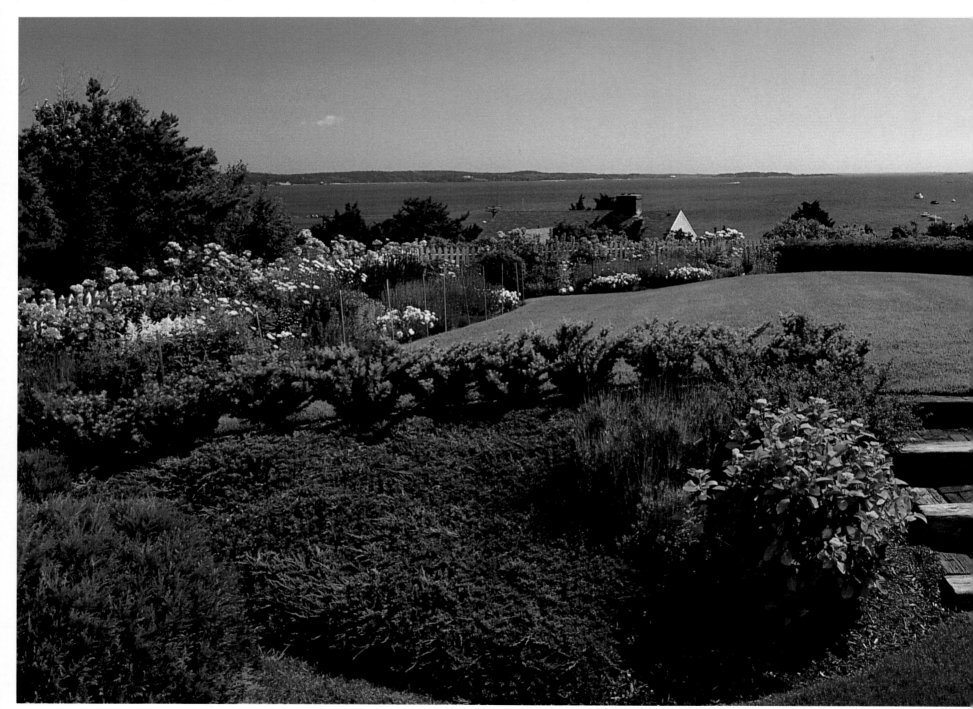

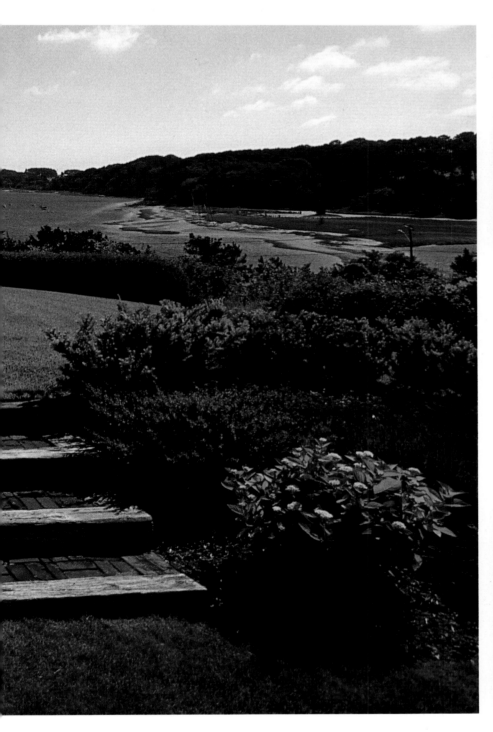

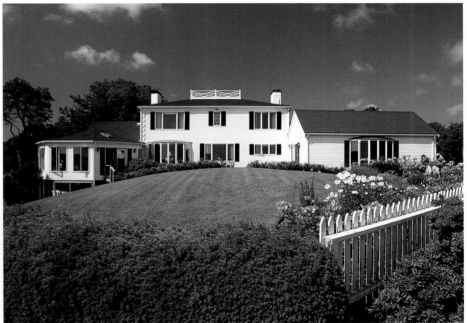

BELOW: Betty Prior roses sweep across the white fence and around the curve up to a boxwood hedge that runs all across the back. White astilbe (*Astilbe* x *arendsii* 'Bridal Veil') and blue lavenders (*Lavandula angustifolia* 'Hidcote' and 'Munstead') are intermixed with yellow Marguerites (*Chrysanthemum frutescens*), white Shasta daisies (*Chrysanthemum* x *superbum*), catmint (*Nepeta faassenii*), dark purple salvia (*Salvia nemorosa*), and blue delphiniums to add contrasting foils to the roses.

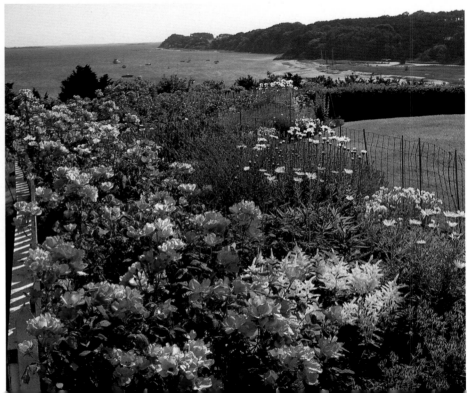

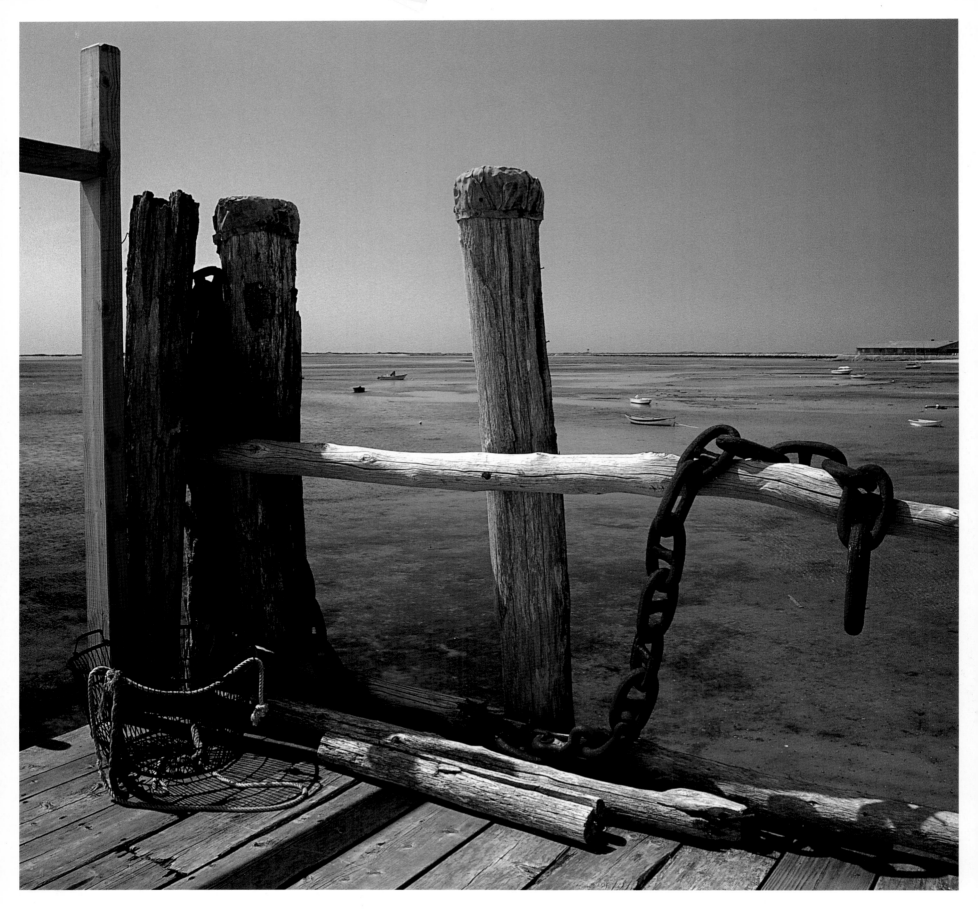

SANDBARS

Set back from the road and behind rose-covered fences and a rich green lawn beneath mature shade trees is this grand, shingled summer home. The house was built in 1928 for the Durand family from Rochester, New York. It was designed by Boston architect Edward Sears Reed, who designed and built two other houses in Chatham in the late 1920s. Situated on a bluff overlooking Chatham Harbor, the house enjoys great views of the water from all the rooms across the back of the house. Down a long set of stairs is the beach. Four little arched doors open into compartments along the side of the garage. They may have been used as changing rooms for the beach since they are fitted out inside with mirrors and benches.

The current owner bought the house in 1992 from the Durand family and, in restoring the graceful old house, made no structural changes except in the kitchen. Behind the covered walk to the left of the main house, five little rooms were made into one large kitchen and dining area, which opened up the vista to the harbor. During the renovation work, the builder found a note behind a mirror in one of the upstairs bathrooms. It read "There are 144 bottles in the secret closet," and was signed "Reggie Moulton, June 1929." Though the secret closet was later found behind the stairs, it no longer contained any of the 144 bottles referred to in the note. The present owner has beautifully refurbished the house, furnishing it with antiques and collections of favorite things.

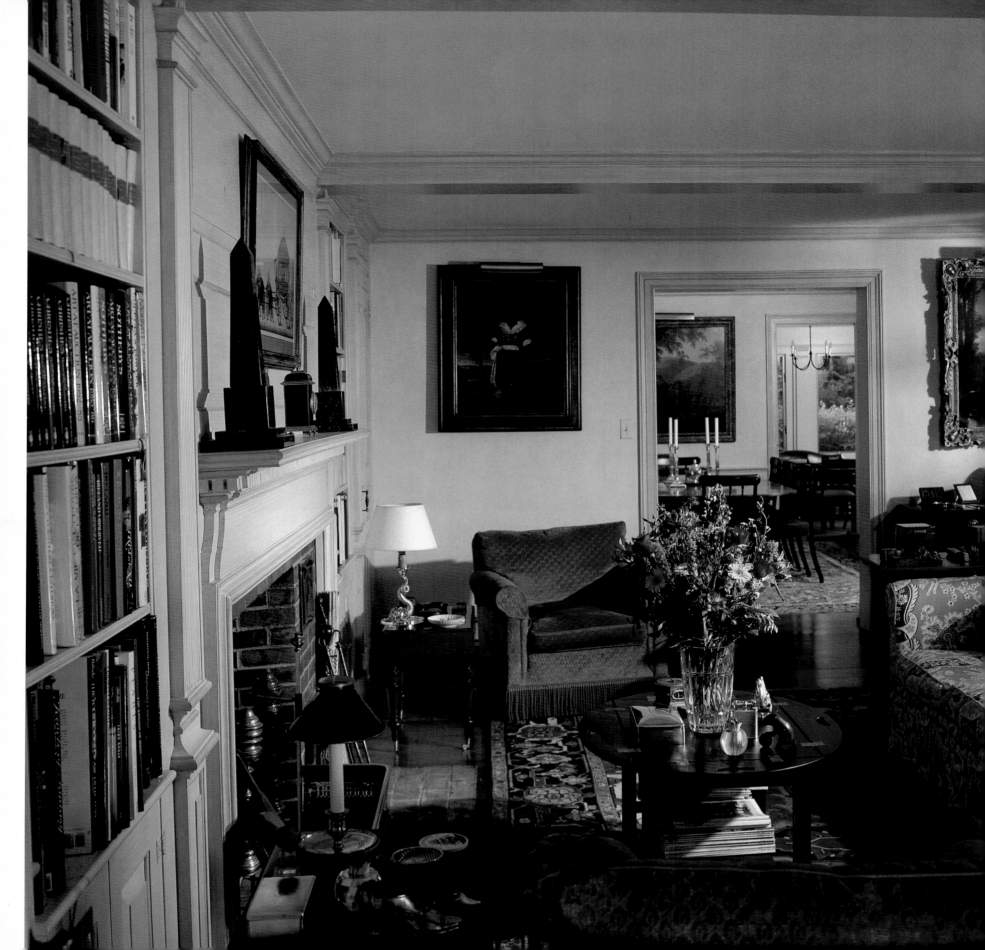

The formal living room and dining room are at the rear of the house, with their windows overlooking the water. Beyond the dining room is a little glass-enclosed game room. The living room is comfortably furnished with a pair of pressed velvet–covered club chairs. An interesting selection of tables holds some of the owner's collections of eighteenth- and nineteenth-century *objets* of French, English, and Dutch origins. In the foreground, next to the sofa, is an English folding coaching table, made of mahogany, c. 1810. A butler's tray coffee table is in front of the sofa. On either side of the doorway into the dining room are two portraits that were painted in India by British artists, the one on the left by Arthur William Devis, and the one on the right, above the desk, by Tilly Kettle.

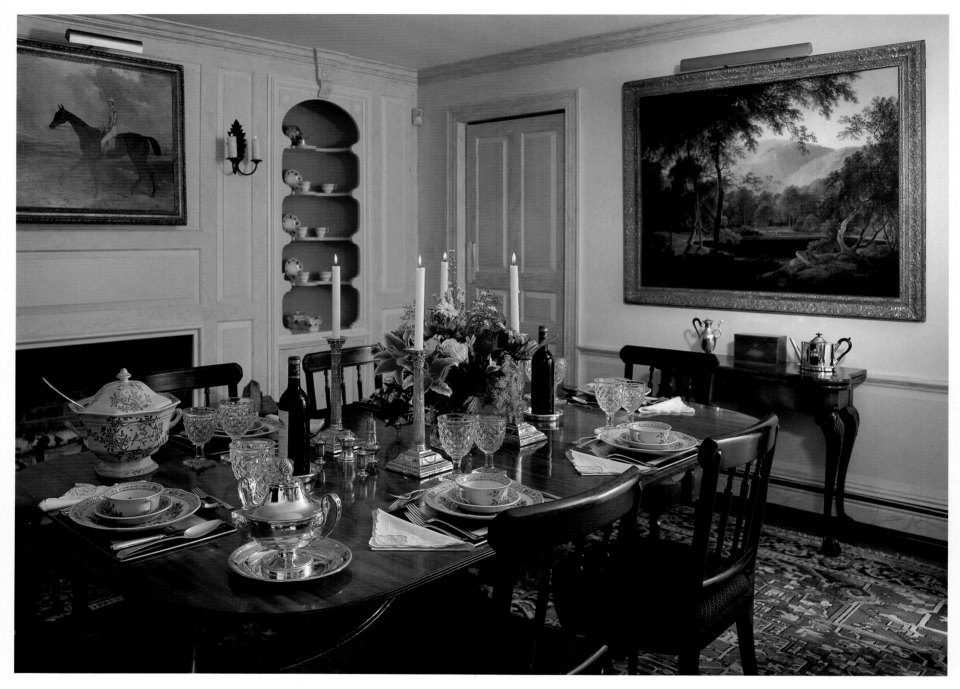

Beneath the table, a nineteenth-century Hamadan rug covers the floor of the dining room. The table holds some lovely eighteenth- and nineteenth-century English and Continental silver, such as the Corinthian-column candlesticks, c. 1790, and a little silver tureen, c. 1810. On a Queen Anne card table with cabriole legs, an English double tea caddy is flanked by a pear-shaped coffee pot, c. 1810, and a silver teapot, c. 1810. The large Anglo-Indian oil painting above the card table is *Woodland Scene* by Thomas Daniel, c. 1820. Above the mantel is a horse and jockey, painted by Harry Hall. In the side cupboard, part of a nineteenth-century red and gold tea set is displayed. The detailing of the fireplace wall is especially fine for a summer home of this period.

———————

CENTER, TOP: The owner collects eighteenth- and nineteenth-century tobacco boxes and snuffboxes. Behind the row of nineteenth-century fruitwood shoes, which are snuffboxes, trimmed in brass and silver, are two large nineteenth-century English tea boxes. Between them is a lion of Lucerne. The original, which is in Lucerne, Switzerland, was made to commemorate the Swiss Guard who died defending Marie Antoinette during the storming of Versailles.

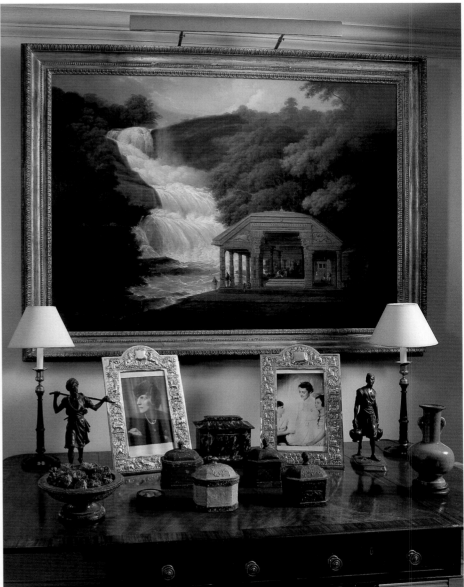

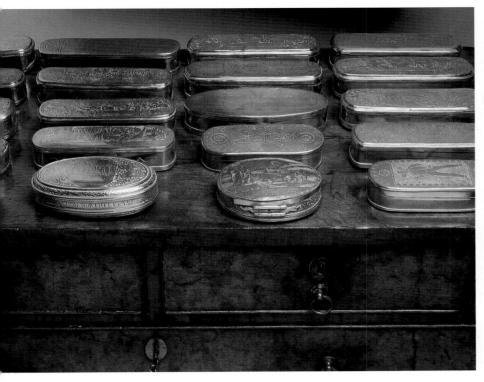

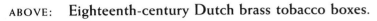

ABOVE: Eighteenth-century Dutch brass tobacco boxes.

TOP RIGHT: A large Anglo-Indian oil painting by Thomas Daniel, *The Country Below the Main Waterfall at Kullalam Tinnevelly District*, c. 1808, hangs above a table that holds a pair of French nineteenth-century bronzes. Family portraits in silver frames flank a North African tortoiseshell tea box. In the center of the table are four Dutch lead tobacco boxes.

RIGHT: Eighteenth- and nineteenth-century walking sticks, made of and decorated with boxwood, ivory, silver, horn, and gold.

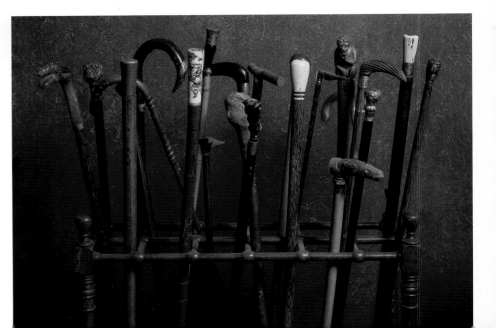

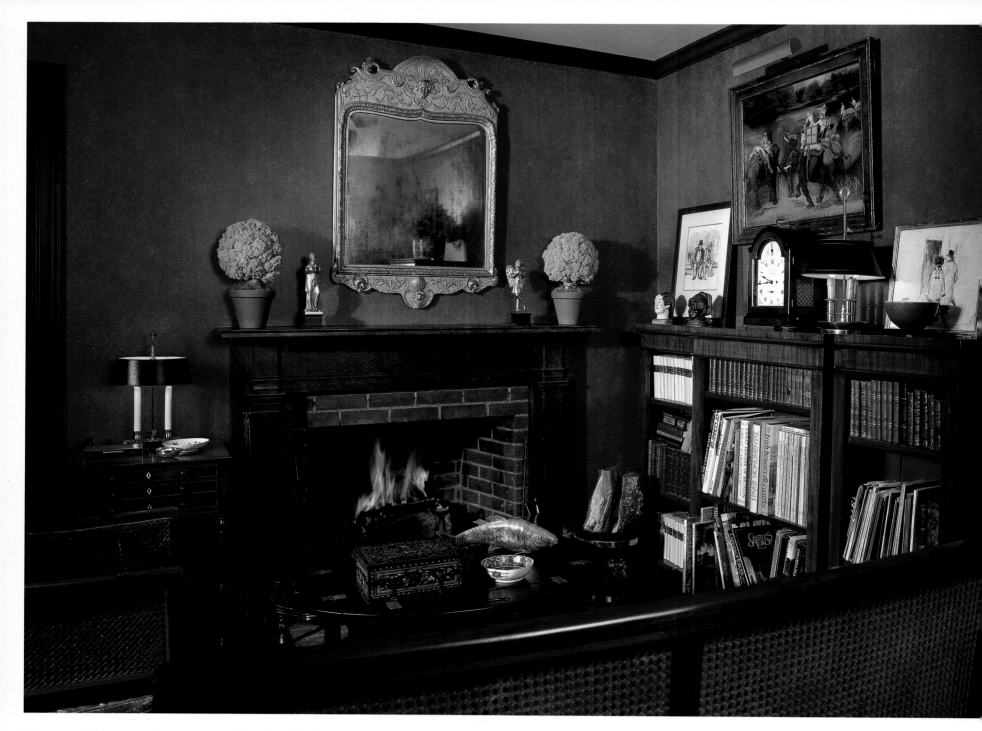

The cozy library, with its sponged red walls, has an early-eighteenth-
century Queen Anne gilt and gesso mirror over the fireplace and an
eighteenth-century English clock on the mantel. The Anglo-Indian
painting above the bookcase once belonged to the lady in waiting for
the queen of Belgium.

An upstairs guest room is quietly furnished with an English Regency writing desk and a Sheraton chest flanked by Regency side chairs, with cane backs and seats. A Tole tea caddy made into a lamp sits on the writing desk in front of the window. A group of six early-nineteenth-century Anglo-Indian lithographs decorates the wall.

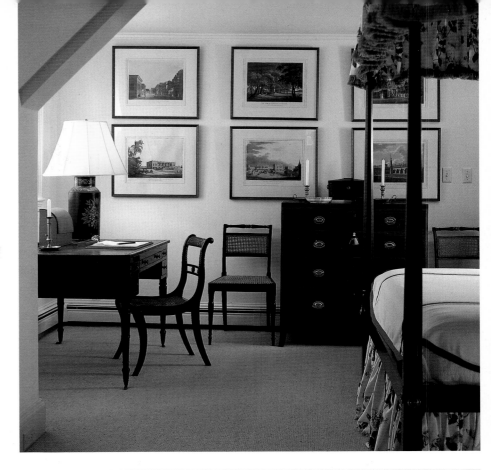

The dining area end of the new kitchen is filled with light from skylights and large windows that overlook the water. An oil painting of an eighteenth-century gentleman with his hunting dog hangs over the mantel and fireplace surround, which came from an office at the Harvard School of Business. Imari-patterned English plates, c. 1810, and a set of graduated pewter measures line the shelves of the Welsh country cupboard. An English Regency side chair, with cane back and sides, is to the left of the cupboard. Yew wood hoop-back Windsor chairs, c. 1820, surround the drop-leaf table.

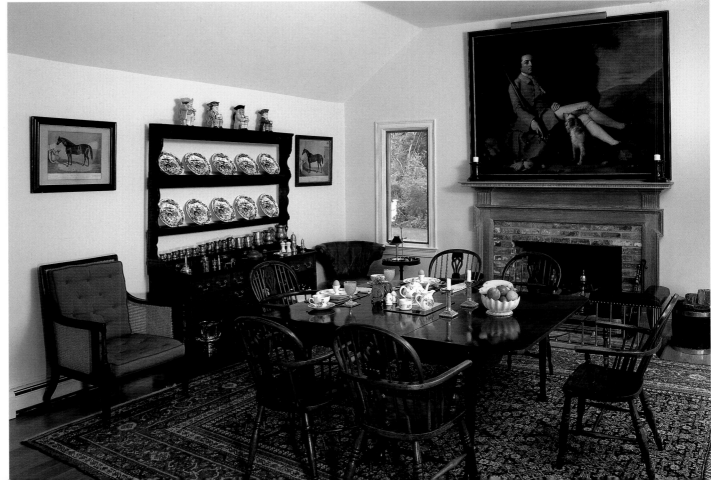

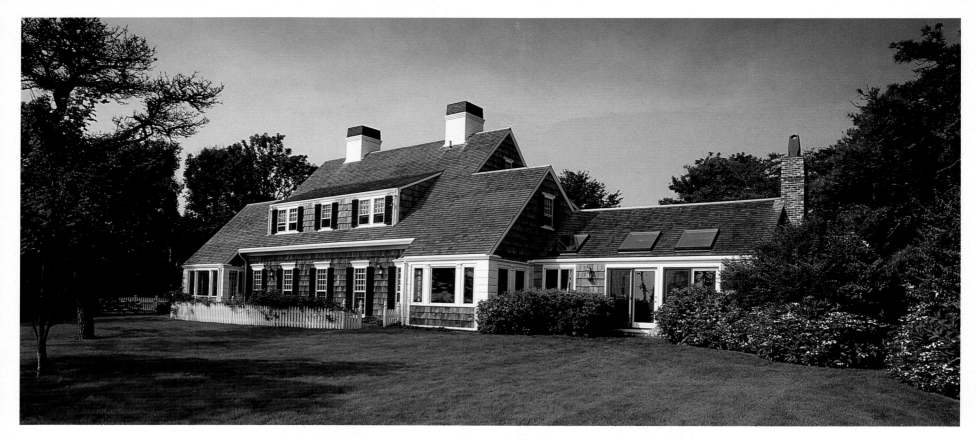

The symmetry of the house is apparent from the back. A screened
porch room on one end is balanced by the glassed-in porch, which is
the game room. The kitchen wing has been completely redone by the
present owner.

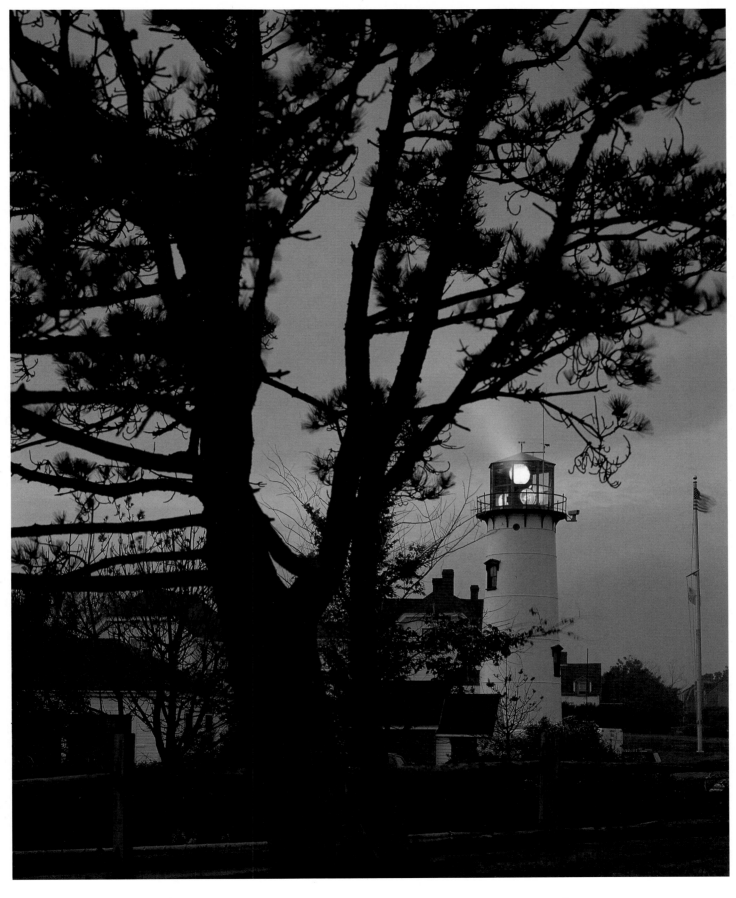

A working landscape gardener, Valerie Piper created a garden that is a reflection of her love for color and the rich patterns it creates. She started her first perennial border in 1988 and has added a little at a time, never dreaming when she started that it would ever reach this size. Valerie took down some trees for more light on one side of the garden; then Hurricane Bob took down others in 1991. Valerie's philosophy is that if you take care of the plants, the plants will take care of the garden. She plants perennials, adds new plants she is experimenting with and raises in her greenhouse, and fills in with annuals between perennial blooms, depending on the season.

RIGHT: Reds and pinks are predominant in late June in this front border, with masses of coral bells (*Heuchera sanguineum*) interspersed with pink dianthus (*Dianthus plumarius*) in the foreground next to purple hardy geraniums (*Geranium endressii* 'Johnson's Blue'). Deep red dahlias are already in bloom in late June, having been started in the greenhouse. Red valerian (*Centranthus ruber*) is in the back, along with foxglove. Blue bellflowers (*Campanula persicifolia*) form a backdrop to yellow primrose (*Oenothera missouriensis*) next to and behind the dark orange Asiatic lilies.

BELOW: Asiatic lilies are an unusually early blooming variety.

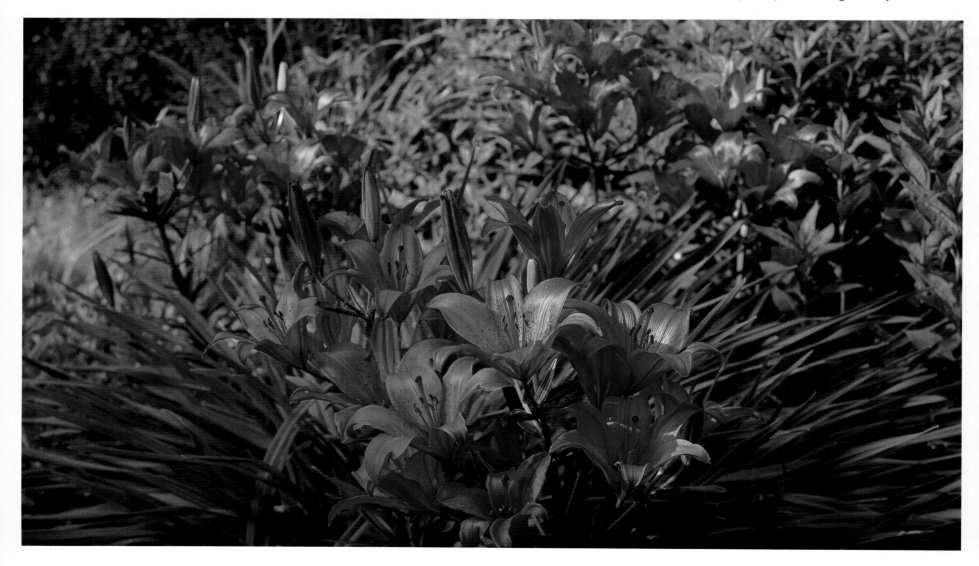

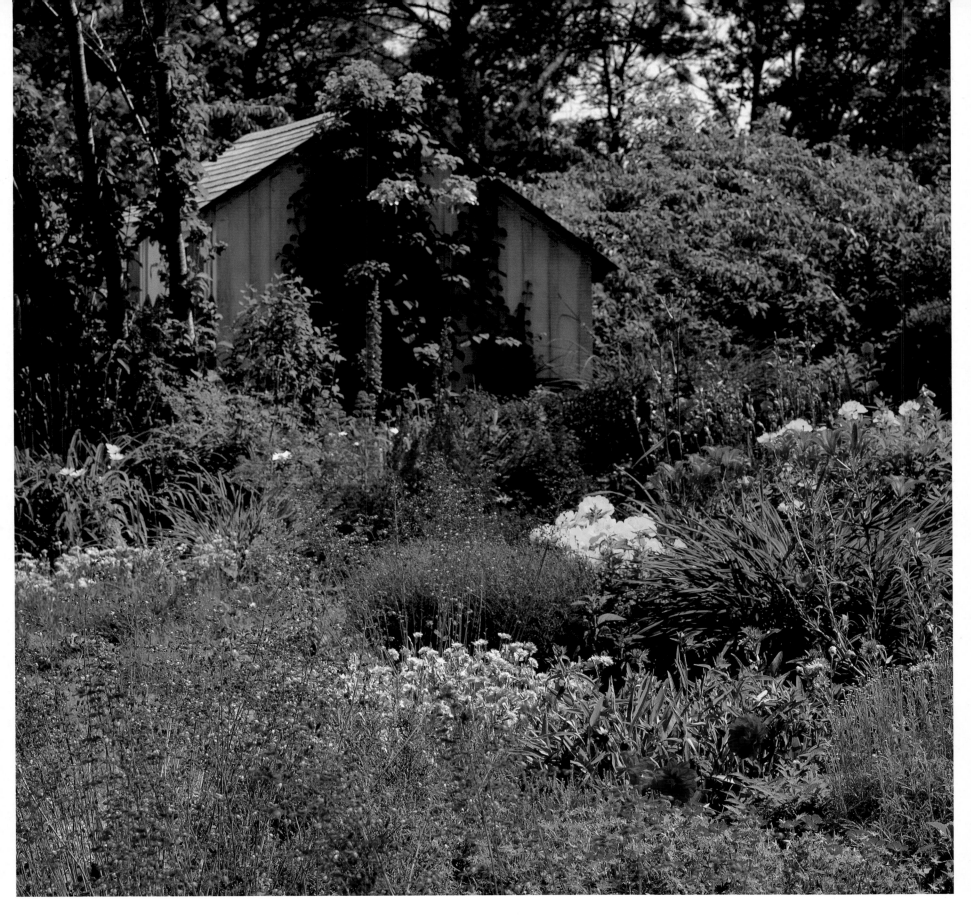

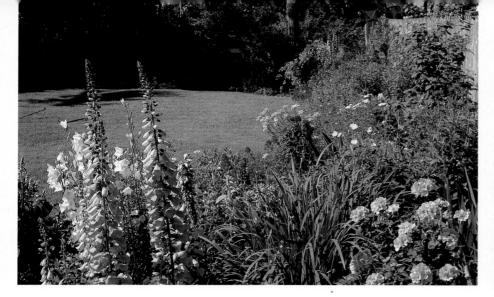

Pink foxglove (*Digitalis purpurea*) and white campanula start this section of border on the left. Siberian iris backed by red valerian are next to dark blue *Campanula glomerata* and two shades of pink painted daisies (*Chrysanthemum coccineum* 'Pyrethrum').

Multi-colored Russell lupines and foxglove provide subtle variations of color in late June.

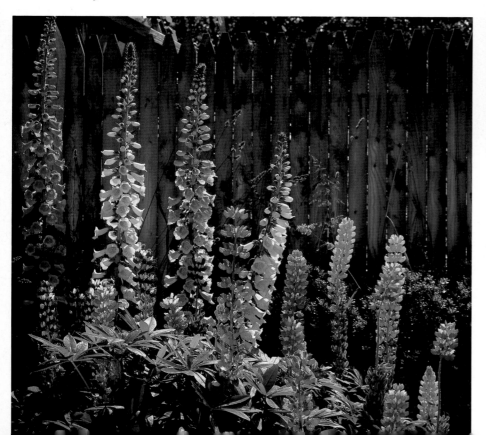

Catmint (*Nepeta cataria*) in front and dark campanula behind are the perfect foils for bright pink painted daisies.

RIGHT: Turtleheads (*Chelone obliqua*) blooming in August with loosestrife (*Lythrum virgatum* 'Morden's Pink').

BELOW: Orange zinnias, blue annual bachelor's buttons, and yellow helianthus are colorful in the late summer garden.

BELOW RIGHT: Deep red and yellow dahlias 'Collarette Dandy' have rich color and bloom all summer. Valerie starts these dahlias from seed in her greenhouse for late June blooms that continue through till frost.

MORGAN'S WAY

This rambling two-story house was built as a simple ranch some twenty-five years ago. In 1987 Will Joy and Page McMahan began transforming it by gutting the little cottage and putting on new windows and doors. They created a second story consisting of a cathedral ceiling in the living room, with a library niche on one side at the top and a little sitting area on the other. A new master bedroom wing has a summer living room above. Finally, in 1991, they added the enormous deck that sweeps around the back and cantilevers out over a steep hillside. It connects all the rooms across the back to the pool area.

Though the house is contemporary in style and feeling, there is an essence of the eighteenth-century inside in the use of wood in construction and in detailing. From a seemingly quiet exterior on the front, the house on the inside dramatically opens up and, as it is designed to do, brings the outside in.

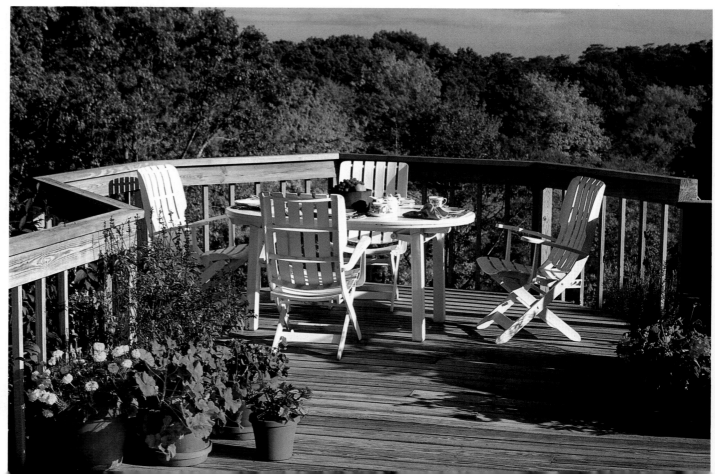

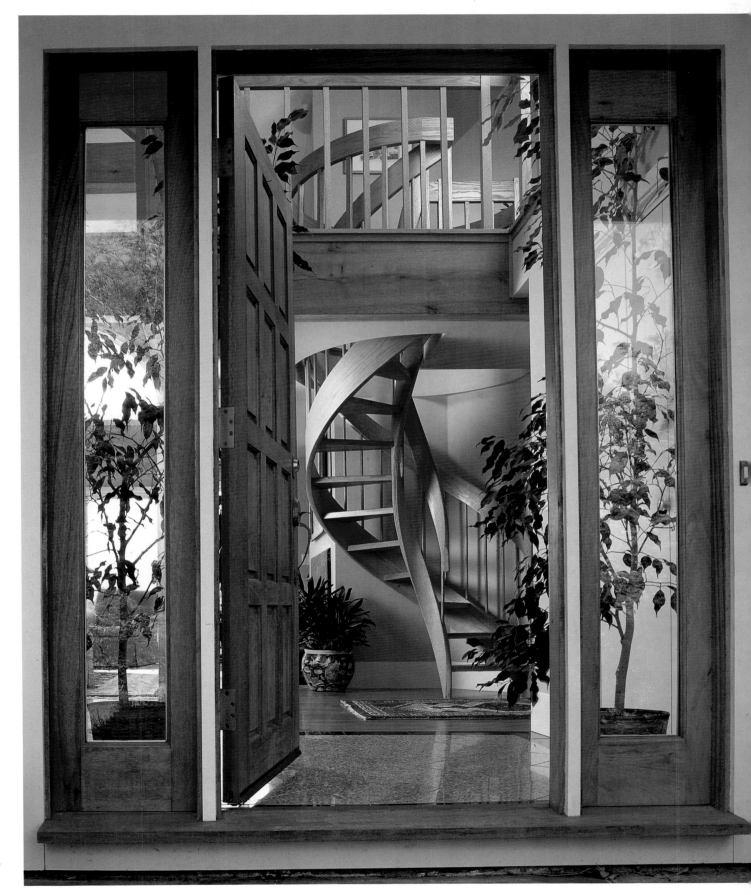

Glass panels on either side of the
front door frame the sculpted
circular stair that appears to take
flight to the upper floor. The
stairway was built in York, Maine,
for the house.

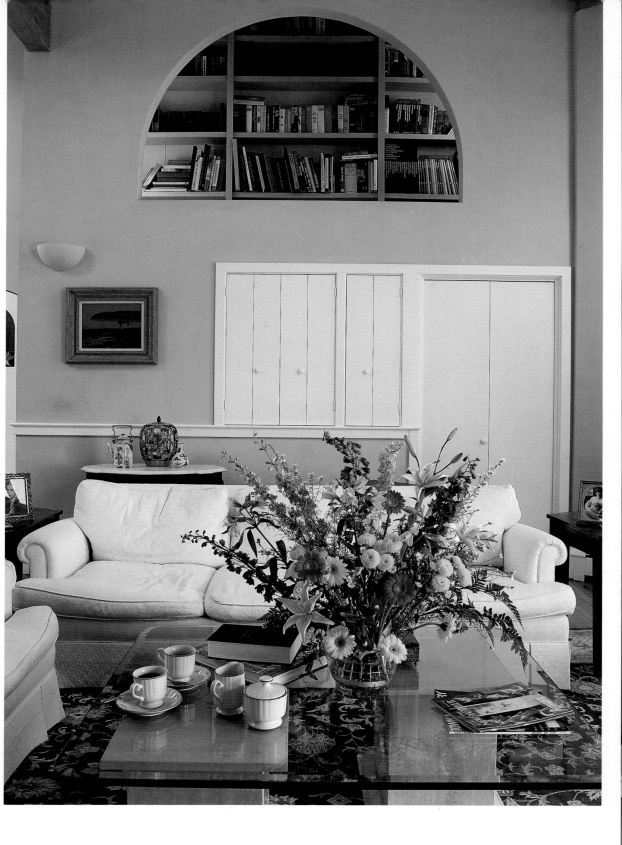
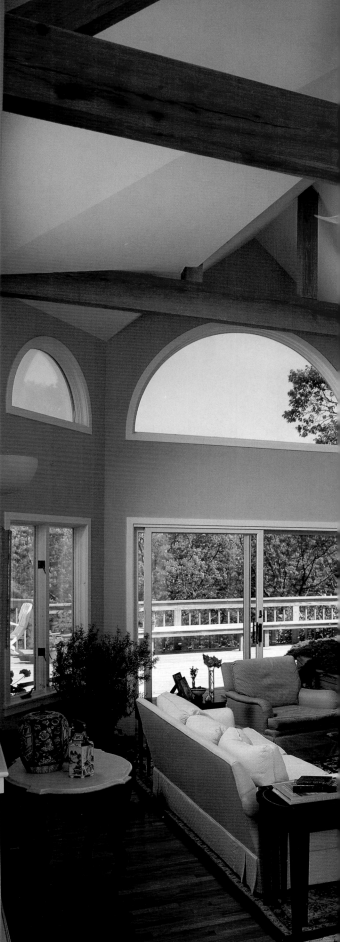

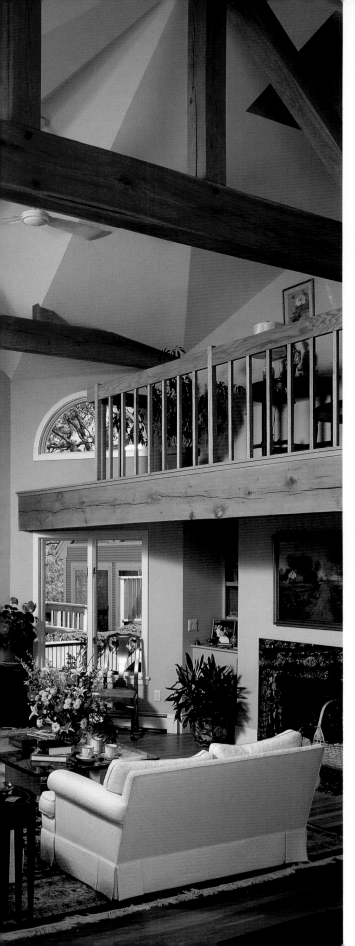

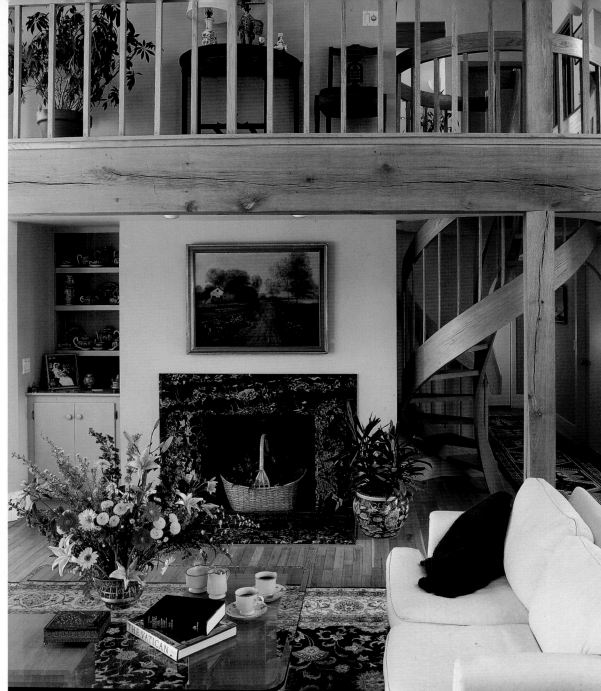

With its glass wall opening on to an enormous deck with expansive views, the cathedral-ceilinged living room makes the most of light and air. The use of the demi-lune window in the library wall is repeated across the top of the outside walls overlooking the deck. A balcony at the top of the circular stair separates the upstairs summer living room and office from the two-story main living room. The painting over the marble fireplace is by E. Ashton Plummer.

In July Betty Prior roses envelop
the deck and the edge of the pool
and guest house.

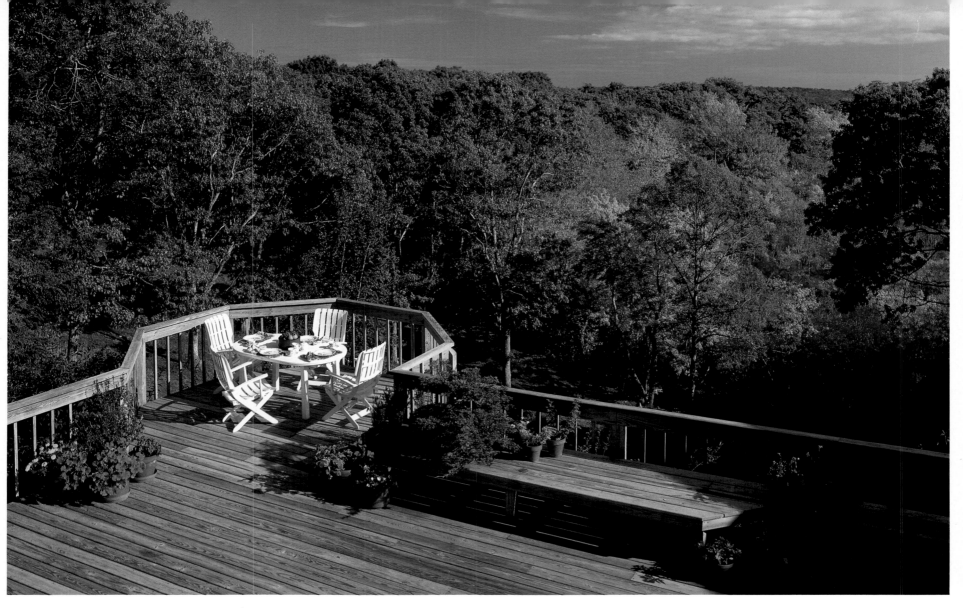

The fall foliage and crisp blue skies of October make autumn a glorious time for outdoor dining on the deck. The deck is high above the hillside and colorful bog below. The house is on an unusually steep grade, being at the top of a ridge of glacial moraine.

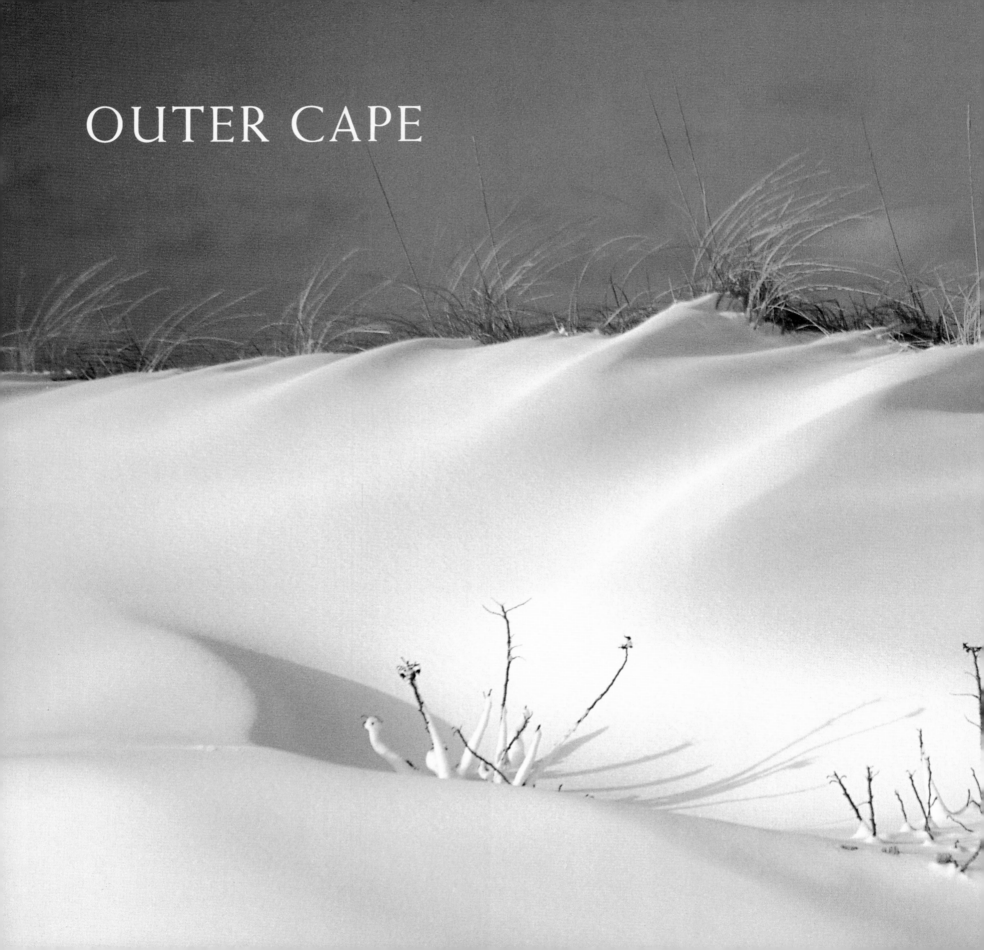

OUTER CAPE

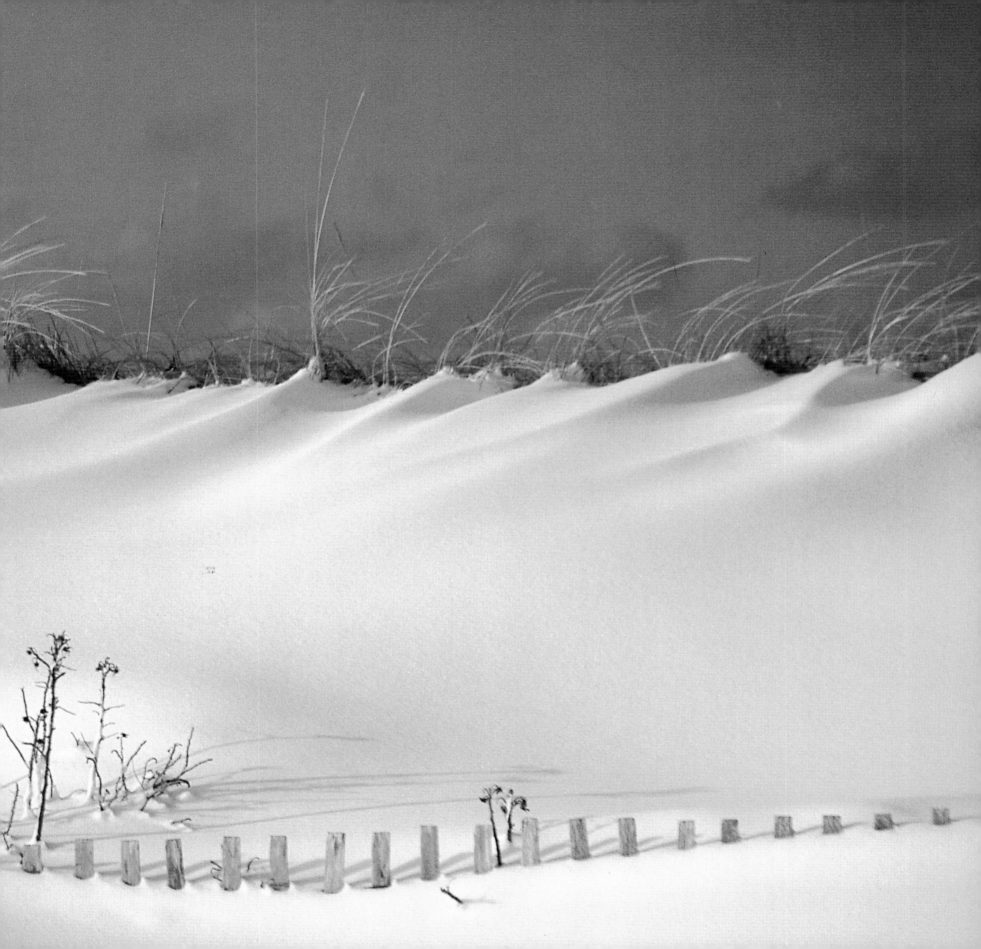

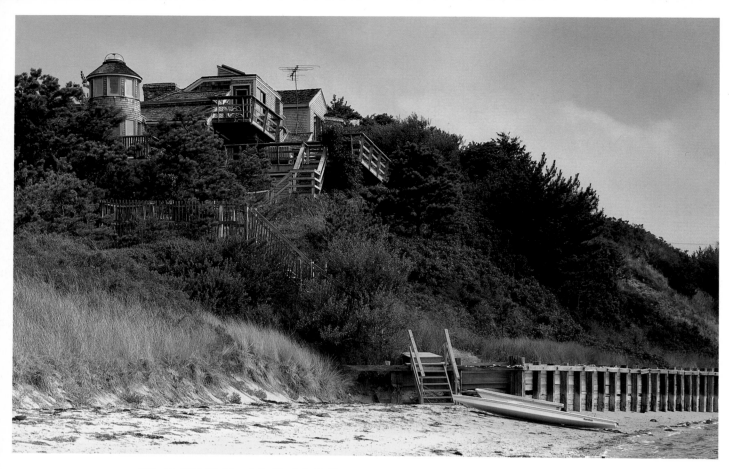

TOWER HOUSE

High on a bluff overlooking Wellfleet Harbor, this rambling turreted summer home was built about fifty years ago as a small fishing cottage. Two small additions, which included the tower and lower-level bedrooms, were made by previous owners about fifteen years ago. In 1988 Chuck and Donna Ward bought the house and updated it for the 1990s, adding a large master bedroom wing and modernizing the wiring and plumbing.

Located on the Outer Cape, the town of Wellfleet has a winter population of about 2,700, which more than triples in the summer. Wellfleet's harbor is one of the most naturally protected on the East Coast. It has been famous for its oysters for centuries. Strict regulations and frequent inspections keep its waters pure, thus maintaining the safety of the oysters, clams, and other shellfish. In 1991, the income from shellfish in Wellfleet exceeded $2 million.

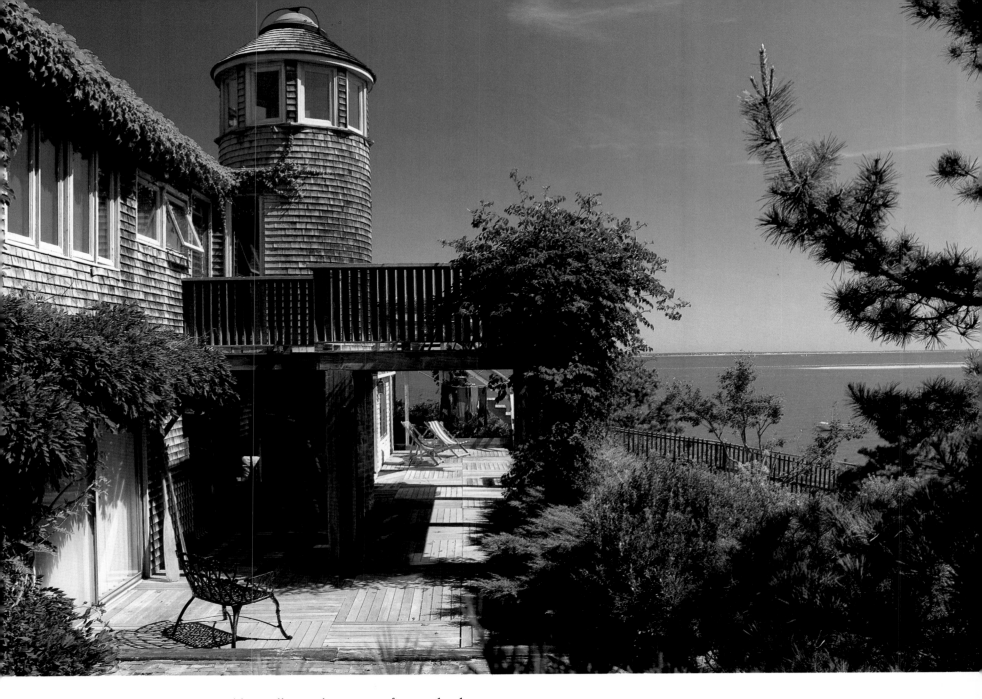

Decks on many levels, long ramplike walks, and a series of stairs lead
from the house down the rosa rugosa—covered bluff to the beach. On
the lowest ground-level deck are four bedrooms, two reached from
inside the tower and two from the outside. There is lots of room in this
house to spread out and have privacy for house guests and owners
alike.

ABOVE: A brick walk lined with terraced beds of perennials topped with profusely blooming Bonica roses leads around the side of the house beneath the master bedroom wing.

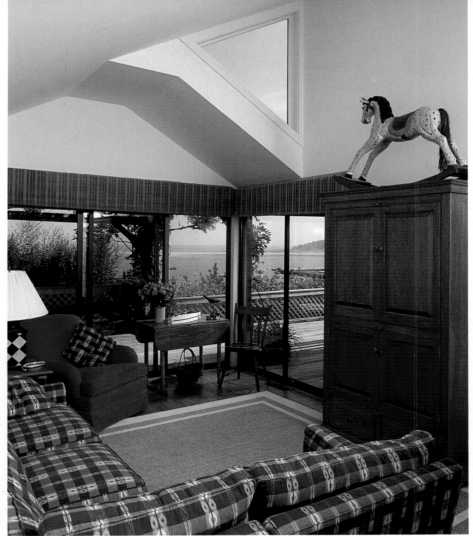

ABOVE: The den is conveniently located between the living room and the children's rooms, with doors opening to the large deck outside that connects all the rooms along the water side of the main living area. Decorated with wooden sculptures of seabirds, decoys, and antique toys from the Cape, it was planned to be a cozy room comfortable for children or adults.

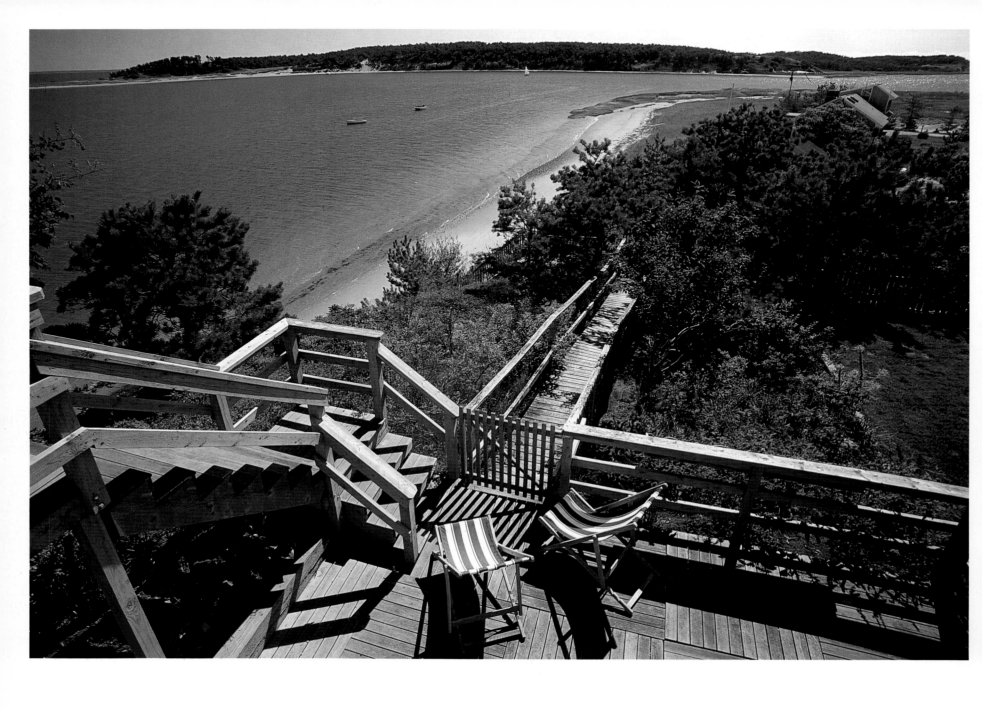

LEFT: The stairs and ramps lead down to the long sandy beach at the foot of the bluff. A more structured garden and side play yard are on the right and a wild rosa rugosa—covered bluff is on the left.

RIGHT: The comfortable living-dining room is part of the original fishing cottage. A loft studio with skylights is on an upper level opening into the living room. All of the paintings in the house are by local Cape artists. The one above the fireplace is by Thomas B. Higham. Avery family china decorates the shelves to the right of the fireplace. Beneath the ceiling under the loft studio is a nineteenth-century painted Swedish armoire. An apothecary chest on a stand makes a sofa table.

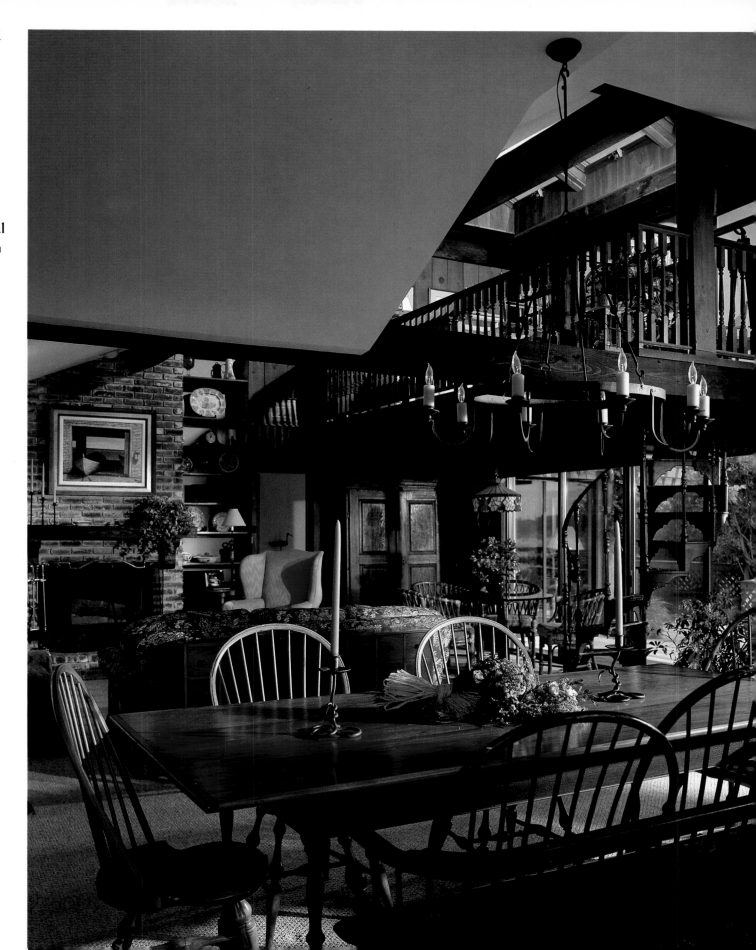

RIGHT: The master bedroom has a glorious view of Wellfleet Harbor and Great and Duck islands.

BELOW: A stained-glass window adds a colorful accent to this cozy little girl's room, with its extensive collection of favorite stuffed toys.

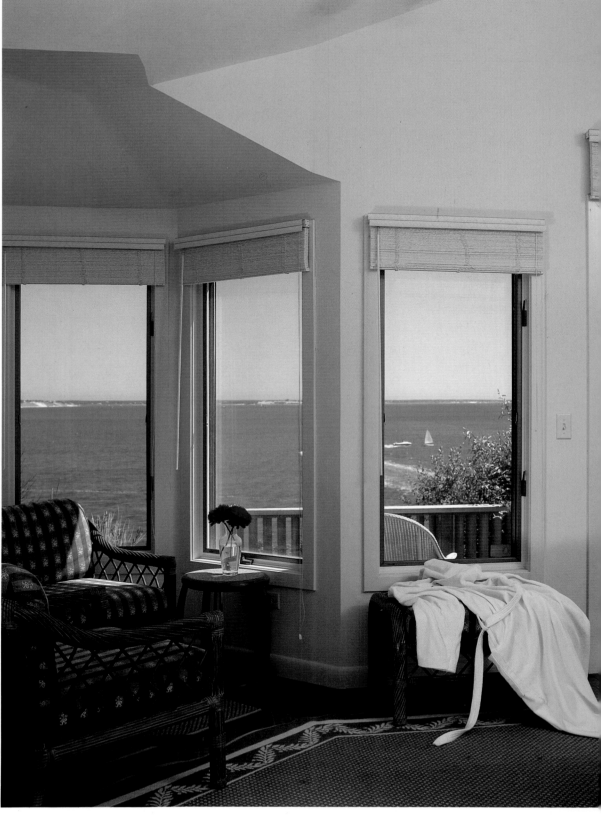

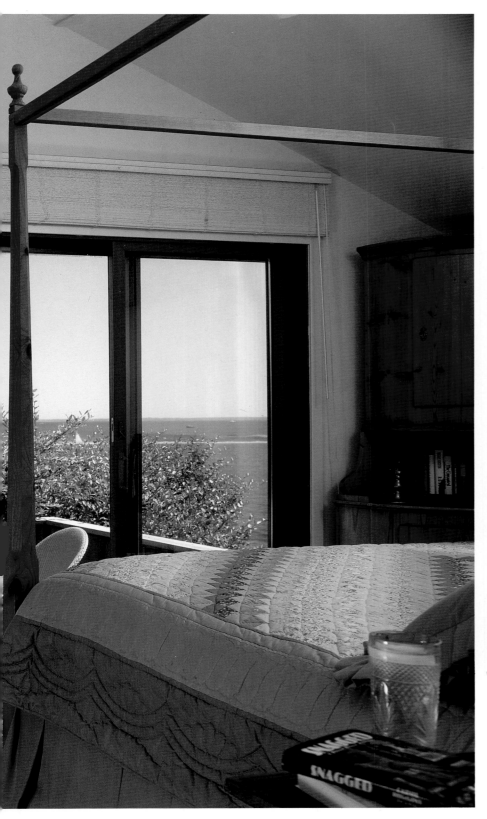

A boy's room, furnished with all the right stuff for a good summer.

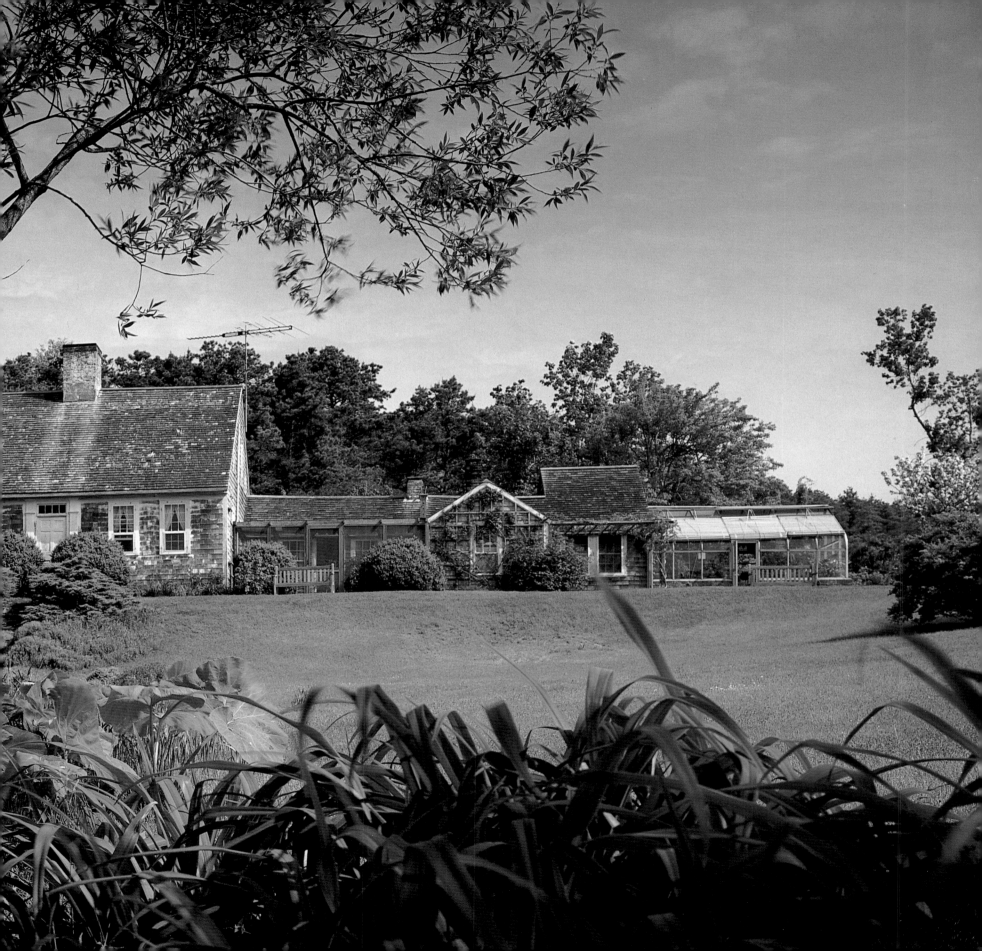

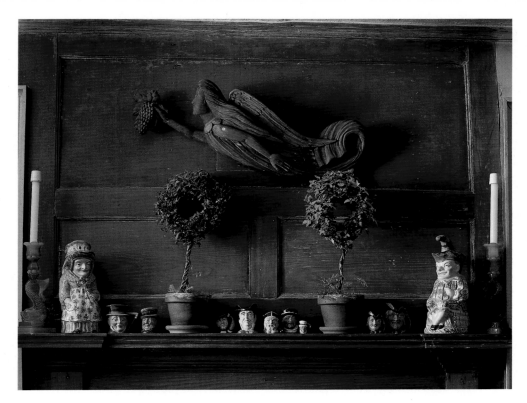

WINDY WILLOWS

Nestled on seventeen acres of farmland in the North Truro hills, Windy Willows has a long history. The property is near historic Corn Hill, so named for the site where baskets of buried corn were found by *Mayflower* passengers when they were exploring the area to see if it would be suitable for settlement after they landed at Provincetown. The property was most likely settled by Thomas Paine, one of the founders of Truro. The house was built around 1750, probably by Caleb Hopkins, an in-law of Paine's. It is a traditional full Cape with all the classic elements of the style: center chimney and fireplace, keeping room across one side or the back of the house, side stairway that curved down around the chimney into the keeping room, two rooms on either side of the front door, one and a half stories, with the upstairs being a loft room. The house stayed in the family that built it until 1918. Like so many early houses, this one was added on to throughout the years. The dining room with its curious cove ceiling was added in the late 1800s. In 1918, two women bought the house from the family that built it and added the kitchen and pantry.

The present owners have stripped all the paneling of its years of multi-layered paint back to its original color. They have also stripped the walls of the old paint back to the plaster in an effort to restore the house to its original look. The house is furnished with period English and American antiques and a great collection of Provincetown art. The grounds are carefully cared for and have gorgeous vistas from hilltops, sunken woodland garden walks, and formally planted borders. Attached to the kitchen is a greenhouse, where the owners raise orchids as well as many plants to be set outside in summer.

ABOVE: **The wooden paneled mantel holds a mid-nineteenth-century Canadian carved wooden angel holding a bunch of grapes. The angel originally adorned one side of a hearse. A pair of Sandwich glass dolphin candlesticks, early-nineteenth-century Punch and Judy pitchers, and a collection of Royal Doulton pitchers line the mantel.**

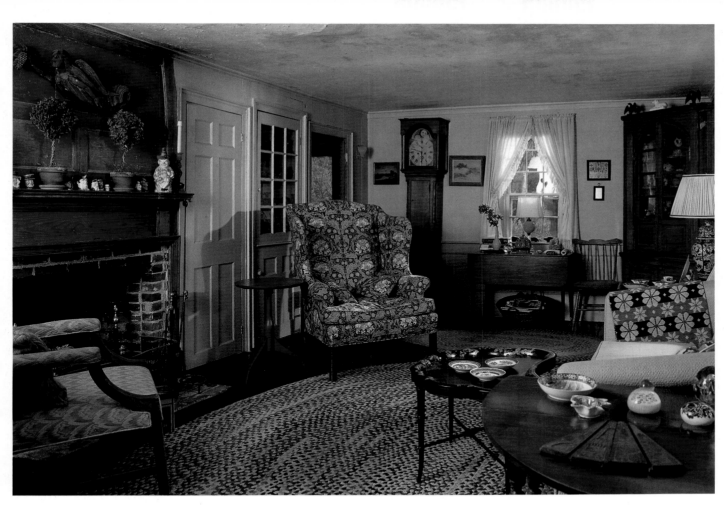

LEFT: The long keeping room is typical of a traditional Cape house. The door at the end of the room opens outside at the foot of the stairs, which originally came down into the room where the cupboard now is, behind the mid-eighteenth-century wing chair and Shaker candle stand. The tall clock was made by Dr. Josiah Leavitt for his own family c. 1790. A Newport Pembroke table holds orchids raised in the greenhouse. The corner cupboard has its original eighteenth-century red paint. In the foreground on an eighteenth-century American gateleg table is a French Canadian maple sugar mold.

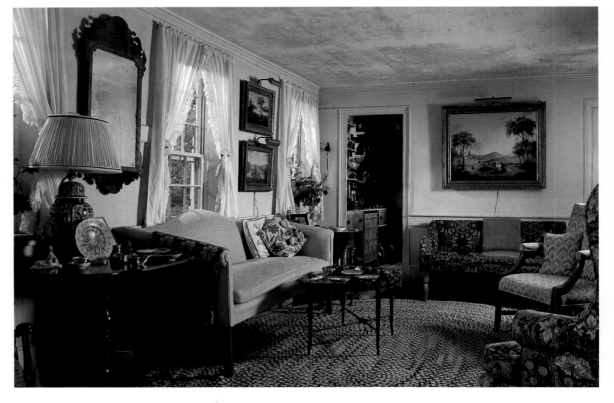

RIGHT: At the end of the keeping room is the buttery, which connects this room to the dining room. An 1830 American primitive hangs above a country sofa. In front of the yellow sofa is an English papier-mâché tray table, c. 1820.

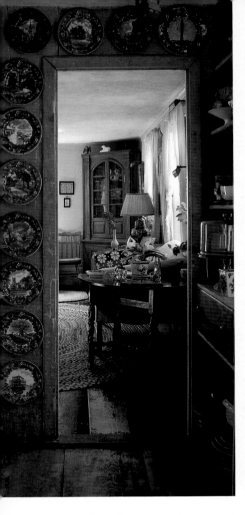

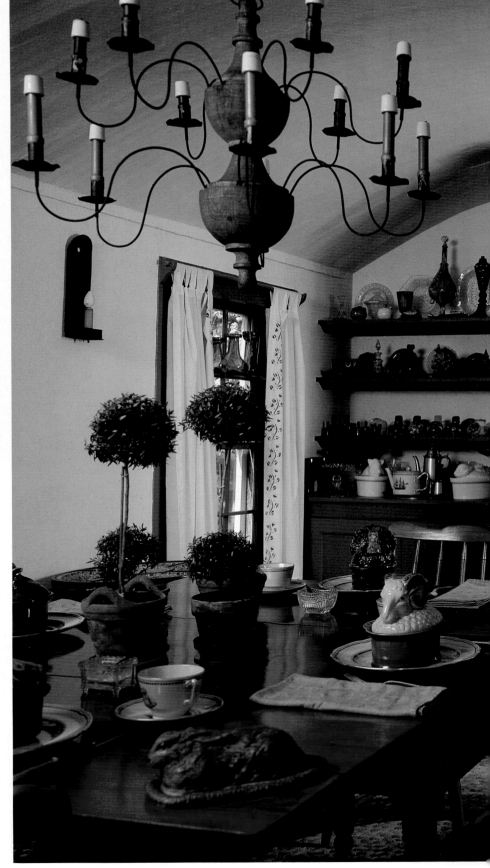

ABOVE: A collection of turn-of-the-century Wedgwood plates with American views frame the doorway into the keeping room.

ABOVE RIGHT: All the shelving, including the spice cabinet in the buttery, is original to the house. A superb collection of rare nineteenth-century glass hyacinth vases is displayed on the window shelves.

RIGHT: The dining room may have been a fish house down by the shore. It was moved here and attached to the house around 1880. Its interesting ceiling was made from steamed and bent laths. Bamboo Windsor chairs, c. 1820, surround an 1830 cherry dining table. The table is set with Portuguese covered casseroles and a French Canadian chocolate mold in the shape of a rabbit. The bird's-eye maple case clock at the end of the room was made in Boston about 1725. The sideboard holds a collection of Sandwich glass.

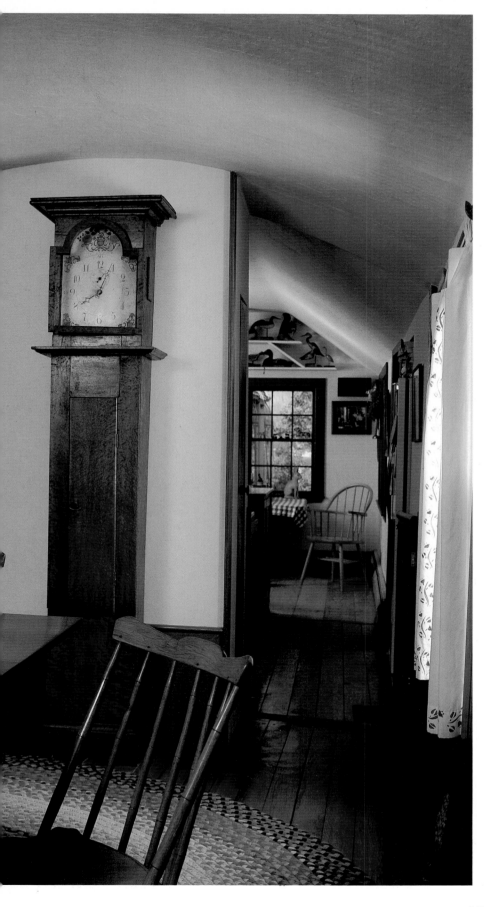

RIGHT: At one end of the dining room is a country server, c. 1820, that holds a mélange of antique English and American pitchers, including yellow-glazed Prattware, a Bennington hound pitcher, Jugtown and Perth Amboy pottery, and a gray Leeds transfer in the back. Above them hangs a painting of the Pamet River in Truro, painted by Vollian Rann, who was one of the original group that formed the Provincetown Art Association in 1914.

BELOW RIGHT: A painting by American Impressionist Daniel Garber was originally an overdoor in the dining room of his house in Bucks County. The copper milk pans were made by the owner's great-uncle.

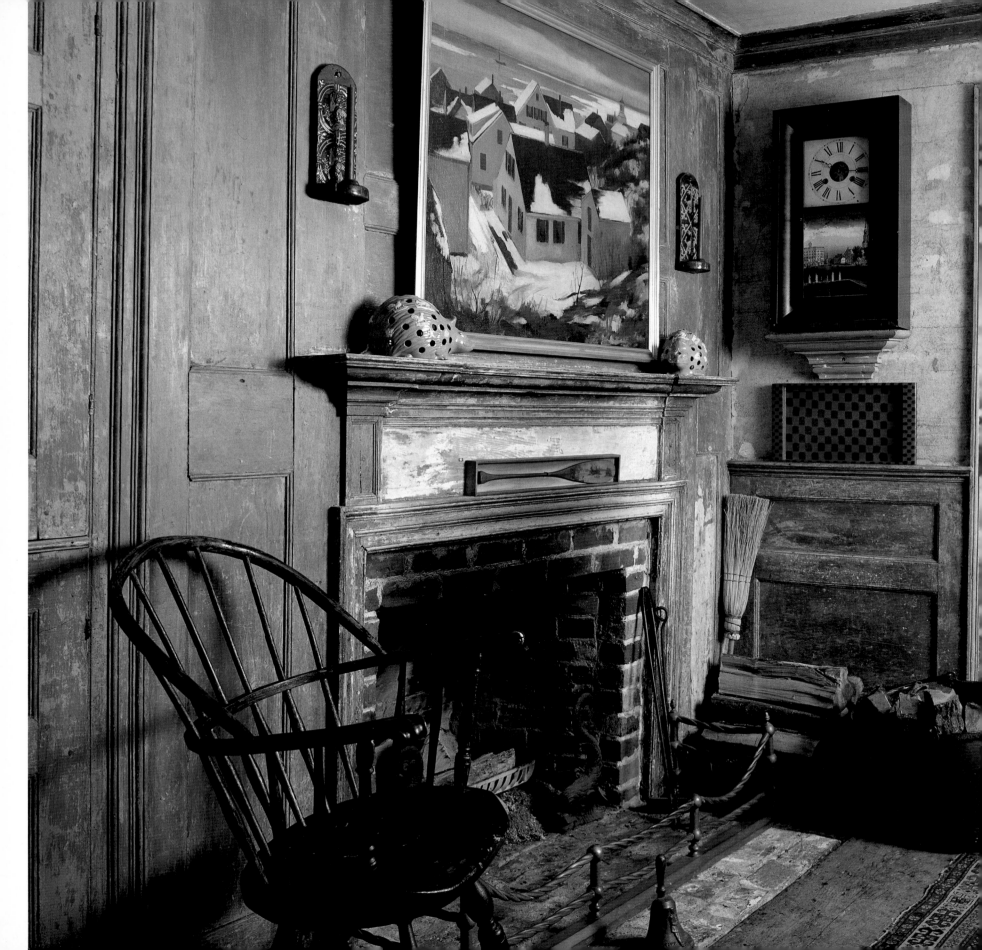

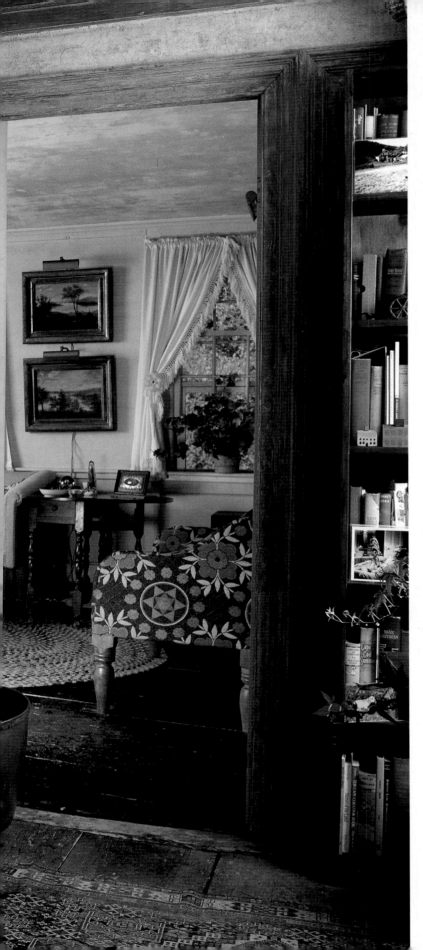

The paneling and wainscoting in the front parlor have been stripped down to their original color. Next to the fireplace, the double cupboard is a common feature of a Cape Cod house. In front of the cupboard sits a knuckle-arm, sack-back Windsor, c. 1770. An untitled painting of Provincetown in winter painted by Vollian Rann, who was one of the first generation of Provincetown painters, hangs over the mantel. The 1936 painting is flanked by a pair of Moravian pottery sconces on the wall and a pair of Wedgwood crocus jars in the shape of hedgehogs on the mantelpiece itself. The turn-of-the-century framed oar is painted with scenes of the Thousand Islands. The wall clock is by Brewster Ingrahams, Bristol, Connecticut, c. 1840. Through the doorway is the keeping room. The two small paintings on the wall there are both American primitives of Lake Magog, which is on the border of Vermont and Canada.

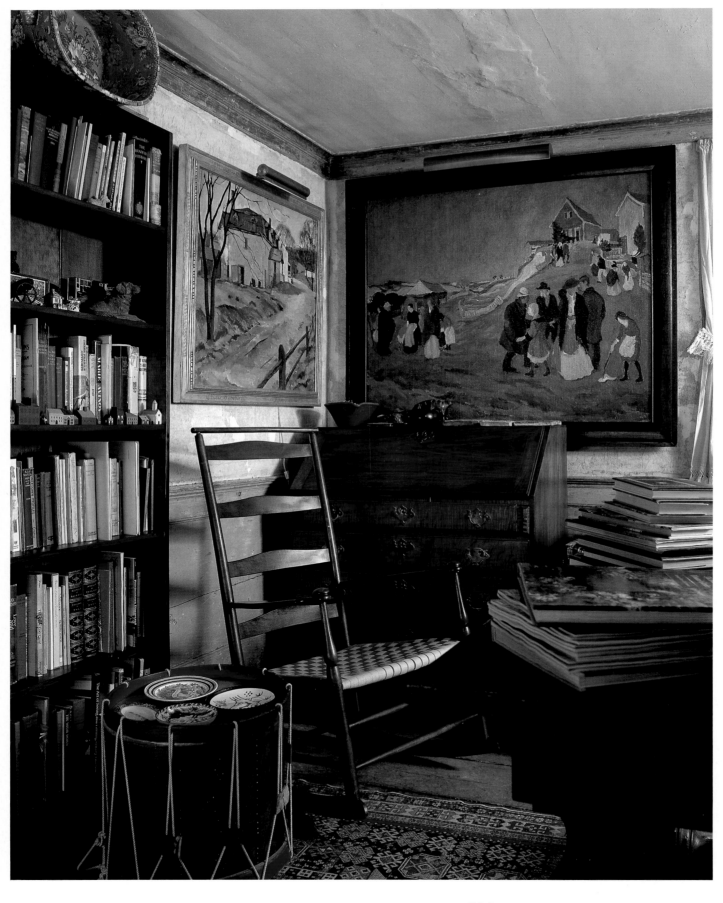

LEFT: Two large paintings fill this corner of the front parlor. The one on the right is *After Church, Provincetown*, painted by Ross Moffett, c. 1917. Moffett was not only one of the founders of the Provincetown Art Association but also wrote a history of the art colony as well. On the left wall is *Late Spring in Bowmanville* painted by Paul Wescott, an artist from Bucks County, Pennsylvania. The drum used as a table next to the Shaker rocker has the label of Ebner Stevens, Pittsfield, Massachusetts, 1814. A Staffordshire footbath decorates the top of the bookcase, and redware and Moravian tiles are on top of the desk.

ABOVE: Maxfield Parrish made the table in the center of the parlor for his own home in Cornish, New Hampshire. The two armchairs are from the Boston State House, House of Representatives, c. 1820, and were bought at auction. The lamp between them was made from a newel post from the building in Brooklyn where Walt Whitman printed *Leaves of Grass*. The owner salvaged it when the building was being demolished. William L'Engle painted the seascape on the left, the other one is by John Hare. Both were Provincetown artists.

RIGHT: Over the fireplace in the bedroom is an oil of Windy Willows painted by Gerrit Beneker in 1928. The hanging shelf is a whale end shelf and holds a collection of souvenir china mostly from Cape Cod. The eighteenth-century canopy bed is from Morven, the Stockton family home in Pennsylvania. A pair of clear Sandwich glass dolphin candlesticks decorate the mantel.

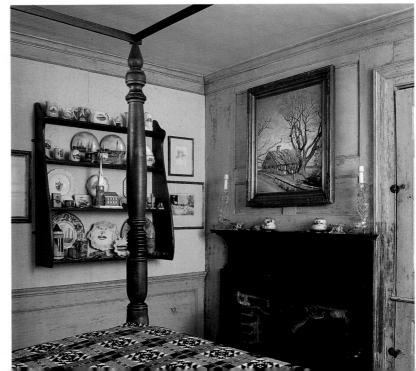

235

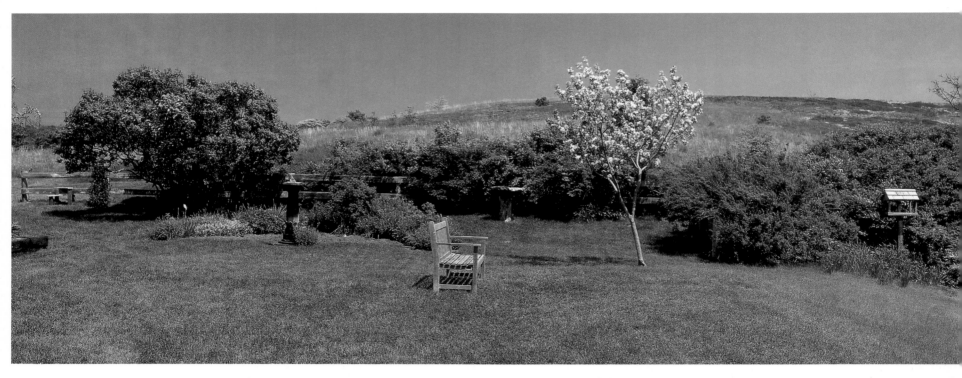

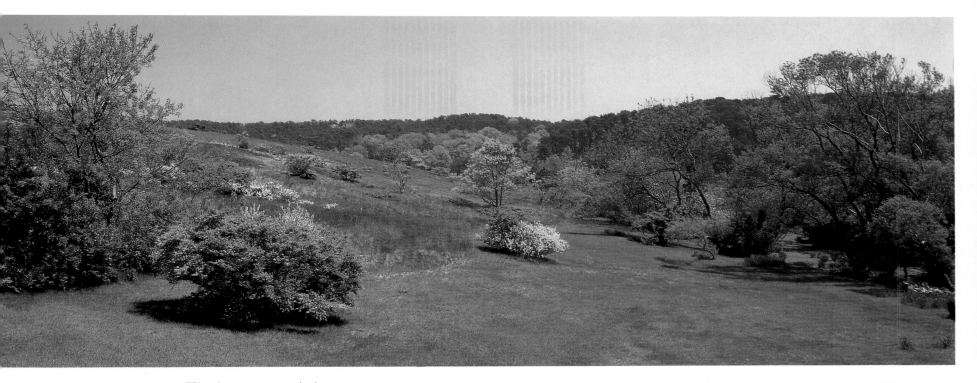

ABOVE: The house is nestled into the hillside of the rolling sandy hills of Truro. Lilacs and a Granny Smith apple tree are in bloom on this crystal clear June afternoon.

LEFT: *Potentilla frutacosa,* poppies, German iris, catmint (*Nepeta* 'Seven Hills'), and tradescantia are all in bloom beneath the parlor windows.

RIGHT: In front of the house, the lawn pitches steeply down the hill with steps leading to the formal circular garden filled with irises blooming in June around a dovecote birdhouse. An outer curved border is planted with herbs, santolina, artemisia 'Powis Castle' and 'Silver Mound', *Stachys lantana,* lavender, chives in bloom, sage, and rosemary for color and texture all season. Framing the foreground, a rose of Sharon is just beginning to leaf.

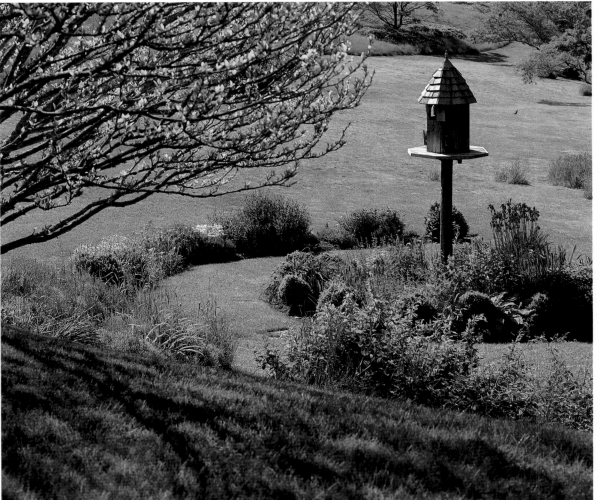

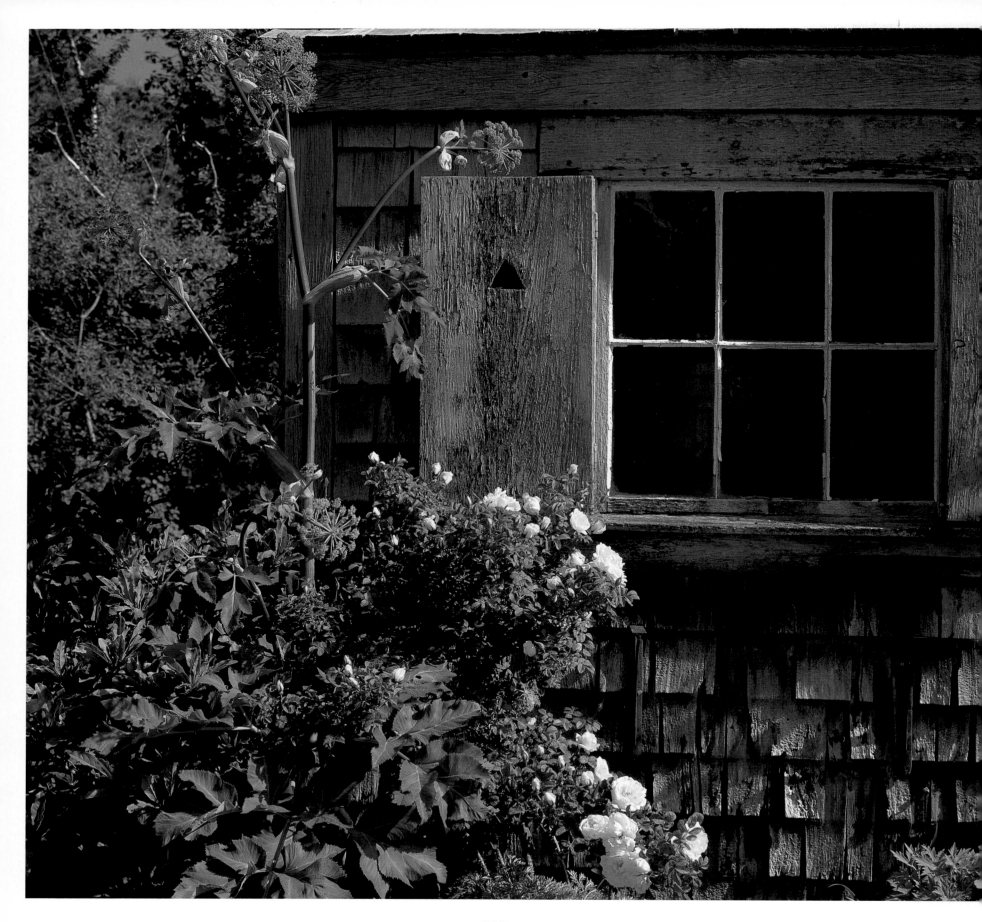

Climbing yellow roses and angelica reach to the top of the window on the shed. A red rose on the right will bloom later in the summer.

OVERLEAF: The sweeping view from the hilltop looking down to the house and the barn across the road, which is the original barn, c. 1800, for the farm, gives a typical sampling of the terrain and landscaping around Windy Willows. In the foreground is the natural mossy hillside covering, which turns into grassy lawn with flowering swampfly honeysuckle (*Lonicera oblongifolia*) and a tall horse chestnut on the sloping lawn, with lilacs and Bridal Wreath spirea nearer the house.

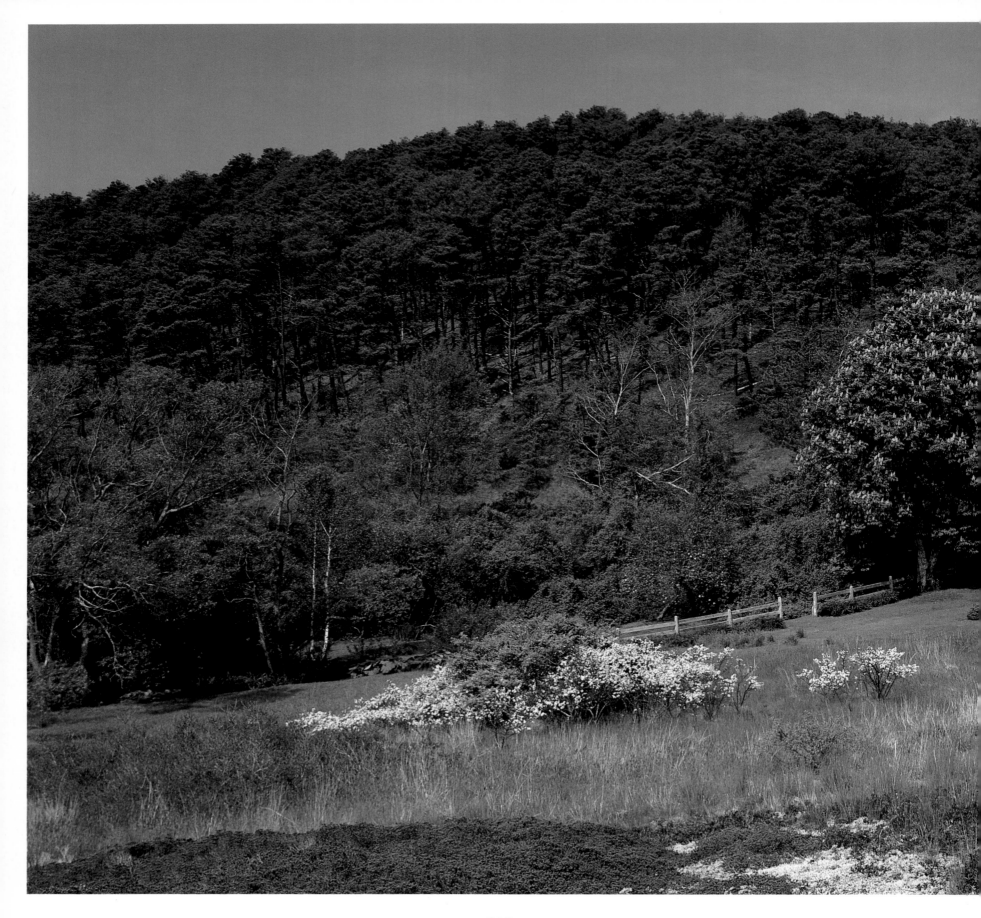

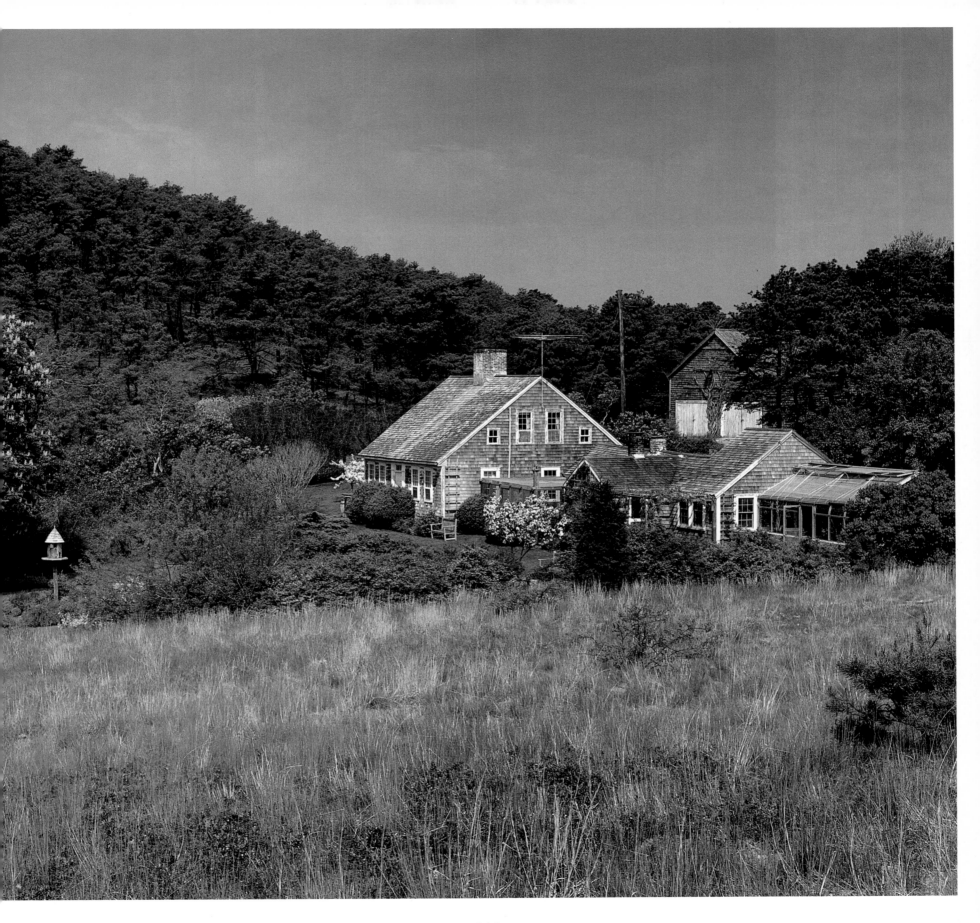

WHITNEY FARMS

The home of Bill Whitney and Michael Baranowski, this little Cape has a long-established air about it. Lushly landscaped with flowering trees and shrubs all around, it could have been there for ages. Bill Whitney bought the house when he moved to Truro in late 1987, after completing his thesis on Provincetown for his degree in landscape architecture at Rhode Island School of Design. Having grown up on a farm in Maine, he always liked old houses, but when he bought this one it looked brand-new, with nothing but sand, two oak trees, and some old pine trees in the back. The first thing he did was pour a pitcher of martinis and ask himself what he could do to make the place look like home.

He began by planting a row of lilac bushes across the front between the house and the road, along with hollyhocks, lupines, and other old-fashioned flowers that grew in his grandmothers' gardens in Maine. In the sandlot in back was a pile of bricks left over from the builders. That became a floor, a platform that defined space in the garden. He began from there, adding brick and slate paths, which wind around through various areas. He then added "walls" of trees and hedges—locust and birch, Japanese maples, privet and boxwood. Then Bill added chairs and benches, animals made of driftwood, trellises and arbors made of twigs, all of which further define the spaces so that they almost become rooms of their own. The intention is to make the whole landscape appear informal and unstructured.

Bill has a fondness for weeping trees, and there are many varieties—cherry, copper beech, birch—dotted around the back. Continuing with the old-fashioned theme, there are sweeps of perennials—columbines, poppies, morning glories, black-eyed Susans and Queen Anne's lace. Annuals add bright color in midsummer. In addition there is a huge vegetable garden, a strawberry patch, and an herb garden.

Inside, in order to make the house look less new, Bill and Michael have added old doorways with glass panels, stripped architectural elements—arches, columns, mantels, brackets, and lights. They took out sliding glass doors and walls between the living room and sun room, and added an old wood stove. These elements combined to make the house look as if it had been added on to and altered for generations.

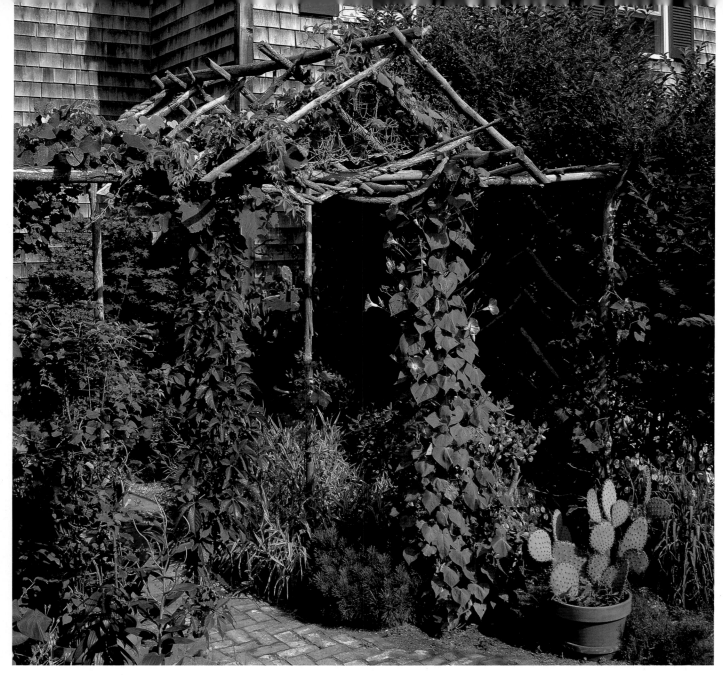

ABOVE: The stick arbor is right off the sun room at the back of the house. Covered with grapes and morning glories, it is surrounded by hollyhocks, not yet in bloom. Pots of cactus are spotted around the whole garden and add contrast and interest.

———————

RIGHT: A stone-edged water garden is planted with water irises, hyacinths, lilies, and pickerel weed. Behind the stone wall are brightly blooming cosmos, helianthus, and a buddleia.

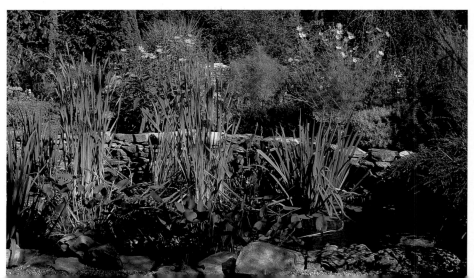

In early June, the lupines are just beginning to bloom around an English beehive, with a low-growing juniper (*Juniperus procumbens nana*) in front. Old-fashioned oriental poppies (*Papaver orientale*) are at their peak farther along the winding brick path. To the right of the path is a weeping cherry (*Prunus subhirtella pendula*).

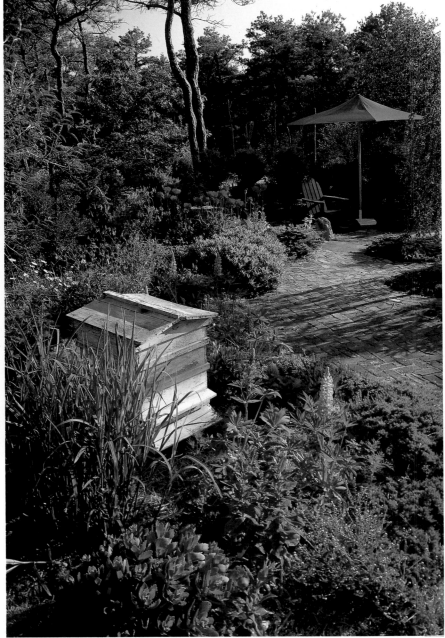

LEFT: A circle garden is at the end of the brick path and entered through a stick arbor, assembled with wooden pegs. To the left of the arbor is an Alberta spruce (*Picea glauca* 'Conica'). The tallest evergreen, to the left of the walk, is a Hollywood juniper (*Juniperus chinensis* 'Torulosa'). Scotch broom (*Cytisus* x *praecox*) on both sides of the path is in luxuriant bloom in late May.

Behind the dark green umbrella is an English boxwood hedge (*Buxus sempervirens*), which makes a lush backdrop to the brilliant red oriental poppies, blooming in June.

RIGHT AND BELOW: The garden in mid-August is rich with color. In the front on the right, around the birdbath, are Queen Anne's lace just finishing, cleome, and behind, anemones (*Anemone hupehensis*). The root sculpture behind them came out of the woods, and once in place, defined the whole area. To the left of the chairs and beyond the brick patio are red cosmos, pink and white cleome, and bright black-eyed Susans (*Rudbeckia fulgida*). Next to and in front of the birdhouse is a locust (*Gleditsia triacanthos*).

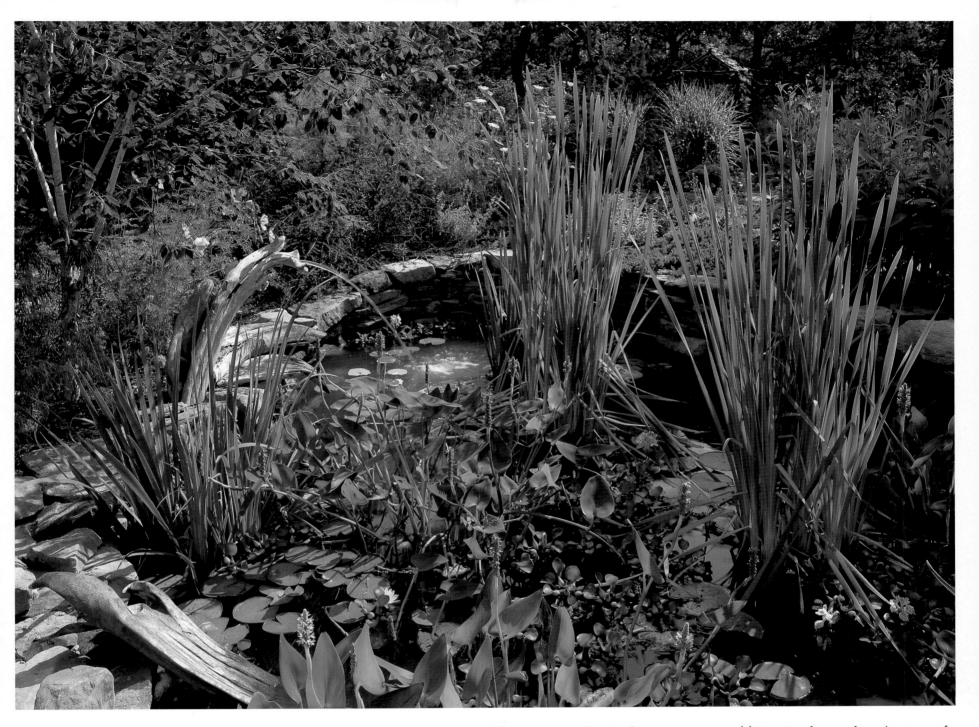

The water garden is the most recent addition to the garden. A piece of driftwood forms the fountain. Two varieties of water irises—blue (*Iris versicolor*) and yellow (*Iris pseudacorus*)—are in the center along with pickerel weed (*Pontederia cordata*) and cattails (*Typha angustifolia*). Water lilies (*Nymphaea* hybrids) and blue water hyacinths (*Eichhornia crassipes*) are blooming in late August.

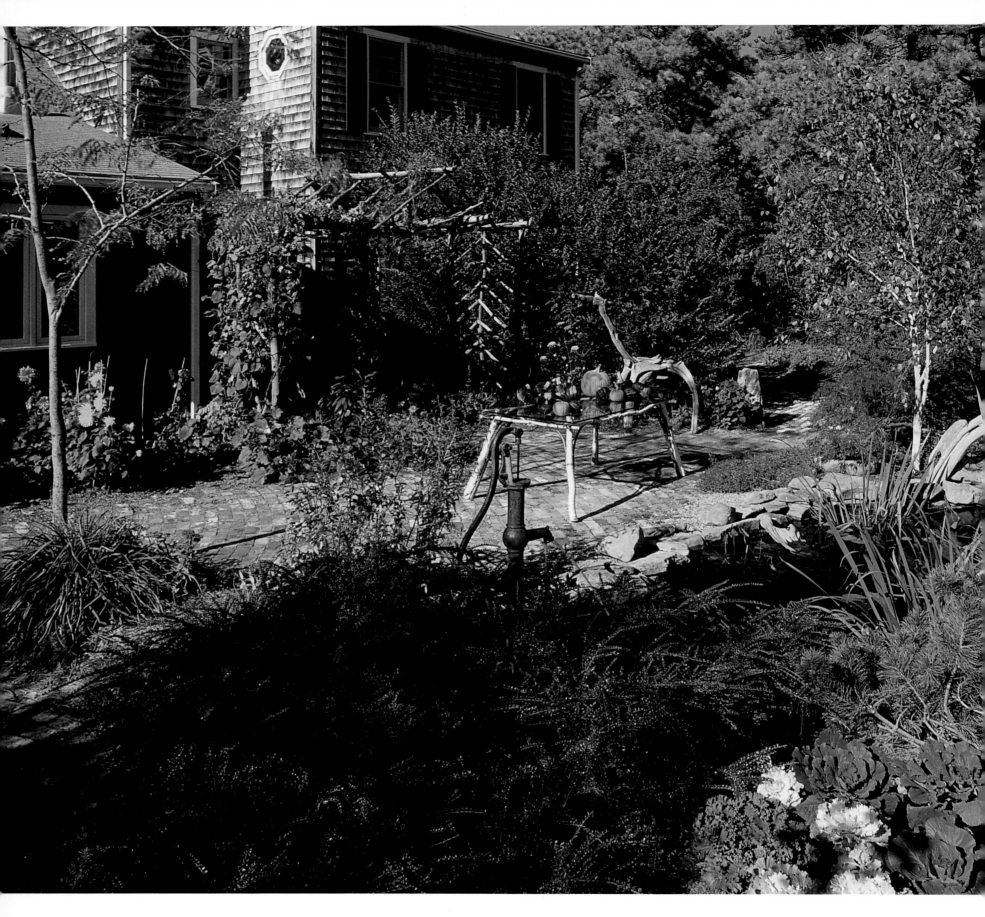

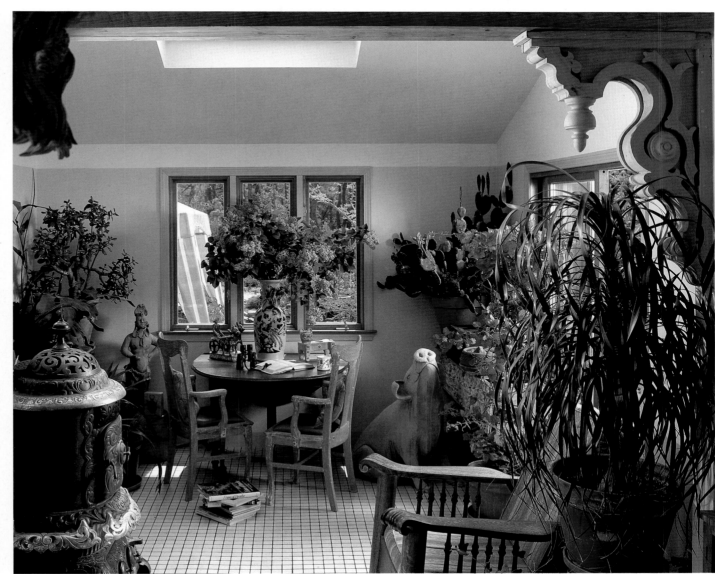

ABOVE: The sun room as it appears in May when the lilacs are in bloom across the front of the house. The wood stove was originally in Bill's mother's bedroom in Maine, and the chair facing it belonged to Bill's great-grandfather. The terra-cotta pig was sculpted by Katherine Van Noorden. The vibrant bougainvillea winters over in the sun room and is moved outside in summer. Pieces of Mexican folk craft decorate the table and stand by the window.

LEFT: A view of the garden toward the back of the house. In late October, the foliage has all turned russet, red, and gold. Dahlias have replaced hollyhocks along the house outside the sun room. In the foreground, cotoneaster (*Cotoneaster microphyllus*) is full of red berries next to ornamental cabbage and kale. The whole garden has a decidedly autumnal feeling.

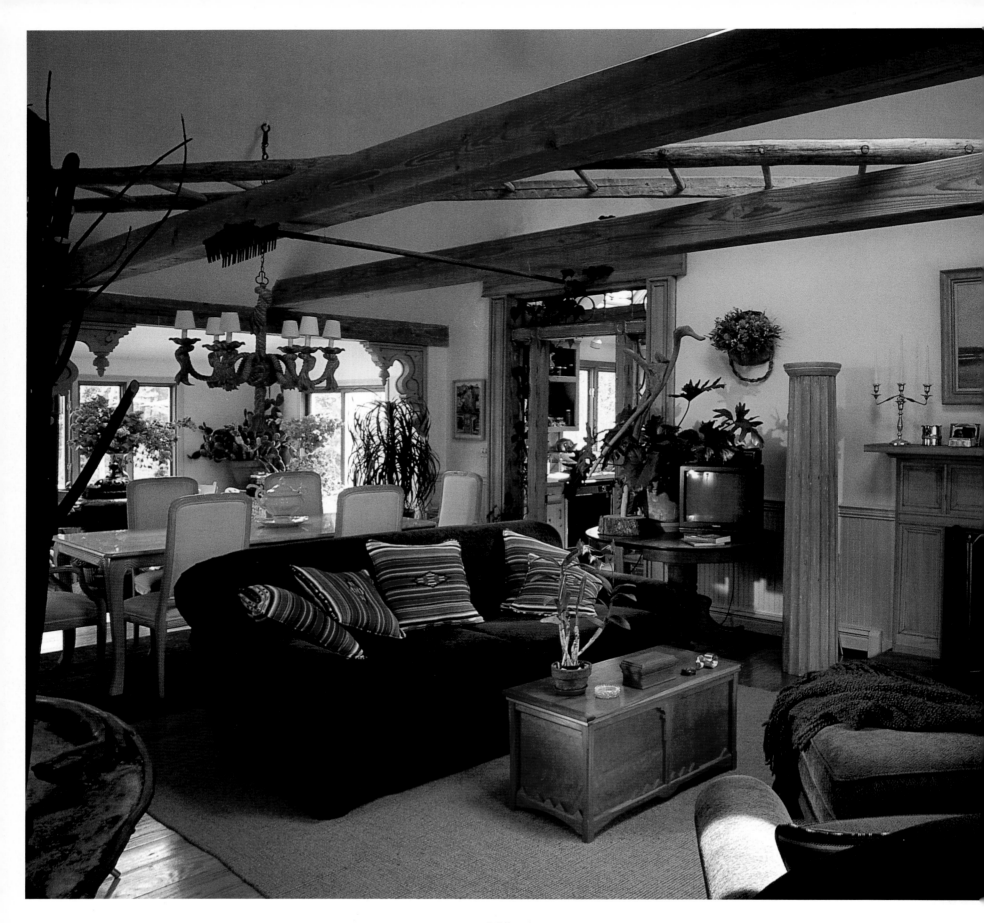

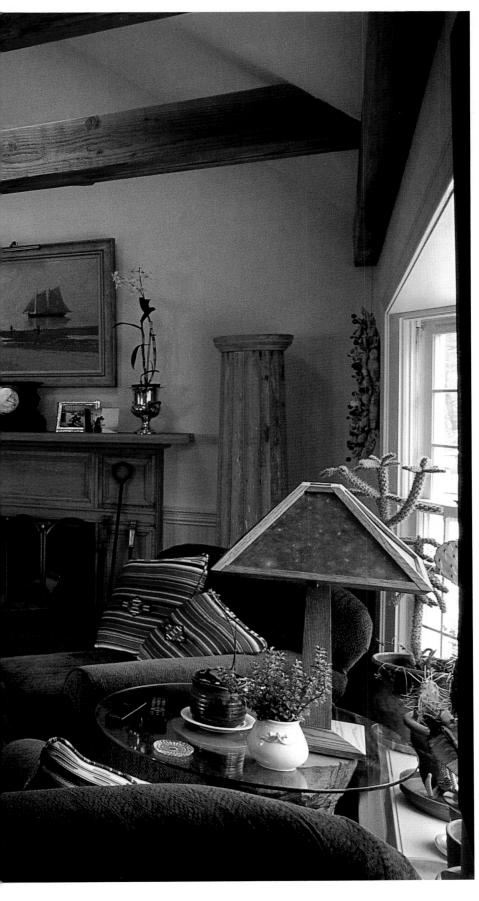

The large living room has been opened up to the sun room at the back. The columns, mantel, and elaborate door to the kitchen are all old architectural elements found, stripped, and added to enhance the living room and give it a seasoned feeling. An oil painting by James O'Neil hangs above the mantel. The nineteenth-century American clock came from Bill's grandmother's attic. The table between the two chairs on the right was made from an old tree trunk whittled down by a beaver. Just visible on the left is a twig and driftwood table made by Kent Hines, who also did the driftwood bird sculpture on the table next to the sofa.

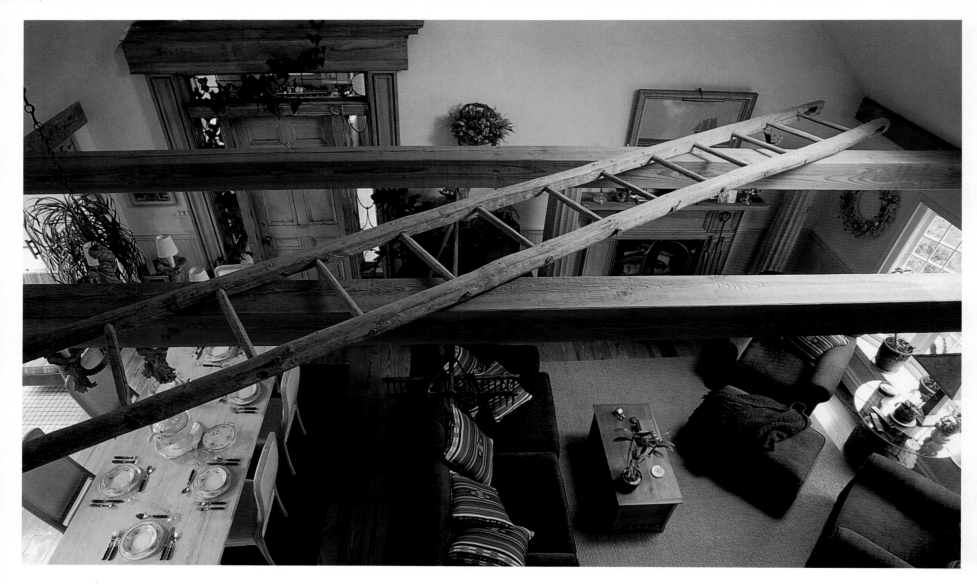

All the ladders used throughout the house have come from barns in Maine. The one resting across the beams was Bill's great-great-grandfather's.

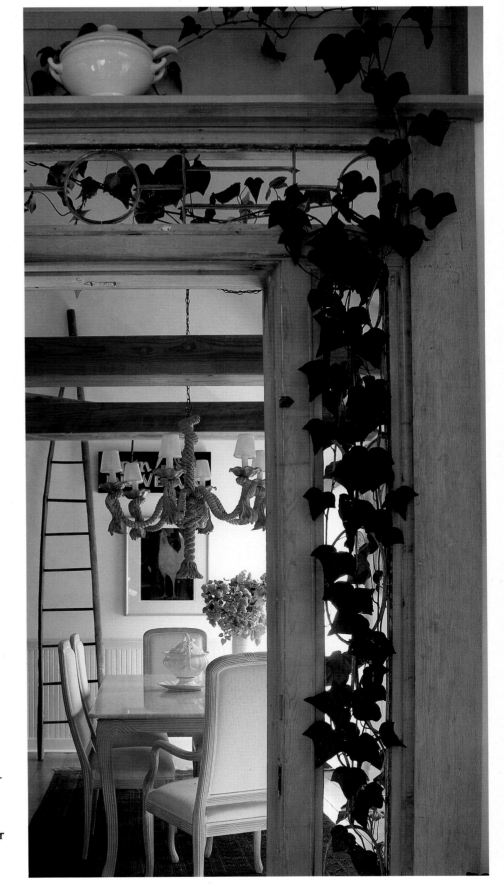

A nineteenth-century ironstone tureen rests on a ledge above the door from the kitchen into the dining room. Another one sits on the marble-topped table. The door, with its decorative glass panels, was added to the house, as was the wainscoting on the far wall. The wooden chandelier was bought at auction on the Cape. An apple-picking ladder leans against the far wall, next to a painting of a rooster by Seleina Trieff.

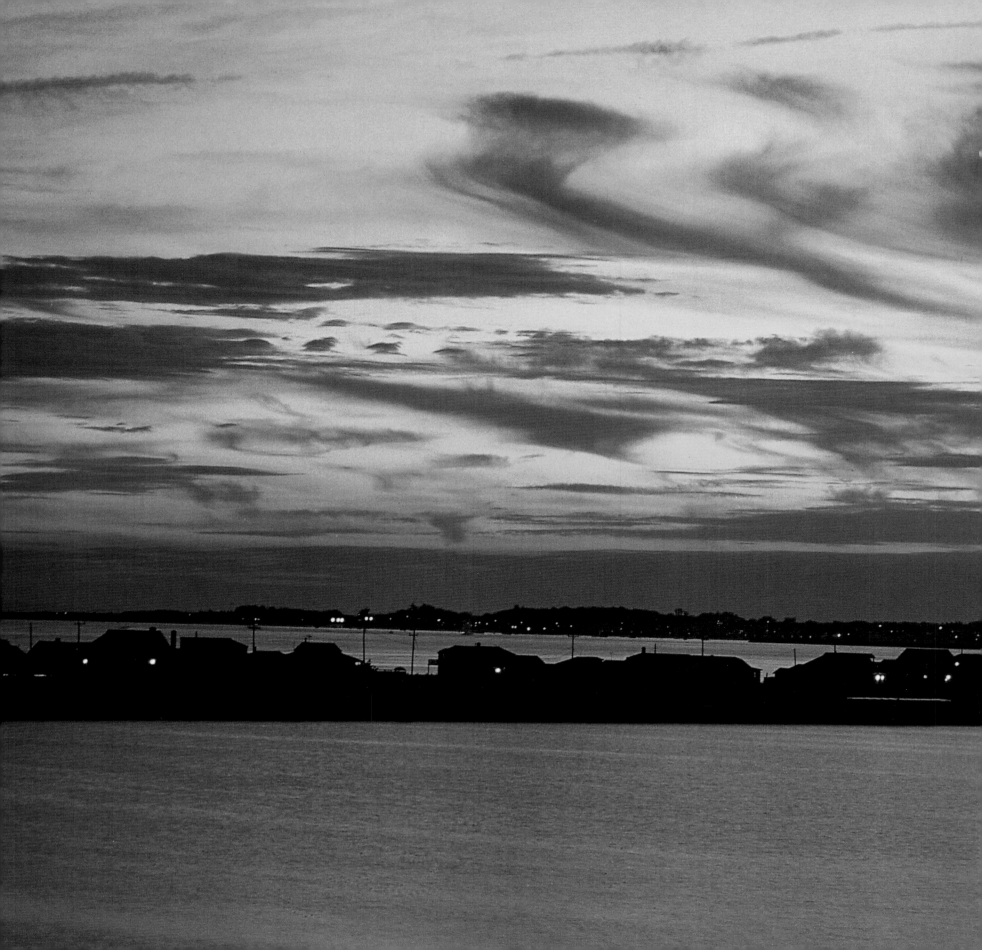

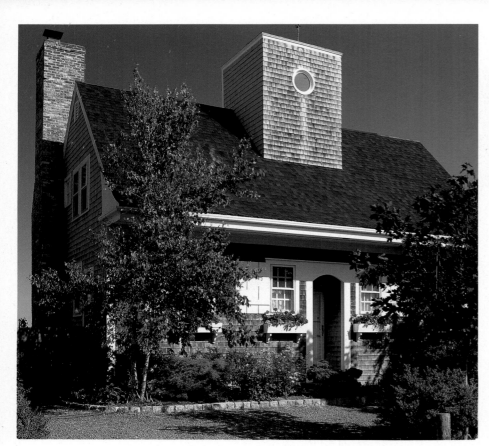

This contemporary New England seaside cottage is the home of Congressman Gerry Studds, who had it built in 1983 as a retreat from the frantic pace of politics and public life. He comes to the Cape and this house by the sea to get in touch with the elements of nature—the ever-changing colors of sea and sky just beyond the back door—and to nurture his soul. The house's layout is simple and is designed with windows opening onto the water wherever possible. The traditional gray shingled front opens into a contemporary living space with the sea beyond.

Behind a hedge of English boxwood (*Buxus sempervirens*), a white birch (*Betula papyrifera*) and a dark red maple (*Acer platanoides* 'Crimson King') frame the front of the house. Betty Prior roses and geranium-filled window boxes accent the front.

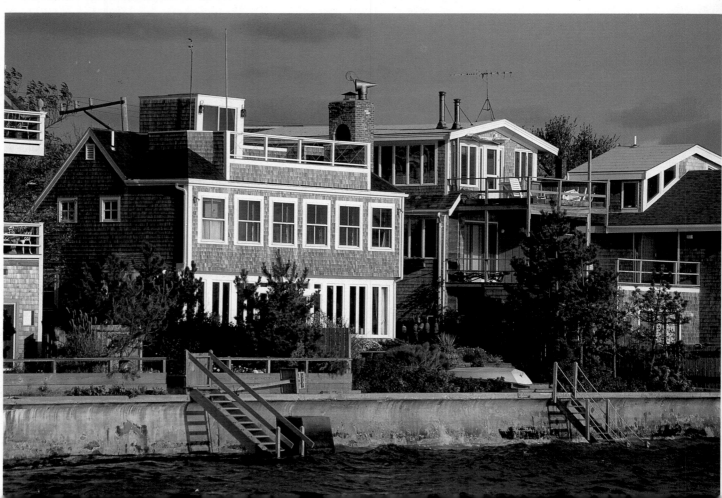

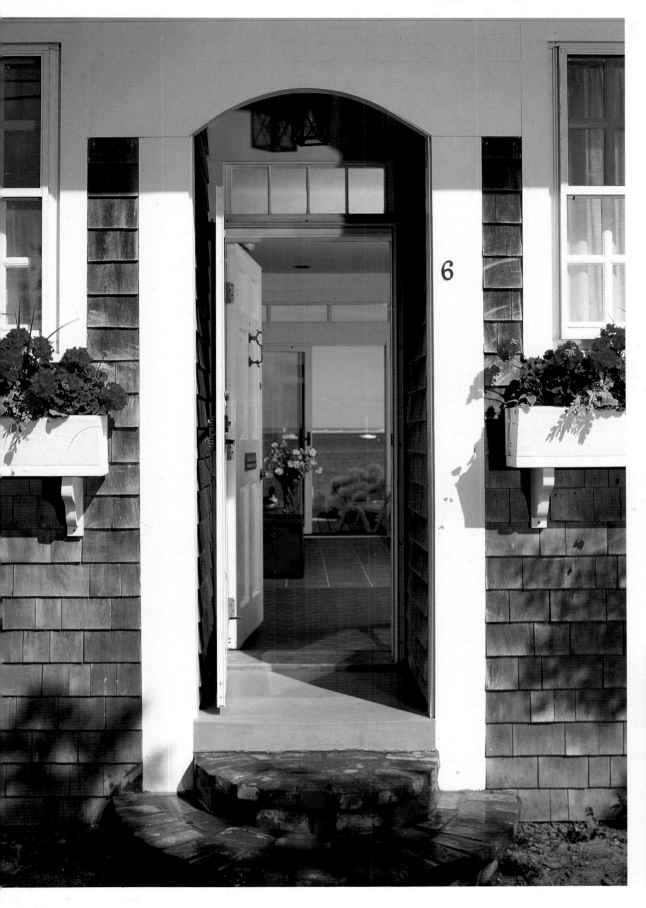

LEFT AND BELOW: Just inside the
front door, the whole house opens
up to the sea. One of the joys of
Provincetown, with its little
houses so close together and right
on the street, is the wide open sea
just beyond.

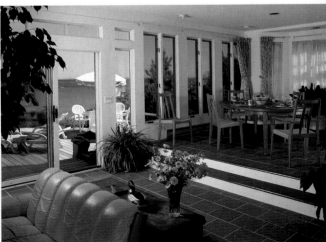

RIGHT: In a relatively small area an entire seaside garden has been planted, including even a tiny vegetable garden in a protected corner. Between the seawall and the raised terrace and boxed gardens are native vegetation of rosa rugosa, sea lavender (*Limonium latifolium*), broom (*Cytisus scoparius*), beach plum (*Prunus maritima*), and sand cherry (*Prunus cistena*), which will all survive salt spray and occasional seawater washing over the seawall.

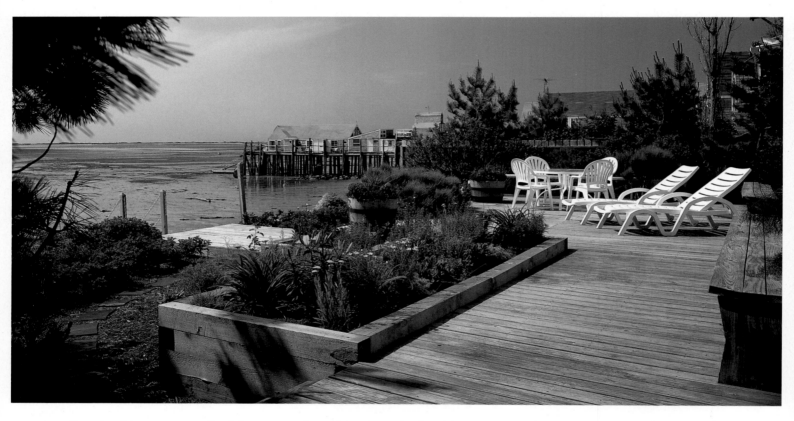

ABOVE: In raised boxes are colorful perennials and herbs, which add softness and color to the deck. Asiatic lilies and daylilies are mixed with catmint (*Nepeta faassenii*), yellow achillea, sedum 'Autumn Joy', coral bells (*Heuchera sanguineum*), and artemisia (*Artemisia schmidtiana*).

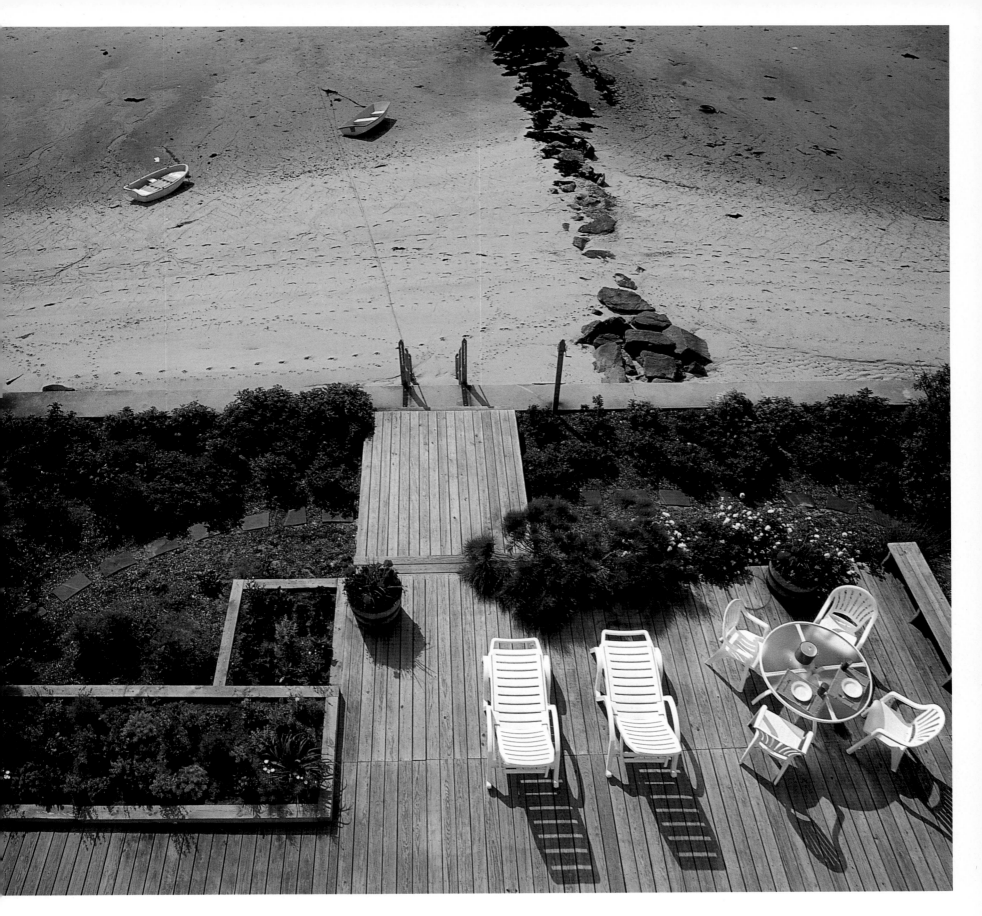

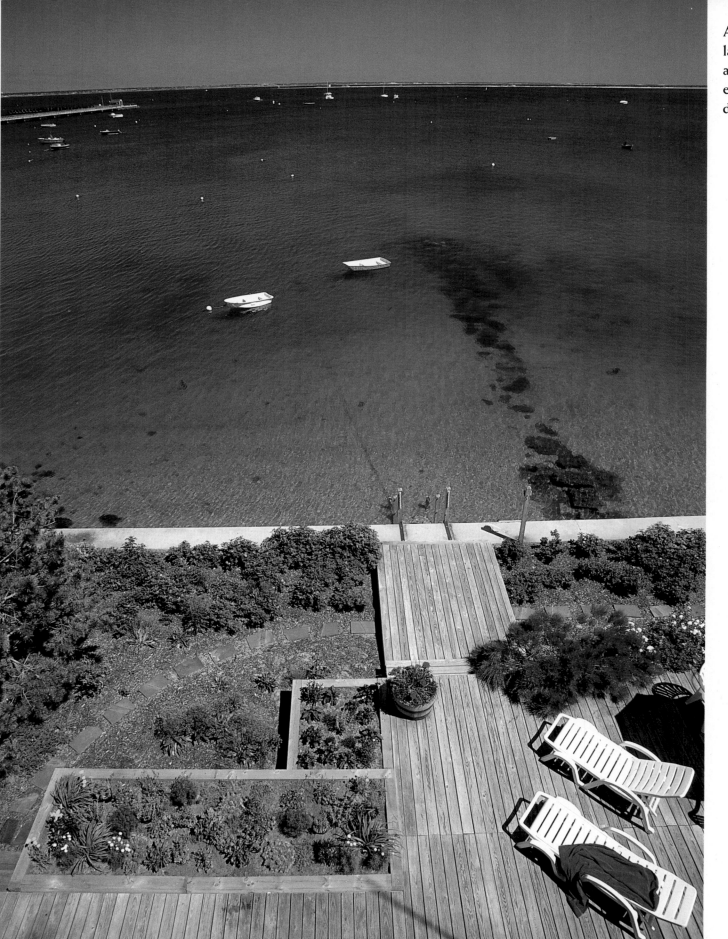

At high tide, the water virtually laps the top of the seawall and on a clear day in June changes from emerald to deep blue as the water depth increases.

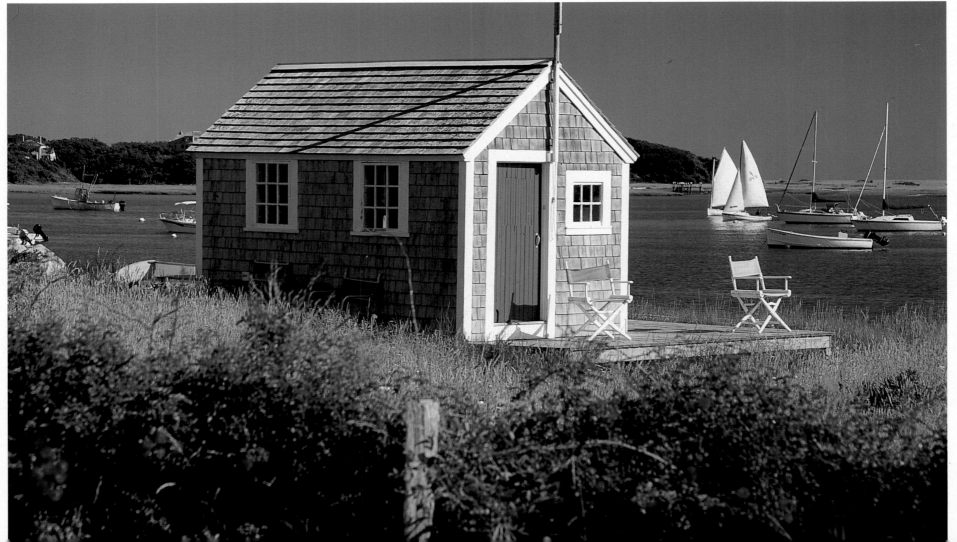

ABOVE AND RIGHT: In mid-August, hydrangeas are flourishing along with Asiatic lilies (*Lilium* 'Sans Souci' and *Lilium speciosum* 'Rubrum'). Behind the pink hydrangea in the center of the garden is a combination of phloxes, accented by Russian sage (*Perovskia atriplicifolia*) in front and monarda behind. All the way back near the wall, orange tiger lilies are finishing and pink and orange dahlias are beginning to flower. Sedum (*Sedum spectabile* 'Autumn Joy') is light green in the late summer.

HIDDEN GARDEN

A tall privet hedge with a tiny sculpted opening leads from the street into this amazingly rich and colorful little garden, which consists of only a thousand square feet. Sandwiched between two cheek-by-jowl Provincetown houses this garden belongs to Tom Stearns. The only thing here ten years ago was an ancient lilac bush, so with the permission of his landlord, Tom started to plant. Now the garden is filled with a profusion of blooms from the very beginning of spring, when hundreds of narcissus and tulip bulbs that Tom plants every fall begin to bloom. The garden then progresses to irises and poppies in late May and early June, followed by roses, phlox, and daylilies, Asiatic lilies and hydrangea as the summer progresses, and finally dahlias, asters, and chrysanthemums until late in the fall. Complementing the flowers are examples of found art—big pieces of driftwood, iron gas columns from Provincetown gas lamps, and an old boat. In winter, the snow-covered iron sculptures have wonderful shapes and even add color to the garden.

BELOW: Because the soil is nothing but sand, Tom adds fifteen bags of manure and peat each year as well as constantly spraying with nitrogen to maintain his plants. Tom moved the bearded iris here from a previous garden, and they were among the first flowers planted here.

———————

RIGHT: The wall, made by a local Provincetown man, was already here when Tom arrived. Gradually Tom has added pieces of iron and other found art to make it an ever-changing sculpture. Lupine and bearded iris bloom in mid-June in front of the wall.

———————

FAR RIGHT: Bearded iris and oriental poppies are exuberant in mid-June.

———————

OVERLEAF: A clematis climbs the old garden shed wall.

EAST END STUDIO

Right on the water in Provincetown's East End is the home and studio of Anne Packard, a third-generation Provincetown artist. When the house was built in the late 1880s, Provincetown was a community of several thousand, whose residents were mostly employed in commercial fishing or the saltworks, two interconnected industries on much of the Cape, but especially in Provincetown. The railroad came all the way out to Provincetown by then, and the community was a hard-working but thriving town. The East End was the working part of town, with windmills for the saltworks and piers dotting the shoreline. The sidewalks were wooden boardwalks.

Anne's grandfather Max Bohm came to Provincetown in 1916 with many other American and European artists who were leaving Europe because of the war. They came to Provincetown for the quality of the light and because this village had the atmosphere of the fishing villages of Brittany and southern France where many of these artists had been living. Max Bohm came as a summer resident, and Provincetown became a base for the family.

Anne spent her summers here as a child and had her first summer job in the house where she now lives. It was a boarding house at the time, and Anne served breakfast to the guests. She moved to Provincetown year-round in 1977 and used the house only in the summer since it was not yet winterized. The water was visible through the cracks between the floorboards and the sky through holes in the roof. In the nor'easter of 1989, the house was devastated, and when Anne rebuilt, the first major step was building a solid bulkhead against the sea and future storms. Anne rewired, replumbed, and winterized the house. She redesigned the house, keeping its original lines but raising the beams and low ceilings and taking out interior walls to make the most of light and air. The result is a home serene in its simplicity. The sea and sky envelop the house, and the entire shoreline of Provincetown is part of the view from almost every room.

The tides are extreme, and at high tide on a windy day the beach is pounded with waves and the water flows right up under the house. On calmer days, the water is like a lake, even when the tide is almost high. When the tide is out, enormous expanses of beach are available, and little boats anchored near the shore are high and dry. Along this stretch of beach have lived Mark Rothko, Robert Motherwell, and Norman Mailer, to name only a few artists and writers who have made their homes here since the early part of the twentieth century, and continuing into the present.

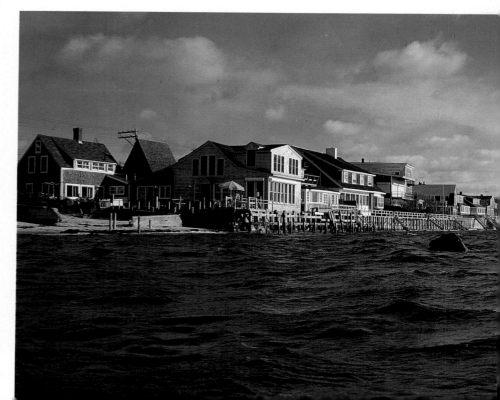

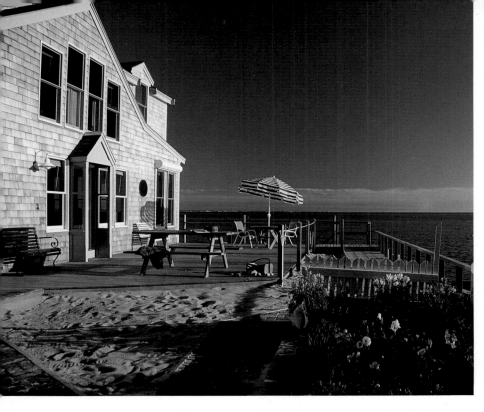

LEFT: A brick walk through the sand leads from the street to the spacious deck outside the front door. A cottage garden is still full of blooms in late October. The house extends out over the water and is farther out than most of the houses on the beach, giving Anne an extraordinary view.

BELOW: The light at the end of the day streams through the windows that run the full length of the house on the water side. At one end of the long living room is the dining area. The breakfront, with its many layers of paint showing through one another, was found in Maine. To its right is a self-portrait of Max Bohm, Anne's grandfather.

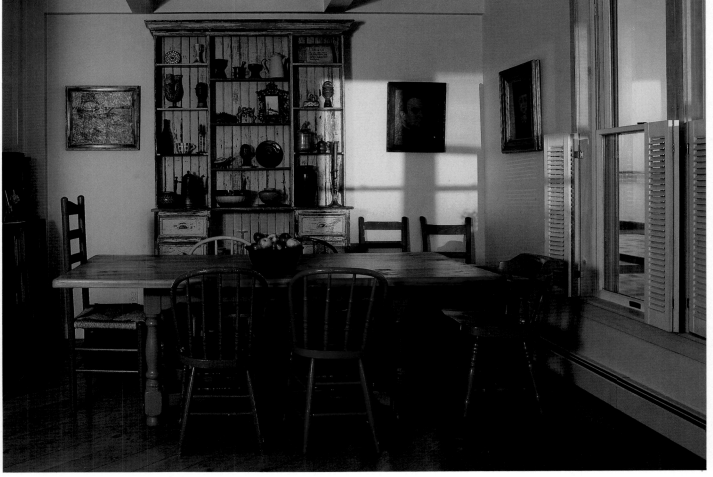

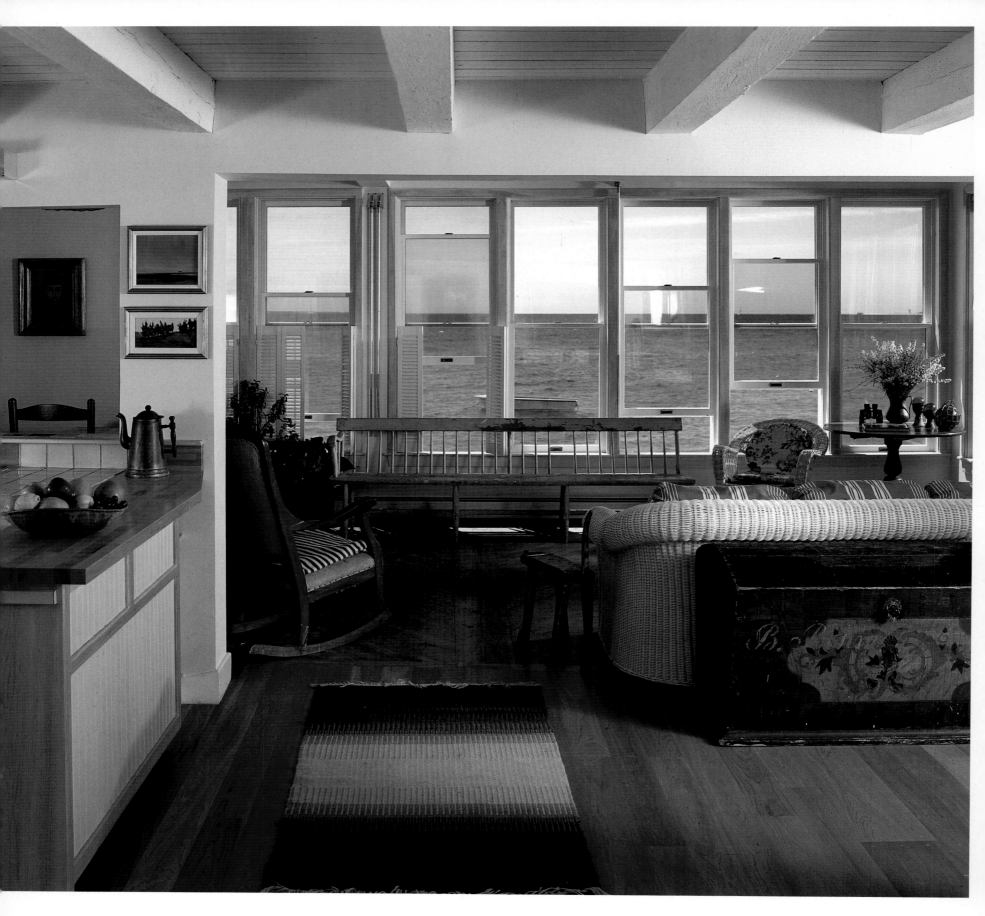

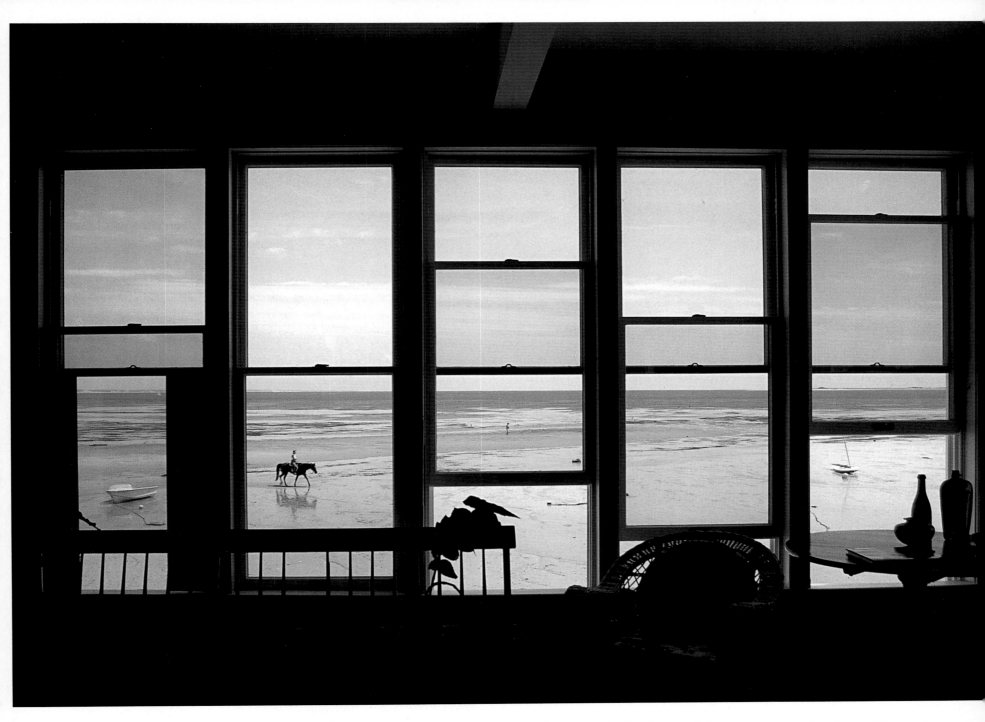

LEFT: The downstairs was originally many small, low-ceilinged rooms with a porch out over the water. As many walls have been removed as possible so that the rooms of the living areas all open into one another. Every room is also open to the outside as well. The floors of the living room have been pickled and stained blue so that the grain of the wood shows through. The low partition divides the combination entrance and sitting room from the kitchen. Beyond the kitchen is the dining room. The painting of the little girl on the window wall is a portrait of Anne done by her grandmother Zella Bohm. The two little paintings on the column between the kitchen and dining room are by Anne. The early-nineteenth-century trunk behind the wicker settee came from Germany with Anne's great-great-grandfather in the early 1800s.

ABOVE: When the tide is low the beach seems to go on forever. Dogs and children, horseback riders, and walkers take advantage of low tide.

An Irish wedding chest, a painting by Max Bohm, and a coyote from Pátzcuaro, Mexico, are combined in the corner of the living room.

The upstairs was formerly four little bedrooms, plus hallways and bathrooms. These rooms had ceilings so low that it wasn't possible to stand upright in most of the upstairs. After Anne raised all the beams

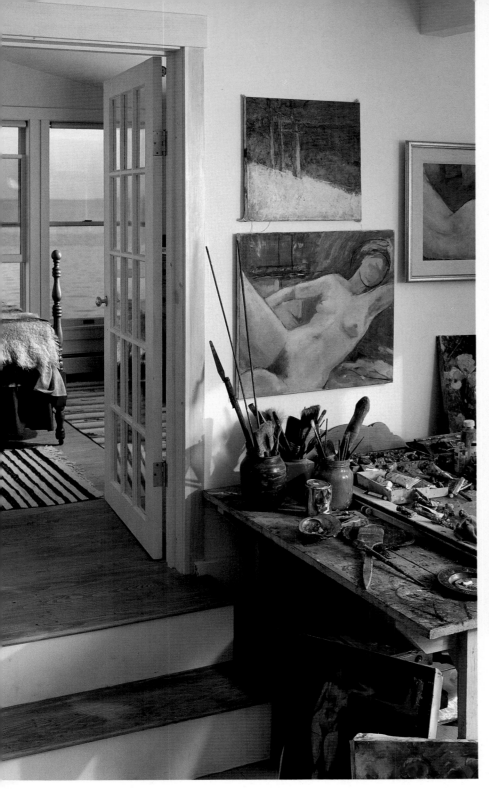

The stairs lead up to Anne's studio. The newel post is from an old bowling alley in Provincetown; the bust is by Louis Durshnik.

and ceilings, removed walls, and added larger windows, the upstairs is now Anne's studio and bedroom, which at high tide seems to float out over the water.

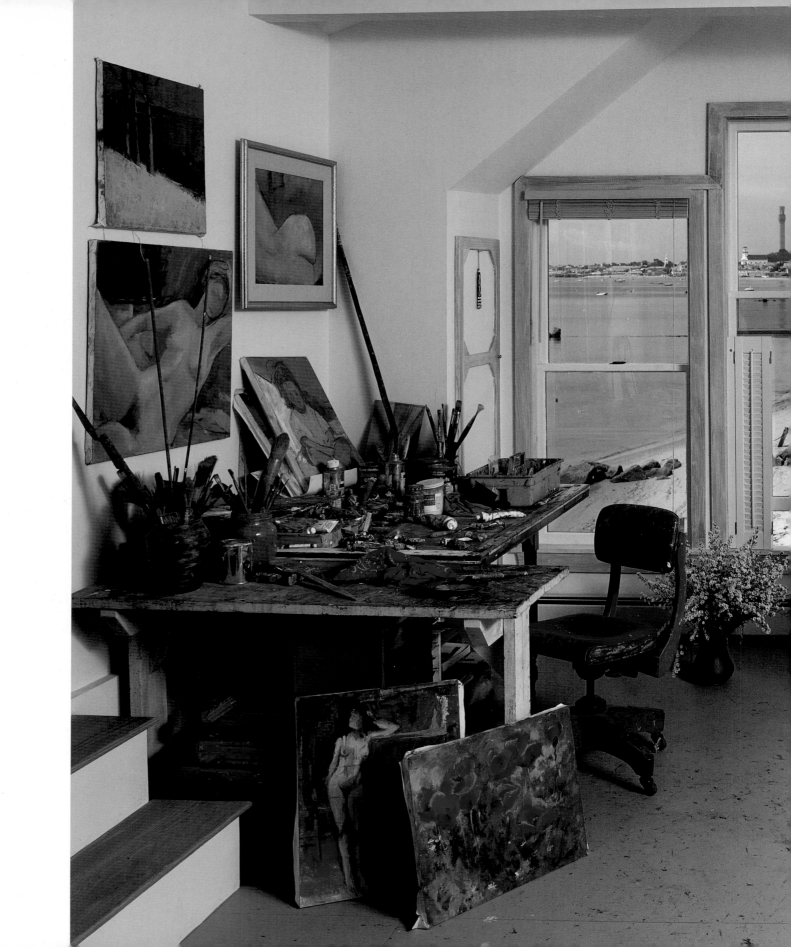

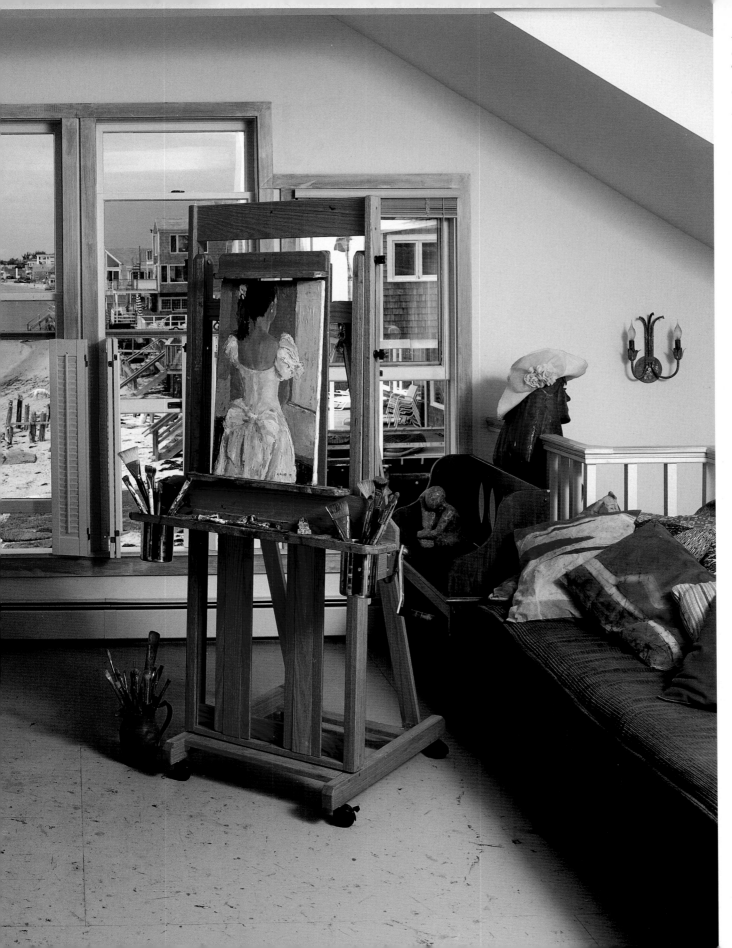

Anne's studio overlooks almost the entire length of Provincetown. The Pilgrim Monument is in the distance. On the easel is one of Anne's portraits of her daughter Susan.

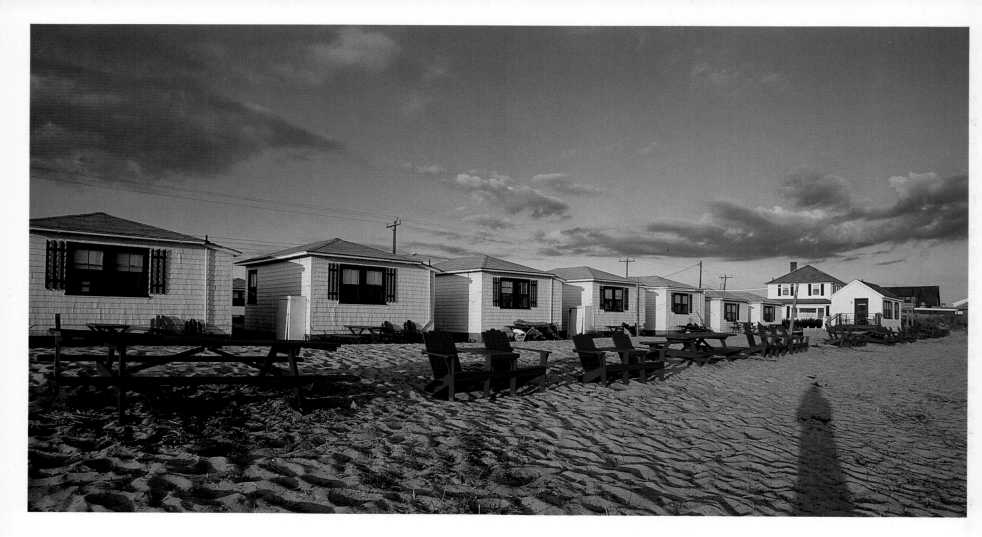

Greg Hadley began working with Taylor Lewis as his assistant in 1984, and since that time assisted Taylor with the photography of eight books, including *Victorious Victorians, Nantucket: Gardens and Houses, Martha's Vineyard: Gardens and Houses,* and *Chesapeake: The Eastern Shore* in addition to innumerable magazine articles and special brochures for historic homes in Virginia, Washington, D.C., North Carolina, Massachusetts, Rhode Island, Connecticut, and New York. When Taylor died suddenly, two-thirds of the way through the shooting of *Cape Cod: Gardens and Houses,* Greg was the indisputable choice to complete the photography on Taylor's book.

Since 1989, in addition to assiting Taylor on his larger projects, Greg has mixed corporate photography with travel photography around the world. He both assisted Taylor with the architectural photography on *Mustique* and worked as a photographer on the project. He currently resides in Arlington, Virginia.

Photographs by Greg Hadley appear on the following pages: i, ix, 18–19, 28–37, 39 top left, 42–43, 44 bottom right, 45, 47, 56 right, 57–59, 63, 72, 74–76, 104–111, 114–30, 132–33, 140–47, 158–67, 176–81, 191–202, 204–208, 212–13, 242–43, 246–48, 254–76. Photograph of Greg Hadley by Bill Geiger.

It was my great fortune to have worked so closely with Taylor Lewis for so many years. As a photographer, Taylor had the skills and vision to transcend styles, adapt to changing technology, and master many types of photography. As a teacher, he was patient and generous, sharing his gift and lending support to me whenever possible. It was an honor to complete this book and have my work appear alongside that of Taylor Lewis.

—*Greg Hadley*

SOURCES

ANTIQUES CONSULTANTS

Michael Bertollini
Paul Madden

ARCHITECTS/DESIGNERS

David Carnivale, pp. 256–60
Anthony Ferragamo, pp. 38–45 (addition)
Thomas Green, pp. 256–60
John H. Harris, pp. 74–76
Joe Kelley, pp. 216–23
Eleanor Raymond, pp. 146–57
Tom Rowlands, pp. 79–89
Richard Seaberg, pp. 208–13
Streibert Associates, pp. 2–15
Richard Wills, pp. 114–23

BED AND BREAKFASTS

Morgan's Way, pp. 208–13
Rive Gauche, pp. 182–89
Spring Hill, pp. 46–53
Wingate Crossing, pp. 20–27

BUILDERS

Bob Baker, pp. 268–75
Cape Associates, pp. 208–13
Ken Cowgill, pp. 78–79
Don Delaney, pp. 216–23
Newton Builders, pp. 2–15 (addition)
Nickerson Homes Inc., pp. 191–93
Rogers and Marney, pp. 74–76, 114–23

DECORATIVE PAINTERS

John Canning, pp. 2–15
Harrisons, pp. 114–23
John Madeiros, p. 48
Gerard Wiggins, pp. 195–201

FLOWER ARRANGEMENTS AND STYLING

Author, pp. 27, 62–73, 79–89, 124–30, 142–47,
 168–74, 176–81, 208–13, 256–60
Michael Baranowski, pp. 250–53, 272
William Baxter, pp. 148–57
Richard FitzGerald, pp. 104–11, 114–23
Diane Madden, pp. 2–15

Becky Overman, p. 128
Helen Pond, pp. 92–103
Herbert Senn, pp. 92–103

GARDEN ADVISORS

Jan Alspach
Valerie Piper
Margaret Koski Schwier
Barbara Streibert
William R. Whitney

INTERIOR DESIGNERS

Bob Baker, pp. 268–75
Helen Baker, pp. 38–45, 124–30
Richard FitzGerald, pp. 104–11, 114–23
Dean T. Hara, pp. 256–60
Gail Hewitt, pp. 216–23
Jean Van Echo, pp. 208–13

LANDSCAPE ARCHITECTS/DESIGNERS

Ron Boucher Associates, Inc., pp. 104–11
G. Rockwood Clarke, III, pp. 124–30
Crossroads Landscape Design, pp. 208–13
Nauset Landscape, pp. 216–23
Wayne Traveras, pp. 74–76
William R. Whitney, pp. 168–74, 208–13, 216–
 23, 242–53, 256–60

LANDSCAPE CONSULTANTS

Gerald D. Moore, pp. 166–67

LANDSCAPE GARDENERS

Leo Seletsky, pp. 158–61
Valerie Piper, pp. 176–81, 191–93, 205–207

STONE WALLS DESIGN

Ray Bernier, pp. 176–81

SELECTED GARDEN AND HISTORICAL REFERENCES

Beston, Henry. *The Outermost House: A Year of Life on
 the Great Barrier Beach of Cape Cod.* New York:
 Henry Holt, 1985.

Boyce, Charles. *Dictionary of American Furniture.* New
 York: Henry Holt, 1985.
Clausen, Ruth Rogers, and Nicholas H. Ekstrom.
 Perennials for American Gardens. New York: Random
 House, 1989.
Crosby, Katharine. *Blue-Water Men and Other Cape-
 Codders.* New York: Macmillan, 1946.
Dirr, Michael A. *Manual of Woody Landscape Plants.*
 3d ed. Champaign, Ill.: Stipes Publishing
 Company, 1983.
Foley, Daniel J. *Gardening by the Sea, from Coast to
 Coast.* Orleans, Mass.: Parnassus, 1982.
Friary, Ned, and Glenda Bendure. *Walks and Rambles
 on Cape Cod and the Islands.* Woodstock, Vt.:
 Backcountry Publications, 1992.
Kittredge, Henry C. *Cape Cod: Its People and Their
 History.* Orleans, Mass.: Parnassus Imprints, Inc.,
 1987.
Medeiros, John D. *Antiquing: The Art of Glazing.* New
 York: Carlton Press, 1986.
Mitchell, Matthew. *The Legends of Hannah Screecham.*
 Boston: Langford Publishing Company, 1993.
Moffett, Ross. *Art in Narrow Streets.* Provincetown,
 Mass.: Cape Cod Pilgrim Memorial Association,
 1989.
Vertrees, J. D. *Japanese Maples.* Forest Grove, Ore.:
 Timber Press, 1978.
Wyman, Donald. *Wyman's Gardening Encyclopedia.*
 Rev. ed. New York: Macmillan, 1971, 1977.

PRODUCTION CREDITS

Design concept by Taylor Lewis
Photo layouts by Taylor Lewis, Robert Reed, and
 Jeffrey L. Ward
Photography assistance by Greg Hadley, Jake
 Jamison, and Chris Cunningham
Copyedited by Shelly Perron and Margaret Koski
 Schwier
Proofread by Susan Groarke, Nancy Inglis, and Pam
 Stinson
Production editorial by Pam Stinson
Composition by N.K. Graphics
Production coordination by Peter McCulloch
Printed and bound by Amilcare Pizzi

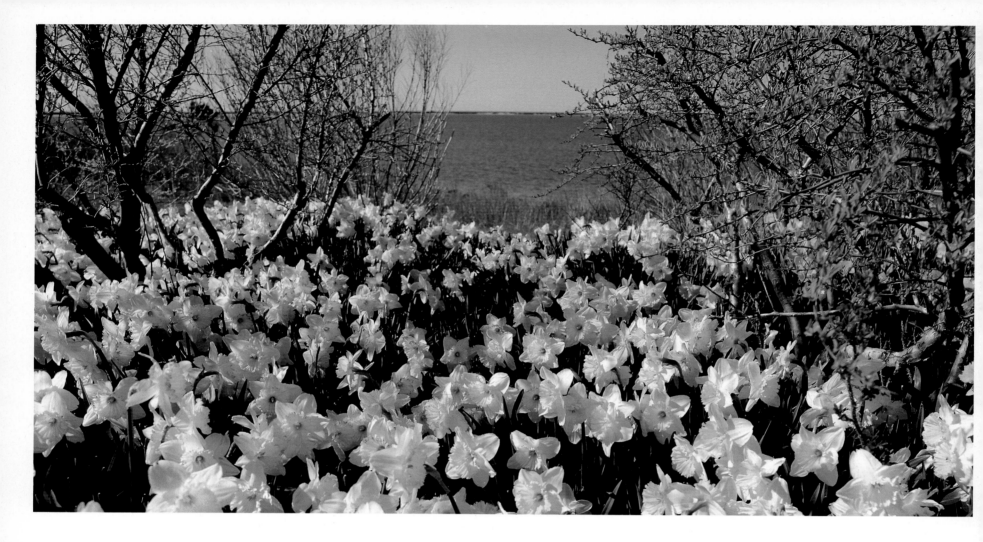

TAYLOR BIGGS LEWIS, JR.

FEBRUARY 22, 1931–JUNE 13, 1993

Taylor Lewis's passion was photography, and his genius was in using photography to bring to life the way people live through their homes—the personal details of their environments, the gardens they create and tend, and the houses they make into homes, each one as unique as its owners. Taylor was a master at capturing the dramatic and poetic scene—a lighthouse at twilight, a shimmering fog-bound pond, a cranberry bog, a tree-lined country road, a sailboat floating in the bay. There are hundreds of memorable images he captured of the world around us. His photographs reach out to the viewer, and invite the viewer in. If the criterion of a work of great photography is its power to arouse emotion in the beholder, then Taylor's photographs must be considered such.

Taylor's career in photography was launched in his father's art studio, first as a model and then as a photographer of models for advertising and magazine illustration in the late 1930s and throughout the 1940s. He won his first photographic contest at the age of thirteen and, also as a teenager, he won the first San Francisco *Call-Bulletin* photo contest. Over his long career, Taylor strove never to do the same thing twice and was always changing and moving forward, both in his photography and his life.

Taylor found joy in his work—an experience not everyone is fortunate enough to have—and he has left a legacy of images that will continue to give pleasure to the readers of his books and the viewers of his photographs.

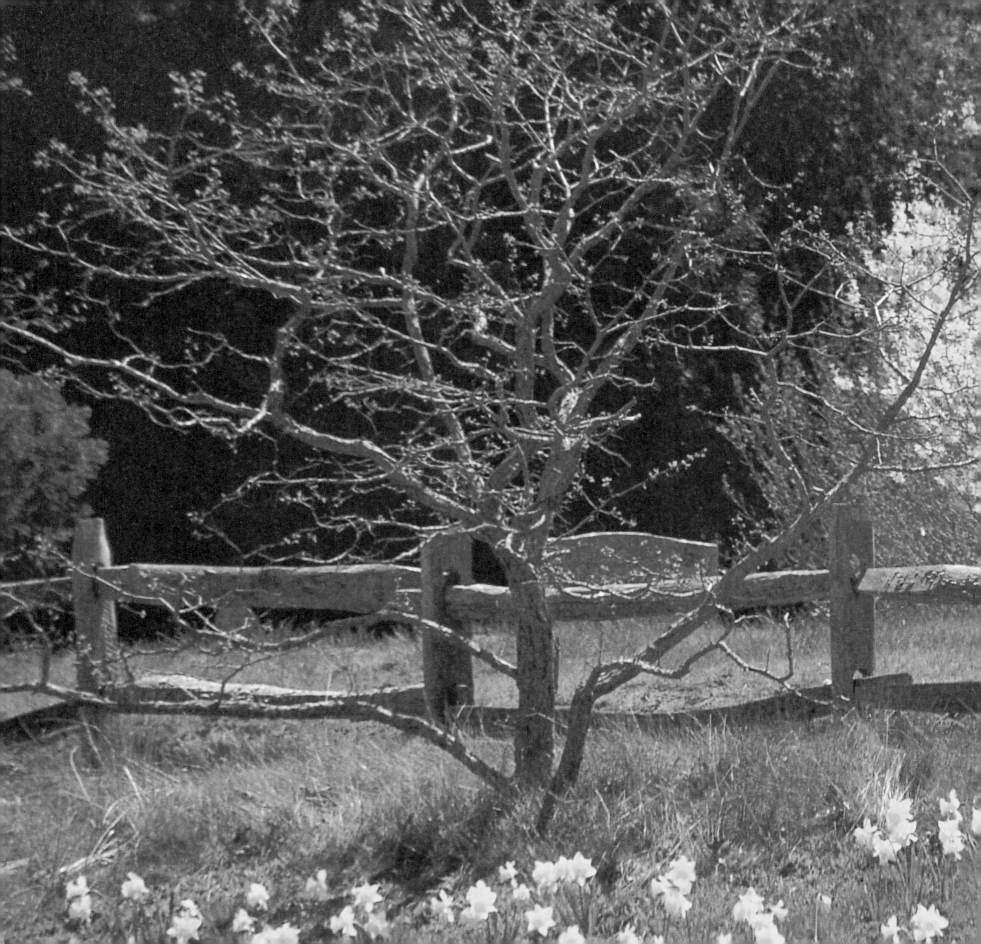